THE PAINTERLY PRINT

Monotypes from the
Seventeenth to the
Twentieth Century

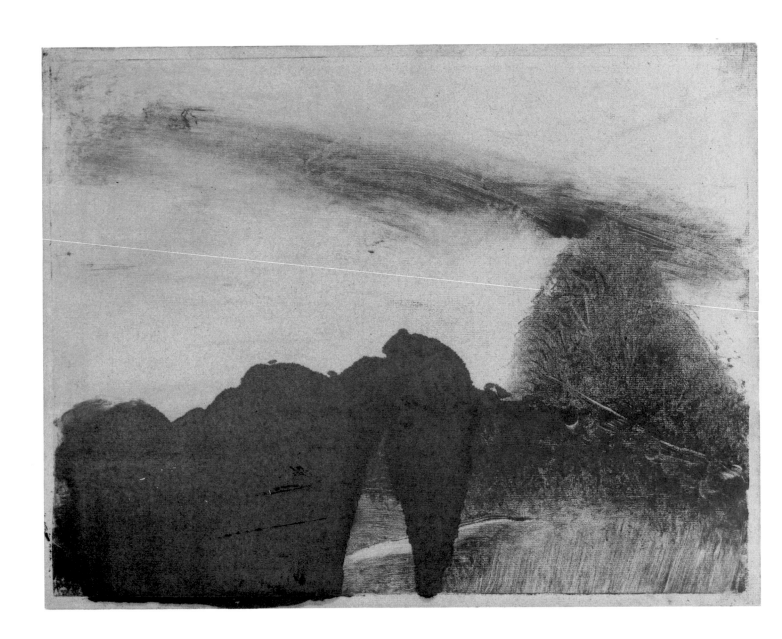

THE PAINTERLY PRINT

Monotypes from the Seventeenth to the Twentieth Century

The Metropolitan Museum of Art, New York

This book was published in connection with an exhibition at The Metropolitan Museum of Art, New York, from October 16 to December 7, 1980, and at the Museum of Fine Arts, Boston, from January 24 to March 22, 1981.

COVER: Milton Avery, *Myself in Blue Beret*, 1950 (cat. no. 89).

FRONTISPIECE: Edgar Degas, *A Wooded Landscape*, about 1890-93 (cat. no. 34).

PUBLISHED BY
The Metropolitan Museum of Art, New York
Bradford D. Kelleher, Publisher
John P. O'Neill, Editor in Chief
Margaret Aspinwall, Editor
Peter Oldenburg, Designer

Distributed by Rizzoli International Publications, Inc., New York

LIBRARY OF CONGRESS CATALOGING IN PUBLICATION DATA
Main entry under title:
The Painterly print.
 Bibliography: p.
 Includes index.
 1. Monotype (Engraving) – Exhibitions.
I. New York (City). Metropolitan Museum of Art.
II. Boston. Museum of Fine Arts.
NE2243.P34 769'.074'014461 80-10441
ISBN 0-87099-223-6 cloth (MMA)
ISBN 0-87099-224-4 paper (MMA)
ISBN 0-8478-5323-3 cloth (Rizzoli)

CONTENTS

FOREWORD

A specific art technique rarely forms the basis – at least successfully – for assembling an exhibition. The process called monotype, however, is so distinctive and so little known despite its rich history and new-found popularity that it deserves special attention and serves as a unifying link for works of considerable stylistic variety.

Monotypes, because they are printed paintings or printed drawings, resemble no other engraved, carved, etched, or lithographed prints. Their surfaces, although flat and relatively smooth, fully record an active and varied manipulation of pigments that precedes transfer to paper. Because the technique lies on the periphery of the classical canons of graphic process, the monotype generally attracts artists who are adventurous with the formulation of their pictures and with the use of their materials. These are usually painters who are also printmakers; and whether they are working on canvas or paper they enjoy the physical activity of drawing and painting as well as the substance of inks and oil colors.

The recent, widespread interest in making monotypes is indicative of the experimental spirit that pervades the graphic arts today. At one end of the spectrum printmakers utilize the mechanical and photomechanical techniques of mass production and at the other, strive to honor, as monotypes do, the individuality of the human hand.

This is the first time that an exhibition surveying the history of the monotype has been presented. Only scant research on the use of the technique had been accomplished before this project was undertaken, and thus three years of investigation were required to collect information and art works. Four curators are responsible for the preparation of this exhibition and its catalogue: Colta Ives and David W. Kiehl in the Department of Prints and Photographs at The Metropolitan Museum, New York; Barbara Stern Shapiro and Sue Welsh Reed of the Department of Prints, Drawings and Photographs at the Museum of Fine Arts, Boston. To their collaboration was added the expertise of an artist and an art historian, both of whom contributed essays to this publication: Michael Mazur, a painter and printmaker who has practiced and taught the technique of monotype for more than a decade, and Eugenia Parry Janis, Professor of Art

History at Wellesley College, whose catalogue and exhibition of Degas's monotypes at the Fogg Art Museum in 1968 stimulated the growth of interest in monotypes as a distinct and fascinating art form.

In addition to those named above, numerous other museum professionals, scholars, and connoisseurs, both in America and in Europe and who cannot be mentioned individually here, have assisted in the realization of this project and all deserve our thanks as well. Finally, we wish to express our sincere appreciation to the institutions and private collectors listed on the following pages who have generously lent works to *The Painterly Print* so that this exhibition could be realized.

PHILIPPE DE MONTEBELLO, *Director*
The Metropolitan Museum of Art

JAN FONTEIN, *Director*
Museum of Fine Arts, Boston

PREFACE AND ACKNOWLEDGMENTS

Technically, the monotype is the simplest form of printmaking. An artist need only ink or paint a surface such as metal or glass and then print the pigments on paper in order to make a monotype. Whereas traditional printmaking techniques like woodcut, etching, or lithography involve the cutting or chemical fixing of a design in a plate so that the image can be repeatedly inked and printed, monotype does not. The direct transfer of a fresh painting or drawing, this process is meant to yield just one ("mono-") print ("type").

The fact that monotypes are unique prints rather than multiples accounts for both their scarcity and their relative obscurity. Until recently so few artists produced monotypes that they were considered curiosities, even among knowledgeable print collectors and connoisseurs. Because of the medium's close ties to drawing and painting, there continues to be a reluctance to accept monotypes as prints per se. Many national print shows, for instance, caution artists submitting entries that "all print mediums are accepted, except monotype."

Not until 1968 when seventy-nine monotypes by Edgar Degas were exhibited at the Fogg Art Museum in tandem with the publication of a catalogue by Eugenia Parry Janis of Degas's extraordinary body of work in this medium was substantial interest in monotypes developed. So spellbinding was the revelation of Degas's all-but-forgotten masterpieces that artists who had never seen monotypes before began making them, and art historians who had never read of monotypes before began researching them. As a result, more than a dozen important exhibitions devoted to the medium have appeared in museums and galleries across the country in the last decade and in that time studies have been devoted to monotypes by Camille Pissarro, Paul Gauguin, Maurice Prendergast, Milton Avery, Marc Chagall, Matt Phillips, Richard Diebenkorn, and Nathan Oliveira. Numerous group exhibitions of monotypes by American artists both past and present have originated in New York, Boston, Northampton, Annandale-on-Hudson, Princeton, Washington, San Francisco, Oakland, Palo Alto, Santa Barbara, and Los Angeles, including a major survey of contemporary works entitled *New American Monotypes* prepared by Jane M. Farmer and now circulating nationwide under the sponsorship of the Smithsonian Institution.

Without the trailblazing accomplished by the directors of these projects, the task of preparing our own study would have been all but impossible.

The aim of this exhibition and its catalogue is to trace the history of the monotype medium from its first known use in the seventeenth century to its more popular practice today. Since much of this territory is traveled by us for the first time, it is certain that grounds for further exploration remain. In the course of our three years' research we have been led to many more artists and works than we could possibly include in this survey, and although we have reviewed hundreds of monotypes in this country and abroad, we have, due to limitations of time and space, focused attention on just forty-two artists whose use of the monotype process effectively expands our understanding and appreciation of the technique and simultaneously offers us visual pleasure.

For the purposes of this survey we have adhered to a definition of the monotype that follows closely that of the eminent print cataloguer Adam Bartsch who published in 1821 what is probably the first description of the process. Bartsch determined that the earliest maker of monotypes, Giovanni Benedetto Castiglione, "liberally coated a polished copper plate with oil color... [and] had it printed on paper..." (Adam Bartsch, *Le Peintre Graveur* [Vienna, 1821], vol. 21, pp. 39-40). The term "monotype" did not appear in print until sometime later, the first instance we know of occurring in the November 1881 issue of the *Art Journal* where reference was made to works in the process by A. H. Bicknell, Charles A. Walker, and William Merritt Chase.

Like Castiglione's monotypes, those included in this catalogue originated as paintings or drawings made expressly to be printed on paper. Other types of transfer methods such as tracing or rubbing are not included within this context, nor are counterproofs of drawings or paintings which are not, as monotypes are, the final products toward which an artist's work is directed. Specially hand-inked etchings, woodcuts, lithographs, and the like which we call "monoprints" belong in a category apart from monotypes since they are printed from plates in which the matrix of a design is carved or otherwise fixed. We have, however, included in this exhibition a few examples of Rembrandt's creatively inked etchings because of their influential role in the origins of the monotype, and also a work by Jasper Johns which bears the ghost of a lithography plate beneath its printed painting thus straddling the distinction between monotype and monoprint. (It should be mentioned here also that no specific connection exists between the picture-making technique under discussion and the typesetting method known in the printer's trade as "monotype.")

Seldom do any two artists use exactly the same methods to produce monotypes, indicating that the medium holds practically limitless possibilities for personal expression. By varying the types of pigments – oil paints, printers' inks, watercolors, and gouaches – along with different kinds of thinners and tools, papers and presses, an extraordinary diversity of results can be obtained. Like any other printmaking technique, however, the monotype is no more than

an instrument in the service of its master. William M. Ivins, Jr., reminds us in his book *Prints and Visual Communication*, ". . . what makes a medium artistically important is not any quality of the medium itself but the qualities of mind and hand its users bring to it. . . ."

Many artists, collectors, art historians, and curators have contributed their time, effort, and the wisdom of experience to the planning and research of this exhibition and catalogue. We are very grateful to all those who showed a generous interest in this project, particularly the lenders who have shared their monotypes with us, as well as Clifford S. Ackley, Brooke Alexander, D. Frederick Baker, James A. Bergquist, David Bindman, Dominique Bozo, Robert Brady, Doreen Bolger Burke, Martin Butlin, Frances Carey, Riva Castleman, Marjorie B. Cohn, Gérald Cramer, Roy Davis, Richard S. Field, Jay M. Fisher, Judith Goldman, Antony Griffiths, Jeffrey Hoffeld, Harold Joachim, Robert Flynn Johnson, Paula Z. Kirkeby, Antoinette Kraushaar, Cecily Langdale, William S. Lieberman, Karin von Maur, Michel Melot, Ann Percy, Bennard B. Perlman, Ronald Pisano, Andrew Robison, Jean-Claude Romand, Anne Schirrmeister, Helen Farr Sloan, Alan N. Stone, Elizabeth and David Tunick, Wendy Wick, and members of the departments of prints, photographs, and drawings at the Museum of Fine Arts, Boston, and The Metropolitan Museum of Art, New York. Eugenia Parry Janis and Michael Mazur deserve recognition for their continued thoughtful assistance.

We wish to express our appreciation especially to the staff of The Metropolitan Museum of Art where arrangements for loans, special photography, and the preparation of this catalogue were ably managed by Joan Ades, Herb Moskowitz, Laura Grimes, Mark Cooper, Polly Cone, Margaret Aspinwall, Peter Oldenburg, Hal Morgan, and Mary Crist.

COLTA IVES, *Curator-in-Charge*
Department of Prints and Photographs
The Metropolian Museum of Art

DAVID W. KIEHL, *Assistant Curator*
Department of Prints and Photographs
The Metropolitan Museum of Art

SUE WELSH REED, *Assistant Curator*
Department of Prints, Drawings and Photographs
Museum of Fine Arts, Boston

BARBARA STERN SHAPIRO, *Assistant Curator*
Department of Prints, Drawings and Photographs
Museum of Fine Arts, Boston

LIST OF LENDERS

Her Majesty Queen Elizabeth II
Mr. and Mrs. Harry W. Anderson, Atherton
Anonymous Lenders and Private Collections
Mrs. Milton Avery, New York
Baker-Pisano Collection, New York
Mr. Gérald Cramer, Geneva
Mr. and Mrs. R. Diebenkorn, Santa Monica
Mr. Jean Dubuffet, Paris
Mrs. Adaline Frelinghuysen, New York
Mr. George Gelles, New York
Mr. and Mrs. Andrew King Grugan, Williamsport
Ittleson Collection, New York
Mr. Jasper Johns, New York
Mr. Henry D. Ostberg, New York
Mrs. Charles Prendergast, Westport
Mrs. Bertram Smith, New York
Katharine Sturgis
Mr. A. Sutter, Paris
Mr. and Mrs. Eugene Victor Thaw, New York
Mr. and Mrs. David Tunick, New York
Mr. Emile Wolf, New York
Mr. and Mrs. Anthony Woodfield, New York

Baltimore, The Baltimore Museum of Art
Brescia, Pinacoteca Civica "Tosio Martinengo"
Birmingham, Michigan, Donald Morris Gallery, Inc.
Boston, Museum of Fine Arts
Cambridge, Fogg Art Museum, Harvard University
Chatsworth, Devonshire Collection
Chicago, The Art Institute of Chicago
Cincinnati, Cincinnati Art Museum
Cleveland, The Cleveland Museum of Art
London, The British Museum
London, The Tate Gallery
New York, Aldis Browne Fine Arts, Ltd.
New York, Associated American Artists
New York, The Metropolitan Museum of Art
New York, The Museum of Modern Art
New York, The Pace Gallery
New York, The Pierpont Morgan Library
Paris, Musée Picasso
St. Louis, The St. Louis Art Museum
San Francisco, California Palace of the Legion of
 Honor (The Achenbach Foundation for Graphic
 Arts)
Stuttgart, Schlemmer Estate
Vienna, Graphische Sammlung Albertina
Washington, D.C., National Collection of Fine Arts,
 Smithsonian Institution
Washington, D.C., National Gallery of Art
Washington, D.C., National Portrait Gallery,
 Smithsonian Institution
Wilmington, Delaware Art Museum

THE PAINTERLY PRINT

Monotypes from the
Seventeenth to the
Twentieth Century

SUE WELSH REED

Monotypes in the Seventeenth and Eighteenth Centuries

Monotypes as we know them today only became relatively common in the late nineteenth century, although the technical knowledge necessary to make them has existed at least as long as intaglio printmaking, since the fifteenth century. A monotype (or single print) is produced by printing one impression from a smooth, unworked surface on which an image has been created with ink or paint. Enough pigment often remains to print or "pull" a second or even a third impression, sometimes called a "ghost" or "cognate."[1]

A related technique is counterproofing. Since at least the sixteenth century, counterproofs from drawings and paintings have been taken on paper to record motifs or to assist a printmaker with reversal.[2] Chalk drawings may be put through the press with a dampened sheet of paper that picks up a fainter and reversed version of the image. Similarly, motifs from completed paintings may be outlined in moist pigments and transferred to paper by rubbing. Printmaking and counterproofing methods were described in many early texts, but as far as is known the monotype was not noted until the early nineteenth century.[3] The means were there; the practice only awaited the right artistic climate to emerge as it did in the seventeenth century.

About the same time, in the mid-1640s, and apparently independently, two painter-etchers, Rembrandt van Rijn in Amsterdam and Giovanni Benedetto Castiglione in Genoa, began to manipulate printing ink on copperplates so as to print a continuous tone, analogous to an ink or watercolor wash. Both were deeply involved with textures of paint and both made hundreds of painterly drawings using brush or other drawing tools that produced a broad stroke. In

their prints, both artists sought tonal effects through the use of drypoint burr, by abrading the plate, and by utilizing accidental or intentional granular biting. The only true printmaking practice available at that time that produced a continuous tone was mezzotint, still in its infancy. Neither artist attempted this method, but instead they "painted" with printing ink on the surfaces of their copperplates. One basic difference separates the two: Rembrandt left a film of ink on selected areas of the surface of his etched copperplates, while Castiglione drew into ink spread on a smooth copperplate to produce the first true monotypes.

Rembrandt's 1634 etching *The Annunciation to the Shepherds* (Bartsch 44) is characterized by an outburst of baroque energy expressed in terms of light and shade. In *Saint Jerome in a Dark Chamber,* 1642 (Bartsch 105), the artist pushed darkness to an awesome extreme (fig. 1). Each of these prints depends for its effects on density of line alone, rather than ink left on the surface of the plate. By the mid-1640s Rembrandt was leaving printing ink on the surfaces of his etched plates to create areas of continuous tone. For two decades he printed impressions from the same plate that may differ dramatically one from the other because of the selective wiping (see cat. nos. 1-4).[4]

One must take into account the impact of the extraordinary etchings of Hercules Segers (1589/90 – after 1633) on Rembrandt, particularly when he created tonal effects by means of drypoint, granular bitten tone, burnished highlights, or a film of ink on the plate. Segers frequently printed on colored grounds and used colored printing inks to make each impression unique and painterly.[5]

Dutch contemporaries and followers of Rembrandt sometimes utilized accidental scratching or bitten tones on their etched plates, as did Rembrandt himself, but they rarely employed surface tone.[6] To our knowledge, neither these printmakers nor Rembrandt ever made a pure monotype. This pioneering step was taken by the Genoese artist Giovanni Benedetto Castiglione.

Early in his career as a painter and draftsman, Castiglione exhibited an interest in the work of northern painters who were active in Italy and whose work explored the dramatic possibilities of chiaroscuro lighting effects. The work of Adam Elsheimer (1578-1610) and the prints after his designs by Hendrik Goudt (1573-1648) could have been known to Castiglione when he was first in Rome between 1632 and 1635. This early sensitivity to the work of northern artists may have led him to study Rembrandt's etchings, imported into Italy by visiting northerners. The motif and technique used in Castiglione's series of oriental heads etched in the late 1640s reflect the influence of similar heads of the 1630s by Rembrandt and Lievens.

Just as Rembrandt was working toward tonal effects in his prints in the 1640s, so was Castiglione. The latter achieved such effects in his etchings by using a close network of scribbly lines, closer to Rembrandt's technique than to any Italian prototype, (cat. no. 8 and fig. 49). Castiglione also tried drypoint burr and

fine abrasions on the plate.[7] Unlike Rembrandt, Castiglione does not appear to have manipulated ink on the surface of the plate to create dramatic differences between impressions. Although an occasional impression is not completely clean wiped, the tonal effect appears more casual than deliberate. Nonetheless, Castiglione did search for tonal effects in printing, and in a unique manner. He separated completely the use of plate tone from bitten line, thus becoming the first practitioner of the monotype process and making a total of twenty-two subjects known today (see cat. nos. 5-15).[8]

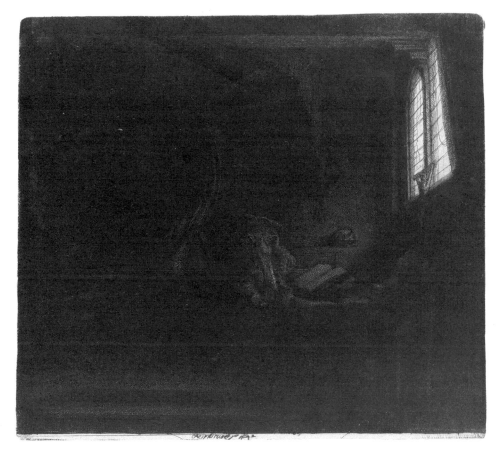

FIG. 1.
Rembrandt, *Saint Jerome in a Dark Chamber*, 1642 (Bartsch 105, first state), etching.

Museum of Fine Arts, Boston; Gift of Lydia Evans Tunnard, 61.1363

Between 1660, the date of Castiglione's last known monotype, and the mid-1870s when Degas took up the same medium, no artist of major importance except William Blake is known to have made monotypes. There exist a few monotypes of inferior quality attributed to unknown followers of Castiglione.[9] Several have been attributed to the French marine painter active in Italy, Adrien Manglard (1695-1760).[10]

While exceptions may turn up in the form of hitherto unknown monotypes, there seems to be good reason not to expect them in either quantity or quality. Between the mid-1600s and 1800 new printmaking techniques evolved that

5

could produce a continuous tone: mezzotint, aquatint, and lithography. Moreover, printmaking separated itself from the painter's studio and there was a growth in the number of professional printmakers whose aim was a large production of well-crafted prints for a growing market. One inclination during this period was toward a clear, linear style, and no painters who were predisposed toward a more pictorial and imprecise effect such as that given by monotypes were known to have made them. Piranesi, who was perhaps the greatest printmaker of the eighteenth century, was not a painter.[11]

There is no immediate historical precedent for William Blake's use of the monotype technique. It evolved from his explorations of printing book illustrations in color. Always experimenting, the poet-printmaker transferred his handwriting and drawings to copperplates, etched these in relief, and printed from the surface of the plate. The first complete book he produced in this method was *Songs of Innocence* (1789). He often colored the illustrations in brush and watercolor. Blake then sought to print additional colors, perhaps to increase his production and sales.[12] Instead of using an established method of tonal printing such as mezzotint or aquatint, he painted thick pigments on a flat surface or on depressed areas of the same plate and printed over the impression of the lines. Of the several books produced by this method in 1794 and 1795, *The Book of Urizen* (1794) bears the closest similarities to the monotypes in its opaque and intense coloration and somber mood.

Eliminating the use of an etched plate, Blake printed the monotypes entirely from a flat surface on which he painted the design. A revealing but partly inaccurate account of his method was given in the early 1860s by Frederick Tatham, an artist who had known Blake toward the end of his life.[13] Subsequently, several artists and art historians have reconstructed Blake's printing methods, and each has made significant contributions to our understanding of the interrelated processes that produced both the books and the monotypes.[14]

It would appear that Blake, who had an aversion to oil paint, used a tempera medium (pigments mixed with egg yolk) with which he painted on millboard (thick cardboard used for book covers). He first outlined the composition in one color and printed this guide up to three times. Next he painted broad areas of color on the board, using a thick, tacky medium (egg tempera or perhaps pigments mixed with carpenter's glue).[15] He printed a second time over the impressions of the line drawing. The monotypes were probably printed in a screw press (used for relief blocks) rather than a rotary press (used for intaglio plates) for there are no platemarks. Occasionally he scratched white lines into the printed pigment. Three identical images, differing only in intensity, were then printed and, when dry, were ready to be finished in pen and watercolor. (There are no readily perceptible difficulties with registration in these twice-printed monotypes. Blake's skill as a printer probably accounts for this, plus the fact that the images were reworked in pen and watercolor.)

In 1795 Blake made twelve color monotypes, pulling up to three impressions

from each (see cat. nos. 16-18).[16] At least eight retouched impressions of the "edition" bear the date 1795 in pen and ink. Other impressions need not have been completed in pen and watercolor immediately. The eight dated 1795 were among twelve sold to Thomas Butts in 1805. Another complete set was offered for sale in 1818, there described by Blake as "12 Large Prints, . . . Historical and Poetical, Printed in Colour."[17]

The twelve monotypes of 1795 contributed significantly toward Blake's development as a visual artist. He went on to paint relatively large, independent works in tempera and in watercolor, especially during the decade 1800-10. As a group, the monotypes remain the most colorful and painterly of Blake's works. It is not surprising that other artists did not pick up Blake's monotype technique, for he was out of the mainstream of English art.[18]

The photographic process came into use in the 1840s and was capable of producing continuous tone; its practitioners rapidly developed refinements and expanded uses. It remained for the etching revival of the 1860s and the reevaluation of Rembrandt's richly inked drypoints and etchings to pave the way for the revival of monotype.

1. See Michael Mazur, "Monotype: An Artist's View," pp. 55-61.

2. References to counterproofs from the sixteenth through the eighteenth centuries may be found in Joseph Meder, *The Mastery of Drawing*, translated and revised by Winslow Ames (New York, 1978), vol. 1, pp. 267, 399-401, 493.

3. Castiglione's technique is described by Adam Bartsch in *Le Peintre Graveur* ([Vienna, 1821], vol. 21, p. 39), where it is referred to as "imitating aquatint," but not named. The first historical discussion of monotypes we know is Sylvester R. Koehler's "Das Monotyp" (*Chronik für vervielfältigende Kunst*, vol. 4, no. 3 [1891], pp. 17-20), where monotypes by Castiglione, Blake, William Merritt Chase, and Charles Alvah Walker are mentioned. Koehler also referred to the specially inked etchings of Rembrandt and Lepic. No mention was made of Degas.

4. Rembrandt also utilized both plate-polishing scratches and a bitten, granular texture that retained ink and gave a tonal effect when printed. This is noticeable on *Clement de Jonghe* (1651) and *Saint Jerome in an Italian Landscape* (1653-54). See Eleanor Sayre, Felice Stampfle, *et al.*, *Rembrandt: Experimental Etcher* (Boston: Museum of Fine Arts, 1969), nos. 31-36 and 51-53; and Christopher White, *The Late Etchings of Rembrandt* (London, 1969).

5. E. Haverkamp Begemann, *Hercules Segers, The Complete Etchings* (The Hague, 1973), pp. 42-49.

6. For further discussion of Dutch seventeenth-century printmakers and the use of tone, see the forthcoming exhibition catalogue by Clifford S. Ackley, *Printmaking in the Age of Rembrandt* (Boston: Museum of Fine Arts, in press [1980]).

7. Pietro Testa and Stefano della Bella each tried for tonal effects in a few of their etchings by means of abraded or granular bitten tone that was then burnished for highlights. One Testa etching (Bartsch 30) so treated is in a private collection, Philadelphia. For della Bella, see Alexandre De Vesme, *Stefano Della Bella, Catalogue Raisonné*, with introduction and additions by Phyllis Dearborn Massar (New York, 1971), pp. 14-15.

8. Twenty-one are listed in Augusto Calabi, "Castiglione's Monotypes: A Second Supplement," *The Print Collector's Quarterly*, vol. 17 (1930), p. 299. One new subject has come to light in Düsseldorf (see Ann Percy, *Giovanni Benedetto Castiglione, Master Draughtsman of the Italian Baroque*, exhibition catalogue [Philadelphia: Philadelphia Museum of Art, 1971], M4, ill.). Two second pulls have also been located; one of *Noah and the Animals* (Percy M10) at the Metropolitan Museum of Art, and one of *David with the Head of Goliath* (cat. no. 14).

9. Two are reproduced (as by Castiglione) in Emilio Ravaglia, "Tre 'prove uniche' di G. B. Castiglione," *Bolletino d'arte*, vol. 2 (1923), pp. 419-22. Both are rejected and a third described by Augusto Calabi in "The Monotypes of Gio. Benedetto Castiglione," *The Print Collector's Quarterly*, vol. 10, (1923), pp. 252-53.

10. Three were in the collection of Randall Davies. See *Catalogue of a Collection of Counterfeits, Imitations and Copies of Works of Art* (London: Burlington Fine Arts Club, 1924), no. 324. A counterproof in red oil pigment attributed to Manglard was recently on the New York market. His experimental nature is attested to in his etchings, which exhibit abraded tone. Further study of his work might reveal some knowledge of Castiglione's monotypes.

11. Piranesi did on occasion experiment with surface ink on several plates of the *Carceri*. See Andrew Robison, *Giovanni Battista Piranesi: The Early Architectural Fantasies, A Guide to the Exhibition* (Washington, D.C.: National Gallery of Art, 1978), nos. 6 and 28.

12. This suggestion was made by David Bindman, who most kindly spent time discussing Blake's monotypes with me. It is implied in Blake's *Prospectus* of October 1793 (reprinted in Archibald G. B. Russell, *The Engravings of William Blake* [Boston, 1912], pp. 210-11).

13. First published by Gilchrist in his *Life of William Blake* (London, 1863) as told to D. G. Rossetti by Tatham. The account has often been reprinted in books and articles on Blake's techniques. See note 14.

14. Blake's printing techniques are discussed by Graham Robertson in his annotated edition of Gilchrist's *Life of William Blake* (London, 1907); Ruthven Todd in his article cited in cat. no. 16; Martin Butlin in his 1971 catalogue of the Tate Gallery Blake collection cited in note 16 below, as well as in his articles "The Bicentenary of William Blake," *Burlington Magazine*, vol. 100 (1958), pp. 40-44; and "The Evolution of Blake's Large Color Prints of 1795," in *William Blake: Essays for S. Foster Damon*, Alvin H. Rosenfeld, ed. (Providence, 1969), pp. 109-16. Also by Robert N. Essick, in *William Blake's Relief Inventions* (Los Angeles, 1978).

15. Blake was enamored of the early Italian Renaissance painters, but often confused their techniques. He may have misinterpreted Cennini's recipe for tempera. On five known impressions of the monotypes Blake wrote the word "fresco," a term he also used to describe his tempera paintings.

16. Six of the monotypes are known today in three impressions; five in two impressions; and one in a single impression. See Martin Butlin, *William Blake: A Complete Catalogue of the Works in the Tate Gallery* (London, 1971), pp. 34-41.

17. Ibid., p. 34.

18. One monotype has been attributed to Samuel Palmer (1805-1881), a Blake follower. See Raymond Lister, *Samuel Palmer and His Etchings* (New York, 1969), p. 105.

EUGENIA PARRY JANIS

Setting the Tone – The Revival of Etching, The Importance of Ink

But after all, there is nothing like printing as Rembrandt did with your own blackened right hand.

PHILIP GILBERT HAMERTON, *The Etcher's Handbook*, 1871

Of the many Rembrandt-inspired ideals that kindled the 1860s etching revival, the most important was that etching can be a great art, not merely a prosaic way of reproducing images. But there was another related ideal that has escaped notice: though primarily linear, etching might rival other media's tonal effects, escape the confines of matrix, mechanism, and multiplication, and soar free, subject only to a moment's mood, fancy, or chance. With the emergence of such notions, printing came to be viewed less strictly as replication during etching's romantic rebirth. It was poetically revised as artists, guided by Rembrandt's example, discovered that wonderful contradiction so dear to the shackled imagination of an age of mechanical reproduction – the unique variant.

Variability found immediate inspiration in printer's ink. Rembrandt had shown in a variety of impressions pulled from a single etched plate that ink could be interpretatively controlled by an artist's marshaling gestures as through regimentation in bitten furrows (figs. 2, 3). "He was its true inventor, for from a simple process he made an art," Charles Blanc wrote in 1861.[1]

As etching partisans began to define Rembrandt's achievement to the late nineteenth century, they forged a crucial link between the medium and the painterly arts that all but obliterated the reproductive associations it had acquired. They accomplished this boldly, not only by elevating etching to the level

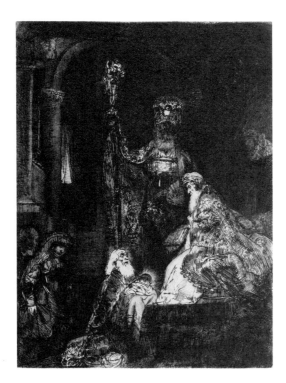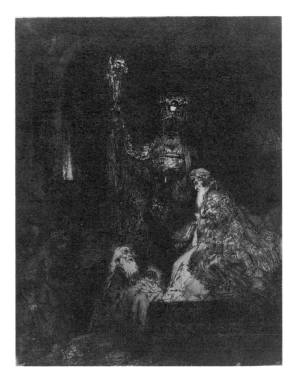

of painting, but by artfully proposing its superiority: "Certainly the most beautiful wash drawing by Rembrandt never would have fetched the same price as a proof of *The Hundred Guilder Print* [fig. 4] or that of *Burgomaster Six* [fig. 5]," Blanc argued to collectors and connoisseurs.[2]

Etching's physical properties also achieved renewed painterly prestige as Blanc recounted Rembrandt's peculiar working methods and established them as the new artistic standard: "In the house he owned in Amsterdam, in Breestraat, Rembrandt had a press and printed his plates himself."[3] Rembrandt controlled every stage of making an etching. He recognized the plate's unforeseen exigencies and administered to them suiting his taste, amplifying his intentions in the process: "Often after having inked them with a pad, he only half-wiped or wiped not at all those parts he wanted to remain muted; in other places where the worn burr no longer produced tone, he reestablished these artificial dusky markings by spreading on printer's ink with his finger. Thus when Rembrandt appeared, the art was transformed. Engraving assumed an unexpected tonality; the print became a picture which instead of having been painted with oils was painted by etching."[4] As conceived by Blanc, the model of the etcher was inextricably connected with intuitive painterly printing. From the pulsating grotto where Christ radiated prophesy to the velvet chamber shrouding a dreamy reader, the master of chiaroscuro had maximized *with ink* his idea to "make all light's marvels scintillate and represent shadow's every nuance."[5]

With nineteenth-century etching's espousal of Rembrandt, ink became a

technique of manipulable shade, paralleled by Barbizon painting's rediscovery of the chiaroscuro of nature (goaded by the revelations of photography) and by the mossy density of Courbet's realism. Directly inspired by Rembrandt but also by the current forms of Dutch art, artists of the nineteenth century transformed painterly printing by assigning ink immoderate importance. It was not the painter-etchers who readily embraced the stylish gossamer of shade. This originated in unlikely quarters and took eccentric form: mavericks of the revival (professional printer, amateur, and painter alike) lavished ink on their plates and exaggerated inking and printing into a veritable cuisine. Justifiable only in part through Rembrandt's precedent of inventive daubing, ink in the hands of a significant minority became an impertinent sauce "hollandaise."[6]

Nearly all etching advocates preaching to their acolytes acknowledged "artifical printing" as a viable theory of etching, the necessary corrective to remedy a great art gone dry, or as the exceptional drollery of dilettantes. Most artists avoided the sauce's obvious artistry (in Manet's etching it is virtually nonexistent).[7] Overall it was ruled out as a dangerous aberration for it threatened to subvert the revival's most cherished goal, the restoration to etching of painting's caprices via spontaneous, lithe, and tremulous etched line. The murky undercurrent continued nonetheless. It was a radical offshoot of the revival, but never characterized as such because its deviance was so peculiar. Few foresaw that ink's new superfluity augured a revolutionary direction for printmaking. Its

FIG. 4.
Rembrandt, *Christ with the Sick around Him, Receiving Little Children ("The Hundred Guilder Print")*, about 1649 (Hind 236), etching, drypoint, and burin, second state.

Museum of Fine Arts, Boston; Gift of Mrs. Horatio G. Curtis, M35559

FIG. 5.
Rembrandt, *Jan Six*, 1647 (Hind 228), etching, drypoint, and burin, second state.

The Pierpont Morgan Library, New York

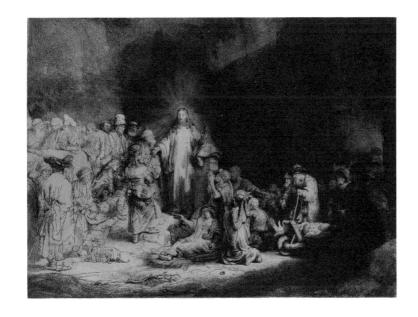

"art" was too facile, the motives of its champions, largely undaunted and unskilled amateurs, questionable.

Ranks of amateurs and minor masters distinguish etching from 1860 onward. This so addled the critics that they were hard put to write about the published work impartially.[8] If the etching revival is ever to be properly understood (a matter not particularly helped by the demurral of our own epoch's most eminent writers on prints),[9] the innovative role of amateurism will require fresh consideration. For setting aside the achievements of its masters (which undoubtedly would have occurred despite the revival), it is clear that the etching revival's general encouragement originated one thing: it permitted dilettantism the illusion of artistic seriousness and rewarded mediocrity with critical accolades.[10] This was sufficient to cause general alarm. But it was exactly the breakdown of artistic hierarchy certain artists were looking for. With an underground of enthusiasts promoting disdained technical practices to conceal faltering skill, limitless horizons of experimentation were projected to painters. This turn of events is awkward for criticism. It is more convenient to credit an aberrant influence to artist-experimentalists. But by the mid-nineteenth century important painter-etchers acknowledged indebtedness to the expressive professional printer and the vibrant amateur, all of whom taught one another.

Wayward inking is the etching revival's untold story. It originated with the recommendations of Rembrandt scholars, such as Blanc, that aspirant etchers pull their own impressions. Experienced etchers joined the chorus. Maxime Lalanne, of the Société des Aquafortistes, heart of the revival in Paris, devoted unprecedented attention to "the impression." In the period's most reflective treatise, he counseled: "It would be so advantageous if each artist would pull his proofs himself. Rembandt is the most illustrious example of this, as he has been of so many ideas we use today."[11]

Treatises on etching published before 1860 usually omitted explanations of inking and proofing. They focused entirely on biting lines, aquatint, or other procedures. "Proving the plate" was to be left to a workman printer.[12] The imperative behind this expression rang of an engraving-dominated morality in etching that the revival was bent on terminating. Whatever good existed in a plate had better be bitten in to stand the test of the pressman's soulless transfer. No wonder a marked similarity was noted between this theory of etching and the production of calling cards.

Etching's recent auxiliary role in the industry of reproductive engraving had relegated it to a limbo of compartmentalized and inexpressive moribundity which the revival sought to remedy by placing a great premium on effortless spontaneity in drawing and in printing. The drawing standard was difficult enough to attain – "l'eau-forte ne blague pas."[13] To emulate Rembrandt's liberal ways with ink as well, even with the best treatises to guide them, direct instruction was required: "An etcher ought to learn to print with a good workman. All that can be taught of the art may be communicated in a week, and the

rest is an affair of natural taste and acquired experience. It is, however, certainly true that nobody can print a plate except the artist who made it, or a clever workman labouring under his direct personal superintendence, and that all printing not done under these conditions is little more than an approximation. An inexperienced etcher fancies that he has nothing to do but to send his plate to an established plate-printer, and get a proof as he would of his visiting-card. But artistic etchings and visiting-cards are very different things."[14] Thus wrote P. G. Hamerton, an ardent and influential critic-connoisseur, typifying the new encouragement and the new morality.

Lalanne also advised collaboration. In so doing he defined etching in terms of the variations among proofs and thus began to evolve new criteria for etching as an art: "An etched impression often deviates from uniformity. Susceptible to the demands of harmony and to individual character in execution, it is variable in its effects and becomes an art in certain instances when the artist and the printer are united in their purpose, the worker apprehending the artist's intentions, the artist accepting the worker's experience."[15] The aim of collaboration, sincere in its attempts to regenerate a lost sensibility, was to teach the artist to print and make the workman more aware of the requirements of the plate. It also laid down the ideal of unimpeded individuality through technique.[16]

The model workman was found in Paris. He was the printer Auguste Delâtre (1822-1907), regarded as an inspired technical genius.[17] According to Seymour Haden, if Delâtre had lived during the seventeenth century, Rembrandt himself would not have pulled his own impressions![18] In his first account of the French etching club, Hamerton, also a keen amateur etcher, was unreservedly enthusiastic about Delâtre: "Printers generally dislike etchings, because they can make nothing of them. The French Etching Club has been peculiarly fortunate in this respect. It happened some years ago that one or two artists who etched, discovered a journeyman printer *who printed their works with such taste and judgment that they declared the proofs were as much his work as theirs.* Such a man was not to be lost sight of, and he soon became known amongst artists. When M. Cadart, the publisher, took up etchings, he knew where to find his printer. M. Delâtre, formerly the workman in question, has now a considerable *atelier* where several presses are always at work on nothing but etchings. He loves a good etching and is himself an etcher. No one in Europe that I know, prints etchings with so much *expression.*"[19]

Expression is a key word in Hamerton's account, and it came to exert a curious dominance through a veil of mystifying ink engulfing the etched line. Delâtre set the tone, as it were, with a process he called *retroussage,* also known as "coaxing." Actually a wiping gesture consisting of passing a rag gently across the plate in a delicate caressing manner to make the ink rise out of the lines and spread itself in a dark tint, *retroussage* resulted in a print with a richer and softer appearance resembling drypoint.[20]

As a printer Delâtre played a dual role, not unconnected to the dubious

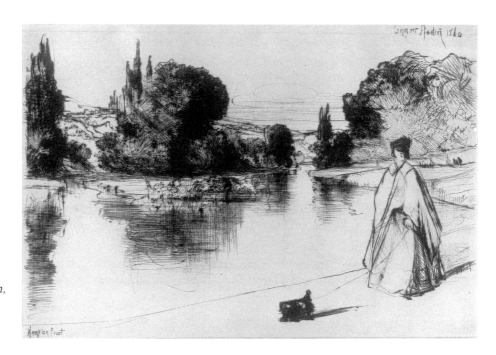

reputation of the etching revival in general. He was at once the artist's guide and the tastemaker amateurs could implicitly trust. The latter included Hamerton: "A great part of the printer's skill consists in leaving a very thin film of ink unequally over the etched part of the plate.... This tints the surface of the impression, in a way often highly favorable to its beauty."[21]

This expressive veil of beauty, good for virtually one impression seemed to liberate etching from dry rigor, rules, and the relentless jaws of standardization. It touched past and present: it was the royal road back to Rembrandt; and by abundantly displaying process materials in ephemeral form that visualized air and the changing light of day, it became Impressionism's ultimate engraved equivalent. The inky film also fed printmaking's ever incipient romanticism:[22] it was the muffled cry in the quest for beauty as bafflement.

The inky film touched etching's major stylistic polemic: romantic chiaroscuro versus a modern etching of *"écriture."* Hamerton's and Lalanne's advice to etchers distinguished between artificial printing (*divers modes d'impression*, where plate tone variously used supplements bitten line) and natural printing (*épreuves naturelles*, impressions which prove the plate, with all tonality achieved through line). This distinction, soon turned into a crisis of principle with ethical proscription forcibly expressed as Hamerton's enthusiasm for Delâtre's peculiar interpretative mode cooled. The brainchild of professionalism as etching's ultimate corrective was rejected, not in favor of modernism but of an etching morality. Hamerton came under the sway of a force if only slightly more influential than himself, not less so for being the better artist. Seymour Haden, surgeon, fluent master of drypoint, and fierce opponent of any kind of etching

14

not pulled "naturally" (from permanent intaglio lines), used Rembrandt to justify clean-line printing.[23] He allowed for ink tone only if attributable to the blurry bleeding drypoint line (at which it will be recalled he was highly skilled; fig. 6) or to deep line having been multi-bitten with acid (fig. 7). (Rembrandt obviously could be held up as a model for almost any etching issue.)

When Hamerton wrote about Delâtre again, he showed a notable change of heart: "Of my own master..., Auguste Delâtre, ...he is an artist in feeling.... *His fault is towards overprinting, so that he hardly* can *print simply,* even when the plate requires it, and his workmen have all got the habit of what may be called interpretative printing which is good when the printer thoroughly understands his plate, and just as bad and dangerous when he does not. Simple black ink in the lines, and clean paper between them, are not generally aimed at or cared for by printers of Delâtre's school: in the endeavor to give artistic richness to plates, they are liable to a loss of delicacy, extending even to muddiness. Notwithstanding these faults, which are no more than the defects of his qualities, and due to artistic instincts sometimes working in a wrong direction, Delâtre is, on the whole, the most intelligent printer of etchings living."[24]

It had gone too far. Expression had become a habit. The apprentice depended on such an expert at his peril. Spontaneous *"écriture"* was the test of the etcher,

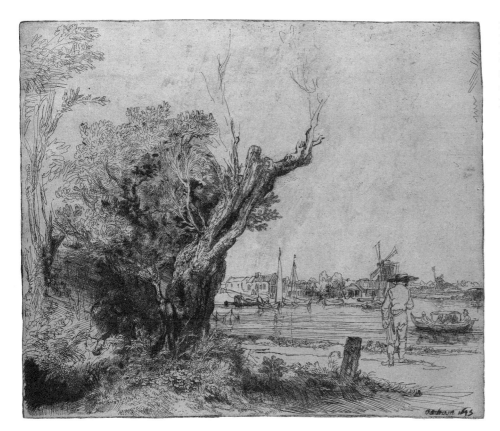

FIG. 7.
Rembrandt, *The Omval,* 1645 (Hind 210), etching and drypoint, second state.

The Art Institute of Chicago; The Clarence Buckingham Collection

15

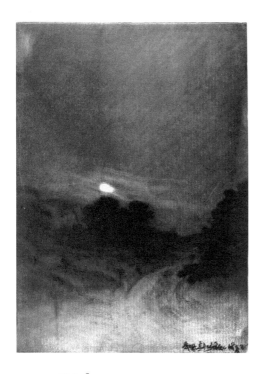

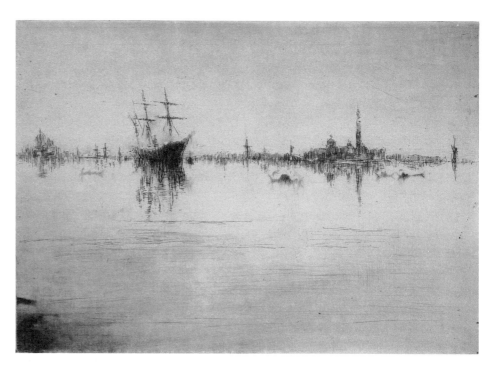

FIG. 8.
Auguste Delâtre, *Effet de lune,* about 1888, etching and plate tone.

Bibliothèque Nationale, Paris; Cabinet des Estampes

FIG. 9.
James A. McNeill Whistler, *Nocturne,* 1879, etching.

The Metropolitan Museum of Art, New York; Gift of Felix M. Warburg and his family, 1941 (41.1.200)

but inking was the crossroads – etching's Scylla and Charybdis: "Etchers are almost as much in the hands of their printers, as authors in those of their translators.... Still better will [the reader] realize it when experience of printers, and practical work in prooftaking, shall have revealed to him that a wonderful power for good and evil may be exercised in the action of wiping an inked plate.... Some years ago I shared more than I do now the views of Delâtre about interpretation: *this was due to the weakness of my own etchings at that time, which benefited by his treatment, and would not have supported natural printing.* But as soon as I discovered that whatever the printer could do to help a plate could be done with far greater certainty by the etcher himself, upon the copper, it seemed desirable that the printer should restrict himself to the simpler duty of rendering what the etcher had done, and that the etcher should take the trouble to set his plate into such a condition that no fair and conscientious workman could do it injustice. I found, too, that from close personal observation of Delâtre's workmen, that the principle of interpretation was a very dangerous one to allow; for they seemed to me to interpret everything in one manner, treating every plate as if it were weak, and required to be sustained artificially. Thus I had the greatest difficulty in getting them to print any plate clearly and brilliantly, even when it most needed clearness."[25]

To reject Delâtre's expressive formula, poor Hamerton was forced to admit incompetence. Now it is a repentant amateur who advises eliminating dependence on the professional workman as artist. Still favoring artistic judgment in printing and fostering the rarity of each proof, Hamerton's final counsel is a lenient range of what is acceptable: "All extremes of treatment, from extreme

16

dryness and brilliancy to extreme richness and fulness, may be united in the same proof; and *what is called artificial, in contradistinction to natural print-ing, may be carried so far, that the proof itself becomes a work of art.* An etcher may amuse himself in taking highly artificial proofs of this kind, and vary his effects in a curious manner; but professional printers ought to be kept to the simplest work, and if that fails to make the etching look well, let the etcher be blamed and not the printer. It is certain that any valuable quality which artificial printing can reach, may be reached by the art of the etcher, rendered by natural printing only."[26]

Etchers did amuse themselves. Even among entrenched "clean-liners," forays with ink's epicurism have begun to surface.[27] Proverbial exceptions that bear out the rule of a revival without rules, these "painted" prints are startling in their freshness. Exaggerating Delâtre's propensity to twilight-ize every landscape with ink (fig. 8), his followers made "night pieces" relegating etched line to the merest scaffolding. A master etcher such as Whistler would elevate the notion into a series of *Nocturnes,* each of which reconstitutes Venice through a differ-ent veil of plate tone (figs. 9, 31). But others rarely developed the content of the original etched plan beyond the novelty of giving each proof its inky flourish of individuality. The varied proofs of a minor master, Adolphe Appian (1818-1898), are examples of ink cheerfully managed to charge each proof with a personaliz-ing *demi-teinte* (figs. 10, 11, 12).[28]

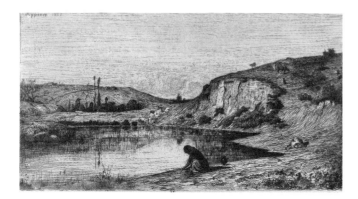

FIG. 10.
Adolphe Appian, *Un Rocher dans les communaux de Rix (Ain),* 1862 (Jennings 4), etching, first state.
Bibliothèque Nationale, Paris; Cabinet des Estampes, Curtis collection

FIG. 11.
Adolphe Appian, *Un Rocher dans les communaux de Rix (Ain),* 1862 (Jennings 4), etching and plate tone, first state.
Bibliothèque Nationale, Paris; Cabinet des Estampes, Curtis collection

FIG. 12.
Adolphe Appian, *Un Rocher dans les communaux de Rix (Ain),* 1862 (Jennings 4), etching and plate tone.
The Art Institute of Chicago

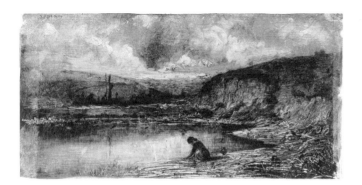

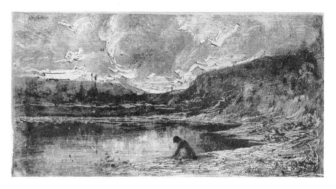

The eccentric who amuses himself by varying his prints artificially in a "curious manner" was allowed by Hamerton as an exception. But Whistler's veils of confusion and Appian's caprices are nothing compared to the manipulations of Vicomte Ludovic Napoléon Lepic (fig. 13). Hamerton's exception defines the œuvre of one of the most extreme artificial printers of them all.[29] Lepic is the *un*repentant amateur with a positive addiction to inking. His obsession with variety symbolizes the revival's radical undercurrent which required such extremes to infect others with an expressive idea.

Lepic discovered, as had all other etchers who printed their own plates, that each impression could be made unique by inking the plate anew for each printing.[30] This discovery seems to lead universally to claims of authorship. Delâtre had called his interpretative technique *retroussage.* Lepic in turn christened his *"eau-forte mobile"* (variable etching). He published *Commet je devins graveur à l'eau-forte* (1876), which summarizes and illustrates his experiments of the sixties.[31] These prints consist of several series of inked variations which increase the mist of *retroussage* to a thick overlay of literal representation. An etched landscape is made to suffer every conceivable manifestation of nature's whim and light's passage by changing the amount and configuration of plate tone: a cleanly wiped plate proclaims full daylight; gradations of ink mist into what seems like an unending sequence of crepuscular *orages* (figs. 14, 15, 16); a little circle wiped out of the dimness sheds moonlight over all (fig. 17); thick layers of ink in shapes of trees add rich and ephemeral foreground vegetation (fig. 18). Inspired by the imagination's response to the arrangement of fluid materials with direct observation of nature now only a memory, the motifs lend themselves easily to combinations, and Lepic has joined the latter two in a quaint pas de deux (fig. 19). Man-made disasters are also suggested by the pattern of ink's mobility: an etched windmill inkily bursts into flame, scandalizing an otherwise imperturbable Dutch river scene (cat. no. 19).[32] With all this manipulation, the etched linear plan begins to seem, by comparison, oddly staid. The etched peasant leaning on his staff in the *Vue des Bords de l'Escaut* sequence persists in exactly the same stance "day" and "night," weathering storm and spectacle. These inked theatrics of light and time must be seen in sufficient numbers to appreciate Lepic's lengths of fanatical ingenuity, but the prints are more interesting for the larger ideas that inspired them.

Lepic's text is similar in this regard. With its puffed-up tone, it is important as a record of the penetration of notions of middling inventiveness into higher levels of art and technics. Lepic, amateur, member of the Société des Aquafortistes, also sought a remedy for dull and uninspired etching—his own. But his imagination really took flight as he explained the significance of his search. Lepic claims to have single-handedly inspired a new course for modern printmaking. This is not only outrageous; it is correct. Lepic recollects: "I was struck by the falseness of modern engraving at the time, and the double cause threatening it owed to its every progress which was pushing it down a bad road.

It had become as dry as it had become fine and with extraordinary levity, it had rejected or repudiated the art of the masters, namely, the art of Rembrandt where one finds such powerful effects. It had repudiated them, I say, in refusing to use the printer's ink which alone permits their being obtained."[33] Lepic's misemphasis may be forgiven in the heat of his testimony.[34] We have already traced the moral dilemma of the repudiation to which he refers by recounting the printing education of an amateur like Hamerton whose example perfectly reflects the general perplexity.[35] In taking up Rembrandt's "powerful effects" of ink, Lepic merely joined the crowd at Delâtre's. But his independent position is believable because even the great printer had hardly conceived of such representational extremes with ink (nor, need we add, had Rembrandt).

It seems essential to all revivals to misconstrue their sources in order to gain the qualities they need. The etching revival was no different. It exaggerated Rembrandt's use of plate tone to an apparently meaningless degree, making of etching a *blague,* a romance of mud. By reinforcing the deliberate spatial and narrative vagueness of chiaroscuro, Rembrandt's manipulation amplified the incomprehensible spiritual dimensions of mortal events. The slightest alteration of ink represents a delicate shift in his constantly evolving artistic conception of a subject. Through excruciatingly subtle inking variations, for instance in *The Entombment* (cat. nos. 1-4), the prints almost respire with the barely breathing Christ and his sighing mourners. In Lepic's characterizations of natural ephemera, on the other hand, ink is the most elegant means of concealing content's empty storehouse. To the extent that they enliven the etched plan, the effects either detach into fragments or smother the original content. Lepic's inking stimulated artists far greater than he precisely because of its syntactic faults, and he is to be credited with this awareness. Lepic's ingenuity lies in devaluing the etched line altogether, which is only a symptom of the revolutionary change in printmaking that became devoted to exploiting materials' expressive physique.

For Lepic this involved redefining the notion of *peintre-graveur,* from the painter-printmaker to the printmaker who pulls his own impressions and inevitably makes the most of inking: "The artist who used etching should be a painter or draughtsman who uses the needle *and the rag* as another uses paintbrush and pencil.... With a stroke of the finger or a dirty rag full of ink, I make a beautiful proof where the consummate practician only produces a dry, graceless plate.... The painting in engraving is in printing alone which gives it life and charm, without which etching is only a metier like any other."[36] Lepic's "secret" is the liberal use of ink and rag with which "I can transform all subjects following my fancy."[37] He claimed to have pulled one plate of *Vue des Bords de l'Escaut* eighty-five different ways. As has been suggested, knowing about these practices produces a greater impact than seeing the prints. Lepic defined his innovation precisely and showered it on his fellow artists with parental generosity: "I claim authorship for 'variable etching,' that is for the

FIG. 13.
Cremière, *Portrait of Vicomte Ludovic Lepic,* 1860s, photograph.
Musée national du Château, Compiègne

19

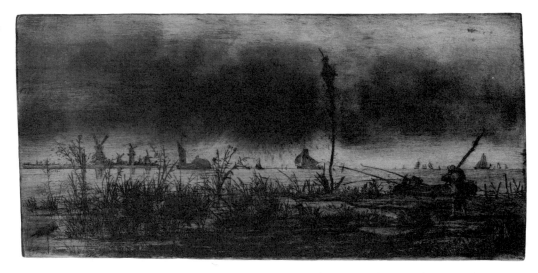

FIG. 14.
L'Orage.

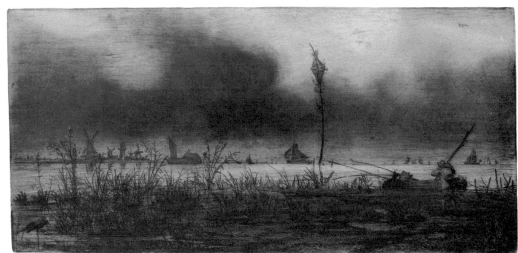

FIG. 15.
Après l'orage.

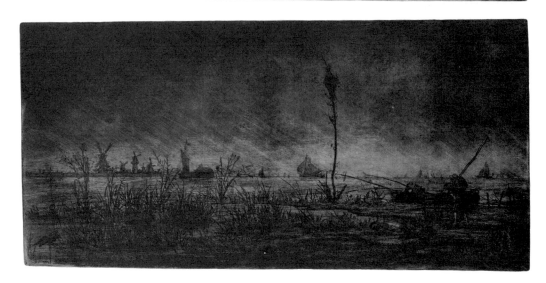

FIG. 16.
La Pluie.

20

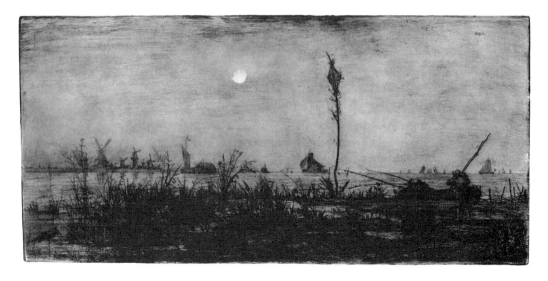

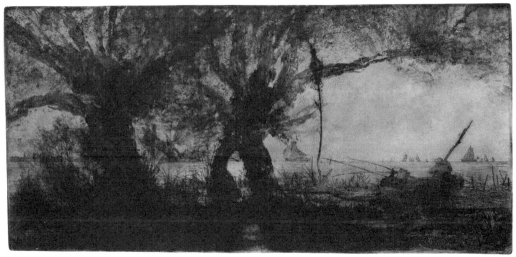

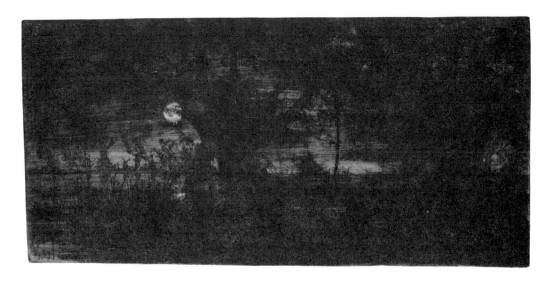

21

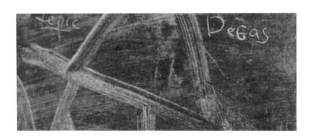

FIG. 20.
Edgar Degas, *The Ballet Master* (detail
of upper left corner), about 1874-75,
monotype, dark-field manner.

National Gallery of Art, Washington, D.C.;
Rosenwald Collection

labor of art that permits us to break with common practices and obtain such
results with the liberty of ink and rag. Besides, regarding its exclusive control,
without their having to ask for it and even to those publishers of engraving
who might request it, *I bequeathe my rag to all artists!*"[38]

As he wrote, Lepic's bequest was already an accomplished fact. One or two
years before the publication, Edgar Degas had pulled an impression from a
drawing made with greasy printer's ink on an unetched plate. Lepic's name is
scratched into the ink at the upper left corner (figs. 20, 24). It precedes Degas's
own, declaring as the artists did of Delâtre that "the proofs were as much his
work as theirs."[39] These "printed drawings" (cat. nos. 22-34), revolutionary in
Degas's art and the art of the late nineteenth century, others called monotypes.[40]
Degas made several hundred of them from the mid-seventies to the early
nineties.[41] "No art is less spontaneous than mine," he insisted. With these
printed drawings, he contradicted himself and further complicated his pecu-
liar relation to Impressionsim. Degas's monotypes are inconceivable without
the etching revival's undercurrent of aberrant inking and the epidemic of
amateurism. For in spite of his own previous investigations into Rembrandt's
etching art, it was only through Lepic's influence that Degas was susceptible to
its exaggeration. In the hands of a great draftsman, Delâtre's mysterious mud
leads to the most abstractly sensual nudes of the period (cat. nos. 24-26)[42] and the
literal representational field of black ink becomes the visual basis for the most
obsessive fancy of Degas's subject matter, the representation of the dark theatri-
cal stage as a source of enthrallment and fantasy (cat. no. 22).

By devaluing etched line, Lepic promoted the notion of ink's imaginative
potential, but he probably owes his first pure monotype to Degas. There is a
printed ink drawing of a terrier (Lepic was also a dog breeder) most likely from
1876 (fig. 21), dedicated to Hélène Andrée, the actress and agreeably dissolute
companion of Marcellin Desboutin in Degas's painting *L'Absinthe,* of the same
year. Degas made another double portrait including Desboutin in 1876 which
rounds out the Lepic relationship.[43] It shows Desboutin intent on making a
drypoint, with Lepic at his side; in the background Degas has included a cop-
perplate and Lepic's hallowed "rag."

Degas passed along the idea of printed drawings to Camille Pissarro (cat. nos.
35-40) and Mary Cassatt; Forain and de Nittis certainly felt its influence from
him as well. In the eighties when the only stigma of artificial printing was that

infused into it by Symbolism, and monotype was being "invented" all over Europe and America,[44] Degas fondly recalled Lepic in a letter to a friend: "Do you remember the good times spent with this queer fish?"[45]

To the "mainstreams of modern art" let us add the undercurrents and the backwaters. Théophile Gautier[46] and others have suggested that etching in the 1860s was a poeticizing reaction against the dolorous spectrum of positivism hiding in photography's mechanical ghost; but the two media really express the same tendency. Both were regarded as mechanical sciences where the illusion of unimpeded individuality through mere technical practice exerted a compelling universal attraction. By beckoning to and benefiting from many who were not artists, etching is similar to photography, whose art and unique visual language were also established through the amateur's disinterested experiments and love of trial and error. With enthusiasm carrying the day, amateur etchers, through a *romance of materials*, opened the floodgates of expression. These cooks, stylists, and zealous pretenders cannot be categorically dismissed, despite the mediocrity of their results. The tenacity of their belief was too great and radiated

FIG. 21.
Vicomte Ludovic Lepic, *Untitled*, about 1876, monotype, dark-field manner.
The Baltimore Museum of Art

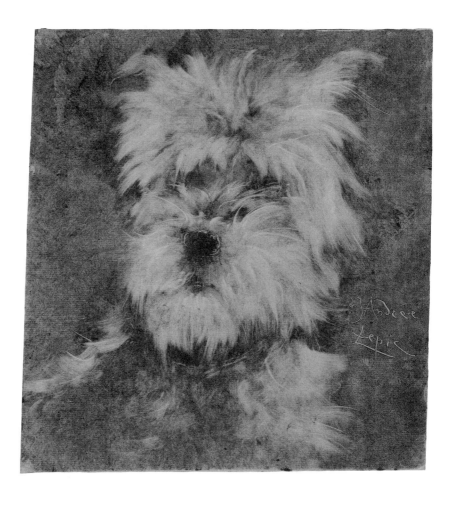

beyond them. Such situations only bear out the current suspicion that nineteenth-century art did not jump like a mountain goat from one peak of achievement to another. Artistic change was multiform, with every leap into the future conditioned by the sideward and backward glance.

1. Charles Blanc, "De la Gravure à l'eau-forte, et des eaux-fortes de Jacque," *Gazette des Beaux Arts*, vol. 9 (Paris, 1861), p. 195. (English translations of all French texts are mine.)

2. Ibid., p. 194.

3. Ibid., p. 196.

4. Ibid., pp. 196-97.

5. Ibid., p. 195.

6. In the 1860s the taste for tone, especially the kind etching could achieve, was at a peak in all the graphic arts and greatly in demand by collectors of old and new prints. When older prints were put out in new editions, they too bore the mark of the sixties. The first published editions of Goya's *Disasters of War*, pulled in 1863, bear a steely gray film from ink left on the plate between the etched lines. This gossamer is not found in editions of *Caprichos* published during Goya's lifetime nor in proof impressions of the *Disasters* pulled by Goya himself. The popularity of photography's continuous tone may also account for the imposition of tone on other graphic arts in this way.

7. "Décidément, l'eau-forte n'est pas mon affaire" (Edouard Manet quoted from *L'Estampe impressioniste*, catalogue by Michel Melot, [Paris: Bibliothèque Nationale, 1974], p. 51). This remark establishes Manet's position vis-à-vis the artistic exploitation of technique for its own sake. He wasn't interested. Etching, urged upon him by others to further his ideas in painting was simply another means of drawing; needless to say, it showed off his prodigious skill to advantage.

8. Many critical responses to the revival's portfolios have a patronizing tone. Charles Baudelaire's brief note, "L'Eau-forte est à la mode," published in the *Revue anecdotique*, April 2, 1862, was expanded into "Peintres et Aquafortistes," in *Le Boulevard*, September 14, 1862, soon after the society's first publication of etchings appeared. The first version is a display of enthusiasm, a salutation to etching: "Décidément, l'eau-forte devient à la mode," and ends: "Donc, vivé l'eau-forte!" The second version brings up the dangers in making etchings – the capricious practitioner's notion of boldness might be exposed as slackness; etching reveals faults as well as strengths. Baudelaire thus alluded politely to the glaringly uneven quality in the first publication. Emerging from Baudelaire's two reviews is the desire to encourage despite the dangers of the revival's popular appeal. This conclusion is reinforced by his letter to Théophile Gautier asking him to support "cette réaction en faveur d'*un genre* qui a contre lui tous les nigauds" (quoted by Jacques Crépet, *L'Art romantique* [Paris, 1925], p. 466 [italics mine]). Janine Bailly-Herzberg in *L'Eau-forte de peintre au dix-neuvième siècle, La Société des Aquafortistes, 1862-1867* (2 vols.; Paris: Léonce Laget, 1972) records other criticism and reproduces the five critical prefaces to the etching portfolios by Gautier, Janin, Burger, Castagnary, and Montrosier (vol. 1, pp. 266-77).

9. The etching revival and etching club of the 1860s in France have a curious reputation. Cadart published the work of many great etchers of the time including Millet, Manet, Corot, Daubigny, Meryon, Whistler, and Haden. Yet Arthur Hind draws his conclusions from the work of the amateurs: "A. Cadart did most to bring third-rate work to the fore in the publications of the *Société des Aquafortistes* (1862-67), [and] in *L'Illustration nouvelle* (1868-1873)" (*A History of Engraving and Etching from the 15th Century to the Year 1914* [New York, 1963], p. 321). In a

similar spirit, William Ivins questioned the revival's being one at all. Etching had already reached an unequaled technical peak in the first half of the nineteenth century in the workmen reproducing the drawings and paintings of Turner. "It is one of the greater ironies that the much touted Revival of Etching...was actually not a revival of the craft...but the adoption of the technique by a group of on the whole rather poor draughtsmen and incompetent technicians who in one way or another managed to gain the attention of the public...the emphasis on etching as such was an escape from the problem of draughtsmanship and design" (*Prints and Visual Communication* [Cambridge, Mass.: M.I.T. Press, 1968], pp. 100-101).

10. This is evident in *The Etching Renaissance in France: 1850-1880* (catalogue by Gabriel P. Weisberg [Salt Lake City, 1971]), an exploratory exhibition (probably the first in America to revive the revival), and in Bailly-Herzberg's important definite documentary study that superseded it, and illustrates the contents of the society's portfolios. Neither study raises the revival's peculiar critical issues.

11. Maxime Lalanne, *Traité de la gravure à l'eau-forte* (Paris, 1866), p. 85.

12. An example of such a treatise is Henry Alken, *Art and Practice of Etching* (London, 1849).

13. Jeanniot wrote this in 1911, quoted in *L'Estampe impressioniste*, p. 52. This was the voice of experience repeating Gautier's earlier wisdom: "C'est qu'elle ne peut mentir" (Bailly-Herzberg, vol. 1, p. 267).

14. Philip Gilbert Hamerton, *Etching and Etchers* (London, 1868), p. 348; hereafter abbreviated *E and E*.

15. Lalanne, p. 85.

16. "Cette *Société* n'a d'autre code que l'individualisme....aucun genre ne prévaut, aucune manière n'est recommandée" (Bailly-Herzberg, vol. 1, p. 267). Gautier's lines prefacing the society's first album, 1863, contain the points of connection between the revival and Impressionsim (*L'Estampe impressioniste*, p. 35). This source also alludes to Bailly-Herzberg's similar conclusion.

17. A good account of Delâtre's career as a printer is in E. Bénézit, *Dictionnaire des peintres, sculpteurs, dessinateurs et graveurs...*, rev. ed (Paris, 1948-55), vol. 3, p. 145. The best detailed survey of Delâtre's theories of inking by a contemporary is in Henri Béraldi, *Les Graveurs du XIX siècle, guide de l'amateur d'estampes modernes* (Paris, 1886), vol. 5, pp. 168-74. Bailly-Herzberg (vol. 1, pp. 1-10) discusses Delâtre in an amply documented synthesis of many sources in addition to these, including contemporary criticism of his "sauce abondante" (p. 6). Even Pissarro was chagrined: "Il sauce trop" (ibid.). Her study does not pursue the argument surrounding Delâtre's inking or its significance. This is introduced in Melot's entry on Delâtre, the "imprimeur impressioniste" in *L'Estampe impressioniste* (p. 31), a source laced with allusions to painterly inking as another means of characterizing the printmaking of Impressionism.

18. Béraldi, vol. 5, p. 169.

19. Philip Gilbert Hamerton, "Modern Etching in France," *Fine Arts Quarterly Review*, vol. 2 (January-May 1864), p. 74 (first italics mine); hereafter abbreviated *FAQR*.

20. Hamerton, *E and E*, p. 354.

21. Hamerton, *FAQR*, pp. 74-75 and note.

22. Pierre Georgel explores the lingering romanticism expressed through chiaroscuro in printmaking in "Le Romantisme des années 1860, Correspondance Victor Hugo – Philippe Burty "(*Revue de l'art*, no. 20 [1974], pp. 8-36) through the taste of Hugo and his definition of the "problem of etching" as a conflict of "clair-obscur et d'une écriture 'moderne.'" Hugo's search for "universal antitheses" expressed in light and shade led him to prefer Whistler's etchings with their "chaos de brumes"; Manet's and Jongkind's "écriture moderne" didn't interest him (pp. 30-33).

23. In a letter to his wife around 1867, Hamerton wrote: "This evening I am to spend with Haden again; for he has a magnificent collection of etchings and will help me very much with my book. So now I am sure of the right quantity of assistance in my work" (Philip Gilbert Hamerton, *An Autobiography, 1834-1858, and a Memoir by His Wife, 1858-1894* [London, 1897], p. 328). Haden was known to have, among other things, a collection of choice impressions by Rembrandt.

24. Hamerton, *E and E*, 1868, pp. 349-50 (italics mine). *Etching and Etchers* appeared in several subsequent editions including 1876, 1880, and 1883. Each reflects changes in the popular taste for tone and Hamerton's own vacillations by differences in emphasis regarding the printing of etched plates. For example, by 1883, very little space is devoted to printing; Delâtre is not mentioned, and Hamerton says that artifical printing, when badly done, is intolerable. To support this he adds: "Mr. Ruskin condemns it altogether" (p. 442). In 1882, in *The Graphic Arts*, a treatise on the varieties of drawing, painting and engraving, Hamerton brings up the subject again saying that leaving some ink film on the plate is all right and that clean wiping is a form of dogmatism not at home in the fine arts (pp. 339-40). The controversy about *retroussage* did not subside quickly; in fact, it seems to have become increasingly an issue in the later years of the century. The question appears in other treatises, like that of R. S. Chattock, *Practical Notes on Etching* (London, 1883), who devotes pages 60-65 to it. Rembrandt is again held up as a model by both sides, but Chattock concludes that there is nothing wrong with *retroussage*, that after all, ink is a medium too.

25. Hamerton, *E and E*, 1868, pp. 350-51, 352 (italics mine).

26. Ibid., p. 354 (italics mine).

27. Many of these forays by Huet, Delâtre, Appian, Jacque, Lepic, Guérard, Bracquemond, and Jeanniot belonging to French collections were exhibited for the first time in *L'Estampe impressioniste*, at the Bibliothèque Nationale in 1974. Such experiments were regarded by their makers as complete works through inking alone. And the exhibition makes an important distinction with Burty's comment about Guérard who was not an "imprimeur" but a "tireur d'épreuves" (p. 73). I have uncovered other examples, among them works by Forain and de Nittis.

28. Fourteen prints pulled in "manières de monotypes" were given by Atherton Curtis to the Bibliothèque Nationale (*L'Estampe impressioniste*, p. 33); Melot discusses several other "pièces uniques" by Appian in that library (ibid.). See also, Atherton Curtis and Paul Prouté, *Adolphe Appian, son œuvre gravé et lithographié* (Paris, 1968). I am illustrating here another belonging to the Art Institute of Chicago.

29. Hamerton certainly did not understand modernist etching, but he might have had a preference for aristocrats. Compare his attack, in the *FAQR* article, on Manet's contribution *Les Guitanos*, to the Etching Club's first exhibition in 1862-63, as "the most hideous piece of work which French realism has yet produced.." (p. 99), or his remarks on Corot: "... if possible, a worse draughtsman than Daubigny," "...M. Corot owes a great thanks to Delâtre for the way the etching is printed" (p. 105), to the elusive encouragement given to Lepic's contribution, *Pour les Pauvres*, "Many of M. Lepic's drawings of dogs are spirited and fine. This dog's face is eager and intelligent, and really very well done. The wiry texture of the hair is quite truly given and the bright eyes beg eloquently for the poor dog's master" (p. 103).

30. Many etchers, especially the weaker ones, were encouraged by the methods of Delâtre (note Hamerton's own admission above in the text). Even good etchers followed the preference for moderately toned plates, but no etcher, either in France, England, Germany, or Italy arrived at anything approximating the extreme *application* of Lepic's experiments at this time.

31. Vicomte Ludovic Lepic, *Comment je devins graveur à l'eau-forte* (Paris: Cadart, 1876). Raoul de Saint-Arroman in *La Gravure à l'eau-forte, essai historique*, published with and preceding Lepic's essay, introduced Lepic in the following way: "...Le Pic, qui ose faire de l'eau-forte mobile, à deux degrés, complétant les audaces de la pointe par celles du tampon" (p. 75).

32. The variations in this exhibition and those illustrating the present essay are from the renowned *Vue des Bords de l'Escaut* series, about which Loys Delteil observed: "Lepic amateur et graveur à ses heures – qui se piquait d'avoir obtenir d'une même planche une *Vue des Bords de l'Escaut* 95 [Delteil adds ten to Lepic's number] aspects differents par le moyen de l'encrage poussé aux extrêmes limites de la fantaisie" (*Manuel de l'amateur d'estampes du XIX^e et du XX^e siècles* [Paris, 1925], vol. 2, p. 331).

33. Lepic, p. 91.

34. It is difficult to know how to credit Lepic's observations. They reflect Charles Blanc's and Philippe Burty's summations of etching's major problems, which Delâtre's printing seemed single-handedly to be correcting. Lepic insists that the revival coincided with his own awareness of ten years before. His earliest attempts to correct the situation failed and that only sixteen years later: "...puis, poursuivant toujours mon idée de me servir de l'encre pour obtenir des effets inattendus, et de plus en plus convaincu que tel était le procédé de Rembrandt et autres..!" (p. 99). "Convinced," one feels, during the course of the sixties by the tracts, essays, and articles which always mentioned the precedent of Rembrandt. It is important to remember that Delâtre had begun to change the course of etching in the studio of Jacque and Marvy in the *mid-1840s* (Béraldi, vol. 5, p. 169).

35. Hamerton's views are prosaic and didactic, but more valuable to the present study since he speaks not as an impartial critic but rather reports from within the movement itself. When he argues critically, it is as a practicing etcher swept up in the actual concerns of the revival at all levels.

36. Lepic, pp. 102-103 (italics mine). He mentions being encouraged by Gavarni who maintained an interest in his work until his death. Lepic quotes Gavarni: "Vous avez trouvé en gravure ...ce que j'ai trouvé en lithographie" (p. 101).

37. Ibid., p. 114.

38. Ibid., p. 115.

39. See note 19.

40. Degas never used the word "monotype." Rouart (*Degas à la recherche de sa technique* [Paris, 1945], p. 55) says that Degas actually rejected calling the impressions by this name. It first appears in the *Vente d'Estampes, Catalogue des eaux fortes, vernis-mous, aquatintes, et monotypes, par Edgar Degas, et provenant de son atelier* (Paris, November 22-23, 1918). Degas described the works as "dessins faits à l'encre grasse et imprimés" (drawings made with greasy ink and put through a press), when he exhibited a number of monotypes at the third Impressionist exhibition, April 1877. See the list of Degas's works in that exhibition in Lionello Venturi, *Les Archives de l'Impressionism*, 2 vols. (Paris, 1939), vol. 2, p. 260. Béraldi noted Degas's work with ink in the following way: "Cette latitude de l'impression en taille-douce est assez étendue pour permettre à un dessinateur de prendre une planche *sans aucune gravure*, d'exécuter sur cette planche un dessin avec de l'encre d'impression, et obtenir, après un tour de presse, une *estampe* (le peintre Degas a fait plusieurs estampes de cette espèce)." A few sentences later, Lepic's experiments are also noted (p. 172).

41. See Eugenia Parry Janis, "The Role of the Monotype in the Working Method of Edgar Degas," *Burlington Magazine*, vol. 109, Part I (January 1967), pp. 20-27; Part II (February 1967), pp. 71-81; *Degas Monotypes* (Cambridge, Mass.: Fogg Art Museum, 1968); and "The Monotypes of Edgar Degas" (Ph.D. dissertation, Harvard University, 1971).

42. Eugenia Parry Janis, "Degas and the 'Master of Chiaroscuro,'" *Museum Studies 7*, Art Institute of Chicago, pp. 52-67.

43. P. A. Lemoisne, *Degas et son œuvre*, 4 vols. (Paris, 1947-49), vol. 2, no. 395.

44. As far as I can tell, pulling an impression in this way was almost never mentioned in etching handbooks or treatises dating from the second half of the nineteenth century that devoted sizable discussions to printing. It is an outgrowth of etching effected by artists who printed their own plates. It seems never to have been regarded as important enough for there to be a prescribed method or even a name for it until around the 1880s when the medium of *monotype* was independently "reinvented" by the American painter Frank Duveneck and the Duveneck "boys," as his artistic circle was called, in Germany. This may account for Sylvester R. Koehler's awareness of the process and the title "Das Monotyp" for his article on inking in *Chronik für vervielfältigende Kunst*, vol. 4, no. 3 (1891), pp. 17-20.

45. Marcel Guérin, ed., *Lettres de Degas* (Paris: Editions Bernard Grasset, 1945), pp. 65-66. Loys Delteil noted: "Degas connut aussi assez intimement deux autres graveurs, le vicomte Lepic et Marcellin Desboutin. Nul doute qu'il n'apprît aussi de ces deux amis quelques-unes de recettes, dont le premier surtout était très friand" ("Degas," *Le Peintre-graveur illustré*, [Paris, 1919] vol. 9, Préface, pp. unn.).

46. Bailly-Herzberg, vol. 1, p. 266.

BARBARA STERN SHAPIRO

Nineteenth-Century Masters of the Painterly Print

From the end of the eighteenth century when William Blake executed his highly original printed drawings until nearly the last quarter of the nineteenth century, the art of monotype lapsed into disuse. Its so-called reinvention was assumed by those painter-printmakers who determined that the manipulation of ink on a plate was an accessible and unusual means of artistic expression. Two exponents of this philosophy, Adolphe Appian and Ludovic Lepic, began in the 1860s to examine the dramatic effects of light and dark and the rich tonalities that could be obtained by wiping and brushing ink across a smooth surface (copper, zinc, or celluloid), then printing the result. There was usually, however, an etched matrix which served as the scaffolding for the varying painterly qualities they achieved. Loosened, perhaps, by the flowering of lithography and the advent of photography and certainly inspired by a renewed interest in the etching achievements of the seventeenth-century Dutch master, Rembrandt, these printmakers moved away from the more conventional means of reproducing multiple printed images. Herein lay the seeds of the Impressionist print and its preoccupation with light, tone, and implied form; once the artists removed the etched lines, the monotype was revived.

Whatever were the motivating forces, it is safe to say that Edgar Degas was the greatest innovator and practitioner of the monotype medium in the nineteenth century. Whether it was the importance of inking as practiced by the Société des Aquafortistes under the direction of the printer Auguste Delâtre or the efforts of Lepic and his imaginative, inky experimentations; whether it was photography and its use of collodions and gelatins on a plate as well as the positive/negative and light/dark results that could be obtained or simply a time when Degas was exploring and altering his own pictorial style, there was a confluence of events

29

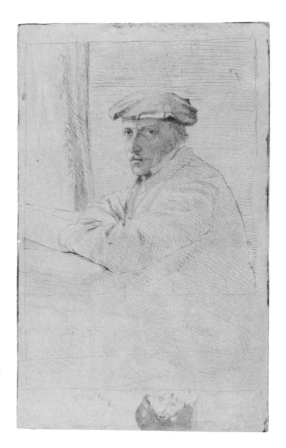

FIG. 22.

Edgar Degas, *The Engraver Joseph Tourny*, 1857, etching.

The Metropolitan Museum of Art, New York;
Bequest of Mrs. H. O. Havemeyer, 1929,
The H. O. Havemeyer Collection, 29.107.56

and ideas that persuaded him to consider painting on a plate and printing the image as a significant part of his total artistic production.

From about 1875 to 1885, the third decade of Degas's artistic career, his innovations of iconography and style were equally matched by his profound scientific deliberations of new techniques and methods. A reworking of an etching made in 1857 and printed almost twenty years later was certainly influenced by Lepic's *eau-forte mobile* and indicated Degas's need to restudy a problem as well as his ability to change the overall intention of the original concept. The plate for the etched portrait *The Engraver Joseph Tourny*, 1857 (fig. 22), was retrieved and reprinted in several variants (fig. 23) with a heavy ink tone that recalls the rich, painterly effects achieved by Rembrandt. The broad smear of ink that was irregularly wiped away and Degas's fingerprints throughout the image are convincing evidence that this print served as an introduction to his experimentations with monotypes.

It is generally accepted that the artist's first attempt with the medium, *The Ballet Master* (fig. 24), was made about 1874-75, with the direct help and supervision of his friend Vicomte Lepic whose firm signature suggests that he acted as technical adviser. The content of the monotype, however, is decidedly Degas's.[1]

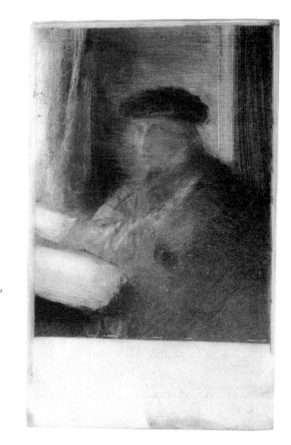

FIG. 23.
Edgar Degas, *The Engraver Joseph Tourny,* variant C,
about 1870-75(?), etching with plate tone.

The Metropolitan Museum of Art, New York;
Harris Brisbane Dick Fund, 1927 (27.5.5)

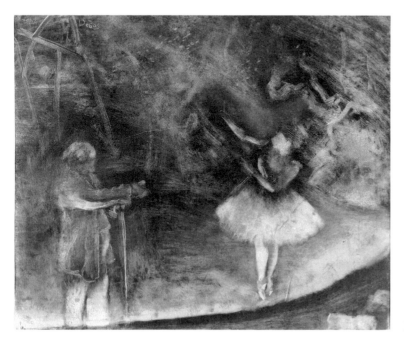

FIG. 24.
Edgar Degas, *The Ballet Master,* about 1874-75,
monotype in black ink.

National Gallery of Art, Washington, D.C.;
Rosenwald Collection.

Originally, Degas began with the profound black monotypes from which he wiped the figurative elements. Later, he tried a second method whereby he painted directly on the plate with a brush and printer's ink and reversed the effects. Searching for new expressive possibilities, he moved from a negative (or subtractive) process to a positive (or additive) process, and at times he combined the two methods as for the illustrations to *La Famille Cardinal* (cat. no. 30).

Some years later, in 1890, Degas again approached making monotypes and again initiated a new manner. He completed a group of landscapes painted with oil color, printed the plates, then heightened many of the sheets with pastel (cat. nos. 31-33). The spirit and intent were different, however. They were no longer documents that recorded his interest in modern urban life – the café-concert scenes, the theater loges, the brothel settings, the dancers, the women at their toilette. Instead, these works were abstract fantasies of colored light that brought him the closest to the Impressionist aesthetic. By 1893 Degas ceased making monotypes; his production of about four hundred and fifty images derives from a relatively brief period in his long life, of a little over fifteen years, 1874/5-1892.

For Degas, the painting on a plate represented a final release from the Ingres tradition of precise linear draftsmanship and gave him a sense of freedom and flexibility that he could not attain in any other medium. By painting, wiping, cleaning, and maneuvering the oily pigments on a plate, Degas could establish general, suggestive forms which had the potential to be altered or clarified later. Once he applied his gorgeous pastels to the monotype base, his works were "finished" and, significantly, he had adapted "to his own artistic needs what was newest and most interesting in the techniques of his [Impressionist] contemporaries."[2]

It is believed that Degas was not familiar with the monotypes made by Giovanni Benedetto Castiglione and that he did not know of the seventeenth-century artist's methods.[3] Although the invention of making monotypes cannot be attributed to Degas, he did more than any other artist to make the medium an important and viable artistic process; his innovative researches alone added another dimension to the historical chronology of the painterly print.

Camille Pissarro was certainly acquainted with Degas's monotypes when they were shown in the third Impressionist exhibition of 1877 in which he also participated; yet he probably first encountered the technique intimately when the two artists were collaborating on an etching project about 1879-80. They tried complex combinations of intaglio techniques, and one can easily imagine that painting and wiping printer's inks on a plate was attempted as well.

Although Pissarro's monotype œuvre is infinitely smaller than Degas's, it is certain that he appreciated the medium and seriously regarded these efforts as finished, self-sufficient works. A body of monotypes has emerged (about thirty) that are a testament to his continued interest.[4]

Degas's monotypes, as a whole, were carefully prepared, deliberate works of art. Pissarro, on the other hand, set to work on the plate with vigor and applied the ink in a more direct manner. There are no dark-field monotypes with inky configurations from which an image was extracted. His figural contours were clearly defined and the images immediately comprehensible, not pseudo-abstractions created by tone.

For the most part, Pissarro's monotypes were painted in black and white, although he often added touches of color or dark accents to increase the pictorial effect; usually, an oily residue can be found on the verso of the monotype sheet that gives evidence to the comparatively heavy application of the opaque pigment. The viscosity of the inks that he used on his plates makes for unclear surface distinctions, and at times it is difficult to decipher whether these touches were added to the plate or to the surface of the sheet after printing. There is the possibility that Pissarro was not completely satisfied with the finished impressions and could not resist heightening the image; yet his personal feelings about printing methods almost insists that he would have made his decisions before subjecting the painted plate to the etching press. In a comment about Whistler's specially inked etchings and drypoints, Pissarro wrote: "We [Pissarro] would like to achieve suppleness *before* the impression is printed."[5] In any case, Pissarro made his own interpretation of the medium – he touched up the picture with heavier pigments, changing the integrity of the smooth surface. In the same way that his canvases of the 1880s and 1890s were brushstrokes of thickish paint, so his monotypes were layers of ink textures, thereby extending the possibilities that could be realized in this medium. Pissarro was not interested in pursuing the making of monotypes. He obviously enjoyed drawing on a plate but did not feel the need to incorporate the method into his working procedures. His desire to achieve luminous painterly effects would be accomplished in his enormous production of prints and paintings.

Of special interest is one monotype, *Femme portant une manne* (fig. 25), which is a transfer from a painting and, in normal circumstances, would be considered an offset or counterproof; the support, however, is a zinc plate which Pissarro retained, touched in, and enjoyed as a small painting. The method of execution is obscure (note the registration marks on the monotype sheet). Both the painting and its monotype cognate represent the different effect Pissarro gave many of his motifs through the inventive use of technical processes.

Just when Degas had concluded his experiments with monotypes, Pissarro and Paul Gauguin seem to have taken up the interest. Although it is known that Degas owned three of Gauguin's monotypes,[6] there is no evidence that Gauguin ever saw any of Degas's monotypes or considered them as a source of inspiration. When one discusses Gauguin's works, it is necessary to disregard the "orthodox" vocabulary and techniques, and to evaluate his efforts in light of his own substitution of tools and procedures. For the purposes of this catalogue, his

FIG. 25.
Camille Pissarro, *Femme portant une manne,* about 1889, monotype in color.

Collection of Paul Prouté, Paris.

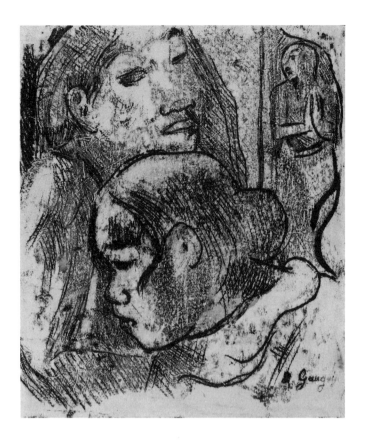

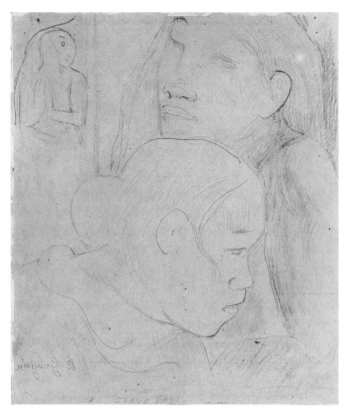

FIG. 26.
Paul Gauguin, *Two Marquesans,*
about 1902, traced monotype.

Philadelphia Museum of Art; Purchased
with funds from Frank and Alice Osborn
Fund

FIG. 27.
Verso of fig. 26, showing Gauguin's
graphite drawing for making the
traced monotype.

watercolor monotypes of 1894 and 1902 are regarded as unique independent representations of painterly prints, and his so-called traced monotypes have not been included. In the latter technique Gauguin depended on the amount of ink on a base sheet, the texture of the paper, the size of the instrument, and the pressure used to delineate the image. Gauguin described the process: "First you roll out printer's ink on a sheet of paper of any sort; then lay a second sheet on top of it and draw whatever pleases you. The harder and thinner your pencil (as well as your paper), the finer will be the resulting line." [7] These "printed drawings," as Gauguin called them, were in essence the result of offset or tracing processes rather than self-sufficient compositions transferred from a painted smooth surface. The original graphite drawing of the traced monotypes is completely retained and can be examined on the verso of those sheets that are not mounted down (figs. 26, 27). These innovative but offset prints are not included in order to clarify more precisely the definition of the monotype medium.

When he first began to make woodcuts in 1894, Gauguin set aside a whole tradition of cutting woodblocks; simultaneously, he extended the contemporary understanding of making monotypes. Rather than manipulating oily pigments on a hard, smooth surface, Gauguin transferred watercolors and opaque watercolors (gouache) from a different matrix to a sheet of paper. Whether it was a single sheet of paper or an assemblage of pieces of cardboard, paper, or wood to

form the support (just as his woodblocks were made up of sections of hard, fine-grained European boxwood), Gauguin strived for unique works of subtly printed, colorful images in a medium that responded to his thematic interests. What began as an outgrowth of woodcutting, perhaps even a reaction to the garishly printed Louis Roy woodcut impressions, became by the end of his life a procedure to attain unusual decorative paintings. Just as Degas had pushed the parameters of making monotypes, so Gauguin, unmindful of that master's efforts, explored other directions and further exploited the medium.

Considering Degas's enormous production of monotypes and the recognition and appreciation accorded him by his colleagues during his lifetime, it is surprising that his impact on his fellow artists in this medium was not more profound. Those who were within his closest circle, such as Mary Cassatt, and those who were most influenced by him, such as Toulouse-Lautrec, did not flourish with this technique. Only Gauguin, who essentially pursued his own procedures, integrated the making of monotypes into his working methods. Mary Cassatt, who collaborated with Degas as well as Pissarro on a projected print journal, *Le Jour et la Nuit*, made only one monotype (fig. 28) and that depended on a soft-ground outline. There are, in fact, two impressions of the monotype with variations of composition on the page.[8] Mary Cassatt painted bright oil-color pig-

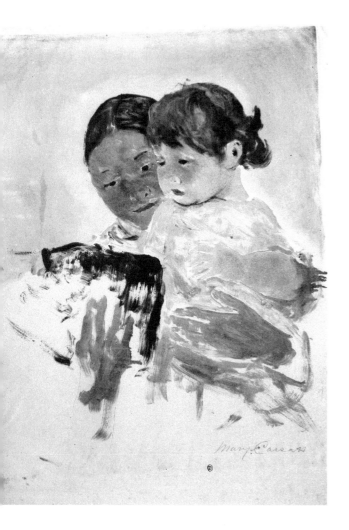

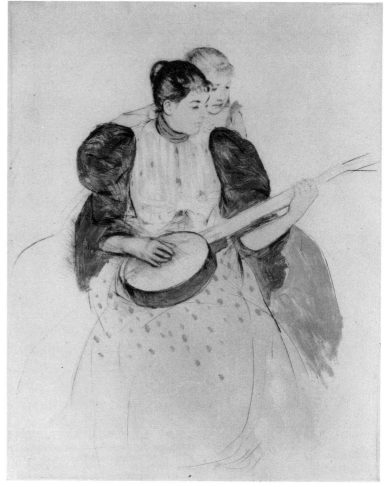

ments of a mother and child, all controlled and directed by the slight figural line. In a print executed about 1893-94, entitled *The Banjo Lesson* (fig. 29), she again included painterly touches on the sleeves and part of the dress, but this example is in reality another manifestation of her outstanding color prints executed in 1891. Considering her more precise and elegant working methods, it is understandable that the making of monotypes would not appeal to her.

Toulouse-Lautrec, who freely admitted his debt and admiration for Degas, did not demonstrate a commitment to the medium. Although each one of his four monotypes is an imaginative representation, he was not inspired to experiment further. His monotypes are less innovative stylistically and technically than his other graphic art and do not reveal the same skill with oil pigments that he

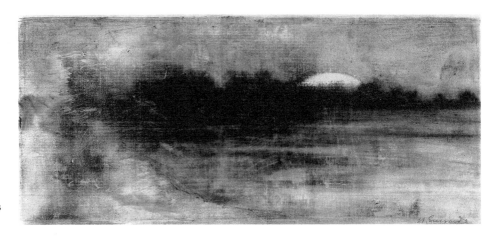

FIG. 30.
Henri Guérard, *Soleil couchant*, possibly 1870, monotype in black.

Bibliothèque Nationale, Paris; Cabinet des Estampes

showed with multicolor lithographic crayons. Lautrec was fascinated with lithography and its multiplicity of impressions and was especially intrigued with the art of poster design. Beyond his paintings, he made over three hundred and fifty lithographs in less than ten years; for him the multiple printing stones, workshop atmosphere, and brilliant colors most likely precluded his making unique monotype impressions.

There are other contemporaries of Degas who made monotypes, but their work, of less artistic vision, was only realized in a few undistinguished examples. Henri Guérard (1846-1897), artist and printer, made his own etchings and printed the plates of others with the same devotion. He was friend, printer, and adviser of technical processes to Edouard Manet so it is not unusual that he made monotypes. *Soleil couchant* (fig. 30), luminous and uncomplicated, was directly influenced by the master of inking, Auguste Delâtre, a professional printer. There is reason to believe that this monotype was printed about 1870, at least four to five years before Degas's first efforts, and anticipates the master's extraordinary dark-field monotypes. Jean-Louis Forain (1852-1931), protegé of Degas, employed the dark-field manner, but his three known works were not

technically inventive and his subject matter was essentially derivative of Degas's. Théophile Steinlen (1859-1923) and Louis Legrand (1863-1951) also discovered the secret of spreading ink on a plate and printing the image; although their efforts were serious, they were less talented in the medium.[9]

James A. NcNeill Whistler (1834-1903), the American artist who resided in England, must be considered separately – a unique painter-printmaker who was interested in unusual atmospheric effects but whose prints retained the barest of etched skeletons. In 1879-80 Whistler executed a series of etchings in Venice to relieve his financial difficulties, intending that they should be made into editions. By printing the plates himself, he could guarantee the supple and charming results. Whistler made rapid etched sketches on copperplates, then used, in most cases, a warm brown ink and a variety of papers to transform his observations of Venice into veiled, dreamlike visions. He depended on plate tone, the film of ink left on the surface of the plate, to provide a nocturnal glow. Many impressions bear his pencil notations on the verso indicating his affection for a special proof; see, for example, the words "selected proof" on the verso of the Boston Museum impression (fig. 31). Whistler was merely a step away from making monotypes – and, in fact, one is mentioned in a 1920 article but has never been found.[10] Although each impression evolved into a different experience through uncommon inking and wiping, there was always the etched design required for the sake of multiplicity rather than uniqueness. Whistler, however, combined his talent for painting with his printmaking instincts and skills and achieved his own hybrid of painterly prints.

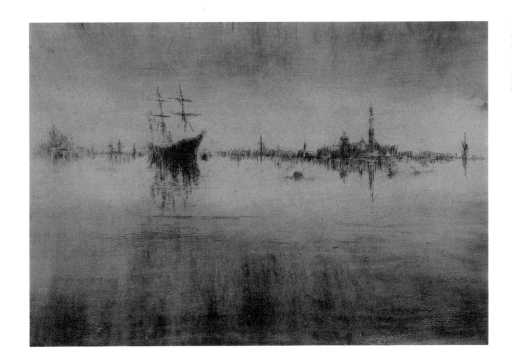

FIG. 31.
James A. McNeill Whistler, *Nocturne*, 1879, etching.

Museum of Fine Arts, Boston; Bequest of Mrs. Henry Lee Higginson, Sr., 35.1196

The emphasis here has been on masters of French art whose careers embraced and reflected a turbulent period of history, when social, literary, and artistic forces all struggled for recognition. These artists responded to the new modes of expression and vision and welcomed innovative ways to convey their intellectual understanding of these phenomena. Nonetheless, it was only those few painters who embraced printmaking with enthusiasm and ease who were able to regard the creation of monotypes as a natural and necessary outgrowth of their multiple artistic skills. The process, however, did not work in reverse: those printmakers who were not *peintres-graveurs* had no interest in making monotypes; the spontaneity and directness of painting a unique image on a plate combined with the precision required in the act of printing – two distinctly different disciplines – simply never appealed to them.

When one considers the enormous outpouring and variety of work produced during the last quarter of the nineteenth century, it is surprising that so few artists considered monotype as a splendid manifestation of talent and technical skills. Those innovators who cherished the medium were the ones who laid the groundwork for the new, young artists of the twentieth century, such as Picasso and Matisse, who, in turn, expanded the artistic possibilities intrinsic in the making of painterly prints.

1. This first attempt is discussed thoroughly by Eugenia Parry Janis, *Degas Monotypes* (Cambridge, Mass.: Fogg Art Museum, 1968), p. xviii and cat. no. 1. It is interesting to note a citation by Campbell Dodgson, "Quarterly Notes," *The Print Collector's Quarterly* (vol. 16 [London, 1929], p. 3), who wrote: "M. [Ambroise] Vollard is said to possess a monotype by Lepic retouched by Degas." This may pinpoint more precisely the provenance of Degas's first monotype but the attribution to Lepic is definitely incorrect.

2. E. P. Janis, "The Role of the Monotype in the Working Methods of Degas," Part I, *Burlington Magazine*, vol. 109 (January 1967), p. 27.

3. See Sue Welsh Reed, "*Monotypes in the Seventeenth and Eighteenth Centuries*" (pp. 3-8) for a discussion of Castiglione and references.

4. There are over twenty small monotypes of indeterminate technique that Pissarro apparently made for his children. They seem to have served as instructive "games" – small landscape vignettes – that are entirely unlike his prominent monotypes. Pasted in albums, many are still owned by descendants of the artist.

5. John Rewald, ed., with the assistance of Lucien Pissarro, *Camille Pissarro: Letters à son fils Lucien* (Paris: Albin Michel, 1950), p. 33, in a letter dated "Osny, 28 février, 1883."

6. Richard S. Field, *Paul Gauguin: Monotypes* (Philadelphia: Philadelphia Museum of Art, 1973), p. 46, n. 9.

7. Ibid., p. 21.

8. Another impression of the Cassatt monotype is in the Bibliothèque Nationale, Paris, Cabinet des Estampes.

9. At the same time in the nineteenth century, there were other artists, outside France, who made monotypes. We mention their names, knowing that others may eventually be presented: James Nasmyth (English, 1808-1890) whose work is cited by Dodgson ("Quarterly Notes," p. 4) as an "isolated emergence of the monotype." There are seven of his monotypes in the British Museum collection that bear dates ranging from 1876 to 1877; these were probably in response to the English etching clubs so popular in those years. Pompeo Mariani (1857-1927) practiced making monotypes in Italy and a few examples are housed in the Ambrosiana Collection, Milan (see Lamberto Vitali, *Incisioni Lombarde del Secondo Ottocento all'Ambrosiana* [Vicenza: Neri Pozza Editore, 1970], p. 45, nos. 80-83, ill.); also mentioned are Luigi Conconi (1852-1917) and Vittore Grubicij de Dragon (1851-1920).

10. Malo Renault, "Le Monotype," *Art et Décoration*, vol. 37 (1920), pp. 53-54. "Whistler...est aussi représenté dans le riche écrin que forme la collection Sainsère par un rare monotype en couleurs, un *Femme vue de dos* aux nuances irisées d'opale."

DAVID W. KIEHL

Monotypes in America in the Nineteenth and Early Twentieth Centuries

Except for the well-known monotypes by Maurice Prendergast, American artists' experience with this printmaking process during the late nineteenth and early twentieth centuries has not received the critical attention garnered by such French contemporaries as Degas, Pissarro, and Gauguin. As interest in the American prints by museums, collectors, and dealers has grown, more monotypes have emerged from artists' estates and old collections, thereby providing a larger body of work to augment and illustrate the meager information found in contemporary literature, art magazines, and exhibition catalogues. For some artists, a single example may now represent what must have been a larger body of material, and is certainly not sufficient for a thorough stylistic analysis of the role of the monotype in an artist's œuvre. For others, a larger body of material can now be studied more critically. Various articles in contemporary art periodicals which illustrated or discussed monotypes stressed the process and not the purpose or role these prints had in an artist's development. The artists themselves were often reluctant even to record their opinions of and experiments with the monotype in their letters, diaries, or studio journals.

Between 1880, the traditional date for the introdution of the monotype to the American art world, and the early 1900s, a large number of monotypes were made and exhibited by American artists. The popularity of the process stemmed not only from its novelty, but also from the opportunities it presented artists for displaying bravura painterly technique. Many of these artists remain in obscurity today, some because of changes in scholarly and public taste, and others for their basic lack of technical skill. The American experience with the monotype before the turn of the century can best be characterized by the work of four artists: Frank Duveneck, William Merritt Chase, Charles A. Walker, and Maurice Prendergast. The first three, all of whom were among the earliest American

proponents of the process, used it for a variety of reasons. The fourth was the only American painter to fully integrate the monotype into his total artistic production, something not achieved by the others. In the early years of the new century, other artists began to use the monotype; among them, the artists connected with Robert Henri and John Sloan created a number of very important images.

An early link between the European and American experience with the monotype may most likely be found in the art schools of Munich and, a few years later, in Florence and Venice, where Frank Duveneck and his "boys," a group studying with him, worked between 1878 and the early 1880s. This frolicsome group of artists was a spirited addition to the Anglo-American communities in these two cities. Otto Bacher, one of the "boys," was also a printmaker and he took his press with him.[1] Bacher did not record how or when the first monotypes or, in this case "Bachertypes," were made by the group. He simply noted that they were made "as a means of entertainment" during social evenings at the homes in the Anglo-American communities. The monotypes would then be raffled off among the guests or given to the hosts. Bacher reported that Whistler recalled seeing a number of the group's prints at the house of a woman in England.[2] The monotype by Duveneck *Indians Warily Approaching Encampment* (cat. no. 46) documents, by a note accompanying it, this practice of distributing the prints at the end of the evening.[3] It would be simplifying the situation to label the monotypes from the Duveneck circle as only a more artistic variant of the parlor game. Rather, it was a "fun" version of printmaking through which these young painters were learning much about composition by light and shade. One such student was Charles A. Corwin, who made at least one etching and one monotype while in Venice.[4] The latter (cat. no. 47), pulled in 1880, is one of the great portraits of Whistler, a close friend of members of the Duveneck circle. Bacher believed that Whistler changed his attitude toward tonal wiping of the etching plate as a result of the monotypes that he saw on his visits to Venice.[5] It seems entirely possible that Whistler himself tried the process, but as yet, no documented or attributed pure monotype has surfaced.

Duveneck and William Merritt Chase were close friends during their time in Munich in the late 1870s. Before Chase returned to New York in 1878, having spent time with Duveneck in Venice painting and studying the Old Masters, he may have seen monotypes being made there or have learned of the process at a later date in letters from Duveneck. He exhibited his own monotypes publicly in 1881,[6] and again in 1882 at the Fifth Annual Black and White Exhibition at the Salmagundi Sketch Club.[7] While not the first to show monotypes in America, Chase, as a fashionable painter and as an art teacher, was influential in popularizing the process.

Chase's bravura style of painting was not easily adaptable to the linear nature of the more conventional intaglio processes. The dark-field method, with its

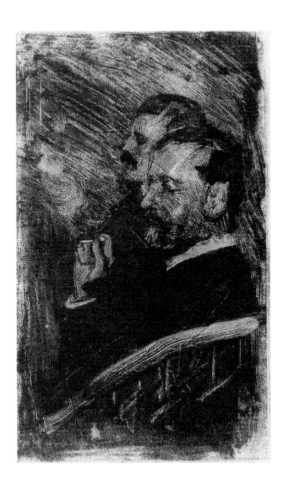

FIG. 32.
Irving Ramsey Wiles, *Study of two men, one smoking*, about 1890-1900, monotype in black ink.

Baker-Pisano Collection

dependence on both brushwork and the wiping action of rags, swabs, and fingers, was a fortunate discovery for him. Only one of Chase's monotypes, however, can justly be considered a masterpiece to rival his work in oil. This large study of a woman, *Reverie* (cat. no. 48), is noteworthy not only for its unusual size but also for the rich and velvety effect of the printer's ink. The subject of this sensitive study is probably the artist's wife, who served as his model for numerous paintings in the 1890s. Chase's monotypes included a number of other subjects: a few nudes, several heads of women, a series of male busts in "period" dress, a group of landscapes probably printed in California with a washing machine wringer, and several sensitive self-portraits (cat. no. 50). Since most of the surviving examples come from his heirs, Chase's monotypes, except for those exhibited in the early 1880s, were probably made for his own purposes.

Chase most likely used the monotype process as a teaching tool in his classes at the New York School of Art and in California. His only known monotype in color, a landscape, has a listing of students on the verso.[8] It was a practical method for teaching composition in terms of shadowy darks and lights. Chase may also have presented the monotype as an artistic experiment that could produce some interesting pictures, especially when several colors were used. Chase's students evidently tried the process, as can be seen in the monotype by Irving Wiles of two men in profile, one smoking (fig. 32). Wiles created not just a well-conceived and well-executed composition, but also a striking pair of portraits in this very painterly print. Another student at the Chase school was Edward Hopper.[9] At least five monotypes have survived in his estate, all small heads and figure studies, some with additional color added before printing. Two of these monotypes are printed on envelopes of the New York School of Art, both postmarked in the fall of 1902.[10] While Wiles made a more painterly composition, Hopper's small monotypes, such as the head of a man shown here (fig. 33), are strictly compositional studies in terms of dark shadow and brilliant lights.

In contrast to this artistic, if not lighthearted, approach was the serious attitude of Charles A. Walker of Boston, who treated the final print as a painting rather than as a print (see cat. no. 51). According to art critic Sylvester Koehler, Walker discovered the monotype process in 1881, independent of European travel or contact with the Duveneck circle,[11] and his enthusiasm for the technique was soon put to the public test with exhibitions in Boston in November 1881 and in New York at Knoedler & Co. that December. The review of the New York show in the *Art Journal* for December 1881 noted that Walker had successfully tried the process with a variety of subject matter. While his monotypes, both in black and white and in color, display a great dexterity, they reveal a rather limited artistic vision that lacked the spontaneity and invention found in the work of Duveneck and Chase.

The monotype process achieved a predictable popularity among the painters of the late nineteenth and early twentieth centuries as it allowed an inexperi-

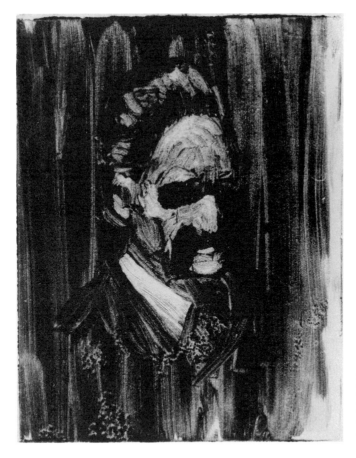

FIG. 33.
Edward Hopper, *Man's Head,* about 1902, monotype in black ink.

Whitney Museum of American Art, New York; Bequest of Josephine N. Hopper

enced printmaker the freedom of using a printmaking process without demanding a great degree of technical skill or a radical change of subject matter. Still, a number of striking and very competent impressions did emerge. Among the earliest makers of monotypes in America was Albion H. Bicknell, a contemporary of Walker's in Boston. His surviving prints indicate his mastery of the medium and an understanding of its limitations, and he too had exhibitions of his monotypes in Boston during the early 1880s. One of the most prolific minor artists making monotypes was the New York actor Joseph Jefferson, remembered today for his exclamation "God Bless that Little Church Around the Corner." He mastered the technical aspect of the process but lacked the imagination to exploit his subject matter. Other artists who are known to have used this process as part of their total artistic production include William F. Hopson, Herbert W. Faulkner, Ernest Haskell, Peter Moran, George E. Brown, Thomas Raphael Congdon, and Edward Ertz.

It is with Maurice Prendergast that we find the first thorough integration of this technique into an American artist's total production. The monotype clearly suited his artistic needs; he worked as easily in monotype as in oil or watercolor

43

during the fifteen years he used it.[12] Prendergast had at least one distinct advantage over his contemporaries: his visits to Paris in the late 1880s and early 1890s would have brought him in contact with the work of avant-garde French artists and even the possibility of knowing some of the artistic production of the multitalented Degas.

Close to two hundred monotypes survive to show Prendergast's use of a limited repertoire of subject matter to explore the medium. Like his watercolors and the few oil paintings from the same period, the monotypes have their own distinctive character, even though the imagery in all the work is often identical. With the monotype, Prendergast could get a silvery Whistlerian effect which is more difficult to achieve with the traditional methods of watercolor and oils. The transfer of oily ink onto dampened paper under the evenly applied pressure of the printing press, or the selective pressure of a utensil such as a spoon, accounted for much of this effect. Prendergast's monotype images are frequently blurred, as areas of color are emphasized over the delineation of details. In particular, his monotypes of young girls strolling in parks or fields (see fig. 34) or on the seashore usually become a play of pattern, their white dresses indicated with quick wipings of the ink across the surface of the plate. Many of them have a surface softness that may be attributed to the fact that they were second pulls.[13] Both pulls of some images still exist (cat. nos. 53 and 54). Prendergast may also have let the inked surface of the plate dry slightly before printing. Small creases and other tension signs so often found in his monotypes were the result of the overly wet paper necessary to attract the partially dried ink.

Prendergast's monotypes were exhibited by museums, dealers, and art societies during his lifetime and, more important, while they were being produced. During the late 1890s and the early 1900s, Prendergast frequently included monotypes among the watercolors and oils sent to various exhibitions, identifying them only by title, not by medium. Though it would have been unlikely for an artist at the turn of the century who was interested in making monotypes to be unaware of Prendergast's work, few monotypes by contemporary artists seem derivative of his work. The utter charm of his images of women and young girls in the park or at the shore, women hurrying through wind and rain, and street scenes in cities like Boston and Paris has kept the monotypes of Prendergast popular among American collectors.

Some of the most delightful monotypes by early twentieth-century American artists were made by members of what has been called the Ashcan School. Sketching was a frequent evening activity for Robert Henri and John Sloan and their wives, and often in company with other artists and with various of Henri's students. Sloan had his own etching press, so etchings were frequently made. In the entry in his diary for August 7, 1907, Sloan noted one such evening: "Henri came to dinner in the evening and we had a little monotype fun with the etching

press."[14] Monotypes which can be associated with these evenings, like George Luks's *Cake Walk* (cat. no. 67), impart the spontaneous and good-natured fun of these evenings as images emerged from the inked surface in a shorthand of quick wipings.

Sloan was more interested in the various graphic processes than most of the other members of this circle of artist friends (with the addition of Prendergast, Ernest Lawson, Arthur B. Davies, William J. Glackens, and Everett Shinn, the group was known as The Eight). The monotypes by Luks, Glackens, and Shinn

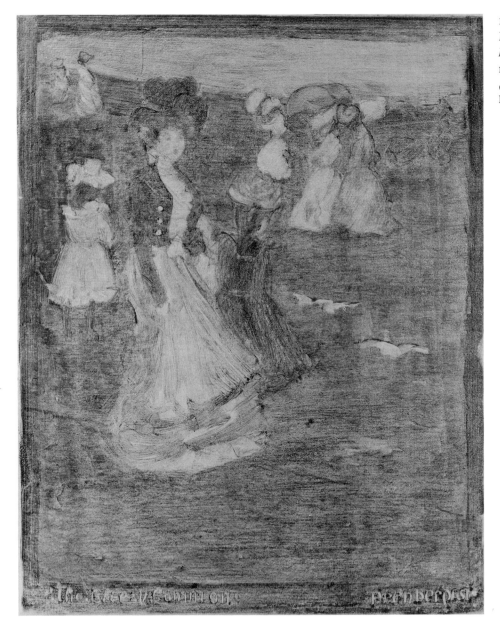

FIG. 34.
Maurice Brazil Prendergast, *The Breezy Common*, about 1895-97, monotype in oil colors.

Collection of Mr. and Mrs. Raymond J. Horowitz

45

(who called his "pastel monotypes")[15] were most likely the result of Sloan's interest in printmaking. Because of Sloan's already mentioned diary entry for August 7, 1907, it has also been assumed that Henri learned the process from him. In fact, it was probably the reverse. As early as 1898 and while in Paris, Henri noted in his diary that he made monotypes during a period of several weeks.[16] His friendship with the Canadian artist James Morrice brought him into contact with various contemporary French artists such as Bonnard and Vuillard, and he may thus also have learned of Degas's work in monotypes. An even more likely source, however, may have been his own contemporaries, recent students at the Académie Julian, where the monotype process may have had a basic part in the curriculum.[17]

The other two members of The Eight tried the monotype process, too. Ernest Lawson made at least two landscapes in colors which are closely related to his work in oils. Arthur B. Davies, on the other hand, experimented with the medium sometime between 1895 and 1905. The few known examples from this period show great variety in style and in mastery of the technique. He may have learned of the monotype either directly or indirectly through Prendergast's work. Davies apparently abandoned further experimentation with the process and devoted much time to etching, aquatint, and lithography.

A goodly number of monotypes were made by other artists active in New York City during the early decades of this century. Albert Sterner probably made nearly a hundred monotypes. Many of these, frequently in several colors, show a technical dexterity as well as a familiarity with a variety of stylistic influences not often found in his etchings and lithographs. His main problem was not in mastering an artistic technique but in finding his own unique style. Sterner's monotypes frequently illustrated contemporary articles on his own work as well as on the process itself.[18] Both Eugene Higgins and Abraham Walkowitz made monotypes. While both artists studied in Paris, their art reflected different schools of thought. Higgins's bulky shapes plod through life in a murky world, his own interpretation under the influence of the Barbizon painters. Walkowitz, on the other hand, showed more variety in his monotypes, and while some are similar in subject to Higgins's works, a number seem governed by a knowledge of Cézanne's painting. Large bulky figures fill the picture space. Walkowitz made several monotypes, mainly of beach scenes, which are conceived in terms of bold, bright color. Both artists were exhibited by Alfred Stieglitz at his gallery "291"; the former because the surface quality approached that of the platinum print, the latter because of his modernism.

A short introduction to the American experience with the monotype at the turn of the century can only begin to cover the rich variety of images produced by the many artists who made use of this printmaking process at the time. Much of this activity centered in New York, with traveling exhibitions being sent to museums in other cities. Christian Brinton and Frank Weitenkampf both noted

the existence of a New York Monotype Club started by former American students at the Académie Julian, such as Albert Sterner, Ernest Peixotto, and Louis Loeb,[19] though to date no further information on this group or any exhibition of their monotypes has been found. A series of color monotypes of various New York scenes was made by Charles F. W. Mielatz and reproduced for distribution by the Society of Iconophiles in 1908. F. Luis Mora and Gifford Beal made several interesting monotypes with circus subjects. The West Coast should not be forgotten as there were a number of artists centered in Oakland, California, who made and exhibited many monotypes during the first quarter of this century and definitely prior to Chase's visit there in 1914. Among these artists are Gottardo Piazzoni, Clark Hobart, Perham W. Nahl, Xavier Martinez, and William H. Clapp.[20] These, and others, found that the immediacy of the printed image and the ease of production enhanced the rich, painterly qualities of the monotype process. It is hoped that as investigation progresses into contemporary literature, personal and studio diaries, and private papers of the artists of this period, a clearer understanding will emerge of the role of the monotype for these people, for they have left a distinctive group of painterly prints that demands our consideration.

1. Otto Bacher, *With Whistler in Venice* (New York: Century Co., 1908), pp. 116-21. See also Hugh Patton, *Etching, Drypoint, Mezzotint* (London, 1895). Patton related his initial experience with the monotype and the Duveneck circle in Florence: "I came across this method of working on copper in Florence, in the year 1882, where it was practiced by some young American etchers, Munich students (by the little group, in fact, know as the 'Duveneck Boys,' Mr. Frank Duveneck being the leading spirit). It was practised by them however, rather by way of pastime, than as a serious form of art.." (p. 104).

 While critical of the method, Patton saw some merit in it: "As I have hinted, the practice of 'monotype' is rather to be regarded as a pastime, than as a serious form of art, but to the etcher who has a press beside him it will prove a very fascinating method of trying broad strong effects in an impressionistic way. When carried out in too much detail, much of the effect is lost" (p. 106).

2. Bacher, pp. 116-21.

3. Note accompanying this Duveneck monotype: "In the Villa Ball. Florence. Italy. The winter of 1883 and '84 – Original Monotypes On copper plates in oil paint with the finger, a stick & a rag – Every Monday Evening printed one copy on an old press set up in the hall. These were given to Kate and myself. They are by Frank Duveneck.– All the others Mrs. Thomas Ball had."

4. Sylvester R. Koehler, *Etching* (New York, 1885), p. 163. Koehler refers to a "Whistlerian" etching by Charles A. Corwin. Corwin did not return to etching or even the monotype after he left Venice.

5. Bacher, pp. 116-21.

6. Frank Weitenkampf, *American Graphic Art* (New York: Macmillan, 1924), p. 109.

7. *Catalogue of the Fifth Annual Black and White Exhibition* (New York: Salmagundi Sketch Club, 1882), p. 23, no. 491. Chase's entry in the exhibition was untitled, and he did not indicate

what resale value he placed on the print. Monotypes by Charles A. Walker (no. 222, *Surf at Nahant*) and A. H. Bicknell (nos. 259 and 342, both untitled) were also in the exhibition.

8. This monotype is presently in the collection of the Achenbach Foundation for Graphic Arts, California Palace of the Legion of Honor, San Francisco.

9. By the time Hopper became a student at the New York School of Art, Henri was also a member of the teaching staff.

10. Gail Levin, *Edward Hopper: The Complete Prints* (New York: W. W. Norton & Co. in association with the Whitney Museum of American Art, 1979), p. 9 and pls. 1-5. A helmeted head of a man is on an envelope postmarked November 12, 1902, while another portrait head is on an envelope with an earlier postmark, September 30, 1902.

11. Sylvester R. Koehler, "Das Monotyp," *Chronik für vervielfältigende Kunst*, vol. 4, no. 3 (1891), p. 17. Koehler described a visit to Walker's studio in 1881 soon after Walker had developed the monotype process for himself. Koehler also included an account of the conversation between himself and the artist.

12. The earliest monotypes by Prendergast seem to date about 1891 and the latest about 1905. After this time he exhibited paintings almost exclusively.

13. Hedley Howell Rhys, *Maurice Prendergast 1859-1924* (Boston: Museum of Fine Arts, 1960), p. 34. "He [Prendergast] rather cryptically outlined his method of producing them in instructions that he gave to his only pupil, Mrs. Oliver Williams, in 1905: 'Paint on copper in oils, wiping parts to be white. When picture suits you, place on it Japanese paper and either press in a press or rub with a spoon till it pleases you. Sometimes the second or third plate is best!'"

14. Bruce St. John, ed., *John Sloan's New York Scene* (New York: Harper & Row, 1965), p. 120 (April 7, 1907).

15. Weitenkampf, p. 135.

16. Conversation with Bennard B. Perlman, August 31, 1979, and letter from Perlman to the author, September 30, 1979.

17. Cecily Langdale, *The Monotypes of Maurice Prendergast* (New York: Davis & Long Co., April 4-28, 1979), p. 9.

18. Photographs of Sterner's monotypes illustrate the following articles: W. Lewis Fraser, "American Art and Foreign Influence," *The Quarterly Illustrator*, vol. 2, no. 5 (January, February, March 1894), pp. 2-9; Christian Brinton, "The Field of Art: Monotypes," *Scribner's Magazine*, vol. 47, no. 4 (April 1910), pp. 509-12; Christian Brinton, "Apropos of Albert Sterner," *International Studio*, vol. 52, no. 207 (May 1914), pp. lxxi-lxxviii.

19. Brinton, "The Field of Art: Monotypes," p. 512.

20. *Monotypes in California* (Oakland, Calif.: Oakland Museum, October 17-December 17, 1972).

COLTA IVES

The Modern Art of Monotype

Ever since the Impressionists demonstrated that paintings could be made with pure colors and brushstrokes that were not only loose but disconnected, artists have felt freer to reveal their processes. Traces of the artist's brush, once painstakingly concealed, now are proudly exhibited, for both the activity of the creative hand and the materials in its service are considered, in themselves, powerful means of expression. The twentieth century's particular involvement in the physical act of picture-making and in the special qualities of paint, ink, and the flat surface of stretched canvas or a sheet of paper are clearly reflected in our paintings, our drawings, and in the process of monotype, now more popular than ever.

The idea of creatively inking metal plates and woodblocks passed from the nineteenth into the twentieth century through the hands of Degas and Gauguin to Munch, to German Expressionists, and to Kandinsky, who in 1904 carved woodcuts so sparingly that most features had to be filled in by hand before printing (fig. 35). The strong commitment to printing materials that has always been felt in northern Europe surfaced at this time also in grained and rough-hewn woodblocks sometimes hand colored before their printing by Ernst Ludwig Kirchner and his followers. Although German Expressionists did not, to our knowledge, produce any monotypes, their craftsmanly approach to printmaking was inherited by the staff of the Bauhaus at Weimar who, it is said, encouraged students to experiment with monotypes in a "materials familiarization" course.[1]

There is nothing so complicated about making monotypes that prevents an artist from discovering the process on his own, especially if he has practice in printmaking and a love of experimentation, as did Pablo Picasso, Georges

49

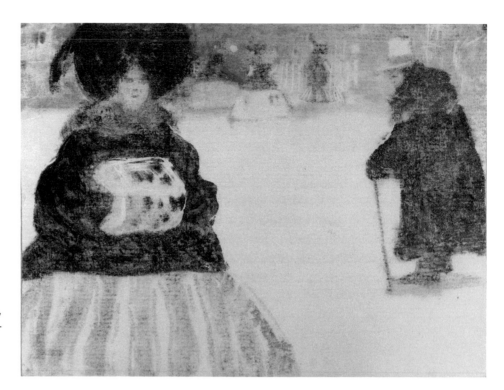

FIG. 35.
Wassily Kandinsky, *Winter Day,* 1904, woodcut, inked by hand in several colors before printing.

Gabriele Münter Bequest, Städtische Galerie, Munich

Rouault, and Henri Matisse, all of whom are brilliant examples of the traditional *peintre-graveur,* and who printed monotypes between 1905 and 1917 when the decisive art styles of this century were taking shape in Paris. Each of these painters apparently adopted the monotype technique independently, at different times, and for different reasons: Rouault, in a restless period of technical trials; Matisse, as part of the diversion printmaking provided him during World War I; Picasso, out of curiosity first, and for exercise later, in the mid-1930s when the graphic arts gave him refuge.

When Dada and Surrealism emerged in Europe in the late teens and twenties, their precepts began to exert as powerful and enduring an influence on the production of monotypes as on the general direction of art in this century. The acceptance of any material at hand as a potential ingredient of art cleared the way for Jean Dubuffet and Mark Tobey, for instance, to introduce leaves, threads, crumpled papers, sponges, and the like into monotype printing. Max Ernst's inventive processes like his "frottages," or rubbings of botanical and other elements, helped open artists' eyes to infinite technical possibilities, as did Paul Klee's use of unorthodox materials and unusual methods like oil transfer drawing and printing with inked string.[2]

A great contribution of the Dadaists and Surrealists to the credibility of the monotype medium is owed to their promotion of naive art, the art of children, art that is untrained and created spontaneously. On their terms doodling, graffiti,

even spots and spills became potentially artful. Experiments with accidental blots and stains using transfer methods date at least as early as Leonardo da Vinci, turn up with Victor Hugo's moody little landscapes of the 1850s, and again with the splotchy "doubles" portraits Max Beerbohm made in 1917. The Surrealists recognized the suggestive power of the ink blot just as Hermann Rorschach had around 1920, and in 1936 in their magazine *Minotaure*, André Breton described and illustrated ink-blot transfers called "décalcomanies," made by himself, Yves Tanguy, Marcel Jean, and others (fig. 36).[3] The charm of these ink-squeezed prints lies at least as much in their chance creation as in their turbid looks since, like Surrealists' "automatic drawings," they sprang from a mix of happenstance and intuition.

The appeal of scribbles, strokes, drips, and wipes is unmistakable in the monotypes of Dubuffet, Adolph Gottlieb, Robert Motherwell, Jasper Johns, and, naturally, Joan Miró, the most durable of the original Surrealist group. It plays a prominent role also in the work of Oskar Schlemmer, Tobey, and Sam Francis, all of whom studied Oriental art and calligraphy in search of fresh ways to handle pigments. Their love of "free" lines and "natural" textures, so much in evidence in their paintings, is responsible for these artists' attraction to monotype.

The twentieth-century monotypists represented in this exhibition are remarkably well versed in a wide range of artistic media. Although nearly all are best known as painters, many have worked in sculpture and collage, most are prolific draftsmen, and every one of them has practiced traditional printmaking in etching and lithography. The urge to experiment, the need to explore every possible way of visually expressing themselves is pervasive in this company and is the single greatest factor in their adoption of the monotype technique.[4] Georges Rouault's complicated maneuvers with aquatint and photoengraving, Marc Chagall's quirky handling of lithography, and the mixed ordering and coloring of printing stones practiced by Dubuffet and Francis typify the many ways in which these artists push processes to extremes.

In the last two decades, an active interest in technical invention has been encouraged in American print workshops such as Tatyana Grosman's ULAE atelier on Long Island, where particularly creative and indulgent offerings of specially prepared printing plates, custom-mixed inks, and hand-laid papers have fostered risky adventures on the parts of Motherwell, Johns, and others. By luring a new generation of artists to lithography, which she did in the early 1960s, Mrs. Grosman helped revive a dying art. Once painters saw that they need not, as printmakers, be enslaved to lines engraved or etched in metal but could gesticulate freely with liquid color and tone, printmaking became a plausible outlet for Abstract Expressionism and thus gained new credence as a painter's medium.

Many artists have begun making monotypes after mastering traditional printmaking techniques then, proceeding to hand-ink their plates or hand-color their prints, they have ultimately come to print their drawings and paintings

FIG. 36.
Marcel Jean, untitled "Décalcomanie," illustrated in the article, "D'une Décalcomanie sans objet préconçu," by André Breton, published in *Minotaure*, no. 8 (1936), pp. 18-24.

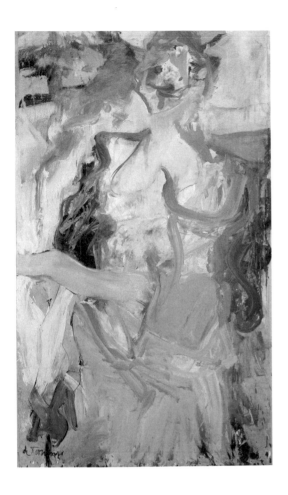

directly without intervening steps to chemically "fix" and reink them. Nathan Oliveira, on the other hand, first considered printing his paintings after he found promising images transferred accidentally from his canvases onto the papers used to protect them overnight. Willem de Kooning has for some time valued his paintings' counterproofs, having taken impressions of his wet canvases by pressing paper or vellum on them. He sees these offsets as part of his working process and may study them, experimentally cut them into pieces, or occasionally preserve them as interesting works in themselves, although he has never intentionally set out to create a picture in this way (fig. 37).[5]

Sometimes artists who would have preferred to paint had conditions allowed it have turned alternatively to making monotypes. Dubuffet, for example, started concocting his *empreintes* after moving to Vence, where his studio was too cramped for much work on a large scale. Milton Avery, first, and later his friend Adolph Gottlieb elected monotyping when weakened health restricted activity.

Although it has been said that most printmakers discover the mysteries of monotypes on their own while tinkering in the workshop, guidance from experienced practitioners has proven invaluable. Through teaching, writing, and the preparation of exhibitions, Matt Phillips has focused considerable attention on the medium. Michael Mazur has introduced scores of students to monotypes in addition to sharing his press with Mary Frank and Jim Dine. In California Nathan Oliveira, who invited Richard Diebenkorn, Wayne Thiebaud, and others to join him in monotyping sessions at Stanford University, is an active, influential spokesman.

More than any other authority, Edgar Degas continues to command the raptest attention and provide the most powerful stimulation to contemporary monotypists. The landmark exhibition of his monotypes at the Fogg Art Museum in 1968 and its catalogue, both prepared by Eugenia Parry Janis, sparked an explosion of new work in the medium and subsequent exhibitions of monotypes by past and living masters in Boston, New York, Philadelphia, Los Angeles, and San Francisco. Most of the artists making monotypes in the 1970s have studied Degas's work carefully and have adopted his techniques involving the dark-ground process (whereby highlights are wiped or scraped into an inky background), the multiple printing of the same plate, and frequently a reworking of second or later impressions with hand-applied colors. Michael Mazur, Mary Frank, Nathan Oliveira, and Richard Diebenkorn have made particularly admirable use of Degas's lessons, utilizing late impressions of their monotypes and the "ghosts" that remain on their printed plates as springboards for the progressive development of compositions.

Interest in monotypes in this century seems to arise less from a desire to deliberately create luxurious, shadowy effects than it does from the modern-day emphasis on the direct and the forthright which requires that a picture's sur-

face, its pigment, and the presence of its creator be immediately felt. And because monotyping forces an artist to work swiftly (before inks or oil paints dry) and thus spontaneously, it challenges the quickness of hands and wits. It may even help to limber up a painter or serve as a proving ground for his ideas as Mazur, Diebenkorn, and Dine have said it can. So long as an artist's working process as well as his personal handwriting are of keen interest to us, his monotypes will be too.

1. Henry Rasmusen, *Printmaking with Monotype* (Philadelphia: Chilton Co., 1960), p. 42. See also Peter Hahn, *Junge Maler am Bauhaus* (Munich: Galleria del Levante, 1979) in which seven monotypes made by Fritz Kuhr while he was a student at the Bauhaus, between 1921 and 1931, are reproduced.

2. Marcel Duchamp, Surrealism's greatest inventor, made only one monotype to our knowledge. A souvenir of Degas's bathers, it is executed in color inks and printed from a gelatine-coated plate on a copying press: *Suzanne Duchamp Washing Her Hair* (1902), listed and illustrated in Arturo Schwarz, *The Complete Works of Marcel Duchamp* (New York: Harry N. Abrams, 1969), p. 375, no. 8.

3. I am grateful to Karin von Maur for bringing this article to my attention. She refers to it also in her new book, *Oskar Schlemmer: Monographie und Oeuvrekatalog* (Munich, 1979), vol. 1, pp. 289-91.

4. The same could be said of other artists who experimented with monotyping in the first half of this century, the most important of whom are as follows: Maurice de Vlaminck (1876-1958), whose monotype *Young Woman Arranging Her Hair* relates to his woodcut of the same title executed about 1906 (see Katalin von Walterskirchen, *Maurice Vlaminck. Verzeichnis des Graphischen Werkes* [Bern: Benteli Verlag, 1974], p. 20 [no. 3] and p. 271, appendix to catalogue no. 3; also *A Catalogue of Fine Prints, 1496-1956* [London: P. and D. Colnaghi and Co., 1979], no. 129); Charles Dufresne (1876-1938), whose lively monotype *Monkeys* is illustrated in Malo Renault, "Le Monotype," *Art et Décoration*, vol. 37 (1920), pp. 49-57 (see also Paul Prouté, *Dessins, Estampes*, sale catalogue, Paris, 1975, p. 95 [no. 274]); Edward Gordon Craig (1872-1966), who, according to James Bergquist, made approximately five monotypes in 1921, some of which are in Mr. Bergquist's possession, while others are in the Bibliothèque Nationale, Paris; Georges Braque (1882-1963), whose two known monotypes dating around 1942 were pointed out to me by Gérald Cramer. One, *The Blue Teapot*, is in a private collection in Geneva.

5. See Thomas B. Hess, "In de Kooning's Studio," *Vogue*, April 1978, p. 236 ff.

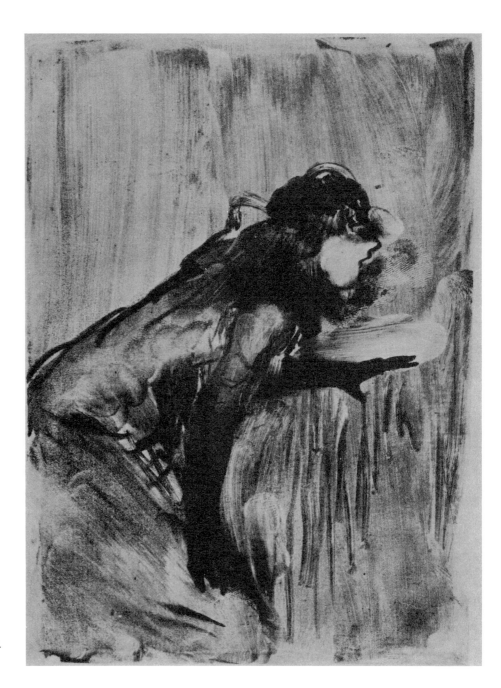

FIG. 38.
Edgar Degas, *Cafe-Concert Singer*,
about 1877-78, monotype in black ink.

Kornfeld and Klipstein, Berne

MICHAEL MAZUR

Monotype: An Artist's View

One close look at Degas's *Cafe-Concert Singer* was all I really needed to get started (fig. 38).[1] This tiny explosive image, a spontaneous gift of the artist's spirit, seemed to have been breathed directly on the paper in one magical gesture. A closer look reveals Degas's labor. His fingers pushed in ink like modeling clay. His painter's cloth wiped out the black ink for luminous whites. His brush added telling contours. At just the right moment he printed his constellation of tones, not much more than a cluster of smudges. But when the paper emerged from the press, still damp and pliant, those little marks became flesh, hair, fabric: a nose and mouth in one line; a gloved hand, corrected and redrawn. They became a spotlighted cafe singer, bawdy and as aggressive as the strokes that made her. The spontaneity and energy in that little print lifts the medium into art.

Monotype is a painter's medium. Although launched in the print shop, it was born of the painter's imagination and restlessness. A perfect tool for improvisation, it waited from the time ink was wiped off the first engraved plate. The only explanation for its taking so long is that artists designed plates but rarely printed them. I'm sure there were several unique images discarded in some printer's trash, the occasional escape from the tedium of this repetitive craft. If Rembrandt and Segers had not taken etching to the edge of the totally unique print, it might have taken still longer to improvise with ink alone.

The Process

Monotypes are unique impressions of ink transferred to paper from a relatively nonporous surface upon which an image has been painted. While there are as many approaches to making these images as there are practitioners, a discussion of the medium can be simplified to include a description of the printing surface, the application of inks, and the method of printing.

Because of its historic relationship to etching, the first surface used was the metal plate, such as the type of copperplate used by Castiglione for his etchings. Etching ink was used and the image was printed under the slow, constant pressure of the etching press. It was probably an early discovery that the amount of pressure needed was very similar to that used to drive the damp paper into the thin grooves of the etched or engraved plate. It can be assumed, I think, that the process used in the earliest monotypes corresponded in nearly every way to the process of printing traditional intaglio prints with the major exception that there was no fixed image — all the ink lay on the surface of the plate.

From the beginning there have been two manners of applying ink and painting the plate. The subtractive or "dark-field" manner involves the coating of the surface with a consistent layer of brown or black ink. The early method would again have corresponded to the preparing of an etched plate before "wiping" but in sufficient quantity to produce an overall tone when printed. In this subtractive manner, the image is wiped out of the darkened field, with rags, fingers, or sticks, which are most likely the shafts of paint brushes that can later be used to brush ink back into a contour, to correct an edge, or build a tone. Removing ink in this way reveals sections of the metal plate which print as luminous areas or crisp white lines (figs. 44-48).

The second traditional manner is the additive or "light-field" manner. Here the clean plate serves as an empty field upon which the image is drawn, very much like painting on a clear canvas (figs. 39-43). If in the dark-field or tone-prepared plate, the ink is viscous and dense, in the light field, it is thinned down with a solvent (turpentine) and resembles a watercolor wash (fig. 41). Dark contours or areas can still be dense, but if delicate halftones are wanted, more solvent must be added to the pigment. The milky quality in some of these tones can be the result of over-thinning.

As the processes of printmaking changed and its technology became at once more sophisticated and more personal, so did the monotype. Ink rollers, made first from leather, then rubber and plastic derivatives, could be used to prepare tonal areas or offset images and play their part in the mixing, layering, or separating of black or colored inks. The changing viscosity of inks could be used to gain results from the different ways these inks behaved in the printing process. And the scale change from the traditionally small plate to increasingly larger formats has had its effect on the choice of tools used in painting and printing.

Other surfaces and manners of printing are part of the technical history of this medium. Monotypes can be press-printed from wood blocks or litho stones, as well as the variety of metal plates used today by printmakers. Lightweight metals and plastics make sense with the increased size of plates. Monotypes can be hand-printed from many surfaces, though glass has frequently been used. Gauguin's monotypes show the use of paper as a transfer material, either for use

as an offset or, with a stencil, as a porous surface through which wet watercolor could be applied.

Simple pressure and lightweight paper has often been enough to secure a rich print. Many painters, ranging from Toulouse-Lautrec to de Kooning, have "printed" from sections of wet canvas, others have worked from their palettes in an effort to take an impression of a particular form or color event.

However the monotype is made, it is characteristic that some residue is left on the printing surface after the print is taken. Second prints of this lighter image are called "cognates" for their kinship with the first impression. While etchings, engravings, in fact all print processes can yield lighter impressions without reinking, these cognates play a special role because they create a new set of tonal values to which new material can be added (fig. 42).

The existence of so many variant procedures in monotype is partly explained by the very lack of interest in documenting the monotype process. Since its beginnings it has not so much been taught as rediscovered and reinvented by each artist who uses it. And each artist brings to the medium the experience of his particular vision and craft.

Inventive additions to the craft of printmaking seem to follow this pattern. An artist wants to reproduce in a print the quality of some aspect of another medium. The tautness of a line from a quill pen becomes an engraving. The search for tonality with this tool ends in the crosshatch or a wash drawing translates into aquatint. These print media, in turn, expanded the possibilities of the material they started out to reproduce. And so it is true of monotype and monoprint media.[2] They bring to printmaking a new vitality just when it seems to be regressing into reproduction.

The Problems

A "painterly" print is still a print. The image is reversed and rarely, if ever, prints exactly as it looks on the plate or block. A great deal of surprise is built into printmaking. Lifting the paper off the printing surface is a tense and revelatory moment. The image is composed of layers of ink and often changes if the viscosity of the inks or paints print differently, especially in the subsequent or cognate impressions. A lot can go wrong. Too little ink may seem sufficient on the plate but will print as a light color instead of the desired rich hue. Too much ink ends in a spreading, glossy disaster. If the pressure of the press or quantity of ink isn't just right, other unpredictables occur. The clean, frozen line made by the brush handle in the deep black field of ink can disappear entirely – hardly what one expected (hence the magic of those few white-line monotypes by Matisse!). And so we must inevitably come back to craft, not quite the printmaker's elaborate, often fussy craft, but craft nonetheless. For in monotype,

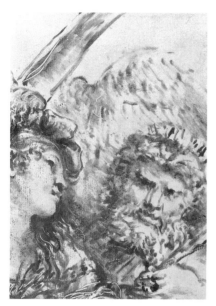

FIG. 39.
Oil pigment was applied to a clean metal plate, much like a drawing on paper.

Castiglione, *David with the Head of Goliath* (detail), cat. no. 13.

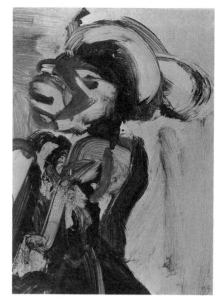

FIG. 40.
Brushstrokes of different consistencies of oil paint created a complex surface.

Rouault, *Clown and Monkey* (detail), cat. no. 79.

FIG. 41.
Ink applied over a turpentine-washed plate produced a mottled surface. Ribbing of laid paper created a grid pattern.

Avery, *Pink Nude* (detail), cat. no. 90.

FIG. 42.
Brushstrokes of fresh dark ink contrast with the lighter residues of an earlier printing.

Diebenkorn, *IX, 4-13-75* (detail), cat. no. 97.

FIG. 43.
Oil paints were applied by spattering. The edges of metal plates stacked one on top of the other were colored and, under pressure of the press, embossed the paper with their outlines.

Francis, *Untitled*, 1977 (detail), cat. no. 99.

Subtractive or Dark-Field Methods

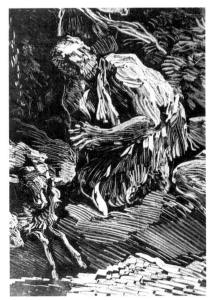

FIG. 44.
Wooden tools of varying thicknesses (perhaps brush handles) were used to remove ink, leaving lines and patches of white.

Castiglione, *The Annunciation to the Shepherds* (detail), cat. no. 9.

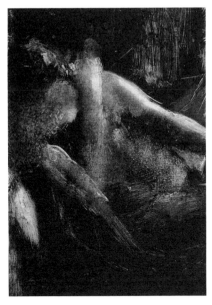

FIG. 45.
Rags, brush handles, and the artist's fingers removed ink from the darkened plate to introduce light.

Degas, *The Fireside* (detail), cat. no. 23.

FIG. 46.
A sharp tool incised white lines in a dense layer of ink.

Matisse, *Seated Nude with Arms Crossed* (detail), cat. no. 80.

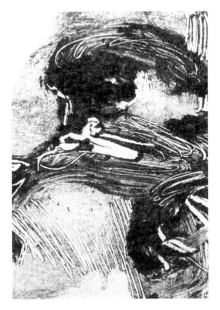

FIG. 47.
Ink was wiped away to leave figures silhouetted and enlivened with scribbles.

Luks, *Cake Walk* (detail), cat. no. 67.

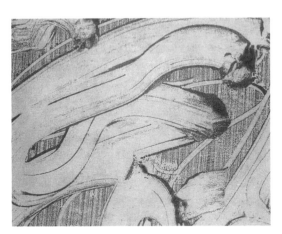

FIG. 48.
Oil color thinned with solvent was removed with brush bristles and handle.

Avery, *Birds and Ruffled Sea* (detail), cat. no. 91.

as in other media, spontaneity is tempered by discipline; energy and expressive gesture by a certain detachment and control.

I know artists for whom the medium is inappropriate. You won't find them making monotypes because it isn't at all suited to the way they work. Even painterliness, after all, isn't all there is to painting. Linear draftsmen, in love with the hard edge or contours of the forms they draw, won't make monotypes. And neither will those who require every mark to keep its integrity, who build their tonalities with careful strokes of a hard pencil or small nibbed pen. They will stay away. The medium works best when images are evoked from the material and not imposed upon it. Detail is best suggested rather than employed. I have always been drawn to those monotypes whose ambition was not to be imitative of a fully performed painting. I prefer to print before it reaches that level of completion. But even as I say this, I know someone will come along and make a particularly nonpainterly monotype; will use elaborate stencils for the hardest of edges; will find a way to transfer detail that would make the stipple engraver jealous.

The time it takes to make a monotype is short compared with most media. Although ink stays workable for a longer period than is expected, the print is usually pulled within an hour and often less. This factor tends to exclude artists who work slowly, but appeals to those of us who are impulsive and thrive on the intuitive leap. Because of the constant lure of the cognate, the chance to add new material to the residue on the plate, the process keeps me working for hours in what might best be described as a "run." This cannot be a daily experience. A common experience for many of the artists using the medium is a series of spurts of activity, producing several prints during a session. Because of the intensity of concentration, because the image cannot simply be put down, these sessions can exhaust both the artist and his ideas over a short span of time.

The Provocation

The recent history of printmaking is complicated and involved with commercial pressures which have had the result of moving the artist away from a direct relationship to the printing process. Many artists, even those most directly involved with print media, have replaced immediacy with technology. The resulting work is really reproduction, crafty and sterile. There has been a discernible reaction to this among painter-printmakers. Editions are smaller and there are more examples of monoprints and hand coloring. These additions from the artist's hand individualize prints, rarify them, and give them a unique quality, a sense of the artist's touch. If they are more direct and simple in technique, they seem all the more mysterious to the viewer. I have never received more questions about craft than I do about monotypes, for the very reason, perhaps, that they are closest to the painter's indescribable impulse and intuition.

If artists are diverse in their technical approach, so do they differ in their reasons for employing the monotype or monoprint media. It is probably true, as in printmaking generally, that the monotype image has its source in the artist's work in another medium. A motif developed first as a painting or drawing is adopted and varied in the monotype. More occasionally, the medium is used to test ideas before they become paintings or prints. A third alternative is the use of the monotype for original material limited to the experience of this medium alone. Degas illustrates all of these possibilities but reserves as a subject for his monotypes those images (from the *maison close* series and Halévy's *La Famille Cardinal*) which belong to the narrative and sequential possibilities uniquely suited to this medium. It is this use of monotype which transcends source and provides for those of us who use it a very special opportunity and a reason, perhaps, for the contemporary resurgence of interest in the medium.

A monotype sequence is not simply a group of variations. A mono*print*, having some fixed element or matrix on the printing surface, is analogous to a musical theme or motif which, though varied, can be repeated at intervals throughout a piece. A mono*type* is a totally unique image, it goes forward in one direction. Each new image informs, and is informed by, the next. This aspect of the monotype gives both the viewer and the artist something very rare; the chance to study the development of an idea as it unfolds. I like to save my complete run of images from a day's work, even if they are eventually rejected, just to replay the way I worked. The history of a painting is private and fleeting. There are layers of ideas reworked and passages, often beautiful in themselves, overpainted to improve the unity of the picture. While this can happen in the painting of the plate, the option to print it at any point allows the artist to document his process. The same opportunity exists in the proofing of a print, in the comparison of one state to the next. But in monotype, this experience is compressed and intensified. Reaction and response are important elements in this process.

The traditionally small scale of prints is given a special meaning in monotype. We experience in them a breadth of mark that is characteristic of larger scaled works. It is certainly this element in the work of Degas that makes his small monotypes so explosive by comparison to his work in other media. It is as if we experience a level of magnificaiton which brings us closer to the mark itself.

Of all the decisions made in the course of this procedure, the decision to print is most crucial. The artist's personal definition of "finish" determines when he prints. Sometimes the image on the plate reaches a certain inevitable stability that defines it as a finished image, one that has come to conform to the artist's preconception. At other times it is not so much a state of completion or rest but a moment of "becoming" which has other qualities perhaps more important than stability. Then the sequence moves along, idea to idea, in a kind of free-associative improvisation. It is the journey, not the arrival, that matters.

All art media are at least partly about their own process. When we look at a given work, we see it not simply as an idea but as a thing, full of information about itself. We experience the hand and brush through the marks they leave, marks which chart the course of the picture. Understanding this process gives us an insight into images, much as maps allow us to understand topography. But the impact of the image is more than process. It is an alchemy of the material into a spiritual substance. This brings me back to the *Cafe-Concert Singer*. Like a work one revisits before leaving an exhibition – a picture that must be remembered – it epitomizes the spirit of working with this medium. It sends me back to the studio wanting to make monotypes, wanting to continue the process, the dialogue, wanting to transcend the material.

1. I was introduced to monotype at the exhibition devoted to Degas's work in this medium at the Fogg Art Museum in 1968. Many artists I know and associate with this medium have cited Degas as a source, either from this exhibition and its remarkable catalogue by Eugenia Parry Janis or from a familiarity with his œuvre.

2. Mono*types* differ from mono*prints* in that they lack a fixed matrix which can be repeated in the manner of a traditional print process. The monoprint is a unique impression or variant of an image that could exist in an edition. In the monotype, only the cognate can be said to bear a resemblance to the original impression. But because it is printed from the fragile residue of the original inking, it is usually greatly diminished in tonal strength. Except where used to superficially repeat an image, monotype is a medium in constant transition and flux with no return to the common basic structure offered by the monoprint matrix.

3. Collaboration is very much a part of the history of printmaking and has figured in the monotype experience. Monotype "clubs" were common at the beginning of the twentieth century; in our generation many artists have worked together with the medium. Nathan Oliveira and I have compared notes about working with other artists; he with Wayne Thiebaud and Richard Diebenkorn, and others in California; I with Mary Frank, Jim Dine, and other friends in Boston and New York. Artists have primarily been responsible for the revival of interest in the medium and this is as true now as it was in the past. Matt Phillips initiated a great deal of interest in monotype in the mid-1960s.

Seventeenth- and Eighteenth-Century Monotypes

Rembrandt van Rijn

Dutch, 1606-1669

The Entombment, about 1654

Etching, drypoint, and burin
Plate, 8¼ x 6⅜ inches (21.1 x 16.1 cm.)

EXHIBITION:
Museum of Fine Arts, Boston, and Pierpont
Morgan Library, New York, 1969 (cat: Sayre,
Eleanor; Stampfle, Felice; et al. Rembrandt: Ex-
perimental Etcher, nos. 80, 82, 84).

REFERENCES:
Bartsch, Adam. Catalogue raisonné de toutes les
estampes qui forment l'oeuvre de Rembrandt.
Vienna, 1797, no. 86. Hind, Arthur M. A Cata-
logue of Rembrandt's Etchings. London, 1923, no.
281.

BIBLIOGRAPHY:
White, Christopher. Rembrandt as an Etcher.
London, 1969. White, Christopher. The Late Etch-
ings of Rembrandt. Exhibition catalogue. Lon-
don: Arts Council of Great Britain, 1969.

These four impressions of *The Entombment* represent those plates of the last two decades of Rembrandt's activity in which selected elements of the composition are picked out by light from their dark surroundings. This end is achieved both by line work in etching, drypoint, and burin, and by the manipulation of ink on the surface of the polished copperplate.

The first and fourth states are clean wiped and were chosen to illustrate the degree of line work on the plate. Most of the additional line work is present in the second state, and the changes made progressively in the third and fourth states, though subtle and effective, are relatively minor. What is pertinent in the impressions exhibited of the second and third states is the film of ink left on the surface of the plate. In the second-state impression the entire plate has been overlaid with a heavy film of ink, so that the participants are barely visible. In the third state, the film of ink was wiped from Christ's body and the closest onlookers who reflect a brighter source of light. The two figures standing at the left and the details of the tomb are masked in shadow. The dramatically different effect of each of these impressions is achieved almost entirely by the way the surface ink was distributed.

Rembrandt's impressions with expressive inking provided the source for a renewed interest in special inking in the nineteenth century and later on in the practice of making monotypes.

S.W.R.

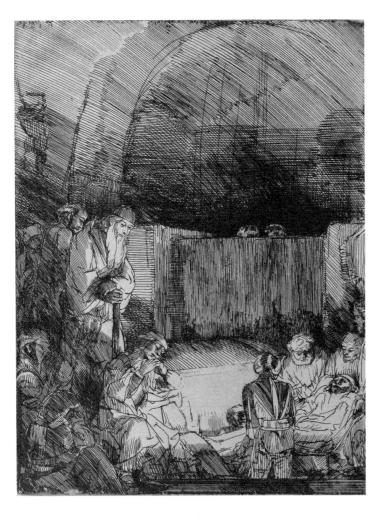

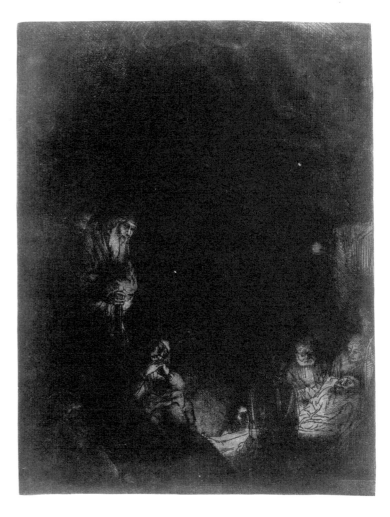

1. First state, clean wiped

The Metropolitan Museum of Art, New York
The Sylmaris Collection, Gift of George Coe
Graves, 1920 (20.46.17)

2. Second state, with surface tone

The Metropolitan Museum of Art, New York
Gift of Henry Walters, 1923 (23.51.7)

3. Third state, with surface tone
The Pierpont Morgan Library, New York

4. Fourth state, clean wiped
Museum of Fine Arts, Boston
Gift of Miss Ellen Bullard, M30801

Giovanni Benedetto Castiglione

Italian, about 1600-1663/65

5. God Creating Adam, 1640-45

Monotype, white line on black field
11⅞ x 8⅛ inches (30.2 x 20.5 cm.)
Lent by the Trustees of the Chatsworth Settlement (Devonshire Collection), Chatsworth

EXHIBITION:
Philadelphia Museum of Art, September 17 – November 28, 1971 (cat: Percy, Ann. *Giovanni Benedetto Castiglione, Master Draughtsman of the Italian Baroque*, M1).

REFERENCES:
Calabi, Augusto: "The Monotypes of Gio. Benedetto Castiglione: A Supplement." *The Print Collector's Quarterly*, vol. 12 (1925), no. 13. Calabi, Augusto. "Castiglione's Monotypes: A Second Supplement." *The Print Collector's Quarterly*, vol. 17 (1930), no. 14. Röhn, Franz. *Die Grafik des Giovanni Benedetto Castiglione*. Inaugural dissertation, Friedrich-Wilhelms University, Berlin, 1932.

BIBLIOGRAPHY:
Blunt, Anthony. *The Drawings of G. B. Castiglione and Stefano della Bella in the Collection of H. M. the Queen at Windsor Castle*. London, 1954.

This may be the earliest known monotype by Castiglione, as Ann Percy suggested in her catalogue for the 1971 exhibition at the Philadelphia Museum of Art. It is not as fully realized in tonalities nor as fluently executed as those dating from 1645 and after. No etched prototype exists, and a distantly related drawing is of considerably later date.[1]

Castiglione's method of executing black-field monotypes was described by Adam Bartsch, the great print cataloguer of the late eighteenth century.[2] Printing ink was spread evenly over a polished copperplate and the ink scraped off with a blunt point to draw the design. The tool used was probably of wood so as not to scar the plate. Castiglione also used stiff brushes. Broad areas of the image could be lightened by wiping ink off with a rag, brush, or fingers. When printed, the wiped areas appeared gray and the lines white.

Platemarks sometimes remain visible on one or more edges of the sheets; printing creases appear as well. Both of these elements indicate that the plates were run through a press. Castiglione pulled second impressions from the inked plates; two pairs are known today from the dark-field monotypes and one pair from the light field (cat. nos. 13, 14).[3]

1. *Adam Naming the Animals*, Windsor 3866.
2. Adam Bartsch, *Le Peintre Graveur* (Vienna, 1821), vol. 21, pp. 39-42, "Pièces imitant l'acqua-tinta."
3. See Augusto Calabi, "Castiglione's Monotypes: A Second Supplement," *The Print Collector's Quarterly*, vol. 17 (1930), no. 13. The relative paleness of a few other monotypes leads one to suspect that they may be second pulls.

Giovanni Benedetto Castiglione
Italian, about 1600-1663/65

6. Temporalis Aeternitas, 1645

Monotype, white line on black field
11⅝ x 7⅞ inches (29.6 x 20.1 cm.)
Signed and dated (scratched): *Gio. Beneditus /
Castiglione / 1645*
Windsor Castle, Royal Library, lent by Her
Majesty Queen Elizabeth II

Shown in Boston only

REFERENCES:
Calabi, Augusto. "The Monotypes of Gio. Be-
nedetto Castiglione." *The Print Collector's Quar-
terly*, vol. 10 (1923), no. 16. Calabi, Augusto. "The
Monotypes of Gio. Benedetto Castiglione: A Sup-
plement." *The Print Collector's Quarterly*, vol. 12
(1925), no. 19. Calabi, Augusto. "Castiglione's
Monotypes: A Second Supplement." *The Print
Collector's Quarterly*, vol. 17 (1930), no. 20. Blunt,
Anthony. *The Drawings of G. B. Castiglione and
Stefano della Bella in the Collection of H. M. the
Queen at Windsor Castle.* London, 1954, no. 215.

BIBLIOGRAPHY:
Dempsey, Charles. "Castiglione at Philadelphia."
A review of exhibition and catalogue. *Burlington
Magazine*, vol. 94, (February 1972), pp. 117-20.

Each of these monotypes repeats in reverse the composition of an etching (Bartsch 24 and 25) and was probably executed shortly afterwards. Both versions of *Temporalis Aeternitas* bear the date 1645. The subject, derived from a Poussin painting of around 1630, alludes to the fleeting nature of man's existence.[1] Each scene is lit by a single torch casting its flickering light on the figures and their surroundings. In the monotypes Castiglione more completely realized the nocturnal lighting effects he sought in the etchings.

He carefully wiped away ink from areas such as the obelisks, columns, urns, and sculptures, and thus created a broad expanse of gray. High-

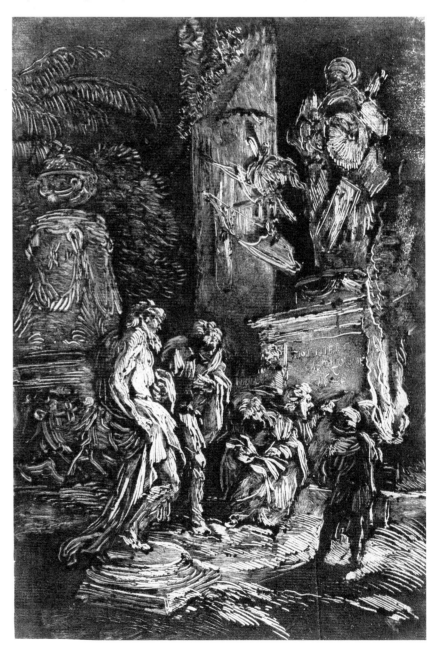

Giovanni Benedetto Castiglione

7. **Theseus Finding His Father's Arms,** 1645

Monotype, white line on black field
11¾ x 8 inches (30 x 20.2 cm.)
Lent by the Trustees of the Chatsworth Settlement (Devonshire Collection), Chatsworth

EXHIBITION:
Philadelphia Museum of Art, 1971 (cat: Percy M3).

REFERENCES:
Calabi 1925, no. 18. Calabi 1930, no. 19.

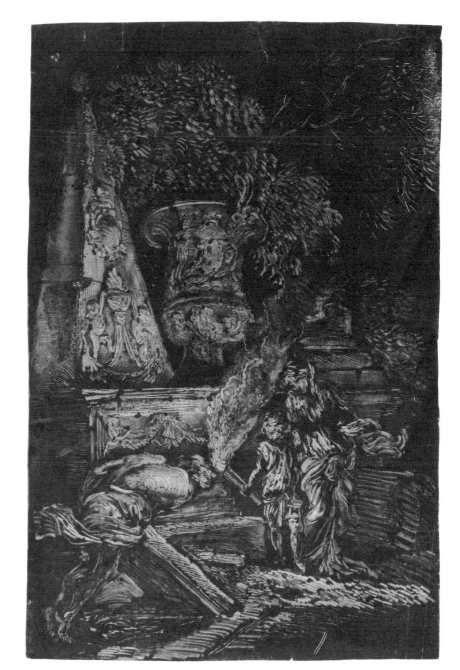

lights and details were added by drawing into these areas with a blunt, wooden tool. The figures were drawn into the black ground with lively strokes of the point while foliage was executed with a coarse brush, and as the ink is only partly removed, the leaves appear to be shrouded in darkness.

<div style="text-align: right">S.W.R.</div>

1. The iconography is further discussed by Ann Percy, *Giovanni Benedetto Castiglione, Master Draughtsman of the Italian Baroque* (Philadelphia: Philadelphia Museum of Art, 1971), p. 140, E13.

Giovanni Benedetto Castiglione
Italian, about 1600-1663/65

8. The Resurrection of Lazarus, about 1649

Monotype, white line on black field
7⅞ x 11 inches (20 x 28 cm.)
Signed (scratched): *Castilione F.*
Graphische Sammlung Albertina, Vienna

REFERENCES:
Bartsch, Adam. *Le Peintre Graveur.* Vienna, 1821, vol. 21, p. 41, no. 4. Calabi, Augusto. "The Monotypes of Gio. Benedetto Castiglione." *The Print Collector's Quarterly,* vol. 10 (1923), no. 17. Calabi, Augusto. "The Monotypes of Gio. Benedetto Castiglione: A Supplement." *The Print Collector's Quarterly,* vol. 12 (1925), no. 20. Calabi, Augusto. "Castiglione's Monotypes: A Second Supplement." *The Print Collector's Quarterly,* vol. 17 (1930), no. 21. Percy, Ann. *Giovanni Benedetto Castiglione, Master Draughtsman of the Italian Baroque.* Philadelphia: Philadelphia Museum of Art, 1971, M5a.

This monotype was probably executed around 1649 and is based on an etching that slightly precedes it in date (Bartsch 6). The etched version of Christ's miracle is illuminated by both artificial and supernatural light and was executed with a well-developed chiaroscuro expressed in networks of scribbly lines, not unlike Rembrandt's calligraphic etching style of the late 1630s (fig. 49).

This monotype follows its etched prototype less closely than do the two previously shown (cat. nos. 6, 7). The source of light from the torch has been retained, but the figure of Christ no longer emits its spiritual radiance. The composition is essentially in reverse, but Castiglione altered the placement of the figures and Lazarus faces Christ toward whom he reaches out.

The monotype was executed with economy and spontaneity. The artist used his hands to pick up ink from the plate, leaving clear records of finger or palm prints in the broad areas of gray. Wooden points of varying widths defined the highlights of figures and setting with energy and confidence. The foliage was drawn with a brush, as before, but a point was used as well to make short flicks in a bold, lively way.

S.W.R.

FIG. 49.

Giovanni Benedetto Castiglione, *The Resurrection of Lazarus,* about 1648, etching.

Museum of Fine Arts, Boston; Harvey D. Parker Collection, P14013

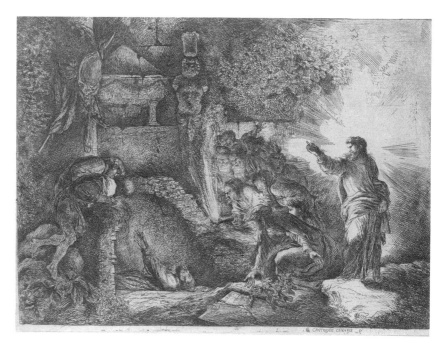

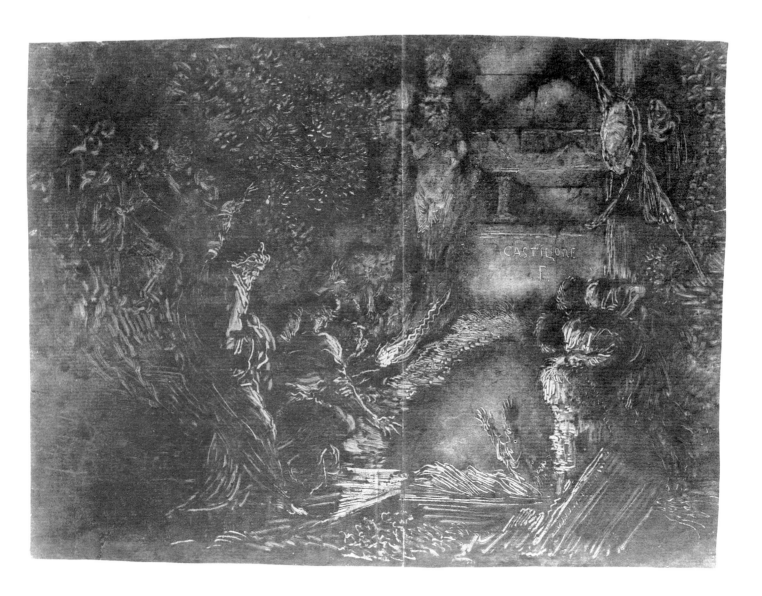

Giovanni Benedetto Castiglione
Italian, about 1600-1663/65

9. The Annunciation to the Shepherds, about 1650-55

Monotype, white line on black field
14⅝ x 9¾ inches (37.1 x 24.8 cm.)
Graphische Sammlung Albertina, Vienna

REFERENCES:
Calabi, Augusto. "The Monotypes of Gio. Benedetto Castiglione." *The Print Collector's Quarterly,* vol. 10 (1923), no. 13. Calabi, Augusto. "The Monotypes of Gio. Benedetto Castiglione: A Supplement." *The Print Collector's Quarterly,* vol. 12 (1925), no. 14. Calabi, Augusto. "Castiglione's Monotypes: A Second Supplement." *The Print Collector's Quarterly,* vol. 17 (1930), no. 15.

10. God the Father Adoring the Christ Child, 1650-55

Monotype, white line on black field; second pull
14½ x 9⅞ inches (36.8 x 25 cm.)
Signed: *Gio Benebetto* [sic] *Castiglione/Genovse*
Windsor Castle, Royal Library, lent by Her Majesty Queen Elizabeth II

Shown in New York only

REFERENCES:
Calabi 1923, no. 7A. Calabi 1930, no. 8 *bis.* Blunt, Anthony. *The Drawings of G. B. Castiglione and Stefano della Bella in the Collection of H. M. the Queen at Windsor Castle.* London, 1954, no. 213. Percy, Ann. *Giovanni Benedetto Castiglione, Master Draughtsman of the Italian Baroque.* Philadelphia: Philadelphia Museum of Art, 1971, M9.

11. The Nativity, 1650-55

Monotype, white line on black field
9¾ x 14¾ inches (24.7 x 37.5 cm.)
Windsor Castle, Royal Library, lent by Her Majesty Queen Elizabeth II

Shown in Boston only

EXHIBITION:
Philadelphia Museum of Art, September 17 – November 28, 1971 (cat: Percy, Ann. *Giovanni Benedetto Castiglione, Master Draughtsman of the Italian Baroque,* M8).

REFERENCES:
Calabi 1923, no. 8. Calabi 1930, no. 9. Blunt, no. 214.

This group of monotypes, all dating from 1650-55, is notable for its baroque fervor both in religious theme and bravura execution, elements that may be seen in Castiglione's paintings and drawings executed at this time both in Genoa and Mantua. The size of each monotype is approximately the same, larger than any of his preceding monotypes. The religious subjects depicted involve mystical, heavenly light rather than the earthly torchlight of the earlier subjects.

The backgrounds are dark and the plates appear to have been richly coated with printing ink.[1] A large proportion of the line work was executed with a blunt tool, sometimes split and double-ended, and resembling a reed or bamboo pen. Fewer expanses of gray are utilized than in the earlier monotypes, while there are more white areas to highlight flesh and draperies, or to suggest shafts of brilliant light. The manifestation of light as a spiritual force pervades these monotypes.

S.W.R.

1. The relative paleness of cat. no. 10 is due to its being a second pull. The first pull (Bibliothèque Nationale, Paris) is appropriately darker.

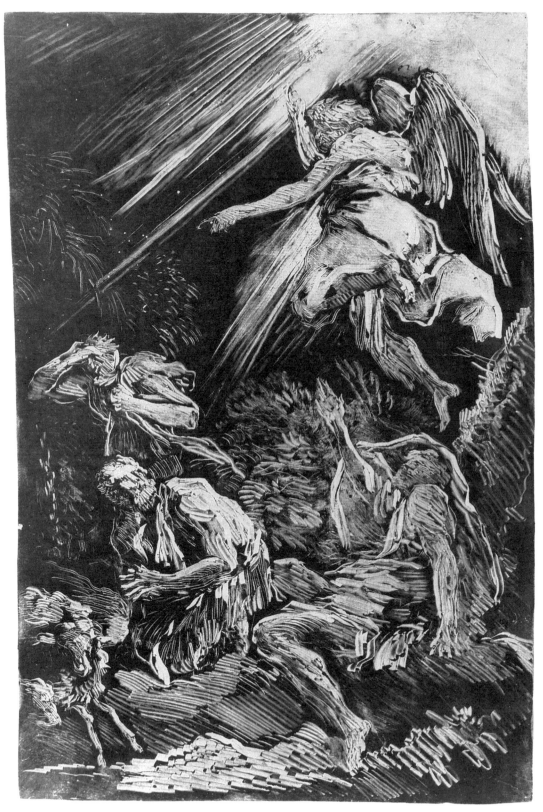

9

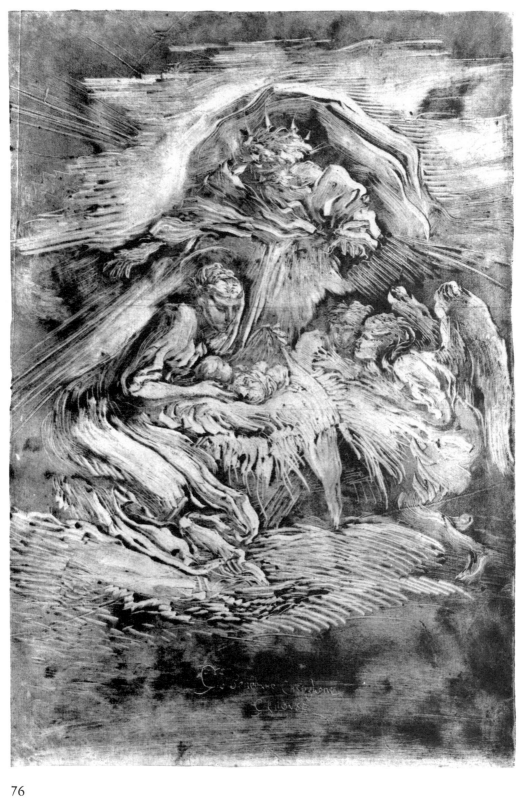

11

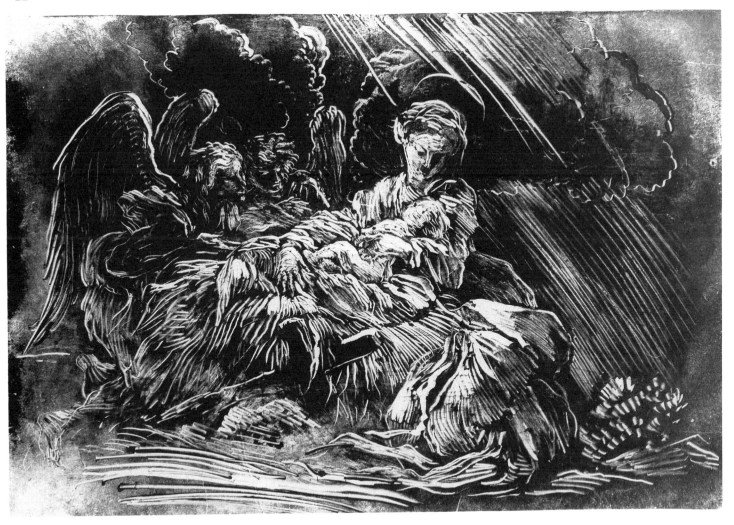

Giovanni Benedetto Castiglione
Italian, about 1600-1663/65

12. Shepherds Warming Themselves before a Fire, 1650s

Monotype, white line on dark field, reworked with brush and pigment
8¼ x 11¾ inches (20.9 x 29.7 cm.)
Graphische Sammlung Albertina, Vienna

REFERENCES:
Bartsch, Adam. *Le Peintre Graveur.* Vienna, 1821, vol. 21, p. 42, no. 5. Calabi, Augusto. "The Monotypes of Gio. Benedetto Castiglione." *The Print Collector's Quarterly,* vol. 10 (1923), no. 4. Percy, Ann. *Giovanni Benedetto Castiglione, Master Draughtsman of the Italian Baroque.* Philadelphia: Philadelphia Museum of Art, 1971, M10e.

The strong, dark forms of the figures and foregound contrast with the pale tonality of the background. To achieve this it would appear that the artist took a plate from which he had already printed one monotype and reworked it with brush, pigment, and a wooden point. If this is the case, Castiglione perceived one of the unique possibilities inherent in the monotype medium, the reworking of a "ghost" image.

S.W.R.

Giovanni Benedetto Castiglione
Italian, about 1600-1663/65

David with the Head of Goliath,
1650-55

13. First pull

Monotype in brown oil pigment on white field,
touched with brown oil pigment
14⅝ x 10 inches (37.1 x 25.4 cm.)
Pinacoteca Civica "Tosio Martinengo," Brescia

REFERENCES:
Calabi, Augusto. "The Monotypes of Gio. Benedetto Castiglione." *The Print Collector's Quarterly,* vol. 10 (1923), no. 5. Percy, Ann. *Giovanni Benedetto Castiglione, Master Draughtsman of the Italian Baroque.* Philadelphia: Philadelphia Museum of Art, 1971, M11 (not exhibited).

14. Second pull

Monotype in brown oil pigment on white field,
touched with brown oil pigment
13¾ x 9¾ inches (34.8 x 24.8 cm.)
National Gallery of Art, Washington, D.C.
Andrew W. Mellon Fund, 1977

PROVENANCE:
Sotheby Parke Bernet, May 18-19, 1977, no. 20.

Castiglione made a large number of drawings in a personal and distinctive technique using brush and oil pigments. Seven similarly executed monotype subjects are known. Their brown hues lead one to believe that the medium used was not printing ink, but the same as that of the drawings – pigments mixed with linseed oil.[1]

The brush monotypes are not all of one date. Of the ones included in this exhibiiton (cat. nos. 13-15), *David with the Head of Goliath* is the earlier. At the right of the composition is the crowned head of King Saul, who was also depicted in lively conversation with David in a brush drawing of horizontal format (Percy 56) and its related dark-field monotype (Calabi 1930, no. 7), which was executed on the same size plate as the one shown here.

In his brush monotypes Castiglione also utilized the white-line technique. In this particular monotype he scratched highlights on David's arm, sleeve, and sword and added linear details to his hair and the plumes of his hat.

The two known pairs of white-on-black monotypes show no retouching on the plate before the second pull, nor on the paper itself. Both sheets of *David with the Head of Goliath,* however, were reworked with the brush and brown pigment to strengthen the printed image. The first pull shows dark brushstrokes added to accent face and hair and to model David's chin and the back of his hat. On the second pull, the artist again worked on the sheet with the brush, primarily to model the giant's head.

S.W.R.

1. See Anthony Blunt, *The Drawings of G. B. Castiglione and Stefano della Bella in the Collection of H. M. the Queen at Windsor Castle* (London, 1954), p. 8.

13

80

14

Giovanni Benedetto Castiglione
Italian, about 1600-1663/65

15. Two Soldiers Dragging a Corpse before a Tomb, 1660

Monotype, brown oil pigment on white field, touched with brown oil pigment
10⅛ x 14¾ inches (25.8 x 37.3 cm.)
Signed and dated (scratched): *G.B.C. / 1660*
Windsor Castle, Royal Library, lent by Her Majesty Queen Elizabeth II

Shown in New York only

EXHIBITION:
Philadelphia Museum of Art, September 17-November 28, 1971 (cat: Percy, Ann. *Giovanni Benedetto Castiglione, Master Draughtsman of the Italian Baroque*, M13).

REFERENCES:
Calabi, Augusto. "The Monotypes of Gio. Benedetto Castiglione." *The Print Collector's Quarterly*, vol. 10 (1923), no. 3. Blunt, Anthony. *The Drawings of G. B. Castiglione and Stefano della Bella in the Collection of H. M. the Queen at Windsor Castle.* London, 1954, no. 216.

Castiglione's latest known monotype, dated 1660, represents an unidentified subject that shows two soldiers clad in armor dragging a corpse toward a group of five figures, one of whom is seated and draped from head to toe. Drawn almost exclusively with the brush, it reveals a small amount of white line work in the foliage. There is scattered retouching by brush and pigment on the paper.

In compositon and execution this monotype resembles a group of Castiglione's horizontal format brush drawings of the 1650s and 1660s that depict biblical and classical subjects (Percy 107-16). Its puzzling subject and antique accessories may reflect the influence of Pietro Testa, whom Castiglione probably knew in Rome.

S.W.R.

William Blake

English, 1757-1827

16. Pity, 1795

Color monotype in tempera touched with pen,
black ink, and watercolor
$10^{15}/_{16}$ x 14¼ inches (27.7 x 36.2 cm.)
Trustees of the British Museum, London
Gift of John Deffett Francis, 1874

EXHIBITIONS:
British Museum, London, Blake Bi-Centenary exhibition, 1957. The Tate Gallery, London, March 9 – May 21, 1978 (cat: Butlin, Martin. *William Blake*, no. 98).

REFERENCE:
Butlin, Martin. *William Blake: A Complete Catalogue of the Works in the Tate Gallery.* London, 1971, p. 38.

BIBLIOGRAPHY:
Todd, Ruthven. "The Techniques of William Blake's Illuminated Printing." *The Print Collector's Quarterly*, vol. 29, no. 3 (1928), pp. 25-36. Bindman, David. *Blake as an Artist.* Oxford and New York, 1977, especially pp. 89-100. Bindman, David. *The Complete Graphic Works of William Blake.* New York, 1978.

Though the subjects of the series of twelve monotypes that Blake made in 1795 form part of his own myth, most also derive from the Bible, Milton, and Shakespeare.[1] *Pity* illustrates lines from Shakespeare's *Macbeth* (Act I, Scene 7):

> And pity, like a naked new-born babe
> Striding the blast, or heaven's cherubin hors'd
> Upon the sightless couriers of the air,
> Shall blow the horrid deed in every eye,
> That tears shall drown the wind....

It is likely that *Pity* was one of the first of the series, since in preparation for it Blake made two pencil drawings (British Museum; ill., Tate 1978) and this unique, smaller, trial monotype.

In this trial, three colors (black, ochre, and green) were printed from a millboard "plate" to define broadly the sky, horses and riders, and a grassy foreground. This monotype does not include the printed outlines that were used in the larger versions. The impression was touched with pen and black ink for linear details and with watercolor for local color. It exhibits clear characteristics of a printed image, most strikingly the textured surface of the tacky pigment. The appealing freshness and directness are not always present in the more highly finished monotypes.

S.W.R.

1. For a discussion of the interwoven imagery of Blake's 1794-95 books and monotypes, see David Bindman, *Blake as an Artist* (Oxford and New York, 1977), chap. 11.

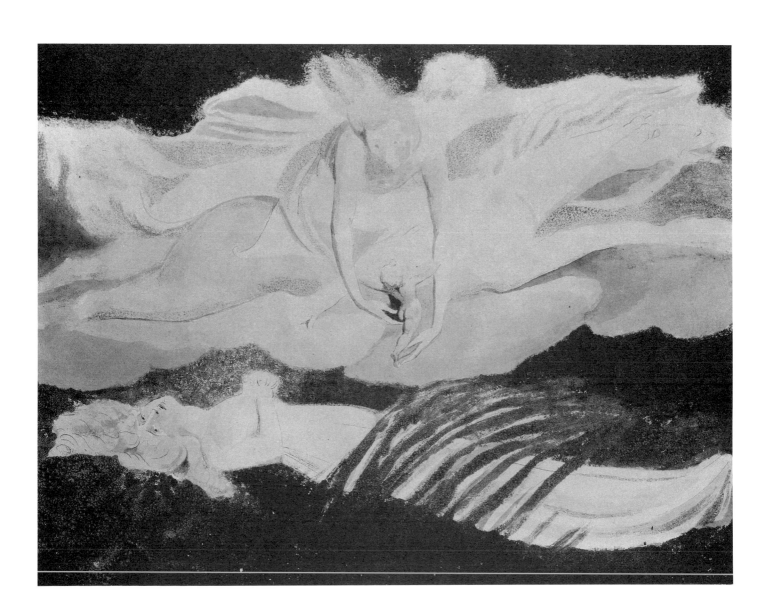

William Blake
English, 1757-1827

17. Pity, 1795

Color monotype in tempera touched with pen,
black ink, and watercolor
16¾ x 21¼ inches (42.5 x 53.9 cm.)
Signed lower right (scratched): *Blake*
The Tate Gallery, London
Gift of W. Graham Robertson, 1939 (5062)

PROVENANCE:
Thomas S. Butts; Thomas Butts, Jr.; Capt. F. J.
Butts; his widow; Carfax Gallery, April 1906, to W.
Graham Robertson.

EXHIBITIONS:
The Tate Gallery, London, March 9 – May 21, 1978
(cat: Butlin, Martin. *William Blake,* no. 95). Prior
exhibitions listed in Butlin, Martin. *William
Blake: A Complete Catalogue of the Works in the
Tate Gallery.* London, 1971, no. 19.

BIBLIOGRAPHY:
See cat. no. 16.

Three impressions are known of the large monotype *Pity;* two are included in the exhibition and the third is illustrated in order to discuss the variations in technique and dating of the three.

The Tate Gallery's version (cat. no. 17) is extensively overlaid with watercolor. The printed color, where it can be isolated, appears to be thick; Blake scratched the rain and his signature into the wet, newly printed pigment. This would appear to be the first pull. The monotype was sold to Thomas Butts in 1805 and was almost certainly one of those completed in pen and watercolor in 1795.

Less heavily retouched in watercolor, the Metropolitan Museum's version (cat. no. 18) shows to advantage the characteristics of printed color. It is also possible to isolate the printed outline, most visibly on the face of the distant horse. Lines describing rain have also been scratched into the thick pigment of this impression. Overall less densely colored than that of the Tate, this is probably the second pull. It does not seem likely that in 1795 Blake retouched every impression of the group of monotypes he made that year. The Metropolitan Museum's version of *Pity,* quite different in its pen work from the Tate's, exhibits stylistic similarities (especially in the face of the prostrate mother) to Blake's *Paradise Lost* watercolors of 1808.

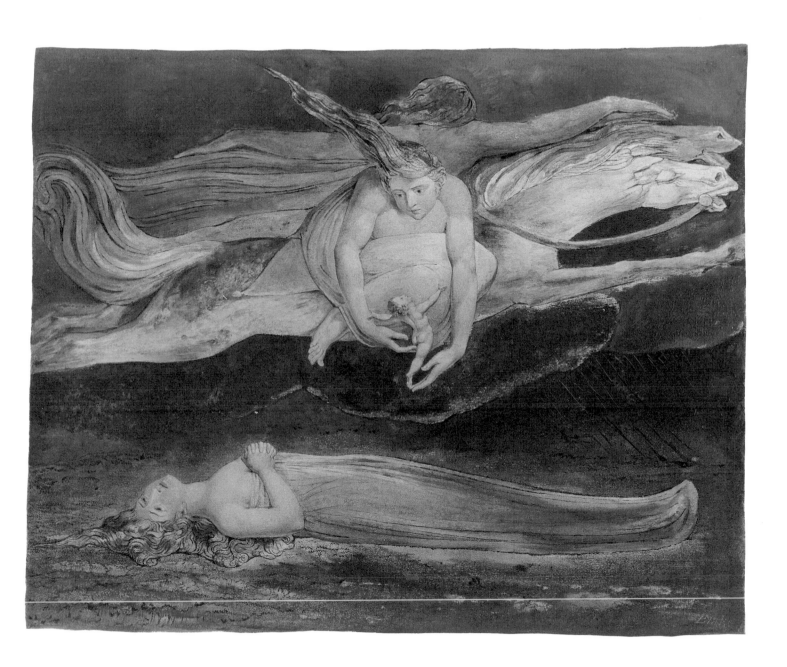

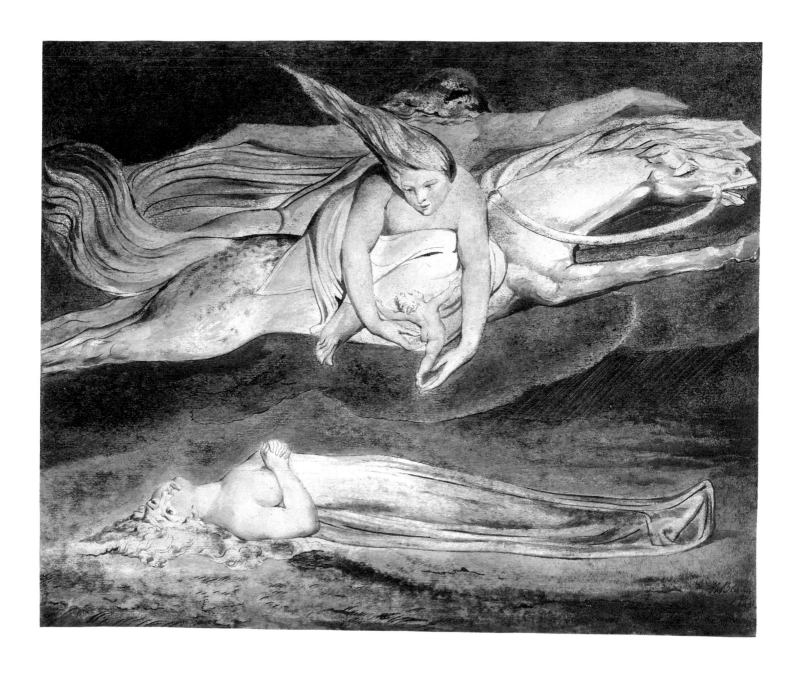

William Blake
English, 1757-1827

18. Pity, 1795

Color monotype in tempera touched with pen,
black ink, and watercolor
15¾ x 20⅞ inches (40 x 53 cm.)
Signed in pen, lower right: *WBlake/inv.*
The Metropolitan Museum of Art, New York
Gift of Mrs. Robert W. Goelet, 1958 (58.603)

EXHIBITION:
Andrew Dickson White Museum of Art, Cornell
University, Ithaca, New York, February 27-March
29, 1965 (cat: Roe, Albert S. *William Blake,* no.
32).

REFERENCE:
Butlin, Martin. *William Blake: A Complete Cata-
logue of the Works in the Tate Gallery.* London,
1971, p. 38.

BIBLIOGRAPHY:
See cat. no. 16.

The third version, and almost certainly the third pull, is in the Yale
Center for British Art (fig. 50). It is pale in tonality, and both the printed
outlines and the watercolor washes are difficult to distinguish. The
minimal pen work defines forms that differ considerably from either of
the other two versions, most notably in depicting a single horse. It
appears never to have been fully completed by Blake and may have
suffered from once having been varnished.

S.W.R.

FIG. 50.
William Blake, *Pity,* 1795 (Butlin 1971, pp. 38, 41 [no. 24]), color monotype in
tempera touched with pen and black ink.

Yale Center for British Art, New Haven, Connecticut; Paul Mellon Collection

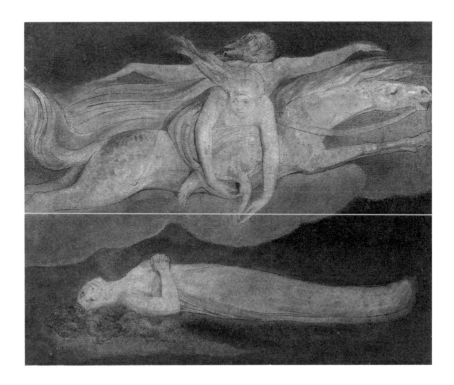

Nineteenth-Century French Monotypes

Vicomte Ludovic Napoléon Lepic

French, 1839-1889

Vue des Bords de l'Escaut

(three impressions), about 1870-76

Etching with special inking
Plate, 13½ x 29¼ inches (34.3 x 74.4 cm.);
sheet, 17¾ x 31⅞ inches (45 x 81 cm.)
The Baltimore Museum of Art
Garrett Collection

19. L'Incendie du moulin

Signed lower left in pencil: *fait et imprime /par Le Pic /24 ep*; signed lower right in blue pencil: *L'incendie du Moulin*

20. Saules et peupliers

Signed lower left in blue pencil: *fait et imprime / par LePic /43 epreuve*; signed lower right in blue pencil: *Saules et peupliers*

21. La Neige

Signed lower left in blue pencil: *fait et imprime par / LePic / 70 epreuve*; signed lower right in blue pencil: *La Neige*

REFERENCES:
Béraldi, Henri. *Les Graveurs du XIXe siècle.* Paris, 1889, vol. 9, pp. 143-45, no. 4. Bailly-Herzberg, Janine. *L'Eau-forte de peintre au dix-neuvième siècle, La Société des Aquafortistes (1862-1867).* Paris: Léonce Laget, 1972, vol. 2, pp. 139-41.

BIBLIOGRAPHY:
Lethève, Jacques and Gardey, Françoise. *Inventaire du Fonds Français après 1800.* Paris, 1967, vol. 14, pp. 59-67. Melot, Michel. *L'Estampe impressioniste.* Paris: Bibliothèque Nationale, 1974, pp. 106-108.

In his catalogue of nineteenth-century etchers,[1] Henri Béraldi discussed the etchings of Vicomte Ludovic Napoléon Lepic and quoted from a treatise by the artist: "Comme je devins graveur a l'eau-forte. . . !" Based on sixteen years of work that began with the Société des Aquafortistes under the direction of Auguste Delâtre, Lepic described how he would etch a composition on a copperplate and then "with ink, a rag, and his two arms," he would transform the subjects according to his imagination. Lepic printed several series of landscape scenes including a view from the banks of the river Escaut[2] and manipulated the ink in eighty-five different manners, submitting an enormous variety of effects. He called this process *l'eau-forte mobile* (the changeable etching).

The three impressions illustrated here are so dramatically different that it is difficult to realize there is the same etched matrix. By applying and removing the dark ink on the plate, by selectively wiping ink from the constant etched lines, and by adding supplementary figural elements, Lepic took a rather modest composition and exploited its visual possibilities.[3] He not only changed the time of day and the season, but he also variously altered the focus of attention, changed the perspective of the composition, and shifted the emphasis of the subject from one plane to another. This series was probably the culmination of his experiments begun in the 1860s.

To suggest that Lepic carried this method to a fruitful and significant conclusion would be exaggerated. The unusual effects that he achieved were ingenious but could have been realized in many fewer impressions and even a perusal of the nineteen sheets in the Baltimore Museum[4] demonstrates that Lepic carried the artful distribution of ink to an extreme. Nevertheless, his role in the development of the monotype medium in the nineteenth century cannot be underestimated; his devotion to painting on the surface of a plate ("I make prints as a painter, and not as a printmaker"),[5] his interest in the effects of light and dark commensurate with the emergence of the Impressionist aesthetic, and, above all, his introduction of Degas to the painterly possibilities of printed drawings must be recognized and appreciated.

B.S.S.

1. Henri Béraldi, *Les Graveurs du XIXe siècle* (Paris, 1889), vol. 9, pp. 143-45. In the *Manuel de l'amateur d'estampes des XIXe et XXe siècles* ([Paris, 1925], vol. 2, p. 331), Loys Delteil mentioned that Lepic obtained ninety-five different impressions from the same plate of *Vue des Bords de l'Escaut.*
2. The river Escaut commences in northern France, then becomes the Scheldt as it flows through Belgium into the Netherlands. This accounts for the Dutch-like elements in the composition.

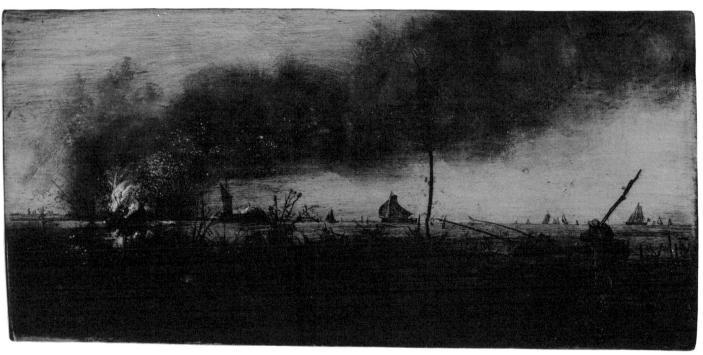

19

3. An examination of *La Neige* and other similar scenes from this series indicates that the splattered snow effects were not produced in the usual manner of wiping ink away with a rag or brush; rather the numerous debossed marks on the sheet suggest that, after inking, Lepic must have dusted the plate with a gritty substance such as a coarse rosin that would prevent portions of the inked lines and tones from being printed on the sheet. Essentially, Lepic blocked out the ink with a resist to create whitened areas; in this unconventional way he manipulated or controlled the ink without using the rag to which he was so attached.

4. The remaining sixteen impressions in the Baltimore Museum of Art inscribed by Lepic are: *Le Soir* ("2" written unclearly); *La Pluie* (10); *Lever de lune* (17); *Une Ondée* (19); *Orage* (32); *Après l'orage* (34); *Lune dans les saules* (39); *Clair de lune* (31); *Les Saules* (45); *La Nuit* (50); [*La Neige*] (55); *Neige dans le brouillard* (57); *Chataignes* (64); *Lever du soleil* (97); *Petit Jour* (98); *La Calme* (99 [could be read as 89]). Although there are no other known impressions of this series nor further documentation, one can assume that the etchings illustrated and discussed here and the Escaut series mentioned by Béraldi and Delteil are indeed one and the same.

5. Cited in Michel Melot, *L'Estampe impressioniste* (Paris: Bibliothèque Nationale, 1974), p. 107.

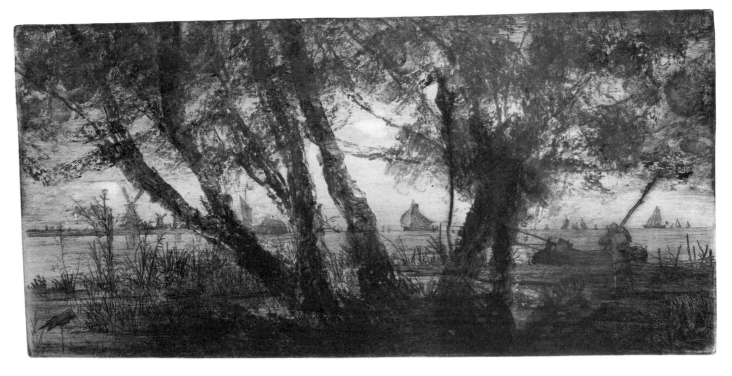

20

21

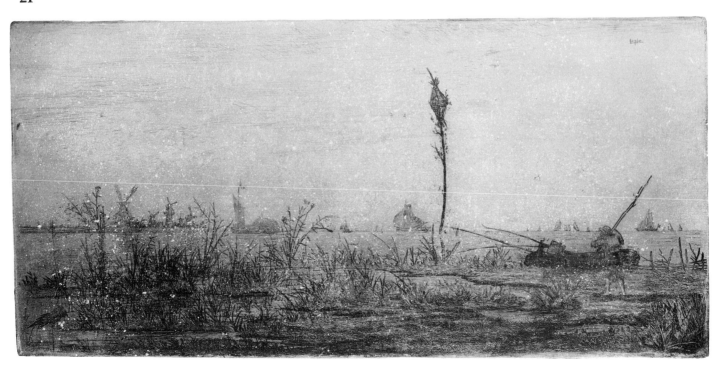

Edgar Degas

French, 1834-1917

22. Dancer Onstage with a Bouquet, about 1878-80

Pastel over monotype in black ink
10⅝ x 14⅞ inches (27 x 38 cm.)
Signed upper left corner in pastel: *Degas*
Collection of Adaline Frelinghuysen,
New York

PROVENANCE:
Mrs. H. O. Havemeyer; to her daughter, Mrs. Peter H. B. Frelinghuysen; to her son, Peter H. B. Frelinghuysen; to his daughter.

EXHIBITION:
Fogg Art Museum, Harvard University, Cambridge, Massachusetts, 1968 (cat: Janis, Eugenia Parry. *Degas Monotypes,* cat. no. 5, checklist no. 12).

REFERENCES:
Lemoisne, Paul André. *Degas et son œuvre.* 4 vols. Paris, 1947-49, no. 515 (listed as pastel). Janis, Eugenia Parry. "The Role of the Monotype in the Working Method of Degas." *Burlington Magazine,* vol. 109, Part II (February 1967), p. 75.

BIBLIOGRAPHY:
See the bibliography and essay in Janis, *Degas Monotypes,* pp. xv-xvi, and xvii-xxviii, respectively. Also essay by Françoise Cachin in *Degas: The Complete Etchings, Lithographs, and Monotypes.* New York: Viking Press, 1975, pp. 75-90.

In the third Impressionist exhibition of 1877, Degas included, among other works, four "printed drawings made with greasy ink" (*dessins faits avec l'encre grasse et imprimés*), thereby indicating his commitment to the monotype medium as an integral part of his working methods. The subject matter of his early monotypes, from about 1874-75 was contemporary with his interests in the café-concert and theatrical environment. *Dancer Onstage with a Bouquet,* one of Degas's first dozen monotypes, reveals his role as viewer *cum* recorder of excerpts from performances at the opera, ballet, and theater.

From the beginning, Degas used nearly all of his dark-field monotypes[1] as underlying structures for many of his most extraordinary pastels. In this example, the majority of the black ink was left exposed, with the exception of the figure which has been reworked with pastel. The bowing dancer who holds a bouquet of flowers, probably from a gentleman admirer, projects from a darkened stage and is caught in the dramatic glow of the theatrical footlights. The implications of artificial light and its distorting effects is a motif that intrigued Degas, unlike his Impressionist colleagues who observed the manifestations of natural illumination.

Like many of Degas's early monotypes, this composition was conceived in broad shapes from which white/light configurations were extracted. From the dark inky field, the artist wiped away with a rag the figure of the dancer emphasizing the distinctive tulle skirt that fans out from her waist. In the same manner, he depicted the crisp paper wrapper that protects the bouquet of flowers. At least six or seven colors of pastel, mainly pinks, greens, and blues, were scribbled across the surface, with the intense pastel work reserved for the facial and neck areas that lie in shadow. The combination of the flat printed background and the light dusting of jewel colors produces a monotype of great luminosity.[2]

B.S.S.

1. The vocabulary of terms used in the entries on Degas monotypes has been explained by Eugenia Parry Janis in her astute examination of this work. See "The Role of the Monotype in the Working Method of Degas," *Burlington Magazine,* vol. 109, Part I (January 1967), pp. 20-27; Part II (February 1967), pp. 71-81; and *Degas Monotypes* (Cambridge, Mass.: Fogg Art Museum, 1968).
2. Janis, *Degas Monotypes,* cat. no. 5. There is no known cognate but a counterproof of the monotype before heightening with pastel may exist.

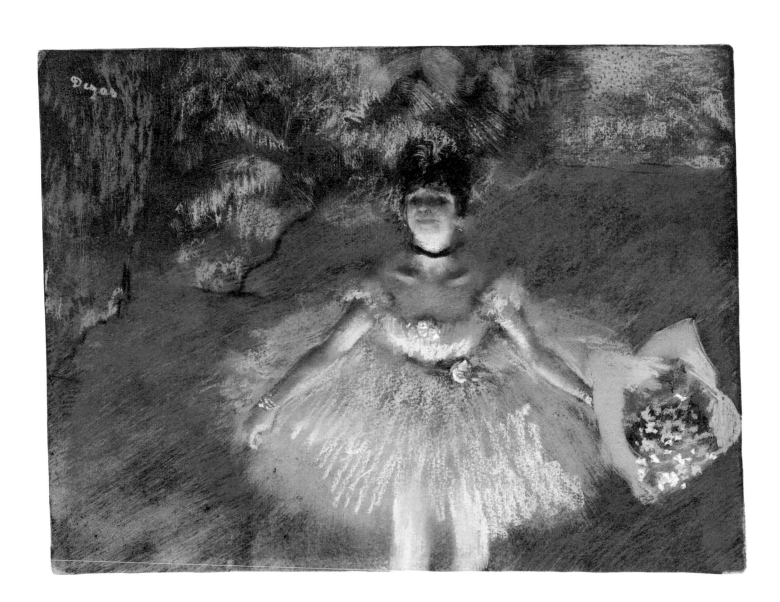

Edgar Degas
French, 1834-1917

23. The Fireside (Le Foyer), about 1877-80

Monotype in black ink
Plate, 16⁵/₁₆ x 23⅛ inches (41.5 x 58.6 cm.);
sheet, 19¾ x 25½ inches (50.2 x 64.7 cm.)
The Metropolitan Museum of Art, New York
Harris Brisbane Dick Fund; The Elisha Whittelsey
Collection; The Elisha Whittelsey Fund; and
Douglas Dillon Gift, 1968 (68.670)

PROVENANCE:
Gustave Pellet; Maurice Exteens, Paris.

EXHIBITIONS:
Fogg Art Museum, Harvard University, Cambridge, Massachusetts, 1968 (cat: Janis, Eugenia Parry. *Degas Monotypes,* cat. no. 37, checklist no. 159). The Metropolitan Museum of Art, New York, 1977 (checklist: Moffett, Charles S. *Degas in the Metropolitan,* no. 3).

REFERENCES:
Adhémar, Jean, and Cachin, Françoise. *Degas: The Complete Etchings, Lithographs, and Monotypes.* New York: Viking Press, 1975, M167. Reff, Theodore. *Degas: The Artist's Mind.* New York, 1976, p. 289 (detail).

BIBLIOGRAPHY:
Janis, Eugenia Parry. "Degas and the 'Master of Chiaroscuro.'" *Museum Studies 7,* Art Institute of Chicago, 1972, pp. 66-67, fig. 17.

FIG. 51.
Edgar Degas, *Scène de toilette,* about 1877-80, monotype in black ink.

Collection of Mr. and Mrs. Paul Mellon

The Fireside, one of Degas's largest and most enigmatic monotypes, is part of a group of dark-field impressions of heavy-limbed nudes who read, prepare for bed, or perform their toilette in a private environment. In most examples, there is a single figure whose presence completely dominates the picture plane; in *The Fireside* two nudes, probably prostitutes, were placed in opposite corners of the composition, dividing it in half. They are self-sufficient, self-involved, and related primarily by erotic gestures.

The blazing fireplace is the single source of light and replaces Degas's usual means of illumination: a window, stage footlights, or gas-lit globes (see cat. nos. 22 and 24). Here the firelight casts its glow on a woman seated at left with legs spread apart – one leg curiously rests on the fireplace mantle decorated with ornaments – and highlights the tall nude companion who stands across the room next to a bed. The figures emerge with difficulty from the tenebrous background and seem to owe their very existence to the eerie reflected light.

Degas covered the plate entirely with black ink and used rags, brushes, and his fingers to extrapolate the shadowy forms; the minimal linework was achieved by scratching into the ink with a sharp tool. With broad, wiped strokes he created the hearth which prevents a total dissolution of the two parts of the design. The lack of definition of the heads, especially the facial expressions, and the overall somber moodiness of the monotype heighten the ambiguity of its loaded content.

According to Janis, Degas's working method was to take two impressions of the nude series from the dark-field monotype plates; the brilliant first impressions were kept by the artist or, on occasion, he gave

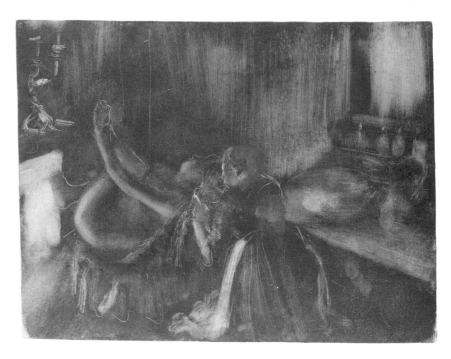

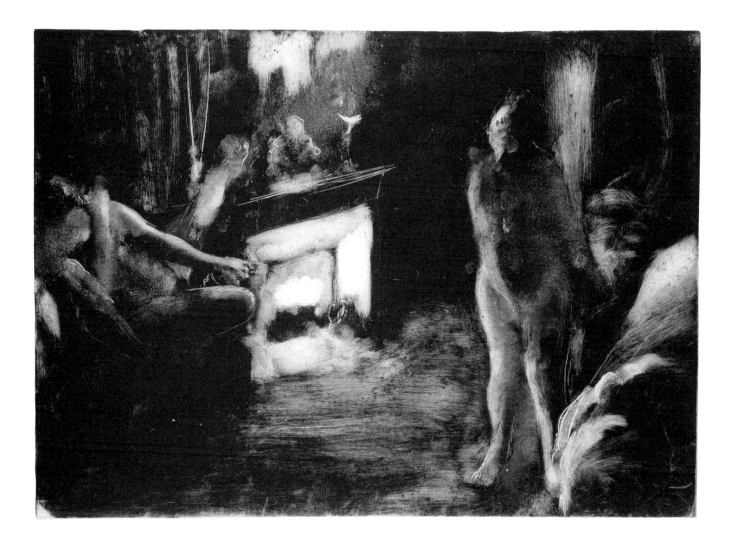

one or two to friends. The second, paler impressions were later reworked with pastel. Thus a double series of monotypes evolved: the dramatic dark black and brilliant white monotypes glowed with the same intensity and in direct proportion to their highly colorful and light pastel mates, a "nighttime to daytime transformation," so to speak.[1] A recognition of this relationship confirms that Degas participated in the Impressionist aesthetic even while working in black and white.

There is no pastel cognate for *The Fireside*; however, another black and white monotype that is surely relevant is *Scène de toilette* (fig. 51), previously unknown.[2] Here Degas depicted the same room but with a new cast of characters. The fireplace at left, partially seen, is again the source of light which spotlights a nude in a chaise longue, drying her legs. The attending maid who combs her hair, the washstand, and the mirror above are highlighted as well.

The design was created by wiping away the shapes which are far less abstract than in *The Fireside*. The extensive lines of definition were scratched into the black ink, with special delicacy for the decorative candelabra on the mantelpiece. Degas created another mood, another moment, and changed the ambience from that of a brothel to a more personal and private setting; in turn, it makes *The Fireside* more readable.

B.S.S.

1. Eugenia Parry Janis, *Degas Monotypes* (Cambridge, Mass.: Fogg Art Museum, 1968), p. xxiii, but first discussed in Janis, "The Role of the Monotype in the Working Method of Degas," *Burlington Magazine*, vol. 109, Part II (February 1967), pp. 79 and fn. 32.
2. This monotype was uncatalogued by Janis or Cachin. It was recently illustrated in Barbara S. Shapiro, *Edgar Degas: The Reluctant Impressionist* (Boston: Museum of Fine Arts, 1974), fig. 7, no. 102. It relates to Janis checklist no. 161, a pastel over monotype.

Edgar Degas
French 1834-1917

24. Female Nude Reclining on a Bed, about 1877-80

Monotype in black ink
Plate, 7⅞ x 16¼ inches (19.8 x 41.3 cm.);
sheet, 8⅝ x 16½ inches (22 x 41.7 cm.)
Inscribed upper left: *Degas à Burty*
The Art Institute of Chicago
The Clarence Buckingham Collection, 1970.590

PROVENANCE:
Philippe Burty (1830-1890); Durand-Ruel; Gustave Pellet; Maurice Exteens; to Paul Brame in 1958; Klipstein and Kornfeld, Berne, May 1962, cat. no. 247; Kornfeld and Klipstein, Berne, June 1970, cat. no. 318, ill.

EXHIBITIONS:
Orangerie, Paris, 1937, no. 208. Ny Carlsberg Glyptotek, Copenhagen, 1948, no. 76.

REFERENCES:
Janis, Eugenia Parry. *Degas Monotypes*. Cambridge, Mass.: Fogg Art Museum, 1968, checklist no. 137. Adhémar, Jean, and Cachin, Françoise. *Degas: The Complete Etchings, Lithographs, and Monotypes*. New York: Viking Press, 1975, M163.

BIBLIOGRAPHY:
Janis, Eugenia Parry. "Degas and the 'Master of Chiaroscuro.'" *Museum Studies* 7, Art Institute of Chicago, 1972.

In this rare instance, it has been possible to exhibit together a black and white monotype and its pastel cognate. The first dark-field impression was dedicated and given to Degas's friend Philippe Burty, whereas the second impression was treated with pastel probably at a later date, about 1883-85.[1] A heavy nude woman awkwardly reclines on a couch, her hand at her side holding a letter. Her flaccid body is spotlighted by the reflections from a nearby globe of light. The brightest white areas were wiped from the black inky surface with a rag, the forms were further modeled by the artist's fingers, and the textured portions of the background were dabbed at with a stiff brush or cloth. At this juncture, Degas scratched into the dark field to obtain the exact sharpness and nuance of accent lines, thus controlling the spread of the voluminous inky forms.

The reclining nude is part of a series of large black and white monotype images that Degas made of females privately resting or performing their toilette. These painterly prints are no more aggressive than their pastel counterparts, although the dramatic positive and negative contrasts and the simplified, abandoned sense of rendering make them seem like bold, sensuous photographs of highly personal observations. Degas himself said, "It's as though one were peeping through the keyhole."[2]

The pastel cognate becomes a startling transformation. Not only has Degas obliterated the light/dark atmosphere and redesigned with color the black and white abstract components but he has literally and figuratively expanded the setting by working beyond the visible platemarks into the top and bottom margins of the second sheet.[3] The dark, box-like interior becomes a bright, more luxurious room. Included are a flowered, upholstered couch with a pale blue cover sheet casually draped under

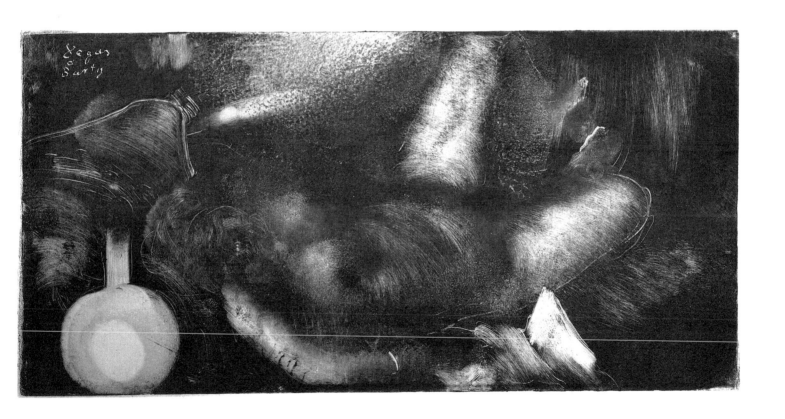

Edgar Degas
French, 1834-1917

25. Reclining Female Nude at Rest
about 1883-85

Pastel over monotype in black ink
Sheet, 13 x 16½ inches (33 x 41.9 cm.)
Stamped lower left in red: *Degas*
Anonymous loan

PROVENANCE:
1e *Vente Degas*, no. 148; to Ambroise Vollard;
Roland Browse and Delbanco, London; W. Shand
Kydd, Esq., London; Christie's, London, June 30,
1967, no. 65; Sotheby Parke Bernet, New York,
May 26, 1976, no. 35.

EXHIBITIONS:
Galerie Beyeler, Basel, *Aquarelle und Zeich-
nungen, Degas*, 1969, no. 10. Svensk-Franska
Konstgalleriet, Stockholm, 1969, no. 2.

REFERENCES:
Lemoisne, Paul André. *Degas et son œuvre.* 4 vols.
Paris, 1947-49, no. 752 (listed as pastel). Janis,
Eugenia Parry. *Degas Monotypes.* Cambridge,
Mass.: Fogg Art Museum, 1968, checklist no. 138.
Janis, Eugenia Parry. "The Role of the Monotype
in the Working Method of Degas." *Burlington
Magazine*, vol. 109, Part II (February 1967), p. 80,
fig. 39.

the figure and over the leg, and a round tray that reflects the clearly defined oil lamp: all are descriptive aids that contribute to the warmth and reality of the room as opposed to the hermetic aspect of the first impression. The large physical size of the woman is now pared down and elongated. Her extended legs create a clear-cut horizontal format that is more consciously and tightly organized than its dark-field counterpart.

The pastels were applied over a barely perceptible ink base in clusters of short vertical strokes. A rose color predominates and touches of dark blue, bright green, and gold add texture; the red tablecloth becomes a prominent focal point. The lamp, which was raised from its original position, continues to highlight the female limbs and, in varying degrees, the flowered fabric behind it. The head and face, previously nonexistent, were also given a new placement and are now summarily indicated with black pastel.

B.S.S.

1. Eugenia Parry Janis, "Degas and the 'Master of Chiaroscuro,'" *Museum Studies* 7, Art Institute of Chicago, 1972, p. 68, no. 12. Janis changed her former dating from about 1880 to 1877, suggesting that a dark-field nude monotype was exhibited at the third Impressionist exhibition in 1877. She proposes that the entire series must have been begun around this time. Lemoisne dated the pastel over monotype about 1883-85 based on Degas's pictorial style and use of the pastel sticks.
2. Quoted in Jean Adhémar and Françoise Cachin, *Degas: The Complete Etchings, Lithographs, and Monotypes* (New York: Viking Press, 1975), p. 86.
3. Horizontal pencil lines were scored by Degas beyond the upper and lower platemarks, a single line is above and three below the base of the lamp. They are covered intermittently with pastel strokes, and the concentrated color work definitely diminishes beyond these pencil marks; see, for example, the unfinished tray on the table and unworked area below the figure. Apparently, Degas decided to compress the image and the pastel work and indicated guidelines where the composition should be terminated.

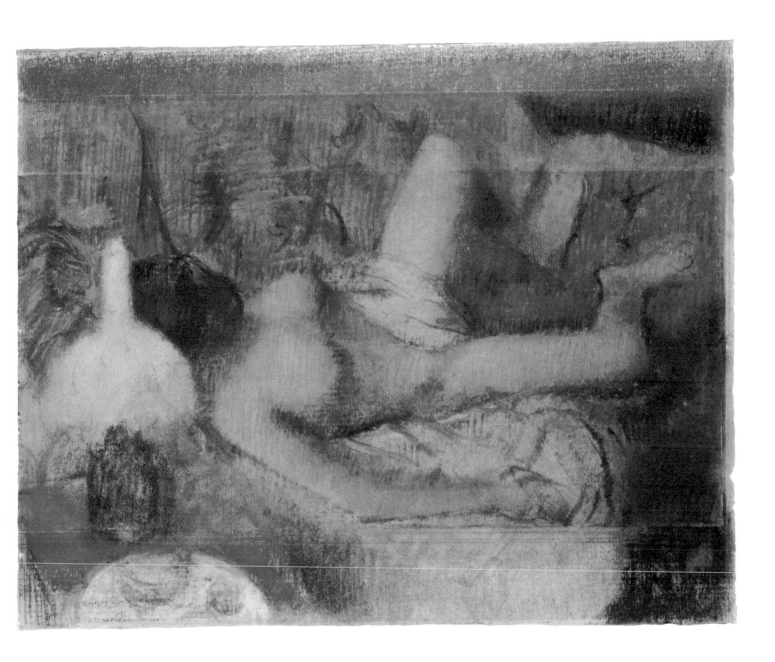

Edgar Degas
French, 1834-1917

26. Nude Woman Combing Her Hair,
about 1877-79

Pastel over monotype in black ink
Plate, 8½ x 6⅜ inches (21.5 x 16.2 cm);
sheet, 11¼ x 9⅛ inches (28.6 x 23.1 cm.)
Signed lower right in the margin in black pastel:
Degas
Ittleson Collection, New York

PROVENANCE:
Marcel Guérin; Galerie Quatres Chemins, Paris;
to Knoedler & Co., New York; to Henry Ittleson,
Jr., in 1954.

EXHIBITION:
Fogg Art Museum, Harvard University, Cam-
bridge, Massachusetts, 1968 (cat: Janis, Eugenia
Parry. *Degas Monotypes,* cat. no. 43, checklist no.
185).

REFERENCES:
Lemoisne, Paul André. *Degas et son œuvre.* 4 vols.
Paris, 1947-49, no. 456 (listed as pastel over
monotype). Ives, Colta Feller. *The Great Wave.*
New York, 1974, p. 43, no. 43.

Degas frequently depicted women bathing, combing their hair, or at various stages of the toilette, but the presence of the male admirer in this monotype suggests the brothel environment. Although the interior furnishings are more lavish than the simplistic bordello backgrounds usually depicted by Degas, the "client," who is unbuttoning his jacket, leaves no doubt as to the setting. Dressed in black and partially cropped by the platemark, he appears as a fragment of a snapshot, while the homely woman, bored and inattentive, continues her daily routine.

With a thin brush the artist has drawn a complicated arrangement of figures, large furniture pieces, and small decorative accessories, such as those that appear on the washstand shelf. The patterned wallpaper and upholstery, devices favored by Degas, were obtained by dragging a rag over touches of oily ink to produce a random, dappled effect. A black and white illustration of the monotype seems so satisfying in the balance of whites, blacks, and the grayish middle tones that it comes as a surprise to find brilliant pastel touches of bright blue, orange/red, flesh pink, and ochre that thoroughly cover the underlying base. There is a mélange of lines and textures, and the intense colors seem to compete with the black dabs and brushstrokes.[1]

B.S.S.

1. See Eugenia Parry Janis, *Degas Monotypes,* (Cambridge, Mass.: Fogg Art Museum, 1968), cat. no. 43, for an analysis of the color intensities.

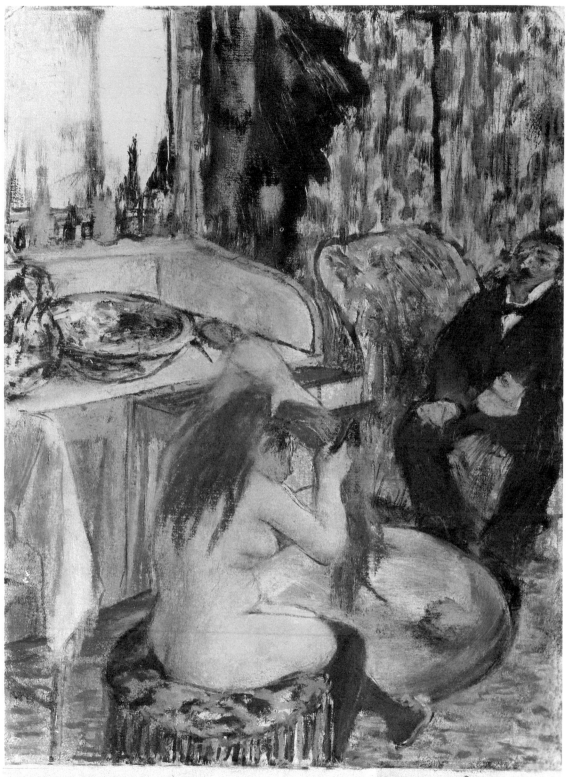

Degas

Edgar Degas
French, 1834-1917

27. **Portrait of a Bearded Man,** about 1876-78

Monotype in black ink
Plate, 3⅛ x 2⅞ inches (8.1 x 7.2 cm.);
sheet, 6¾ x 5⅝ inches (17 x 14.4 cm.)
Oval atelier stamp lower right in margin
Museum of Fine Arts, Boston
William E. Nickerson Fund, 57.554

PROVENANCE:
Vente d'Estampes, probably no. 268, *Portrait d'homme, en buste, de 3/4 à gauche;* Marcel Guérin, Paris.

EXHIBITIONS:
Fogg Art Museum, Harvard University, Cambridge, Massachusetts, 1968 (cat: Janis, Eugenia Parry. *Degas Monotypes,* cat. no. 51, checklist no. 232). Museum of Fine Arts, Boston, 1974 (cat: Shapiro, Barbara S. *Edgar Degas: The Reluctant Impressionist,* cat. no. 91).

REFERENCE:
Adhémar, Jean, and Cachin, Françoise. *Degas: The Complete Etchings, Lithographs, and Monotypes.* New York: Viking Press, 1975, M36.

It has been suggested that the source for this portrait may have been an engraving after a photograph taken of the newly elected senators, which appeared in the contemporary journal *L'Illustration.*[1] The elderly, solemn senator who gazes directly at the viewer contrasts greatly with the vague *flâneur* types who appear as observers throughout so many of Degas's theatrical and brothel scenes. Here an effort has been made to depict realistically a sensitive, thoughtful personality as opposed to the neutral, shadowy figures of the male admirers.

Degas incisively and carefully drew the head, features, stiff collar, and cravat of the bearded man; his coat merges into the background which was painted on the plate with diluted ink.

B.S.S

1. Eugenia Parry Janis, *Degas Monotypes* (Cambridge, Mass.: Fogg Art Museum, 1968), cat. no. 51.

Edgar Degas
French, 1834-1917

28. The Jet Earring, about 1877-80

Monotype in black ink
Plate, 3³/₁₆ x 2¾ inches (8.2 x 7 cm.);
sheet, 7¹/₁₆ x 5³/₁₆ inches (18 x 13.2 cm.)
Oval atelier stamp lower right corner in margin
The Metropolitan Museum of Art, New York
Anonymous Gift, 1959 (59.651)

PROVENANCE:
Vente d'Estampes, no. 281, as *Buste de femme de profil perdu*; bought from this sale by Marcel Guérin (Lugt Suppl. 1872[b]); Loncle Collection (according to Helmut Wallach).

EXHIBITIONS:
Fogg Art Museum, Harvard University, Cambridge, Massachusetts, 1968 (cat: Janis, Eugenia Parry. *Degas Monotypes*, cat. no. 56, checklist no. 243). Museum of Fine Arts, Boston, 1974 (cat: Shapiro, Barbara S. *Edgar Degas: The Reluctant Impressionist*, no. 92). The Metropolitan Museum of Art, New York, 1977 (checklist: Moffett, Charles S. *Degas in the Metropolitan*, no. 1).

REFERENCE:
Adhémar, Jean, and Cachin, Françoise. *Degas: The Complete Etchings, Lithographs, and Monotypes*. New York: Viking Press, 1975, M39.

The small format of one of Degas's most charming painterly prints successfully captures the stylishness of this fashionable lady. The artist has created a tour de force by audaciously turning the head away from the viewer so that she is observed in *profil perdu* (lost profile). The thick mane of hair partly caught up in a chignon was purposely placed directly in the foreground, and the minute earring, the center of focus, drops against the startling white flesh of the model's cheek.

In this monotype, Degas combined the dark- and light-field manners. The ink, relatively thin, was wiped and streaked across the plate in many directions to produce the various components of the design. He used an oilier ink to form the mottled background and dramatically set off the stunning, slight profile. With a thin brush, he drew in the ear, the jet earring, and the eye.

The off-center placement of the drawing on the sheet of paper attests to Degas's casual attitude toward the printing process. There is no known cognate of this unique monotype. Although Degas made other small studies of women in this medium, none is as modish or imaginative as *The Jet Earring*.

B.S.S.

Edgar Degas
French, 1834-1917

29. The River, about 1878-80

Monotype in brown ink
Plate, 3½ x 6⅞ inches (8.9 x 17.4 cm.);
sheet, 7⅛ x 9 inches (18.2 x 22.9 cm.)
Museum of Fine Arts, Boston
Katherine Bullard Fund, 61.1216

PROVENANCE:
Vente d'Estampes, no. 307 (as *La Rivière*); Marcel Guérin, stamped lower right corner (Lugt Suppl. 1872[b]).

EXHIBITIONS:
Fogg Art Museum, Harvard University, Cambridge, Massachusetts, 1968 (cat: Janis, Eugenia Parry. *Degas Monotypes,* cat. no. 65, checklist no. 272). Museum of Fine Arts, Boston, 1974 (cat: Shapiro, Barbara S. *Edgar Degas: The Reluctant Impressionist,* cat. no. 99).

REFERENCE:
Adhémar, Jean, and Cachin, Françoise. *Degas: The Complete Etchings, Lithographs, and Monotypes.* New York: Viking Press, 1975, M180.

Degas composed this small jewel-like landscape by wiping streaks of thin warm-toned ink across the plate and by softening the horizon line with a series of overlapping fingerprints. The rows of trees were created by dabbing at the smeared ink in the foreground, perhaps with a corner of a cloth or a dry, pointed brush, and by painting with a brush the treelike shapes in the background.

Degas's few black and white landscape monotypes of this time are stylistically different from his Whistlerian seascapes of the 1860s, and in most cases they were probably memory impressions of summer holidays that he took with friends in Etretat and Dieppe. As a group they are more intimate in scale and concept than the fifty large colored ink and pastel landscapes of the 1890s.

B.S.S.

Edgar Degas
French, 1834-1917

30. Pauline and Virginie Conversing with Admirers, about 1880-83
For *La Famille Cardinal* by Ludovic Halévy

Monotype in black ink
Plate, 8½ x 6⁵/₁₆ inches (21.5 x 16 cm.);
sheet, 11⅜ x 7½ inches (28.9 x 19 cm.)
Blue-gray signature stamp in lower right margin
Fogg Art Museum, Harvard University
Bequest of Meta and Paul J. Sachs, 1965

PROVENANCE:
Vente d'Estampes, no. 201; Paul J. Sachs Collection.

EXHIBITIONS:
Fogg Art Museum, Harvard University, Cambridge, Massachusetts, 1968 (cat: Janis, Eugenia Parry. *Degas Monotypes,* cat. no. 49, checklist no. 218). Museum of Fine Arts, Boston, 1974 (cat: Shapiro, Barbara S. *Edgar Degas: The Reluctant Impressionist,* cat. no. 104). Smith College Museum of Art, Northampton, Massachusetts, 1979 (cat: Muehlig, Linda D. *Degas and the Dance,* cat. no. 27).

REFERENCE:
Adhémar, Jean, and Cachin, Françoise. *Degas: The Complete Etchings, Lithographs, and Monotypes.* New York: Viking Press, 1975, M66.

Ludovic Halévy, well known for his musical librettos, composed two novellas about *La Famille Cardinal,* stories of the imaginary Cardinal daughters, Pauline and Virginie, who were ingenue ballet dancers at the Paris Opéra. According to the art historian Marcel Guérin,[1] Degas, a good friend of the Halévy family with whom he dined each week, proposed using monotypes as illustrations for a new third edition of the stories to appear in a single volume in 1880.[2] (These would be reproduced by a heliogravure process.) Although numerous designs were made, the project was abandoned, apparently owing to Halévy's dislike of the results (supposedly he considered them too rough and lacking in elegance). They were stored away, and only ten years after Degas's death did the full impact of his efforts become known when the monotypes were put up for auction. In 1939, the Halévy text with etched reproductions of the original monotypes were published together for the first time.

The thrust of the more than thirty images was focused on the part of the story that dealt with the backstage life of the Opéra and its large corps de ballet. Many young, hardworking girls struggled for starring roles, attended by concerned mothers as well as by sophisticated, well-to-do, idle men who admired and flattered the *petits rats.* Often brilliant futures were open to members of the corps, rising in rank to *sujet* under the influential protection of a gentleman admirer.

These illustrative designs were made by drawing with a brush and greasy ink in black or brown on a plate in the same manner that Degas drew on a sheet of paper. As a group, they take on an effect of a cinematic progression, so related are they in size, motif, and technique. In this segment, Halévy, the narrator, and his friends surround the girls, in their white tutus, who with their elfinlike features are characteristic of Degas's vocabulary of facial types. The tall gentlemen in their dark suits and top hats are forceful vertical elements repeated by the lighted framed doorways in the dressing room corridors. The remaining portion of the monotype is moderately gray, culminating in a slightly darker, indistinct shape almost cut off by the platemark. That this is the approaching figure of Madame Cardinal is confirmed by Eugenia Janis who notes that in a cognate impression, the head of the man closest to the wall is turned to forewarn the arrival of the intimidating mother (fig. 52).[3]

For the most part, Degas wiped the ink in varying directions to form the backstage structure and the group of figures using his fingers to adjust contours and tones. The ink was completely removed to create the white ballet costumes and to suggest a source of light from the doorways. He also painted compositional outlines and small floral decorations for the wrists of the sisters.

In the lower corners of the image are a small embossed flower at left and the number 40 at right; since these marks appear on at least two

other images of the exact size from *La Famille Cardinal* as well as on another unrelated image, *Deux Femmes* (Janis, cat. no. 30), one can assume that Degas probably used the same plate repeatedly – painting, printing, then cleaning the plate again. Knowing his predilection for hoarding possessions, this would not be surprising.

B.S.S.

1. Ludovic Halévy, *La Famille Cardinal,* preface by Marcel Guérin (Paris: August Blaizot & Fils, 1939), pp. 3-6.
2. Small pencil studies for the monotype project of *La Famille Cardinal* appear on several pages in one of Degas's notebooks and are convincingly dated by Theodore Reff to about 1878 (*The Notebooks of Edgar Degas,* 2 vols. [Oxford, 1976], pp. 126-27). Not only do these notebook pages indicate that the Halévy illustrations were being contemplated long before the intended date of publication, but they also reveal how seriously Degas considered the task and its method of execution. The monotypes were not meant to be rapid sketches, but well conceived artistic comments with preliminary drawings, monotypes, and some pale second impressions heightened with pastel.
3. Eugenia Parry Janis, *Degas Monotypes* (Cambridge, Mass.: Fogg Art Museum, 1968), cat. no. 49. Although this impression appears, at first glance, to be the second pull from the monotype plate, there are a number of differences in the figures, the composition, and the direction of the wiped ink that indicate the contrary. Degas retained the same general subject and placement but reworked the image, making many subtle alterations (including lightly heightening the monotype with graphite and black chalk). In addition, pale inky fragments remain from the dark first impression, such as the mirror top on the upper left side, the horizontal marks between the dancers' legs, and the shadows of the gentlemen's shoes. The light tonality of this sheet combined with the "ghostlike" touches from the Fogg impression strongly suggest that this monotype is the third pull from the plate; the whereabouts of the intervening second impression are unknown.

FIG. 52.
Edgar Degas, *Pauline and Virginie Conversing with Admirers,* about 1880-83, monotype in black ink.

P. & D. Colnaghi, Ltd.

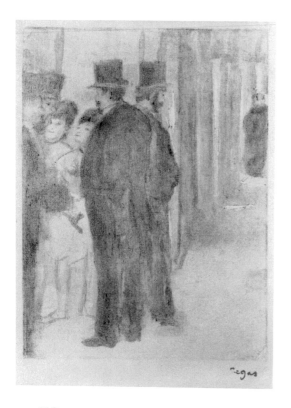

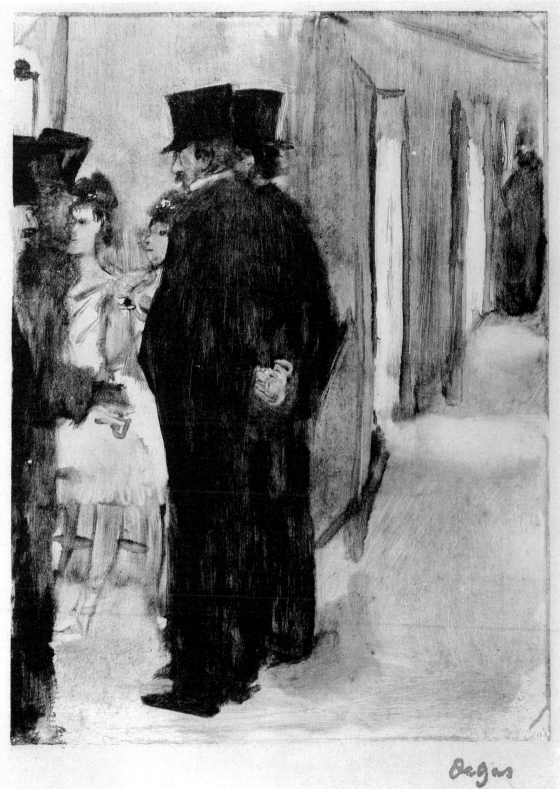

With its strong but well-formed fingers, his hand seized the objects, tools of genius, and handled them with an extraordinary skill, and one saw gradually emerging on the surface of the metal a valley, a sky, white houses, fruit trees with black branches, with birches and oaks, ruts filled with water from the recent downpour, orange-colored clouds flying in an agitated sky, above the red and green earth.

All this ordered itself, unified itself, and tones came together amicably and the handle of the brush traced clear forms in the fresh color.

These pretty things sprang up without the appearance of effort, as if he had the model in front of him.[1]

Edgar Degas
French, 1834-1917

31. Landscape, about 1890-93

Pastel over monotype in oil colors
Plate, 10 x 13⅜ inches (25.4 x 34 cm.);
sheet, 10½ x 14 inches (26.7 x 35.6 cm.)
Signed lower left in red pastel: *Degas*
Museum of Fine Arts, Boston
Gift of Denman W. Ross, 09.295

PROVENANCE:
From the artist to Durand-Ruel, Paris, June 2, 1893; to Durand-Ruel, New York, October 25, 1894; to Denman W. Ross, November 17, 1894.

EXHIBITIONS:
Fogg Art Museum, Harvard University, Cambridge, Massachusetts, 1968 (cat: Janis, Eugenia Parry. *Degas Monotypes,* cat. no. 70, checklist no. 284). Museum of Fine Arts, Boston, 1974 (cat: Shapiro, Barbara S. *Edgar Degas: The Reluctant Impressionist,* cat. no. 106).

REFERENCE:
Janis, Eugenia Parry. "An Autumnal Landscape by Edgar Degas." *The Metropolitan Museum of Art Bulletin,* vol. 31, no. 4 (Summer 1973), pp. [178-79].

This pair of landscapes is representative of a series that Degas executed during the autumn of 1890 at the studio of Georges Jeanniot in Diénay. Excited by a trip through the countryside of Burgundy, Degas expressed these sensations in relatively large monotype compositions. For the first time, he painted with colored inks, brushing and wiping the oily pigments in many directions, to create vague designs of hills, valleys, rocky masses, distant paths: all committed to the plate from his memory and imagination.

In this manner, Degas printed two impressions from the same monotype field and with the addition of pastel work on both images, he fashioned two landscapes of entirely different seasons. The oil colors he employed – blue gray, several shades of green, salmon pink, and hot rose — were brushed on the plate to broadly suggest the hills and scrubby vegetation. A winding road was established by removing the ink cleanly from the plate. Then, with pastels, he worked on the base image, clarifying the abstract forms; for example, the inky patch at left depended on pastel lines and dabs to ascertain the crevices and curves of the rocky hill. In the Boston Museum impression (cat. no. 31), there are touches of lilac pastel along with shades of rose and green that Degas apparently matched to the oil pigments. The combination of the superimposed color layers produces a vibrating chromatic effect, and the warmer tonalities and overall darker appearance of this impression suggests that it was the autumnal version.

In the paler, second impression in the Metropolitan Museum (cat. no. 32), it is worth noting that Degas played with the inks on the plate, although the major compositional elements were retained. The horizontal striations of the hot pink sky in the first impression were essentially replaced with a cool blue band partially applied in short vertical strokes, and much of the bright green pigment as well as the blue-gray inky base of the rocky formation are hardly visible. Furthermore, Degas wiped away a portion of ink above the high tree line to convey a misty view in the distance – as if storm clouds were just lifting to reveal a clearing sky. He also dabbed and pulled at the ghostlike inks to diminish

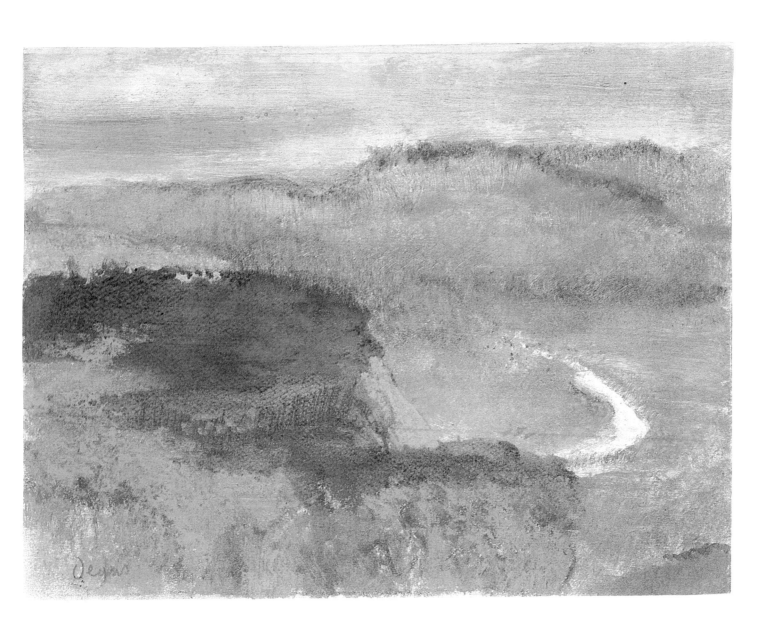

Edgar Degas
French, 1834-1917

32. Landscape, about 1890-93

Pastel over monotype in oil colors
Plate, 10 x 13⅜ inches (25.4 x 34 cm.)
Signed lower left in red pastel: *Degas*
The Metropolitan Museum of Art, New York
Purchase, Mr. and Mrs. Richard J. Bernhard Gift,
1972.636

PROVENANCE:
Durand-Ruel, Paris, New York; Kennedy Galleries, New York.

EXHIBITION:
Museum of Fine Arts, Boston, 1974 (cat: Shapiro, Barbara S. *Edgar Degas: The Reluctant Impressionist*, cat. no. 107).

REFERENCES:
Janis, Eugenia Parry. "An Autumnal Landscape by Edgar Degas," *The Metropolitan Museum of Art Bulletin*, vol. 31, no. 4 (Summer 1973), pp. [178-79]. Reff, Theodore. "Degas: A Master among Masters." *The Metropolitan Museum of Art Bulletin*, vol. 34, no. 4 (Spring 1977), pp. 42-43.

the effect of vegetation. A palette of cool pastels was lightly scumbled over the pale streaky monotype design; the pastel work served as a subtle cover rather than as a vehicle for the articulation of the terrain.

Degas's enthusiasm for producing colorful landscapes extended into the next few years and culminated in an exhibition of over twenty works held at the Durand-Ruel gallery in late 1892 to possibly early 1893.[2] After these years, Degas evidently abandoned the monotype medium as a means of artistic expression.

B.S.S.

1. Georges Jeanniot, "Souvenirs sur Degas," *La Revue Universelle*, November 1, 1933; translation by Eugenia Parry Janis in *Degas Monotypes* (Cambridge, Mass.: Fogg Art Museum, 1968), pp. xxv and xxvi.
2. Howard G. Lay in "Degas at Durand-Ruel, 1892: The Landscape Monotypes" (*The Print Collector's Newsletter*, vol. 9, no. 5 [November-December 1978], pp. 142-47), suggests a precise date of 1892 for the execution of the colored landscape monotypes. This is based on a translation of a conversation Degas had with the Halévy family. Considering that the artist made at least fifty landscapes of this type and knowing his methods in which he often put work aside to be changed or completed later when his interest was renewed, it seems safer to accept the broader time frame of 1890, when he made his Burgundian trip, to early 1893, when his exhibition at Durand-Ruel ended.

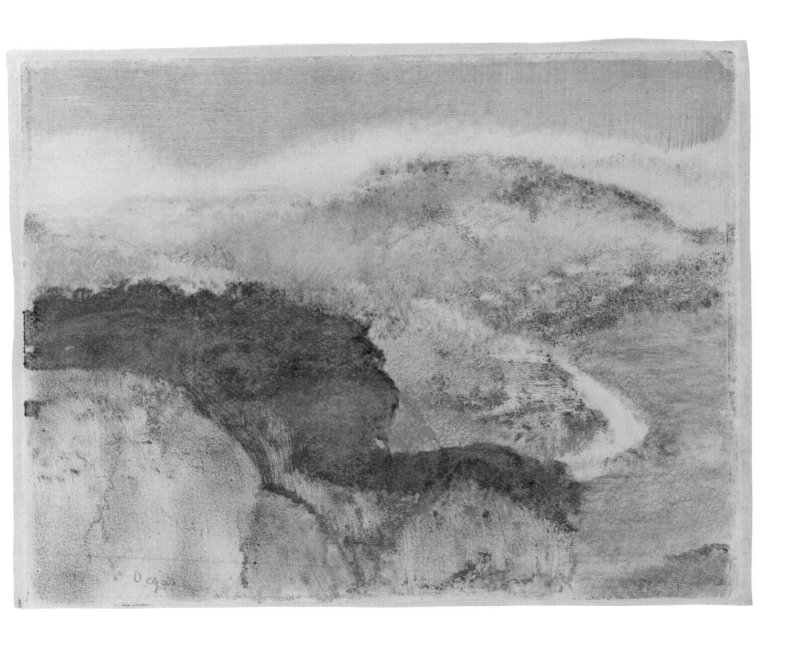

Edgar Degas
French 1834-1917

33. Landscape with Rocky Cliffs,
about 1890-93

Pastel over monotype in oil colors
Plate, 15½ x 11⅜ inches (40 x 29 cm.)
Stamped lower left in red: *Degas*
Private collection, New York

Shown in New York only

PROVENANCE:
4ᵉ *Vente Degas,* no. 39, ill.; René de Gas, Paris
(*Vente,* no. 46, ill.); David-Weill Collection, Paris;
Wildenstein, New York.

EXHIBITION:
Museum of Fine Arts, Boston, 1974 (cat: Shapiro,
Barbara S. *Edgar Degas: The Reluctant Impres-
sionist,* cat. no. 111).

REFERENCE:
Janis, Eugenia Parry. *Degas Monotypes.* Cam-
bridge, Mass.: Fogg Art Museum, 1968, checklist
no. 283.

A compositional pattern emerges in the landscapes that Degas executed following his 1890 trip through Burgundy. The artist drew upon a repertoire of pictorial devices to develop various arrangements of pathways, rivers, or screens of trees (see also cat. nos. 31, 32, 34). Frequently, he would brush or drip oil-base inks onto a plate, creating large, abstract forms directly in the foreground of the picture plane. These natural shapes replaced the stage sets, footlights, or large fans that figured so prominently in much of his work and acted as introductory pieces to his pictures. In this unique vertical format, the rocky cliff placed in *contrejour* to the luminous sky dominates at least half the composition and barely permits the viewer to see the valley beyond.

Degas applied with a stiff brush gold, green, and brownish oil pigments overlaid with matching pastels to create a craggy, verdant landscape; with his fingers he wiped away two small portions, thus attaining a curved river. Pale, cool colors, lightly touched with pastel, were streaked across the sky, and in contrast very dark accents further emphasize the projections and crevices of the cliff.

B.S.S.

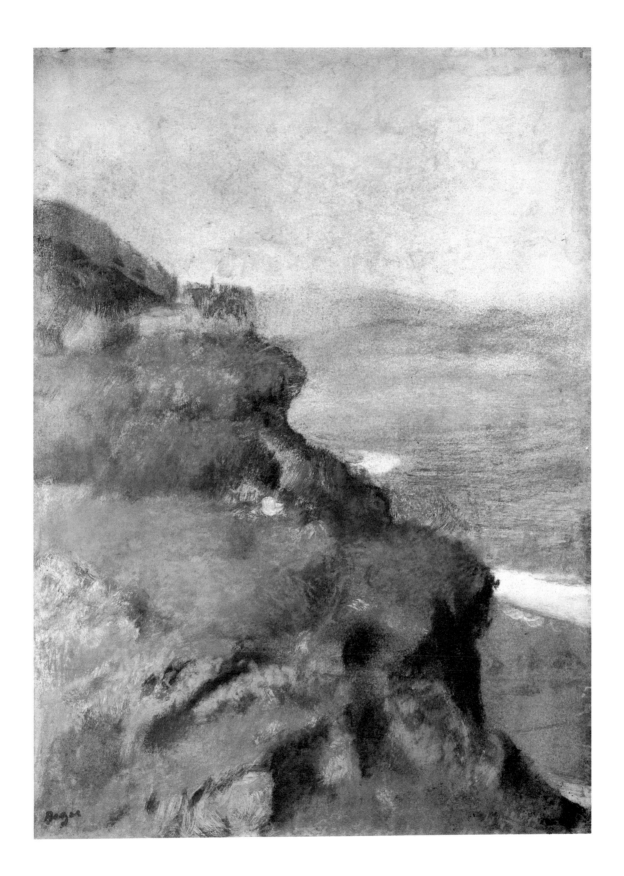

Edgar Degas
French, 1834-1917

34. A Wooded Landscape, about 1890-93

Monotype in colored inks
Plate, 11¾ x 15⅞ inches (29.9 x 40.3 cm.);
sheet, 12¹⁵/₁₆ x 16¹⁵/₁₆ inches (31.3 x 41.5 cm.)
Collection of Mrs. Bertram Smith, New York

PROVENANCE:
Maurice Exteens; Paul Brame and César de Hauke,
Paris; to Sir Robert Abdy; to Valentine Abdy; La
Galerie de *L'Oeil,* Paris; to E. V. Thaw and Co.,
New York.

EXHIBITION:
Fogg Art Museum, Harvard University, Cam-
bridge, Massachusetts, 1968 (cat: Janis, Eugenia
Parry. *Degas Monotypes,* cat. no. 73, checklist no.
297).

REFERENCE:
Adhémar, Jean, and Cachin, Françoise. *Degas:
The Complete Etchings, Lithographs, and Mono-
types.* New York: Viking Press, 1975, M187.

This is probably the most dramatic of Degas's color landscapes in which oil pigments were used without the addition of pastels. The stiff inks – cool blue in the sky with reddish-brown streaks as well as yellow and another shade of green – were applied in numerous directions with a rag or dry brush. A large area of comparatively thin emerald-green ink in the foreground serves the same role as a *coulisse,* the wing of a stage set, from which many of Degas's dancers emerged. The artist painted a fantasy of colorful abstract patterns and printed them on a sheet of pale gray paper; he ignored the more obvious aspects of the terrain. Although the technical means were reductive, the sense of vast space and the implications of natural forms is intensely rich and real.

The possibility that Degas regarded these oil-color monotypes as unfinished works to be retouched later with pastel must be weighed. Although our twentieth-century sensibility admires these color images and finds them aesthetically satisfying, the fact that they were neither signed nor exhibited, as were a selection of his pastel-over-monotype landscapes, suggests that Degas may have considered these striking but "vague" color pieces as substructures to be explored further.

B.S.S.

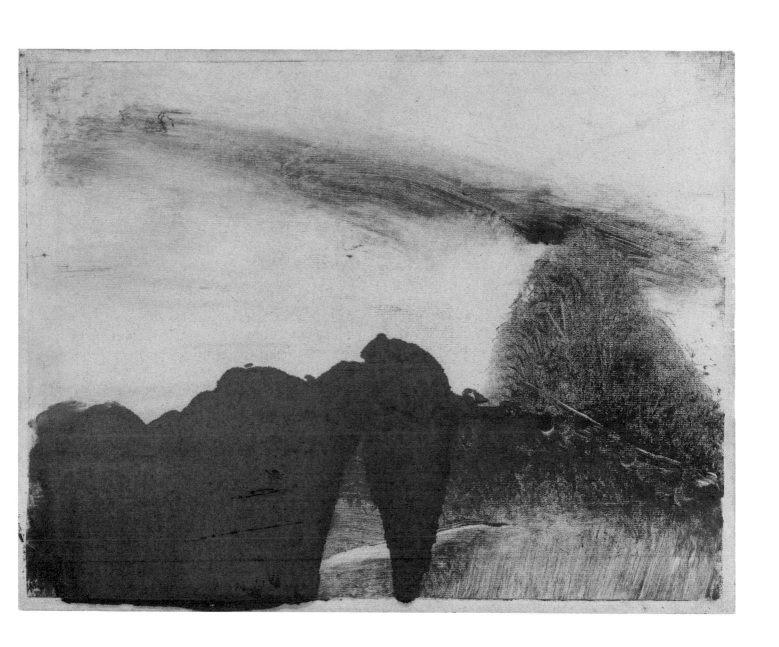

Camille Pissarro

French, 1830-1903

35. Pathway in a Cabbage Field,
about 1880-84

Monotype in black with color
8⅛ x 6 inches (20.5 x 15.3 cm.)
Signed lower right margin in pencil: *C. Pissarro*
National Gallery of Art, Washington, D.C.
Andrew W. Mellon Fund, 1977

PROVENANCE:
3ᵉ *Vente Pissarro,* April 12-13, 1929, no. 246;
Maurice Loncle; Gutekunst and Klipstein, May
15, 1952, no. 246; Ketterer, Pollag Collection,
November 27, 1973, no. 2159; R. M. Light Co.

REFERENCE:
Shapiro, Barbara, and Melot, Michel. "Les
Monotypes de Camille Pissarro." *Nouvelles de
l'estampe,* no. 16 (January-February 1975), pp.
16-23, no. 13.

In this vertical format, Pissarro rendered a landscape that is characteristic of his rural world of orchards, back gardens, fields, and country roads. He freely applied the grayish ink to the surface of the plate and moved it about in many directions: vertically to fashion the tree, with curved swipes to form the cabbage configurations, and horizontally to indicate the high horizon. The narrow dirt pathway was established by wiping away a streak of ink. With a blunt tool, Pissarro further delineated the cabbages by scratching into the ink, he dabbed at the pigments with a rag to effect grassy textures, and with a pointed brush, added a few significant contour lines. A part of the flat band at top was carefully shaped by his fingers to give a view of a distant town with a church steeple.

Pissarro accentuated the pronounced leafy branches of the tree with an extra amount of ink following the initial distribution on the plate. An ochre pigment, which formerly extended to the grassy edge, lends an overall sunny appearance; apparently as an afterthought, Pissarro covered part of the yellow tone, further raising the horizon line.

Pissarro's monotype bears a strong resemblance in composition and technique to a small group of landscapes that Degas made in the late 1870s to the early 1880s.[1] This was the exact time when the two artists were working together on a journal of prints, *Le Jour et la Nuit,* and exchanging information about unusual printmaking processes. There is no question that Pissarro arranged the motif and pulled and spread the ink on this plate in a way directly related to Degas's methods (fig. 53); even the sense of flattened space is reminiscent of Degas's pictorial style.

FIG. 53.

Edgar Degas, *Le Chemin montant,* about 1878-80, monotype in black ink.

Museum of Fine Arts, Boston; Horatio Greenough Curtis Fund, 24.1688

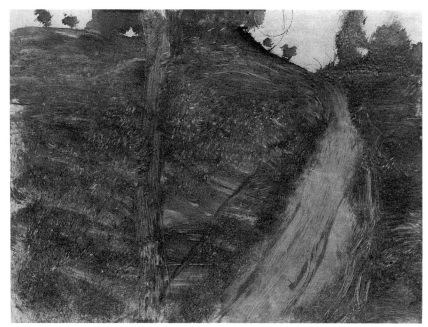

120

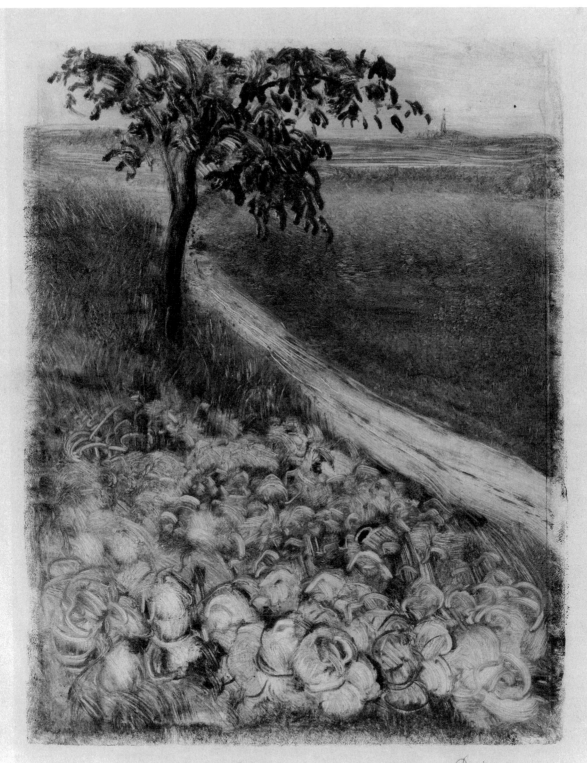

C. Pissarro

It would be convincing to place Pissarro's monotype around 1880 when he was closest to Degas's orbit and when he was making prints of a similar genre, for example, *Le Champ de choux* (Delteil 30). However, based on the geography of the area and on paintings of similar scenes (Pissarro and Venturi 587 and 628), the view on the monotype horizon must be the town of Pontoise with the distinctive church tower of St. Maclou as seen from the plains of Osny.[2] Since Pissarro moved from Pontoise to Osny in 1883 before settling in nearby Eragny in the spring of 1884, a date of execution later than 1880 should be considered.

B.S.S.

1. Eugenia Parry Janis, *Degas Monotypes*, (Cambridge, Mass.: Fogg Art Museum, 1968), checklist nos. 265-73.
2. I am grateful to Richard Brettell for his informed opinion. See also his unpublished doctoral dissertation, "Pissarro in Pontoise: The Painter in a Landscape" (Yale University, New Haven, Conn., 1977).

Camille Pissarro
French, 1830-1903

36. Herding the Cows at Dusk, about 1883-85

Monotype in black
5 x 9¼ inches (12.8 x 23.6 cm.)
Stamped lower right margin in gray: *C.P.*
National Gallery of Art, Washington, D.C.
Rosenwald Collection, 1967

EXHIBITION:
Museum of Fine Arts, Boston, 1973 (cat: Shapiro, Barbara S. *Camille Pissarro: The Impressionist Printmaker*, checklist no. 92).

REFERENCE:
Shapiro, Barbara, and Melot, Michel. "Les Monotypes de Camille Pissarro." *Nouvelles de l'estampe*, no. 16 (January-February 1975), pp. 16-23, no. 11.

With a painterly sweep of the brush and a bravura use of rag and fingers, Pissarro captured the quintessential Impressionist monotype. The setting sun blazes across the sky as a herdsman drives his cows homeward. Although the subject matter is clearly understood, not a single form is precisely drawn. Pissarro wiped away the ink in a diagonal fashion to create atmospheric rays of light from the sun at dusk and repeated this motion to form the curved road that tapers away to the edge of the plate. He dabbed at the roadside areas to suggest grassy vegetation, smeared the pigment to produce the herdsman and cows, then judiciously scratched white accent lines with a pointed tool to delineate the compositional elements.

Pissarro added extra touches of dark, opaque ink to the leafy trees and to the back of the walking figure, increasing the value contrasts. These inky portions and the smudges at lower left seem painted on the sheet but a close examination affirms that Pissarro heightened the figurative images before the plate was printed.

The subject, its format, and textural qualities call to mind Degas's landscape monotypes of the early 1880s,[1] and the overall luminous effect is similar to the sunlight found in etchings made by Pissarro in 1879: *Crépuscule avec meules* (Delteil 23) and *Soleil couchant* (Delteil 22). Yet the comparatively free handling of the ink and the painterly, more generalized forms suggest that this monotype was executed later than his more finished etchings. It anticipates, as well, Pissarro's vigorous monotype works of the 1890s.

B.S.S.

1. Eugenia Parry Janis, *Degas Monotypes* (Cambridge, Mass.: Fogg Art Museum, 1968), cites a monotype (checklist no. 268) of questionable attribution to Degas and relates it to this landscape monotype by Pissarro.

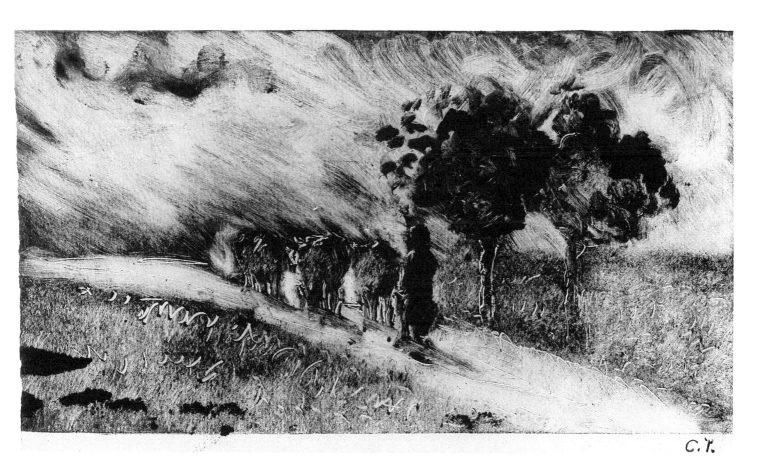

Camille Pissarro
French, 1830-1903

37. Peasant Gathering Cabbages,
about 1890

Monotype in color
11½ x 8¾ inches (29.2 x 22.2 cm.)
Signed lower left: *C.P.*
Emile Wolf Collection, New York

EXHIBITION:
Museum of Fine Arts, Boston, 1973 (cat: Shapiro,
Barbara S. *Camille Pissarro: The Impressionist
Printmaker*, checklist no. 89).

REFERENCE:
Shapiro, Barbara, and Melot, Michel. "Les
Monotypes de Camille Pissarro." *Nouvelles de
l'estampe*, no. 16 (January-February 1975), pp.
16-23, no. 14.

Peasant *Gathering Cabbages* recalls a motif that Pissarro explored earlier in prints and paintings; nevertheless, the loose, open contour lines and the muted palette of colors preclude that it was executed before the 1890s.

This is one of the few monotypes that the artist conceived entirely in color. Usually, Pissarro broadly painted and wiped the black, gray, or brownish inks across a plate and only occasionally added bits of color. Here, the color pigments are an integral part of the entire composition. Pissarro drew, in gray outlines, the sturdy peasant and the cabbage field. Two tones of green ink fill in these forms and ochre-green extends to the upper left of the monotype, suggesting leafy foliage. The ruddy complexion of the woman is repeated in the red-coral stripes that decorate her bodice and hat, while shades of green to blue color her skirt and apron. Some touches of bright green ink further model the vegetables and may have been added to the sheet after the monotype was printed.

B.S.S.

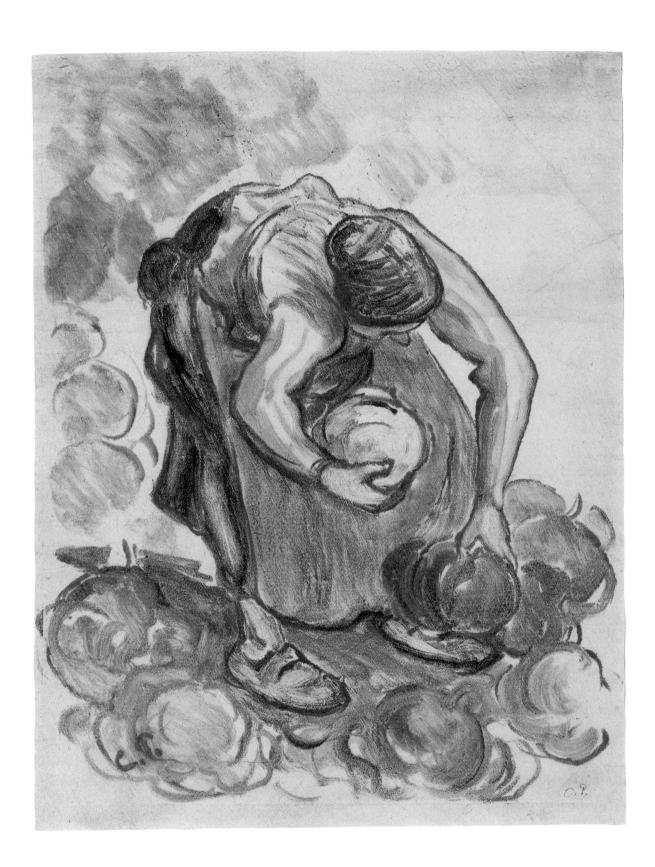

Camille Pissarro
French, 1830-1903

38. Bather, 1894

Monotype in black
4⅞ x 6⅞ inches (12.3 x 17.4 cm.)
Signed lower left in back ink: *C. Pissarro 94*
National Gallery of Art, Washington, D.C.
Gift of Mr. and Mrs. Jacob Kainen, 1977

PROVENANCE:
Viau Collection, Hôtel Drouot, February 26, 1943,
no. 52; Hôtel Drouot, December 5, 1973, no. 30;
private collection, Boston.

REFERENCE:
Shapiro, Barbara, and Melot, Michel. "Les
Monotypes de Camille Pissarro." *Nouvelles de
l'estampe,* no. 16 (January-February 1975), pp.
16-23, no. 1.

This is the only monotype that Pissarro dated, and its execution corresponds to his etched and lithographic prints of bathers in 1894. A letter to his son, Lucien, confirms these endeavors. "The weather is very uncertain for poor painting; I am content to triturate indoors. I have made a whole series of romantic printed drawings [lithographs] which appear to me to have rather amusing aspects: many *Bathers* in all sorts of poses, in landscapes of paradise. Some interiors as well, *Peasants at Their Toilette,* etc., these are the motifs that I work on when I am unable to go outdoors. They are very amusing because of their black and white values – which gives the tone for the pictures. I have heightened some of them with colors."[1]

Two large dark masses of oily ink were painted and wiped on a plate in a manner unlike any other monotype in Pissarro's repertoire. The blacker layer, comprising a stand of trees on a bank and dense vegetation, was superimposed over a lighter tone of dry ink from which an area of luminous sky and reflecting water were wiped. A bather poses tentatively and mysteriously at the water's edge – her figure suggested by vertical wiping strokes and by a few contour lines and scratches. A variety of subtle scratches mingle with dark accents to break down the massiveness of the heavily inked areas so that a more specific definition of the landscape becomes apparent. The creamy paper conveys a warm, sunlit atmosphere and the overall effect is of a private sylvan setting.

B.S.S.

1. John Rewald, ed., with the assistance of Lucien Pissarro, *Camille Pissarro: Lettres à son fils Lucien* (Paris: Albin Michel, 1950), pp. 339-40, written from Eragny, [April] 1894.

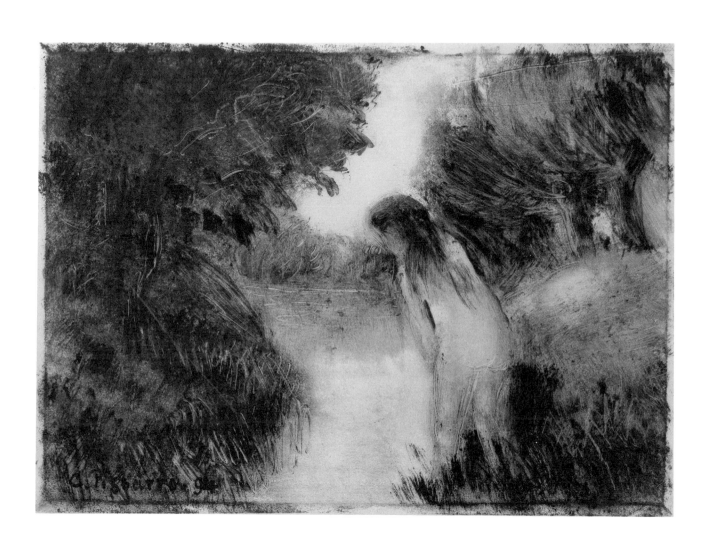

Camille Pissarro

French, 1830-1903

39. Bathers Reclining on a Grassy Bank, about 1894

Monotype in black
5 x 7 inches (12.8 x 17.9 cm.)
Signed lower left in black: *C.P.*
The Achenbach Foundation for Graphic Arts, California Palace of the Legion of Honor, San Francisco

PROVENANCE:
Orovida Pissarro.

REFERENCE:
Shapiro, Barbara, and Melot, Michel. "Les Monotypes de Camille Pissarro." *Nouvelles de l'estampe,* no. 16 (January-February 1975), pp. 16-23, no. 8.

With broad brushstrokes and forceful handling of the rag, Pissarro depicted two peasant bathers reclining on a hillock deep in conversation. He brushed and wiped the ink in varying directions to suggest deep grass, overhanging branches, and the figures prominently placed in the foreground. The heavy nude bodies were further delineated by broken contour lines drawn with a pointed brush, while the foliage is the result of scratching the dry ink with a pointed tool, probably the wooden end of the paintbrush. Additional smudges of very dark ink were applied to the plate after the preliminary work was done to set off portions of the image, especially the spiky leaves and the women's hair; a residue of oil on the verso of the paper corresponds to these particular areas.

The composition is not unlike others by Pissarro for he did, on occasion, depict peasant women resting from their labors on a grassy slope. The tipped-up landscape and a pronounced hill line that duplicates the rhythmic postures of the women is a characteristic motif. Of great significance is the affinity of this image with the monotype *Deux Femmes* made by Degas about 1879 (fig. 54). According to Janis, this is one of two Lesbian scenes known among Degas's monotypes, but it is not unusual given the subject matter of his *maisons closes* series.[1] Although erotic art was not a part of Pissarro's œuvre, there are etchings and lithographs, as well as a few paintings, of bathers alone or frolicking in the water in groups, that may indeed allude to a sensuous inclination at this time. In a letter to his son, Lucien, Pissarro wrote: "I have just completed two etchings of *Bathers.* Amazing! You will see them. They

FIG. 54.

Edgar Degas, *Deux Femmes,* about 1879, monotype in black ink.

Museum of Fine Arts, Boston; Katherine Eliot Bullard Fund, 61.1214

128

are, perhaps, too naturalistic, these are firm-fleshed peasant women . . . !
They will offend, I am afraid, the delicate, but I believe that is what I do
best, if I do not deceive myself. . . ."[2] After this period there were no
further nude studies. Given his rural environment, Pissarro would have
had difficulty engaging nude female models, and these works should be
considered as imaginative studio pieces.

One can only contemplate whether Pissarro had seen Degas's earlier
monotype and many years later, retaining the memory, prepared his own
version. It is worth noting the related designs and similarity of postures;
the fact that the upper figure in both monotypes was darkened increases
their correspondence.

B.S.S.

1. Eugenia Parry Janis, *Degas Monotypes* (Cambridge, Mass.: Fogg Art Museum, 1968), no.
 30.
2. John Rewald, with the assistance of Lucien Pissarro, *Camille Pissarro: Lettres à son fils
 Lucien* (Paris: Albin Michel, 1950), p. 237, letter inscribed "Paris, 21, janvier 1894."

Camille Pissarro
French, 1830-1903

40. Young Girl Combing Her Hair,
about 1894

Monotype with color
5 x 7⅛ inches (12.8 x 18 cm.)
Stamped lower right in gray: *C.P.*
Museum of Fine Arts, Boston
Lee M. Friedman Fund, 60.793

PROVENANCE:
Marcel Lecomte.

EXHIBITION:
Museum of Fine Arts, Boston, 1973 (cat: Shapiro, Barbara S. *Camille Pissarro: The Impressionist Printmaker,* cat. no. 43, ill., checklist no. 88).

REFERENCE:
Shapiro, Barbara, and Melot, Michel. "Les Monotypes de Camille Pissarro." *Nouvelles de l'estampe,* no. 16 (January-February 1975), pp. 16-23, no. 9.

In one of his rare interior scenes, Pissarro executed a monotype that combines painterly style with printmaking techniques. The contours of the girl, the chairs, and pictures in the room were articulated in oily inks with a pointed brush. The bed and floor were wiped in different directions of tonal striations whereas the wall and enclosing bed curtain were dabbed with a rag to indicate rougher textures.

Essentially, this monotype is a study in black and white, with a few small patches of color. Ochre was used on the arms, face, and breast of the young girl; her hair was touched with brown, and her stockings were painted a warm gray. Flecks of bright blue enliven the bed curtains, and the linen at the bottom of the pile on the distant chair is purple. Pissarro also darkened the shadows cast by the bed and curtains to convey solidity.

It is difficult to discern whether Pissarro added all of the color patches before or after printing. His use of differing viscosities of ink makes it hard to analyze his complex technical procedures. Perhaps his instincts for painterly effects insisted that he alter the surface of the finished monotype.

This image and a monotype in the collection of the Metropolitan Museum relate directly to a pastel and a painting dated 1894. The same distinctive bed, small decorative pictures, and straight-backed chair, as well as the same model appear in all these works.

B.S.S.

130

Paul Gauguin

French, 1848-1903

41. Nave Nave Fenua (Delightful land), (Standing Woman), 1894

Watercolor monotype
15¾ x 9½ inches (40 x 24 cm.)
Signed with woodcut seal, lower right: *PGO*
Museum of Fine Arts, Boston
Bequest of W. G. Russell Allen, 60.368

EXHIBITION:
Philadelphia Museum of Art, 1973 (cat: Field, Richard S. *Paul Gauguin: Monotypes*, p. 57, no. 6).

REFERENCES:
Rewald, John. *Gauguin Drawings.* New York: T. Yoseloff, 1958, p. 31, no. 57. Pickvance, Ronald. *Gauguin Drawings.* London: Hamlyn, 1969, no. 60.

BIBLIOGRAPHY:
See also Field's essay in *Paul Gauguin: Monotypes,* pp. 13-19, 38-39.

By the spring of 1894, Gauguin was in Brittany, having returned earlier from his first trip to Tahiti. During this visit to northern France, he fractured his ankle in a brawl with sailors and remained inactive for weeks. This unfortunate accident triggered a production of ten woodcuts and probably, at the same time, his first watercolor monotypes. Although Gauguin went to Brittany to search for artistic inspiration, it seems that he continued to reproduce Tahitian motifs that he carried in his mind.

The standing nude woman shown here is the ideal embodiment of the Tahitian Eve before the Fall set in the garden of Eden and is an exotic pictorial type that recurs frequently in Gauguin's œuvre. She is about to pluck the flower of evil and a lizard replaces the traditional snake as the Temptor. This compelling image appears in numerous paintings, drawings, watercolors, woodcuts, and in ceramic. Gauguin based her figural style and pose on images assimilated from photographs he had acquired of the reliefs from the Javanese temple at Bârâboudour.[1]

The monotype is a harmony of colors – red, brown, orange, green, yellow, blue-gray, and black – a successful combination of printed colors along with light touches of matching pigments painted on the surface of the finished sheet. The blue contour lines are very pronounced and clearly defined whereas the large color areas are striations of diffuse washes of tone. Although Gauguin employed primary colors, they were diluted, and the overall effect is soft and low-keyed. Perhaps this was his reaction to the woodcuts printed by his friend Louis Roy, which were harshly colored and lacked sensitivity to line and color.[2] On the lower right corner is the mark of the round woodcut seal *PGO* that Gauguin favored in 1894.

The accepted theory concerning his techniques is that Gauguin achieved his watercolor monotypes by transferring pigments from one sheet of paper to another rather than from the more traditional metal plate, glass, or piece of celluloid. In only one instance, however, has a single coherent image been found that may have served as the base for a subsequent monotype (see Wildenstein 425, watercolor printed on cardboard).[3] The fact that there are no more of these fully reconciled support images suggests the possibility that the base may have been an assemblage of pieces instead of a single unit – fragments of board, cloth, paper, or even wood. An examination of woodblocks from Gauguin's 1894 endeavors reveals some of the same thin, uniform striations and shallow carved areas that are recognized on portions of the watercolor monotype sheets. Could the variety of textural effects be the result of mechanical means and not due to the nature of the support paper? Were the emphasized blue contour lines, often reinforced in watercolor, a stylistic device or were they needed to register and guide each application of color, to hold the parts together, so to speak? It is difficult to

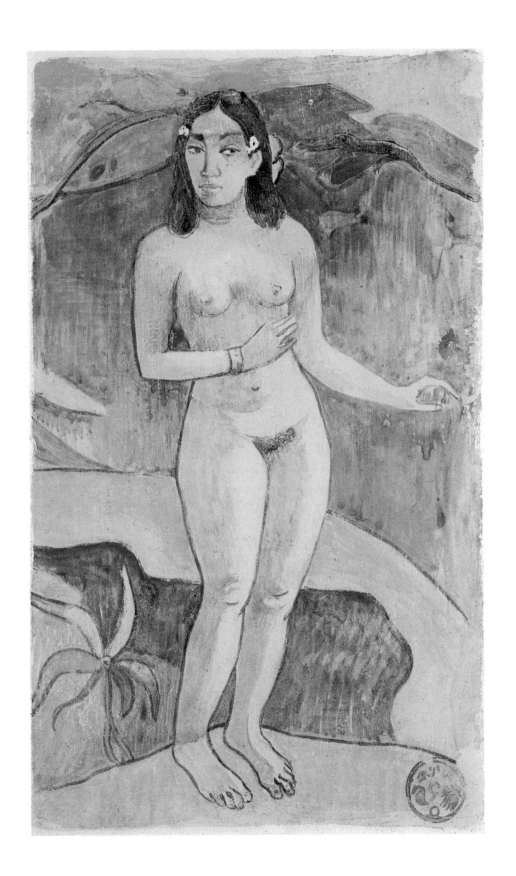

conceive that Gauguin would have prepared a completely rendered image, then taken one impression, and disposed of the original work. Nevertheless, the lack of informed evidence makes one cautious about drawing conclusions as to the matrix material, and only further exploration can determine whether the watercolor monotypes of 1894 as well as the gouache monotypes of 1902 were the result of a single base sheet of paper or a pastiche of supports and stencils.[4]

B.S.S.

1. Richard S. Field, *Paul Gauguin: Monotypes* (Philadelphia: Philadelphia Museum of Art, 1973), p. 57, no. 6.
2. This monotype was formerly glued over an impression of the woodcut *Te Faruru* (Guérin 21) printed by Louis Roy, and both sheets were mounted down on gray cardboard. This use of the Roy impression indicates Gauguin's disregard for the edition.
3. Field, p. 66, cat. nos. 21 and 22.
4. I am grateful to Michael Mazur, who examined these ideas with me.

Paul Gauguin
French, 1848-1903

42. The Pony, about 1902
La Fuite (flight); Le Gué (the ford)
Gouache monotype with addition of gum or varnish
13 x 23¼ inches (33.1 x 59 cm.)
Signed in pencil, upper left: *P. Gauguin*
National Gallery of Art, Washington, D.C.
Rosenwald Collection, 1947

PROVENANCE:
Richard Zinser; Lessing J. Rosenwald.

EXHIBITION:
Philadelphia Museum of Art, 1973 (cat: Field, Richard S. *Paul Gauguin: Monotypes,* p. 140, no. 134).

Based on the type of paper used (machine-made laid paper sent to Gauguin in Tahiti by his dealer Ambroise Vollard in 1902) and on the existence of a group of small oil paintings to which these late opaque watercolor monotypes relate, one can posit their date of execution to a year before the artist's death.[1]

The Pony corresponds to a painting dated 1901 (Wildenstein 597), for which there is a watercolor study, and to one of the so-called "traced monotypes," *La Fuite* or *Tahitian on Horseback.* It has been suggested that this motif derived from Albrecht Dürer's engraving *Knight, Death, and the Devil* (dated 1513), a reproduction of which Gauguin pasted on the back cover of *Avant et Après,* a journal of memoirs and anecdotes completed in February 1903.[2] *The Pony,* which faces in the same direction as Dürer's print, is merely an excerpt of the subject but shows a thematic affinity. Dürer depicted a Christian knight, unmindful of death and the devil, who rides through the "valley of the shadow of death" toward the light of salvation. It is conceivable that Gauguin made a personal interpretation of the engraving with its multiplicity of supernatural detail and couched his own frustrating search for freedom and salvation in this symbolic statement using his inimitable, exotic vocabulary.

About seven known monotypes of the 1902 period share a commonality of technique that is difficult to unravel. Gauguin retained the strong blue contour lines and jewel-like colors – blue, purple, ochre, flesh pink, with touches of bright white – which cover the sheet in heavy impasto and more random strokes. According to Field, some passages contain a gum or varnish, creating a crackling surface of texture, shape, and color.[3] It is possible that the matrix support was stiffer and stronger than paper in order to permit the transferral of these heavily worked compositions.

B.S.S.

134

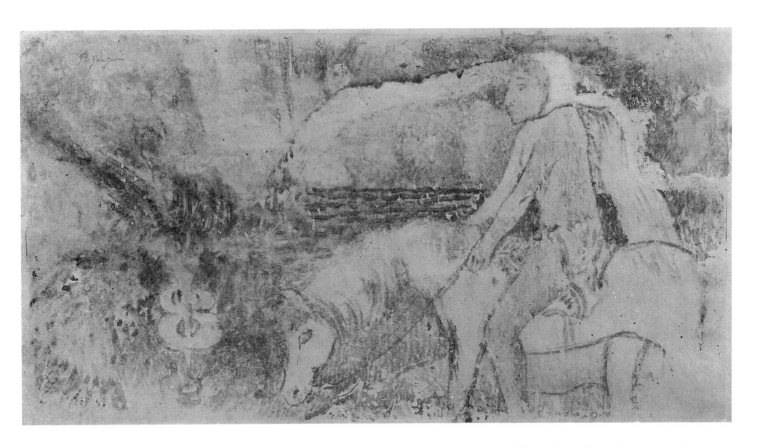

1. Richard S. Field, *Paul Gauguin: Monotypes* (Philadelphia: Philadelphia Museum of Art, 1973), see discussion on pp. 124 and 140, cat. nos. 104 and 134.
2. William M. Kane, "Gauguin's *Le Cheval Blanc*: Sources and Syncretic Meanings," *Burlington Magazine,* July 1966, p. 361. Kane also suggests that the hooded figure may represent Death on a Pale Horse.
3. Field, p. 39.

Paul Gauguin
French, 1848-1903

43. Crouching Tahitian Woman Seen from the Back, about 1902

Monotype in color
Sight, 21 x 11⅛ inches (53.2 x 28.3 cm.)
Signed in pencil, upper right: *P. Gauguin*
Collection of Mr. and Mrs. Eugene Victor Thaw, New York

PROVENANCE:
Ambroise Vollard; Wildenstein & Co., New York; Richard S. Davis, New York.

EXHIBITIONS:
Philadelphia Museum of Art, 1973 (cat: Field, Richard S. *Paul Gauguin: Monotypes*, p. 140, no. 133). Pierpont Morgan Library, New York, 1975 (cat: Stampfle, Felice, and Denison, Cara D. *Drawings from the Collection of Mr. and Mrs. Eugene V. Thaw*, pp. 92-93, no. 103).

REFERENCE:
John Rewald, *Gauguin Drawings.* New York: T. Yoseloff, 1958, p. 38, no. III.

BIBLIOGRAPHY:
See Field, *Paul Gauguin: Monotypes*, pp. 39 and 140, no. 133; and Stampfle and Denison, *Drawings*, pp. 92-93, no. 103.

The crouched woman was employed in other compositions, including one of Gauguin's most notable paintings, *The Call*, dated 1902.[1] In the monotype, the figure is seated in a pool of water, causing a spread of blue ripples, and with head forward, looking down, she concentrates on her toilette. A tapestry of tropical foliage acts as a backdrop for the strong, anonymous figure.[2] The palette of watercolors duplicates the color harmony of the painting – varying intensities of blues, purple, magenta, greens, reds, orange, olive, and brown – but assumes the diffused quality of printed hues that is so characteristic of a monotype. Gauguin retouched the surface of the sheet with white in the water and may have added subtle greenish-gray modeling to the volumetric figure. The customary blue outlines were dually drawn in certain parts, suggesting that they acted as registration lines for the application of the color passages.

There is a tacky effect where the watercolor picked up fibers from the paper, but unlike other examples of Gauguin's late monotypes, there is no thick encrustation of pigment. The manner of printing, the complementary colors used, and the warm-toned paper combine most successfully to give this image a particular luminous and glowing appearance.

B.S.S.

1. Richard S. Field, *Paul Gauguin: Monotypes* (Philadelphia: Philadelphia Museum of Art, 1973), relates this monotype to the period when Gauguin was living in Hivaoa, one of the Marquesas Islands, where he died and was buried. Field therefore proposes the title *Crouching Marquesan Woman*. Felice Stampfle and Cara D. Denison, *Drawings from the Collection of Mr. and Mrs. Eugene V. Thaw* (New York: Pierpont Morgan Library, 1975, p. 93), refer to earlier prototypes, including the traced monotype *Crouching Tahitian Woman* (Field 75), and retain this title for the monotype shown here.
2. Aristide Maillol (1861-1944) owned the traced monotype version and modeled his ceramic sculpture *Woman with a Crab*, about 1905, after this figural pose.

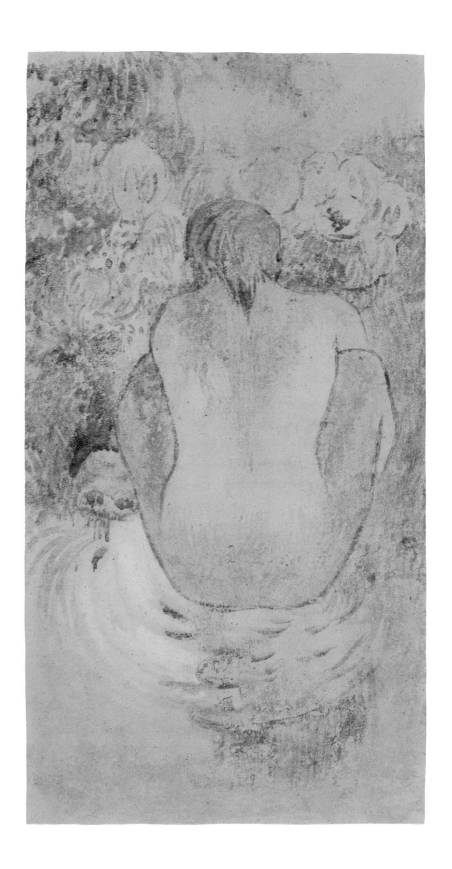

Henri de Toulouse-Lautrec
French, 1864-1901

44. Au Cirque: le Clown, 1899

Monotype in color
Sheet, 19¾ x 14 inches (50 x 35.5 cm.)
Signed lower left with artist's monogram
Aldis Browne Fine Arts, Ltd., New York

PROVENANCE:
Maurice Joyant; Heinrich Stinnes (purchased from Ansler & Ruthardt, Berlin, in 1917); Hollstein & Puppel, Stinnes Collection, November 11, 1936, lot 1267, ill. p. xiii; George Hirschland; private collection, United States.

REFERENCE:
Dortu, M. G. *Toulouse-Lautrec et son œuvre.* New York: Collectors Editions, 1971, vol. 3, p. 532, ill. p. 533, M. 1.

In February 1899 Toulouse-Lautrec collapsed from fatigue and alcoholic addiction and was confined by his family to a sanatorium on the outskirts of Paris. Like other artists of sensitive personality, he could not bear imprisonment, and after a brief period, embarked on a project to prove the integrity of his artistic faculties for himself as well as for his doctors. With the help of his devoted friend and dealer, Maurice Joyant, Lautrec worked on an album of circus drawings, made especially meaningful since they depended on memories from earlier circus visits instead of his usual aide-mémoires of sketchbooks and photographs.

From his confinement came a set of thirty-nine chalk and colored-pencil vignettes of circus rehearsals and performances, and during this time he probably executed his few monotypes.[1] The most distinctive example, *Au Cirque: le Clown*, represents a moment of working out a circus trick. The trainer, holding a whip in one hand and a saddle in the other, observes the spirited horse as it cavorts around the arena. Only one curving diagonal suggests the spatial structure: all other descriptive aids are eliminated—there is no background, shading, or modeling to indicate the placement of the figural elements in their environment. Sketchy contour lines give a sense of animation and a few touches of color—bits of red on the circus ring and face of the clown, green on the saddle, and mustard yellow on the performer's boots—add highlights.

In the drawings, the circus figures are strongly outlined and shaded with extraordinary precision; they firmly project from the totally white background and, because of their exaggerated proportions, take on a sinister effect. In contradistinction, the monotype is summarily implied by brisk calligraphic brushstrokes and is imbued with a sense of vitality and whimsy. Like earlier brush and ink drawings, Lautrec skimmed across the sheet using a thin brush loaded with ink that dissipated before the lines were complete.

Since there is no platemark and his circumstances were limited, it is entirely possible that Lautrec transferred by hand the painted drawing from the plate to the paper. The signature HTL within a circle (a stamped monogram was placed on many of Lautrec's works after his death) indicates that he considered this monotype to be a finished work of art.

B.S.S.

1. There are four known monotypes (and two cognates) listed by M. G. Dortu, *Toulouse-Lautrec et son œuvre* (New York, 1971), pp. 532-33, M. 1-M.6. *Au Cirque: le Clown*, (M. 1), shown here, is the first impression drawn from the plate; a second, paler impression with the monogram stamp (M. 2) is in the collection of Madame Dortu, who inherited the estate of Maurice Joyant. There is an illustration in Loys Delteil, *Le Peintre-Graveur Illustré* ([Paris, 1920], vol. 11, no. 337) that raises questions about whether a third impression of this monotype exists or if the photographic negative of the image was retouched in the process of reproduction. External evidence such as the absence of the HTL stamp on the lower right corner and differences in portions of the figural outlines as well as dissimilar provenances for the impressions discussed here, all contribute to the confusion. More information and examination of all the original works are required.

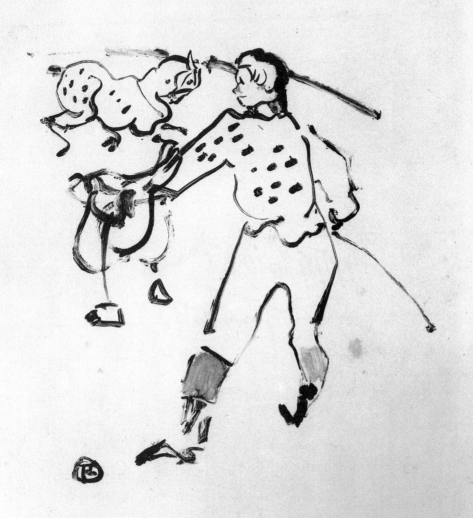

Nineteenth- and Early Twentieth-Century American Monotypes

Frank Duveneck
American, 1848-1919

45. Floating Figure, about 1880
Monotype in black ink
Image, 12³/₁₆ x 16⅞ inches (31 x 42.9 cm.)
Monogram on plate, lower right
Cincinnati Art Museum
Gift of Frank Duveneck, 1913.879

Otto Bacher's brief description of the evening activities of the lively group of young artists studying with Frank Duveneck in Venice, known as the Duveneck "boys," and the masterful group of Duveneck's monotypes that have survived in Boston and Cincinnati have all contributed to Duveneck's reputation as a major early figure in the American monotype experience.[1] In Venice, the etching press belonged to Otto Bacher, and it was he who most likely showed Duveneck how to make prints. The logical step for a painterly printmaker would be the monotype; again, although Bacher may have led the way, Duveneck was very much involved in the process. Whatever their history, Duveneck's monotypes are characteristic of his work. He laid in a picture with broad, painterly strokes, building up the image. With the monotype the reverse was true: the broad strokes were created by wiping the excess ink from the heavily inked surface of the plate. This can be seen best in his figural studies. The enigmatic *Floating Figure* shows his masterful control of the wiping process in what must have been an almost shorthand-like flurry of activity. The figure itself needs the luminosity of the revealed paper to create its ghostly effect.

The boldness of *Floating Figure* contrasts markedly with the more atmospheric large plate, *Indians Warily Approaching Encampment.* While never quite succumbing totally to the influence of Whistler, Duveneck still absorbed and experimented with various Whistlerian notions. Most notable in *Indians* is the feeling of atmosphere over a long, low horizon, an effect exploited by Whistler in the Venetian series. The rather thin wiping of the sky area has allowed the paper to take a more active part in the composition. Against this, in a more characteristic style, Duveneck silhouetted the returning Indians. It is easy to surmise the order in which he worked on the plate after the initial inking–wiping of the sky area, Indians and smoke added with the excess brushed ink, and finally, the prairie grasses worked out with free brushing.

After Whistler's departure from Venice, Duveneck continued to winter in Florence and summer in Venice until later in the 1880s, as

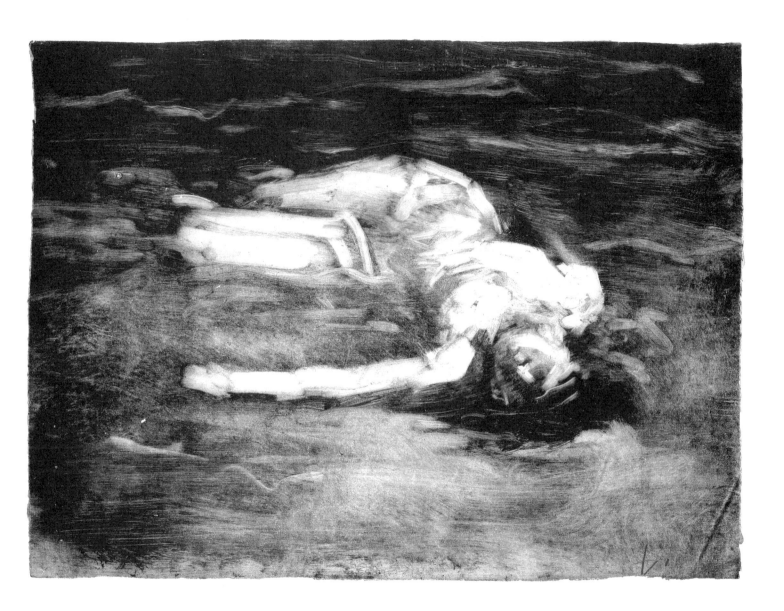

Frank Duveneck
American, 1848-1919

46. Indians Warily Approaching Encampment, 1883-84

Monotype in brown ink
Image, 12¼ x 17⅛ inches (31.1 x 43.5 cm.)
Signed in pencil, lower right
Museum of Fine Arts, Boston
George R. Nutter Fund, 1950 (50.3231)

PROVENANCE:
Susan M. L. Wales.

indicated in the note by Susan M. L. Wales attached to the frame of *Indians*:

> In the Villa Ball [Thomas Ball, the sculptor]. Florence. Italy. Winter 1883 and '84.— Original Monotypes On copper plates in oil paint with the finger, a stick & a rag— Every Monday Evening printed one copy on an old press set up in the hall. These were given to Kate and myself. They are by Frank Duveneck.— All the others Mrs. Thomas Ball had.[2]

The large format of this monotype and most of his other surviving examples seems indicative of work made for presentation rather than amusement. In any case, Duveneck's monotypes and etchings have a stiffness and formality that frequently overwhelms the original idea with slow and deliberate use of plate tone and brushwork. Duveneck was essentially a painter, and the monotype presented him with a process to achieve a more painterly print.

D.W.K.

1. Otto Bacher, *With Whistler in Venice* (New York: Century Co., 1908), pp. 116-21.
2. There are two monotypes in this group by Duveneck; the second example, printed in blue ink, is of a harbor scene. Both prints had pencil identifications written on the verso and further notes at a later date attached to the frames.

Charles Abel Corwin

American, 1857-1938

47. Portrait of Whistler, 1880

Monotype in black ink
Image, 8¹³/₁₆ x 6¹/₁₆ inches (22.4 x 15.4 cm.);
paper, 11½ x 7½ inches (29.2 x 19.1 cm.)
Signed on plate, lower right
The Metropolitan Museum of Art, New York
The Elisha Whittelsey Collection, The Elisha
Whittelsey Fund, 1960 (60.611.134)

Among the rare survivals of evening entertainments of the Duveneck "boys" is this sensitive portrait of Whistler, who was in Venice in 1880. Corwin, like most of the "boys," was a painter whose brief excursions into printmaking were at the encouragement of his teacher Frank Duveneck. Corwin's few etchings are very uncommon,[1] and this may be his only known monotype. His portrait of Whistler reiterates the painterly qualities of this printmaking process. He has brought up the image out of the fully inked plate with deftly handled brushwork and the well-chosen use of thumbwork in the face. Additional ink was added to cast a shadow over the lapel of the coat and to create the famous black ribbon tie.

This portrait neatly coincides with the physical description of Whistler as recalled by Otto Bacher for Joseph Pennell:

> a curious sailor-like stranger...short, thin and wiry, with a head that seemed large and out of proportion to the lithe figure.... It was a background for his curly black hair and singular white lock, high over his right eye, like a fluffy feather carelessly left where it had lodged. A dark sack-coat almost covered an extremely low turned-down collar, while a narrow black ribbon did service as a tie, the long pennant-like ends of which, flapping about, now and then hit his single eyeglass.[2]

Corwin's Whistler, however, is not the proud and flamboyant personality most often seen in portraits. He has instead caught Whistler at a sympathetically pensive and reflective moment, maybe late in the evening at the Casa Jankovitz.

D.W.K.

1. S. R. Koehler published Corwin's etching *Scene in Venice* as pl. 24 in his book *Etching* (New York: Cassell & Co., 1885). This is the most common of Corwin's prints.
2. Elizabeth R. and Joseph Pennell, *The Life of James McNeill Whistler* (London: William Heinemann, 1908), vol. 1, p. 266.

William Merritt Chase
American, 1849-1916

48. Reverie: A Portrait of a Woman, about 1890-95

Monotype printed in ink
Image, 19½ x 15¾ inches (52.1 x 42.6 cm.)
Signed in plate, upper right corner
The Metropolitan Museum of Art, New York
Purchase, Louis V. Bell, William E. Dodge, and
Fletcher Funds; Murray Rafsky Gift; and Funds
from Various Donors, 1974.544

PROVENANCE:
David Daniels, New York.

William Merritt Chase made few etchings, as the body of his printmaking work was monotypes. The bold, bravura quality of his work in oils was most accurately captured by the monotype. Knowing the limitations of the process, he did not depend on it to reproduce multiple images. Two qualities most likely impressed him when he first learned of the process:[1] the necessary speed to create an image suitable for printing before the ink had time to dry and the luminosity given to compositions in black and white. Chase constantly reminded his students that the brain and the hand must be in communion; spontaneity is lost when there is any hesitation.[2] The monotype was a useful technique to hone this precept through practice.

Both spontaneity and luminosity are readily expressed in this portrait of a woman, probably of his wife, entitled *Reverie.* One of the largest monotypes made in America during the late nineteenth century, the image could easily take its place as one of Chase's great portraits. He skillfully brought out the face from the fully inked plate with bold wiping and brushwork, even using his thumb to create the soft textures of the woman's skin and garments. The stump end of a brush made the highlights of lace at the wrist and the facets of jeweled rings. Additional ink, applied with the brush, strengthened shadows and added other costume details. The sensitively modeled face shows all the care given to an oil portrait.

This monotype was backed at some earlier period. It is on thin Japan paper which may have been torn during the printing process or later. Chase was not overly fond of working in black and white but he loved to make monotypes.[3] Besides the pure joy he felt in making them, he found that the luminosity of paper coming through a rich and velvety inked surface gave an image a spark of life often difficult to capture in an oil painting. He may have hung monotypes in windows, as can be seen in the background of his painting *For the Little One,* about 1895.[4] The image in the window is similar to *Reverie* in both style and mood. And, while most likely not this print, such practices could easily account for its weakened condition.

D.W.K.

1. While Chase was in Venice, he may have witnessed Duveneck's early experimentations, or he may later have heard of these achievements in letters from Duveneck.
2. Frances Lauderbach, ''Notes from Talks by William Merritt Chase, Summer Class, Carmel-by-the-Sea, California. Memoranda from a Student's Note Book,'' *The American Magazine of Art,* vol. 8, no. 11 (September 1917), p. 433.
3. Ibid., p. 434.
4. The painting is in the collections of the Metropolitan Museum of Art, accession number 13.90.

William Merritt Chase
American, 1849-1916

49. Woodland Scene, about 1895

Monotype in black ink
Image, 8 x 6 inches (20.3 x 15.2 cm.)
Signed in the plate, lower left corner
Baker-Pisano Collection, New York

For the most part, Chase limited his work in monotypes to head studies of men and women, some in period costumes. Sylvester Koehler noted that Chase exhibited not only "smoke-picture" style heads at the Salmagundi Sketch Club's Black and White Exhibition in December 1880, but also landscape sketches.[1] There are a number of landscape monotypes by Chase that have survived. Most of these are said to be products of his visits to California in the 1910s. This example, dated approximately to the period in which he made *Reverie*, is dependent on the wiping of the plate, with little additional brushwork. Chase created a vista of a woodland glade with sunlight streaming through a break in the trees. He carefully united the two registers of the plate, the top composed for the most part with long wiping strokes to create the tree-trunk screen of the forest, while the rapid thicket of brushwork in the lower register successfully captures the tangle of grasses and small shrubs, with the long stream of light down the center of the plate silhouetting the vertical streak of the foremost tree trunk.

D.W.K.

1. Sylvester R. Koehler, "The Work of the American Etchers: XVIII.— William M. Chase," *The American Art Review*, vol. 2, no. 1 (1881), p. 143.

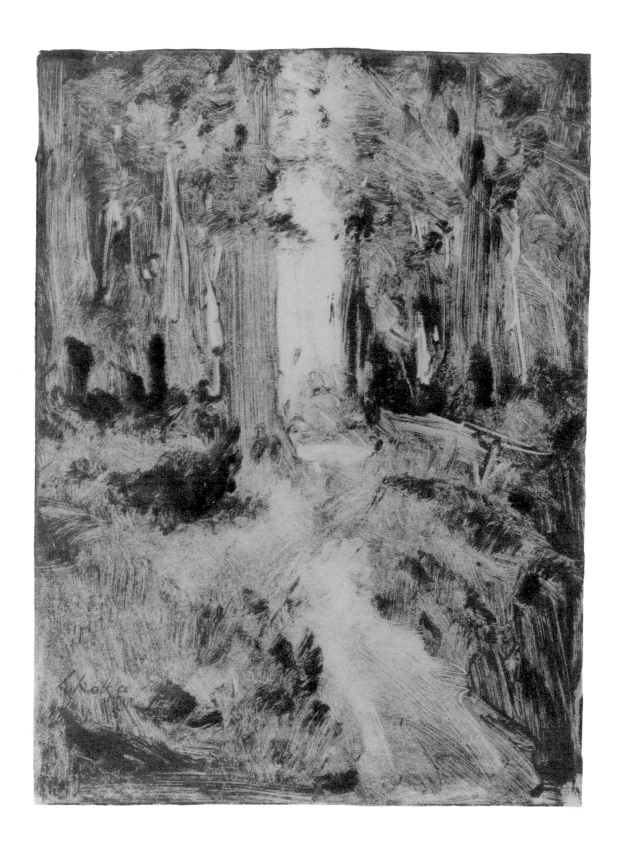

William Merritt Chase
American, 1849-1916

50. Self-Portrait, about 1911

Monotype in black ink
Image, 7¾ x 5⅞ inches (19.7 x 14.9 cm.)
National Portrait Gallery, Smithsonian
Institution, Washington, D.C., NPG.69.26

Chase enjoyed using the monotype process and probably made a considerable number, of which only a small portion survives. Of these, the most interesting series is the self-portraits. In them Chase is wearing a tailored black coat, a pince-nez, and a carefully trimmed beard. He is most often bareheaded, but in one he carefully cocked a top hat on his head. In all these monotypes Chase faced the viewer straight-on and frequently with an amused stare. As a well-established and highly successful artist, he acknowledged his awareness of his stature with this forthright stare. Part of this amusement is expressed in the very painterly and somewhat playful manner in which he brushed the excess ink from the plate. Like Corwin in his monotype portrait of Whistler (cat. no. 47), Chase concentrated his efforts in the likeness. The details of costume and background in both these prints meld into a swirl of fluid brushwork, especially in the lower portions of the plates.

D.W.K.

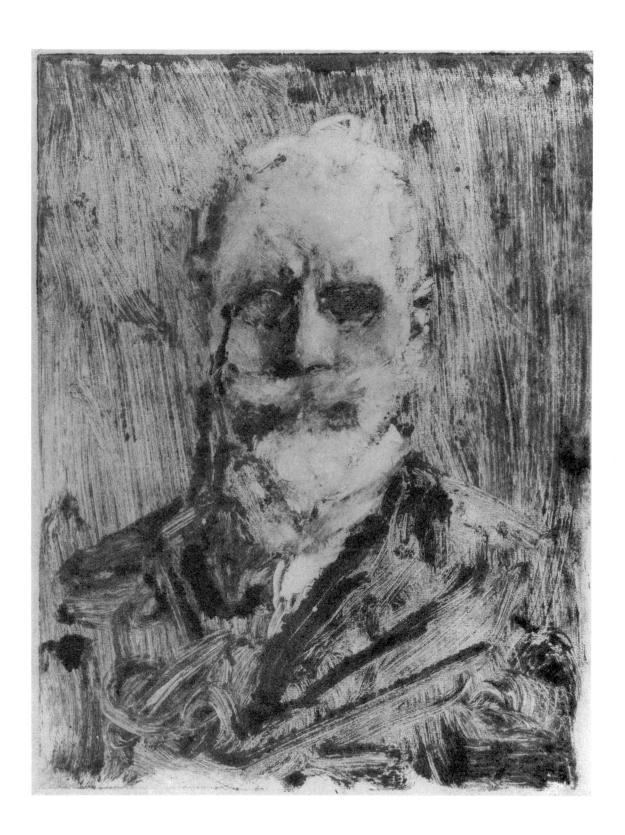

Charles Alvah Walker

American, 1848-1920

51. Trees, 1881

Monotype in black ink
Image, 12½ x 16¾ inches (31.8 x 42.6 cm.)
Signed and dated on plate, lower left
Museum of Fine Arts, Boston
Bequest of Frank C. Doble, 1973.543

Charles A. Walker, one of the early enthusiasts of the monotype process in America, seemingly developed it for himself, without influence from either William Merritt Chase or a member of the Duveneck circle. While it is not clear where he learned the process, by 1881 he had an exhibition of monotypes in Boston and another in December of that year at Knoedler & Co. in New York.[1] Earlier in 1881, Walker had extended an invitation to Sylvester R. Koehler to see his new invention – the monotype.[2] Even though examples had already been exhibited in New York by Chase and others, Walker's enthusiasm for his new discovery was not diminished. He soon devoted his artistic endeavors to the process and abandoned his work in oils. The 1881 exhibitions were followed by others which most likely had great import on the many landscape artists of the late nineteenth century who were not working in the more avant-garde styles.

As Walker became increasingly partial to the monotype, he did not change his choice of subject matter. Landscapes of all kinds, moonlight studies, and marines dominated his paintings as well as his monotypes, a choice of subject matter much influenced by the Barbizon school. While he sometimes used colored inks, many of Walker's monotypes show his mastery of the myriad variations of black and white so easily achieved with this process. He also favored a dark-field, manner as in *Trees*. Here, his painterly use of wiping and brushwork has brought from the inked plate a forest scene of interlaced foliage rich in shadows and sunlight. These effects are not solely the result of the monotype process. Walker was a watercolorist and so was familiar with the contemporary watercolorist practice to selectively scrape the painted surface, revealing the paper. To lighten some of the more densely inked areas, to heighten the dappling effect of leaves, and to add texture to the tree trunks, Walker scratched the printed surface of this monotype with the edge of a knife.[3] In conjunction with his manipulation of the inked plate, the latter practice adds to the bravura quality frequently lacking in the smooth detail of his later monotypes.

D.W.K.

1. "Art Notes. The Monotypes . . . ," *Art Journal*, vol. 43, no. 13 (December 1881), p. 379.
2. Sylvester R. Koehler, "Das Monotype," *Chronik für vervielfältigende Kunst*, vol. 4, no. 3 (1891), p. 3.
3. Letter from Sue Welsh Reed, November 27, 1979, reporting the findings of examination in the conservation laboratory at the Museum of Fine Arts, Boston.

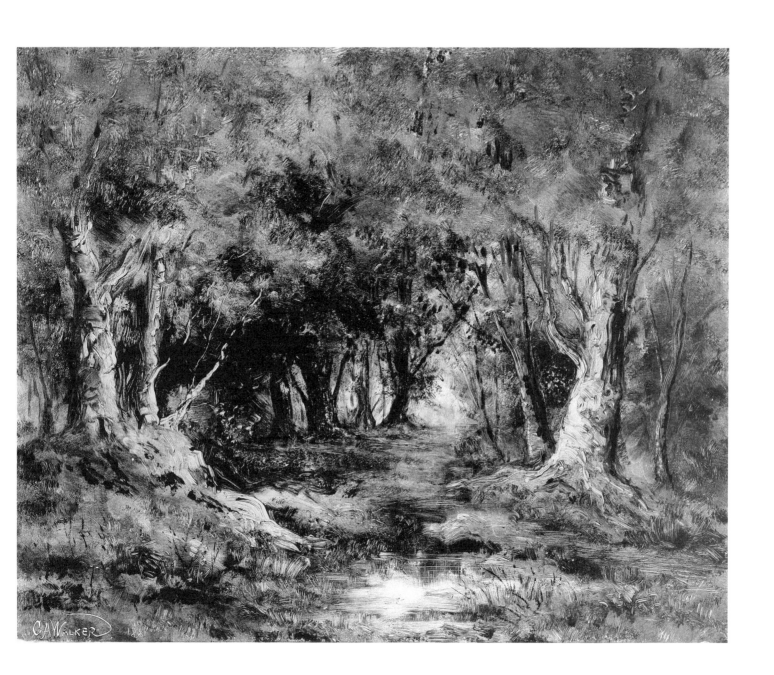

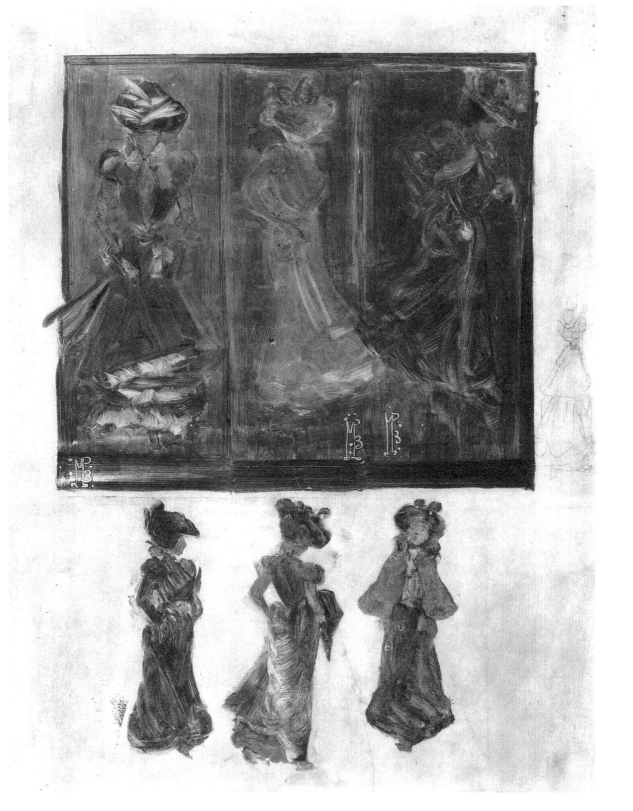

Maurice Brazil Prendergast
American, 1859-1924

53. Street Scene, about 1891-94
Monotype in oil colors
Image, 8⁹/₁₆ x 12⅜ inches (21.8 x 31.4 cm.)
Signed on the plate, at center in window lintel
Collection of Mr. and Mrs. David Tunick,
New York

54. Street Scene, Boston, about 1891-94
Monotype in oil colors
Image, 9 x 12³/₁₆ inches (22.9 x 31 cm.)
Private collection

Prendergast is known to have made multiple printings of his mono-types, and it has been suggested that many of the surviving examples are really second pulls. Usually, where two pulls exist, the later pull has additional work after the printing, but this is not the situation with this pair of Whistlerian street scenes.[1] Instead of strengthening the image after printing, Prendergast reworked the inking before printing. The composition of these street scenes is essentially the same; it is the ultimate effect that was changed. In the earlier pull (cat. no. 53), the patterning of color was carefully created with the brush; Prendergast applied his watercolor technique to the monotype process. The speed necessary to complete this complex image for printing was not betrayed with careless brushwork. For the later pull (cat. no. 54), the artist virtually reworked the entire surface, though without making major changes in the composition. Not only did he smooth out the remaining

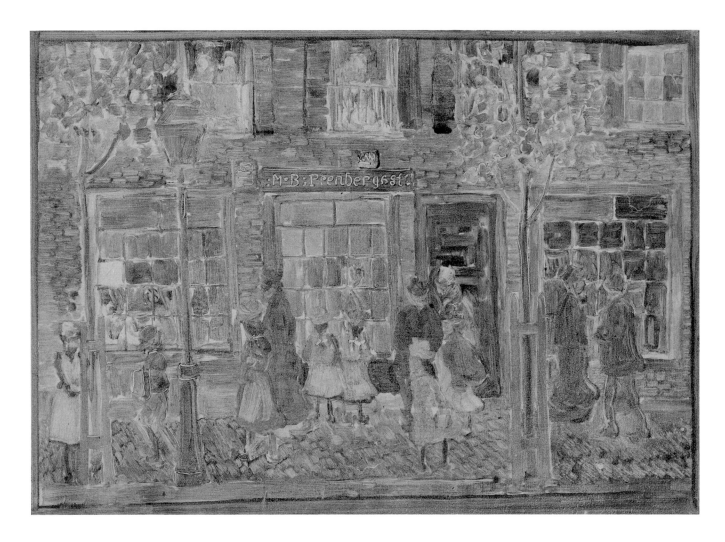

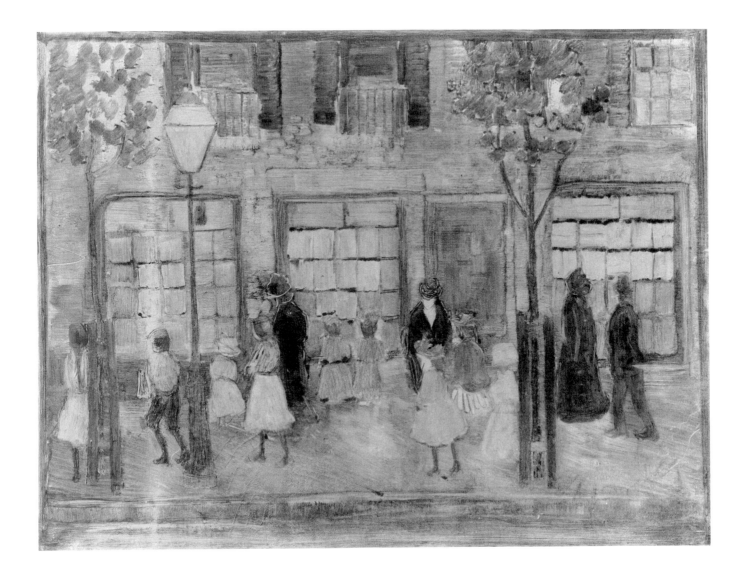

ink of the brick and the sidewalk and make the shop windows more prominent as bold blocks of color, but now the essential shapes of the figures take precedence over the details of costume and silhouettes in motion. The simplified shapes and the details of the composition make this image look more like a monotype than a watercolor.

<div align="right">D.W.K.</div>

1. The counterplay of the trees, lamppost, and even the figures against the horizontal frontality of the façade indicates the influence of Whistler (see Cecily Langdale, *The Monotypes of Maurice Prendergast* [New York: Davis & Long Co., 1979], p. 10. Another artist whose work Prendergast may have known in Paris was Bonnard. Bonnard's work also shows the influence of Whistler, especially in the color lithographs in the series *Quelques aspects de la vie de Paris* of 1895 or 1899 (Claude Roger-Marx, *Bonnard Lithographe* [Monte Carlo: André Sauret, 1952], nos. 56-68 and especially no. 61, *Boulevard*).

Maurice Brazil Prendergast
American, 1859-1924

55. Bastille Day (Le Quatorze Juillet), 1892

Monotype in oil colors
Image, 6⅞ x 5⅛ inches (17.5 x 13 cm.)
Title in French, date, and monogram at bottom of plate
The Cleveland Museum of Art
Gift of the Print Club of Cleveland, 1954 (54.337)

Prendergast's interpretations of perspective are more closely related to his contemporaries in Paris than to his American peers. One of the major influences for French artists of the late nineteenth century was the Japanese print in which a traditional use of vertical recession was often expressed in composition as pattern. In *Bastille Day,* Prendergast lowered the horizon line to the center, so that the visual recession speeds behind the promenading foreground groups. He did not, however, lose his sense of surface pattern. To emphasize the recession, the orange lanterns grow more numerous and smaller toward the center, but these same lanterns create a pattern across the surface of the print with their orange in counterpoint to the rich, dark blue that dominates the monotype. With an economy of brush and stump work, Prendergast has clearly evoked the crowds milling about on the boulevards of Paris. If indeed Prendergast began to make monotypes in 1891, this dated example displays a quick and rapid assimilation of the medium into his total artistic output.

D.W.K.

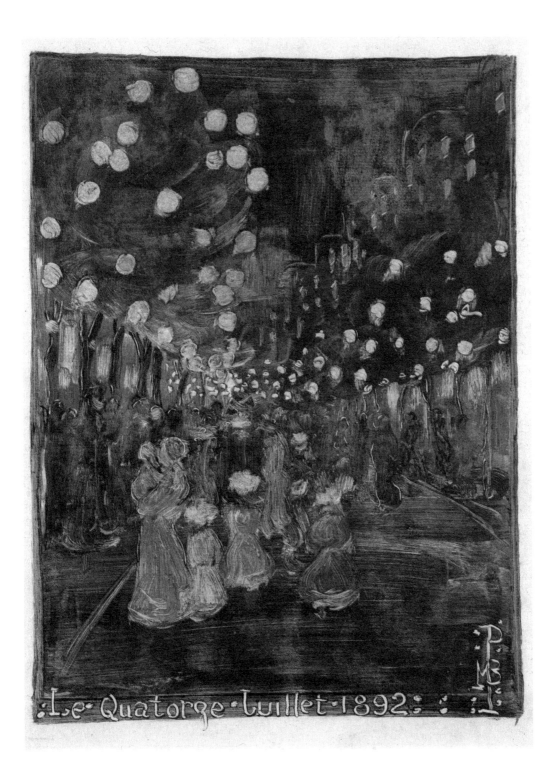

·Le·Quatorze·Juillet·1892·

Maurice Brazil Prendergast
American, 1859-1924

56. Fiesta, Venice, about 1898-99
Monotype in oil colors
Image, 10⅛ x 7⅞ inches (25.7 x 20 cm.);
paper, 15½ x 11¹/₁₆ inches (39.4 x 28.1 cm.)
Monogram on plate, lower right corner
Private collection

Perspective and an interest in pattern are as active a part of *Fiesta, Venice* as they are of *Bastille Day* (cat. no. 55). The cascading sky rockets and the explosion of other fireworks illuminate the umbrellaed flock of viewers crowding the shore. Illumination by falling fireworks was not a new idea, as Whistler had used it often in his nocturnes; but in combination with a Japanese verticality of perspective and a personal interpretation of subject, Prendergast created his own unique image. His careful modulation of the surface ink with both brush and stump end creates a pulsatingly rich surface – the varied texture of the crowds watching the festive explosions – which is reinforced by the verticality of the perspective. *Fiesta, Venice* seems an evening counterpart to the monotypes of girls frolicking in green meadows and lawns, in a composition pushed almost to abstraction.

D.W.K.

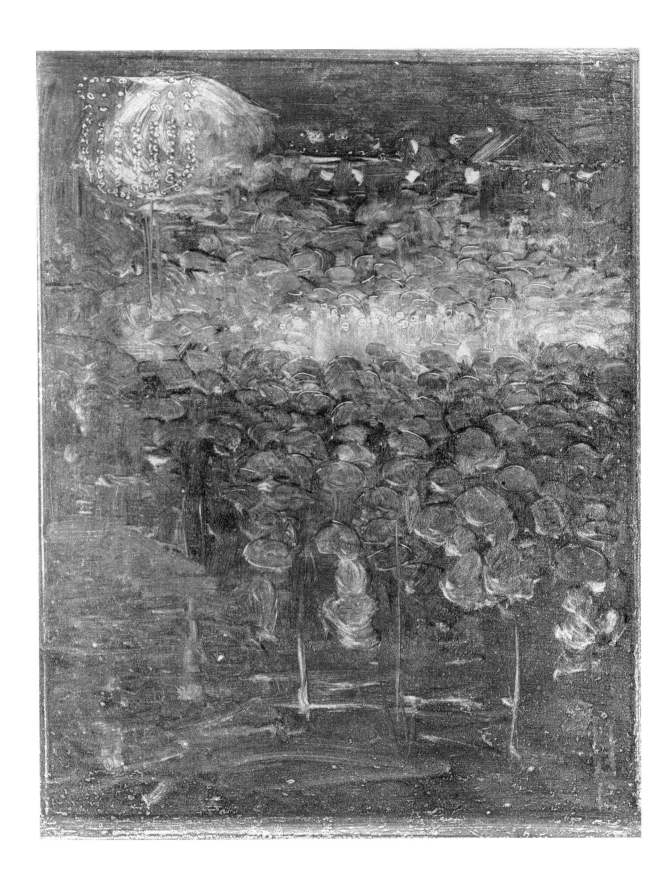

Maurice Brazil Prendergast
American, 1859-1924

57. Nouveau Cirque, about 1895

Monotype in oil colors
Image, 13⅞ x 13¾ inches (35.2 x 34.9 cm.)
Title and signature at bottom of plate
Collection of Mrs. Charles Prendergast,
Westport, Connecticut

Nouveau Cirque, Prendergast's largest known monotype, retains not only its rich, fresh color but also the original frame made by his brother, Charles. One of a small group of circus subject monotypes probably influenced by his visits to the Nouveau Cirque in Paris, it is also one of the few images not dominated by fashionably dressed women and young girls. Women are an important element of this print, nonetheless: the carefully poised acrobat balanced on her horse is about to begin her next feat. Like the six ladies isolated on their plate (cat. no. 52), movement is frozen, the rustle is catching up, and the next step is clearly implied. Others of these circus monotypes are clearer in their presentation of movement, with freer brushwork and looser wiping. Here, the large size of the plate may have called for greater control on Prendergast's part. There is a deliberate quality to his brushwork and wiping as he created this image, yet he never lost the freedom of handling that is a hallmark of his work. The play of strong horizontals of the fore and background white horses with the carefully poised acrobats and clowns and the vertical accents of the flag-draped high-wire supports introduces a strong, abstract quality to this otherwise realistic scene. Abstraction is further emphasized in the placement of the green ball to balance the main horse and by the contrasting outfits of the two clowns on the right. Prendergast created a strong image vibrant with his rich sense of color and the vitality of his brushwork.

D.W.K.

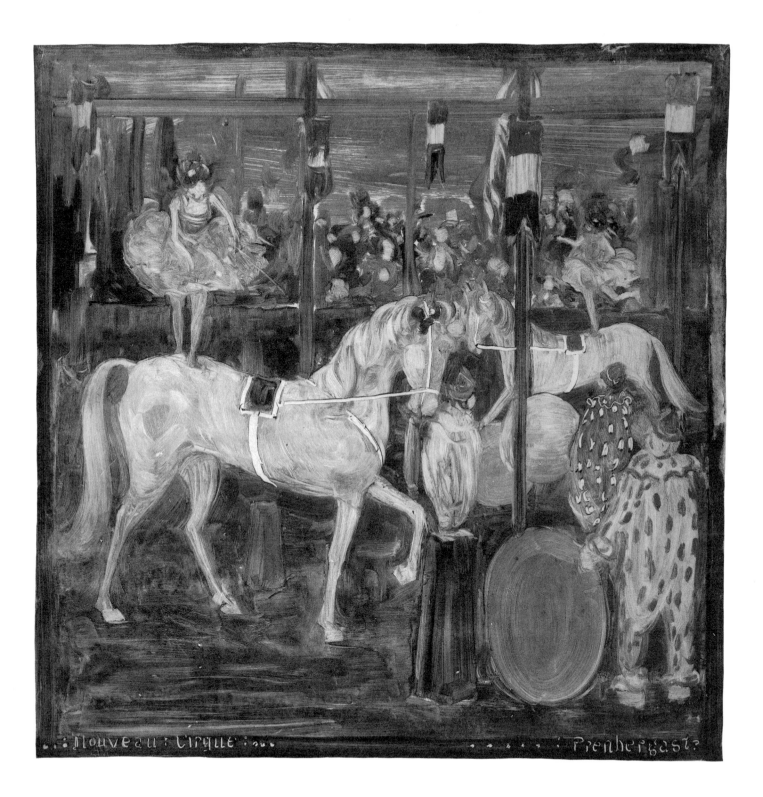

Maurice Brazil Prendergast
American, 1859-1924

58. Orange Market, about 1898-99

Monotype in oil colors
Image, 12⁷/₁₆ x 9⅛ inches (31.6 x 23.2 cm.)
Monogram on plate, lower left corner
The Museum of Modern Art, New York
Gift of Abby Aldrich Rockefeller, 1945 (169.45)

O*range Market* is a powerful and rather unusual picture. It is one of Prendergast's best known monotypes, and he instilled greater dignity and formality in this utilitarian image than he did in his more intimate studies of elegant women. Under a canopy of overshadowing dark umbrellas, the vendors sit and sell oranges. Oranges cover the surface of the print, dominating the composition with their small dabs of color. The paper enhances the intensity of this color, and the dark umbrellas provide the perfect foil, adding to the rich quality of this image. Even though the composition can be read as a defined yet simple image, the well-balanced contrast of dark and light creates a strong sense of visual abstraction. This monotype underscores Prendergast's interest in an abstraction that does not forget or lose the texture and framework of representational images.

D.W.K.

166

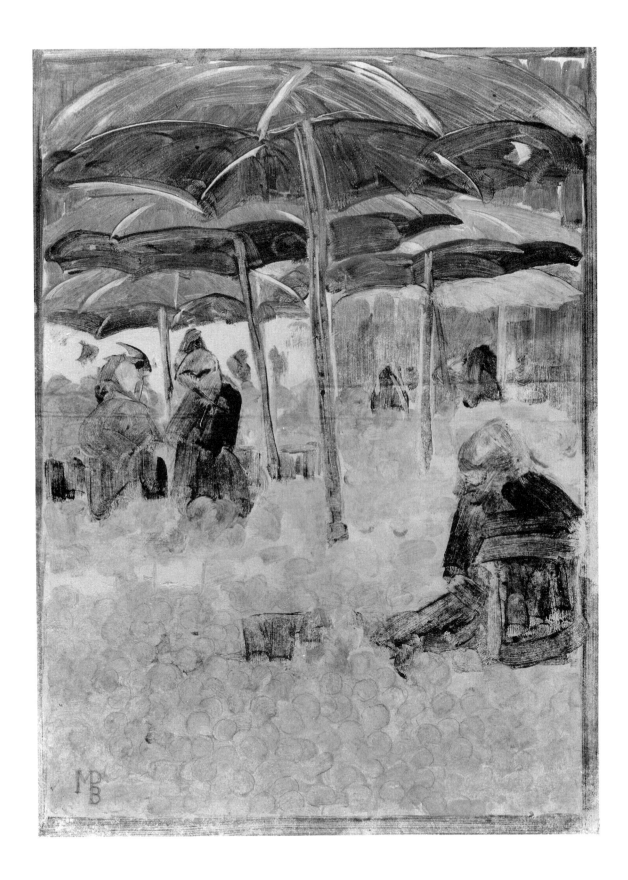

Arthur Bowen Davies

American, 1862-1928

59. Figure of a Young Girl in a Landscape, about 1895-1905

Monotype in colored inks
Image, about 5¼ x 9⅜ inches (13.2 x 23.5 cm.);
paper, 8⅝ x 10⅜ inches (22.2 x 26.3 cm.)
The Metropolitan Museum of Art, New York
Gift of A. W. Bahr, 1958 (58.21.5)

Arthur B. Davies most likely learned the monotype process from his friend and fellow artist Maurice B. Prendergast. Both were members of the group called The Eight. Prior to the famous group exhibition at the Macbeth Gallery in New York in 1908, these artists knew each other through natural gravitation to the avant-garde art circles of New York and through ties of study, either in Philadelphia or, as was probably the case with Davies and Prendergast, in Paris. By 1900, Prendergast had joined Davies as one of the artists exhibiting at Macbeth Gallery. Though none of Davies's four known monotypes is dated, on the basis of style and their relationship to his watercolors, pastels, and lithographs, their earliest date must be after 1895.[1]

In the monotype shown here, Prendergast's influence is strongly felt. Not only is the subject matter reminiscent of Prendergast's many monotypes of women and young girls in parks and other settings, so is the use of a palette with a limited color range. Davies, however, did not slavishly copy Prendergast's work; he exhibited a much greater freedom in his handling of the inks. Whereas Prendergast's images often have a flat surface quality with little acknowledgment to clear spatial recession, Davies effectively used color and variation in wiping and brushwork to add depth. The difference between the fore and middle grounds in the image was created by wiping off the brushed-on green-blue inks to create the foreground foliage. Again like Prendergast, Davies did not have a printing press and so used a spoon or another utensil to print his monotype images.

D.W.K.

1. There are two monotypes in the holdings of the Metropolitan Museum of Art, one at the Museum of Fine Arts, Boston, and one in the collection of a New York dealer. Davies was actively experimenting with both lithography and etching by 1890, but it is his lithographs of about 1895 that most closely approximate his work in monotype. See Frederic Newlin Price, *The Etchings and Lithographs of Arthur Bowen Davies* (New York, 1919) for illustrations of the following prints: no. 72. *Duck Pond,* no. 78. *The Monarch,* no. 137. *David,* and no. 154. *Play Days.*

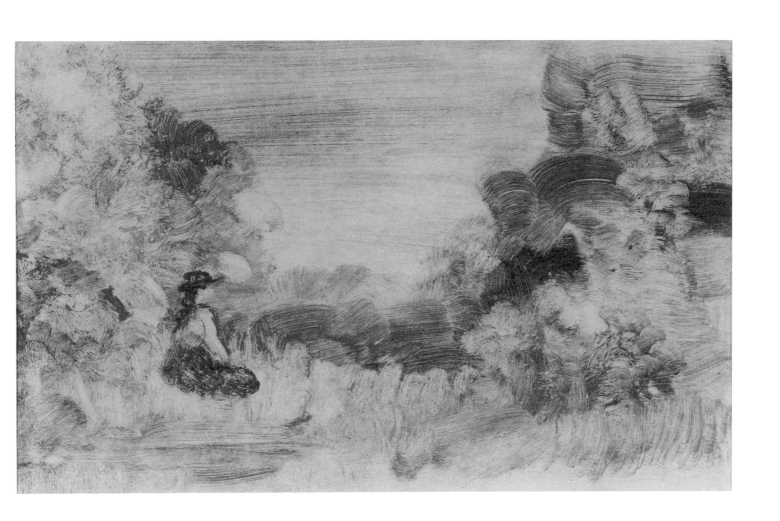

John Sloan

American, 1871-1951

60. Woman Brushing Her Hair,
about 1907

Monotype printed in purple ink
Image, 5⅞ x 4¼ inches (14.9 x 10.8 cm.)
Signed in pencil, lower right margin
Museum of Fine Arts, Boston
Mary L. Smith Fund, 1962 (62.1172)

PROVENANCE:
Estate of the artist.

61. Bathers,[1] about 1910

Monotype in purple ink
Image, 8¹⁵/₁₆ x 7⅜ inches (22.7 x 18.3 cm.)
Signed in pencil, lower right margin
National Collection of Fine Arts, Smithsonian
Institution, Washington, D.C.
Museum Purchase in Memory of Allen Tucker,
1976.23

PROVENANCE:
Estate of the artist.

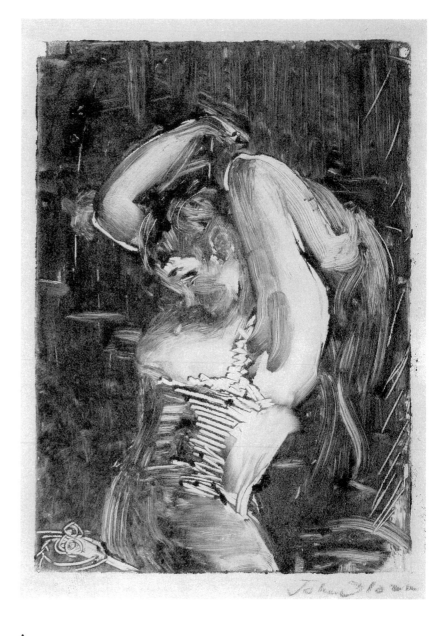

A majority of the monotypes by John Sloan have lightly clothed or nude women as their subject matter. During his early years in New York, Sloan's figure paintings were often from the model, in contrast to his genre pictures which were from memory, as was also the case with his many prints of the period; only the late print series of nudes was from life. It can be reasonably assumed that, as they were the products of relaxation, the monotypes of nudes are not from life but from memory. The subject matter of the small-size plates, such as *Woman Brushing Her Hair*, has the same degree of intimacy as Degas's brothel scenes. The larger plates are less intimate scenes of nymphs and bathers. Size may

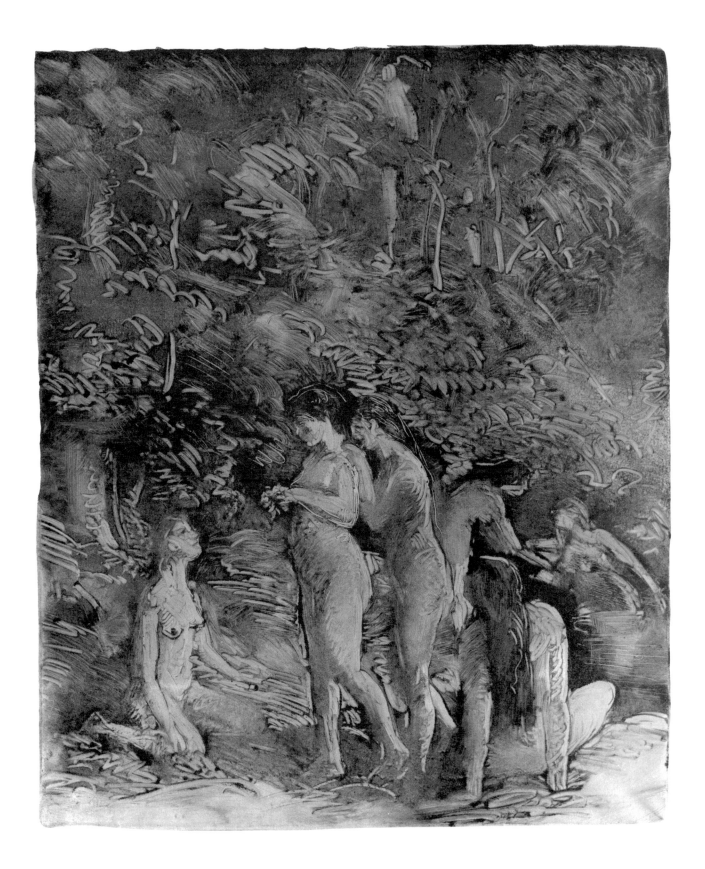

have something to do with when the prints were made: the smaller plates were most likely the product of one of the numerous evenings spent sketching with Henri and other cronies,[2] while the larger plates have the formality of planned work. Indeed, these larger plates were exhibited at Gertrude Vanderbilt Whitney's Studio in 1916 and later that year at the Hudson Guild.[3]

Sloan used the dark-field method for making his monotypes; bringing the image out from the surface coating of black, red, or purple ink by careful manipulation of the brush, rag, and stump end of the brush. In the smaller monotypes, Sloan made greater use of the brush and rag so that the wiping has a more conventional painterly quality. With the larger monotypes, especially *Bathers*, Sloan achieved a surface reminiscent of the dark-field work of Castiglione. If Castiglione's work had any influence on Sloan's large monotypes, it was only available to him through illustrations published in art periodicals. In *Bathers*, the bold use of the brush stump sparkles across the surface like a strong, yet flickering light picking out the details in a darkened space.

D.W.K.

1. This title is a bit confusing. Of the large monotypes exhibited by Sloan in 1916, one of two titles may represent this example: *Bathers* and *Nymphs*. A large monotype in the Sloan estate depicting a bevy of naked women frolicking on a moonlit beach may more likely be *Bathers*. If that is the case, the image shown here of women bathing and conversing may then represent the more classical subject of *Nymphs*.
2. Bruce St. John, ed., *John Sloan's New York Scene* (New York: Harper & Row, 1965), p. 120 (April 7, 1907).
3. The two exhibitions in which Sloan exhibited monotypes are *Exhibition of Paintings, Etchings and Drawings by John Sloan* at New York: Mrs. H. P. Whitney's Studio, 8 West Eighth Street, New York, January 20 – February 6, 1916; and *Exhibition of Paintings, Etchings and Drawings by John Sloan*, Hudson Guild Social Center, 436 West Twenty-seventh Street, New York, February 10 – April 10, 1916.

John Sloan
American, 1871-1951

62. The Theatre, 1909

Monotype printed in black and green ink
Image, 7½ x 9 inches (19.1 x 22.8 cm.)
Signed and dated in pencil, lower right margin
The Cleveland Museum of Art
Gift of Mr. and Mrs. Ralph L. Wilson in memory of
Anna Elizabeth Wilson, 1961 (61.162)

John Sloan rarely turned to the theater for subject matter as he was more interested in life in the world around him than in life experienced through another's interpretation. However, both he and Dolly enjoyed going to the theater and the music halls. The well-dressed people in the orchestra of this monotype probably mirror his first experience with opera. While Dolly was in Philadelphia for medical treatment in February 1909, Sloan bought a ticket to see *Tannhäuser* at the Metropolitan Opera House, and a few days later he saw Mary Garden in *Louise* at Hammersmith's Manhattan Opera House. Both experiences with what he called "Grand Opera fever" elicited favorable comments in his diary.[1]

In *The Theatre*, Sloan exploited the inherent luminosity of the monotype to record the darkened theater interior during a performance. The highlighting effect of reflected stage lighting across the interior is

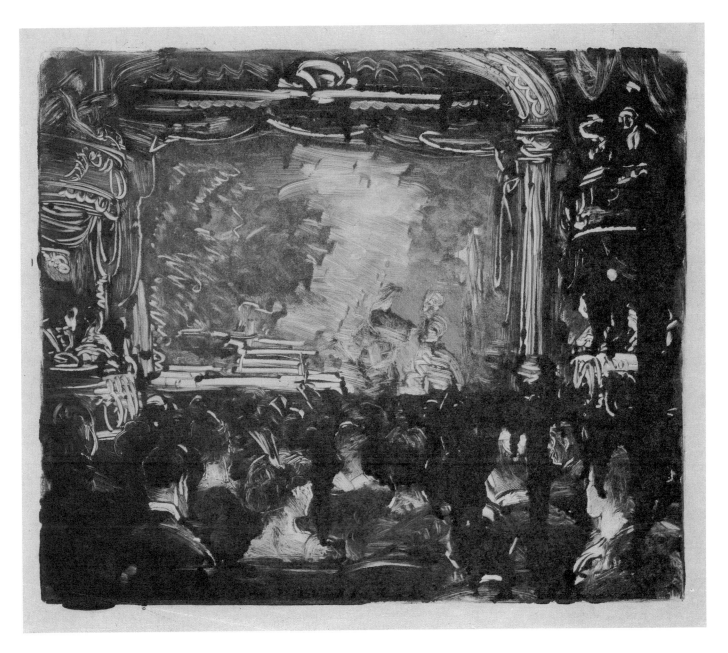

captured by his careful use of wiping and thumbwork in conjunction with the use of the brush stump. But the most startling aspect of this monotype is Sloan's use of green ink to delineate the brilliantly lit stage. Several drips of ink have run down the right side of the image. Evidence of changes in the top right box indicates a reworking just prior to the printing, and the resulting drips are most likely a printing accident.

D.W.K.

1. Bruce St. John, ed., *John Sloan's New York Scene* (New York: Harper & Row, 1965), pp. 291 (February 18, 1909) and 293 (February 24, 1909).

John Sloan

American, 1871-1951

63. Isadora in Revolt, 1915

Monotype printed in purple and red ink
Image, 9 x 7½ inches (22.9 x 19.1 cm.)
Signed in pencil, lower right margin
Collection of Mr. and Mrs. Andrew King Grugan,
Williamsport, Pennsylvania

EXHIBITIONS:
This monotype may have been shown under the
title *Isadora* in the following exhibitions: Mrs. H.
P. Whitney's Studio, New York, January 26 –
February 6, 1916, (cat: *Exhibition of Paintings,
Etchings, and Drawings by John Sloan*, no. 43).
Hudson Guild, New York, February 10 – April 10,
1916 (cat: *Exhibitions of Paintings, Etchings, and
Drawings by John Sloan*, no. 122).

When talking about drawing in 1939, Sloan deplored the tendency of many artists to create a mass of well-developed details. Instead, he insisted that the artist should go after the theme, the big rhythms, and not the embellishments, "just as Isadora Duncan, when she danced, followed the big movements and paid little attention to the lesser ornamentation of the music."[1] Sloan followed his own precepts in this monotype of 1915. The essential earthiness and animal vitality of Isadora's abundant body in movement, defying the conventional terpsichorean modes of the day, is emphasized by the bold brushing of her limbs and the tonal conflicts of the purple and red inks. In 1915, Sloan also made an etching of Isadora in a related dance movement which lacks the defiance and fluid vitality of the monotype.[2] The carefully etched lines, creating a more gentle record of her movements, could never capture the monotype's aura of revolt.

John and Dolly Sloan first met Isadora Duncan at a reception given in her honor by Mrs. W. Carman Roberts on November 14, 1909.[3] Two days later, Mrs. Roberts sent them tickets for Isadora's evening performance. In his diary, Sloan expressed his fascination with Isadora and her dancing for the first time:

> ...we saw Isadora dance. It's positively splendid! I feel that she dances a symbol of human animal happiness as it should be, free from the unnatural trammels. Not angelic, materialistic – not superhuman but the greatest human love of life. Her great big thighs, her small head, her full solid loins, belly – clean, all clean – she dances away civilization's tainted brain vapors, wholly human and holy – part of God...[4]

To Sloan, she represented "*all* womanhood"[5] and, even more important, an artist whose objective was the cultivation of human expression[6]– a purpose not dissimilar to Sloan's.

1. John Sloan, with the assistance of Helen Farr, *Gist of Art* (New York: American Artists' Group, 1939), p. 75.
2. John Morse, *John Sloan's Prints: A Catalogue Raisonné of the Etchings, Lithographs, and Posters* (New Haven: Yale University Press, 1969), no. 172, pp. 195-99.
3. Bruce St. John, ed., *John Sloan's New York Scene* (New York: Harper & Row, 1965), p. 351 (November 14, 1908). Mrs. Roberts was the editor of a number of magazines, including *The Craftsman, Arts and Decoration,* and *The Touchstone.* She was one of the early people to publish articles on the work of John Sloan and other members of The Eight.
4. Ibid., p. 352 (November 16, 1908).
5. Ibid., p. 507 (February 15, 1911).
6. Ibid., p. 522 (March 31, 1911).

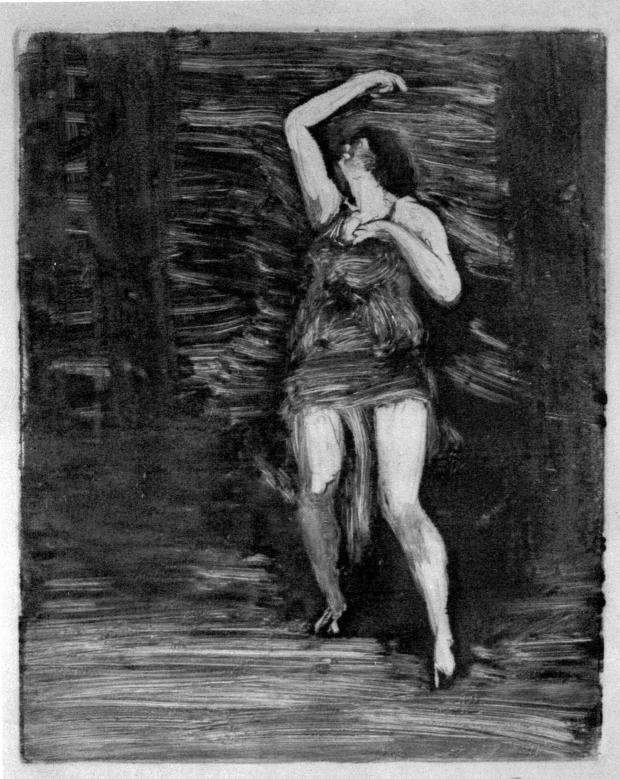

John Sloan

Robert Henri

American, 1865-1929

64. Couple in a Streetcar, about 1907

Monotype in black ink
Paper, 8½ x 11 inches (21.6 x 27.9 cm.)
Initials in pencil, lower right; name in parenthesis
in pencil, lower right (both in John Sloan's hand)
Delaware Art Museum, Wilmington
Gift of Helen Farr Sloan

PROVENANCE:
John Sloan.

65. Satyr and Nymph, 1907 (?)

Monotype in black ink
Paper, 8¾ x 11 inches (22.2 x 27.9 cm.)
Initials in pencil, lower right; name in parenthesis
in pencil, lower right (both in John Sloan's hand)
Delaware Art Museum, Wilmington
Gift of Helen Farr Sloan

PROVENANCE:
John Sloan.

From John Sloan's diary for 1907, we know that Robert Henri made monotypes. While Sloan recorded only one such evening,[1] the conviviality of his circle of artist friends and the availability of an etching press means there were probably more. Souvenirs of Henri's participation in these evenings have survived in the John Sloan estate – *Couple in a Streetcar* and *Satyr and Nymph.* The former is a characteristic subject for this circle of friends who observed and recorded the urban world around them. The latter clearly expresses their joy of life, perhaps in this case under the sometimes erotic hilarity of George Luks or Ira Glackens.

Both plates were totally inked and then the image created by wiping. In *Couple in a Streetcar,* Henri's rapid and almost shorthand-like wiping at times blurred the image; this is especially true in the gentleman's left arm which is barely distinguishable from the seat or in his top hat. The shadowy figure at the left and the odd shadows throughout were thinly applied before printing. The quick and rapid wiping of the evenly inked plate breathed life and action into an image of eternal pursuit as characterized by *Satyr and Nymph.* The even gradation in tone, from light to

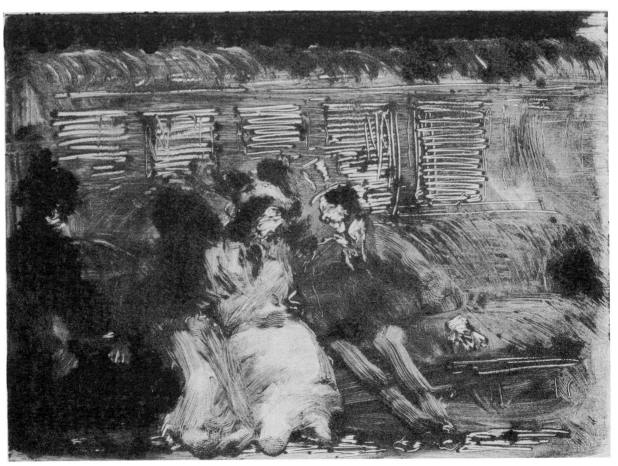

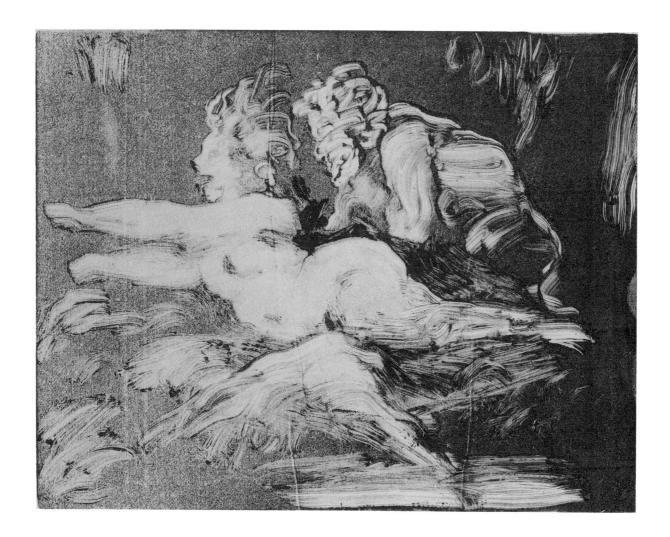

dark (left to right), was most likely the result of Henri's careful control of pressure during the printing process. He gave this inked surface an active role in the composition; the satyr emerges from the shadows of a copse from which the nymph has just escaped. Darker areas around the hair and body of the nymph are the result of excess ink from the wiping process.

D.W.K.

1. Bruce St. John, ed., *John Sloan's New York Scene* (New York: Harper & Row, 1965), p. 120 (April 7, 1907).

Robert Henri
American, 1865-1929

66. Street Scene (Paris), 1898 (?)

Monotype in brown ink
Image, 5¾ x 6¾ inches (14.6 x 17 cm.)
Initials on the plate, lower right corner
Museum of Fine Arts, Boston
Lee M. Friedman Fund, 1963 (63.445)

Henri made his first monotypes while in Paris in 1898.[1] *Street Scene (Paris)* is most likely one of the few monotypes to survive from this early experimentation with the process. The lighted kiosk and the strolling women under the arching trees all suggest a Parisian boulevard scene, one which Henri and his new bride could readily have experienced. The pictorial composition and the sense of atmosphere all suggest a knowledge of the work of Bonnard and Vuillard. Henri's familiarity with the work of the Nabis came most likely through his good friend James Morrice, who was in Paris throughout the 1890s. The sometimes awkward wiping and the dependency on the original inking of the plate, not on extensive reapplication of ink, suggest a recent introduction to the process. Henri did not have a press available and so he, like Prendergast, may have used a spoon or other implement to provide the necessary pressure to print the plate. Several darker streaks in the image may represent the overlapping of whatever implement was used. While his knowledge may have been new and his technique a bit awkward, he mastered the process to a degree of recognizing the pictorial and compositional advantages.

D.W.K.

1. Conversation with Bennard B. Perlman, August 31, 1979.

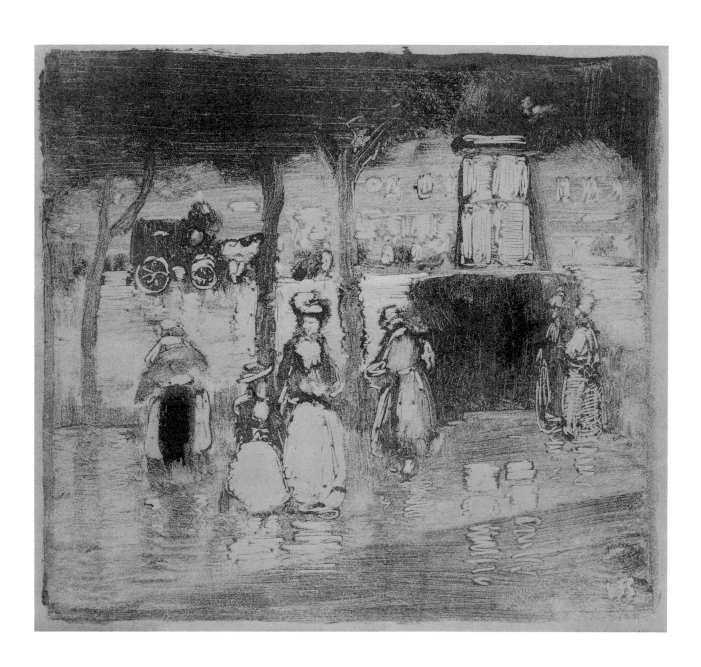

George Luks

American, 1867-1933

67. Cake Walk, about 1907

Monotype in black ink
Sheet, 8½ x 11 inches (21.6 x 27.9 cm.)
Signed in pencil, lower right margin; dated in pencil (John Sloan's hand), lower right margin
Delaware Art Museum, Wilmington
Gift of Helen Farr Sloan

PROVENANCE:
John Sloan.

It seems only natural that George Luks, a close friend of John Sloan, would have a try at making monotypes during some of the many evening get-togethers. *Cake Walk* joyously expresses his love for humanity and especially the humorous side of life. A Negro couple, high-stepping with arched backs, elegantly and gracefully go through a dance routine which by the first decade of this century had become one of the popular dance steps. For this monotype, Luks cleanly wiped the plate to leave a slight surface tone. On this surface, in a feat of placement, he brushed in the elegantly poised couple, frozen in movement, just as they are about to leave the picture frame. Further wiping and stickwork provided the accents of the man's snowy shirt front, the vigorous rustle of his partner's skirts, and the brilliant flashes of laughing teeth and eyes. Luks permeated this monotype with both humorous joy and movement.

D.W.K.

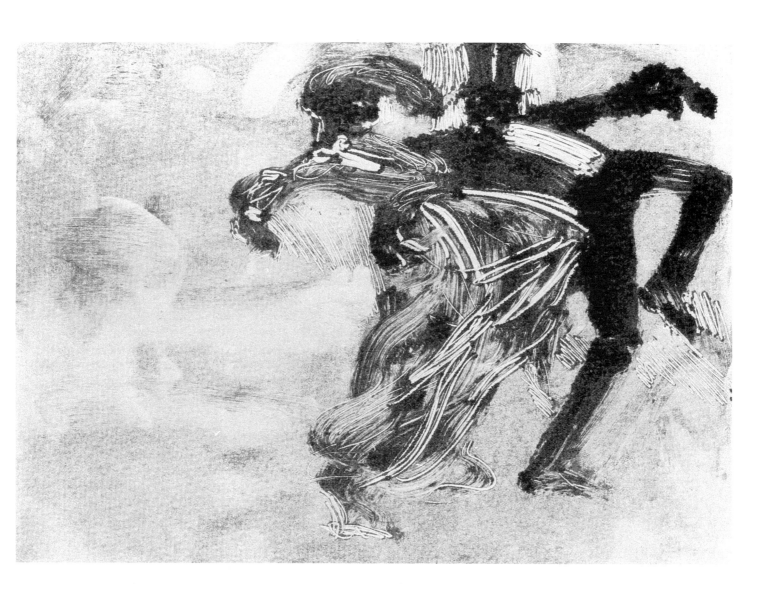

Paul Dougherty
American, 1877-1947

68. Antique Theme, Classical Figures in a Landscape, about 1919

Monotype in ink and oil colors on brown paper
Image, 8¼ x 13½ inches (21.1 x 34.2 cm.)
The Metropolitan Museum of Art, New York
Purchase, Anne Stern Gift, 1977.524.2

It took a bold artistic vision to conceive the enamellike quality of this monotype. The use of oil colors in combination with colored paper and printer's ink enhance its visual and tactile qualities. The oil colors bled into the brown paper during the printing process, giving the surface an unusual sheen rarely achieved just with printer's ink. A group of classical nymphs stands frozen, poised before an altar, in a jewellike atmosphere. The artist put them into the carefully wiped landscape with a minimum of descriptive brushwork. As each oil color created its own aureole in the printing, the surface of the print is not as flat as a monotype composed strictly with printer's inks.

Unsigned, this monotype was purchased with two other monotypes from the daughter of the painter, Paul Dougherty.[1] And so, by association, this seems a reasonable attribution.[2] There is no record of when Dougherty began to make monotypes, though the ascribed dates range over a decade – from about 1919[3] to after 1930.[4] He specialized in marine paintings and several of his marine monotypes have survived. His figural monotypes were mostly large-scale nudes, either single or in groups, on the shore or near rocky inlets. These figures fill the picture space with their boldly wiped, loosely anatomical bodies, and the wiping echoes the hard-edge quality of the brushwork in many of his paintings. In contrast, the monotype shown here not only displays a fluidity of handling but also an instinctive sense of harmonious color. The subject matter and the mood are more akin to the sensibilities of Arthur B. Davies, an artist to whom this work was once attributed. Most of Dougherty's monotypes were made while he was in New York City,[5] and so he must have been familiar with Davies's work in pastels on colored paper. Of the group of Dougherty's monotypes in a New England private collection, several examples are like *Classical Figures in a Landscape*, others relate to his marine paintings, and still others are in different styles.[6] Like New York artist Albert Sterner, Dougherty was adept at working in a variety of styles and modes, of adapting the work of his contemporaries to suit his own artistic needs of the moment.

D.W.K.

1. Conversation with James A. Bergquist and Alan N. Stone at the 1976-77 exhibition of American monotypes at Stone's gallery in Northampton, Massachusetts.
2. *American Monotypes of the Early Twentieth Century* (Northampton, Mass.: Alan N. Stone Works of Art, December 6, 1976 – January 8, 1977), no. 7.
3. Frank Jewett Mather, "Paul Dougherty's Monotypes," *Vanity Fair*, vol. 12, no. 5 (July 1919), p. 44.
4. *Paul Dougherty: Paintings, Watercolors, Monotypes* (Portland, Me.: Portland Museum of Art, March 16 – April 9, 1978), nos. 42-46, 50.
5. Conversation with James A. Bergquist, October 18, 1979.
6. Ibid.

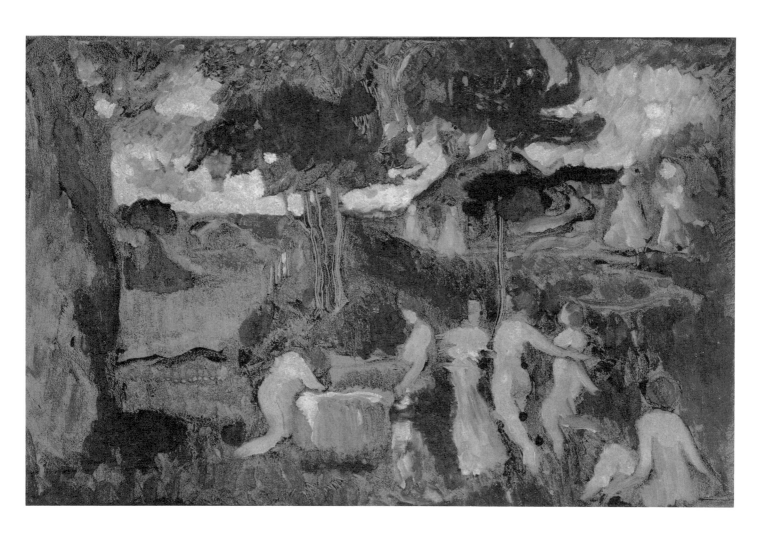

Abraham Walkowitz

American, 1878-1965

69. Three Nude Men Asleep, 1909

Monotype in brown ink
Image, 8⅞ x 12 inches (22.5 x 30.5 cm.);
paper, 9⁷/₁₆ x 12⅜ inches (24 x 31.4 cm.)
Signed and dated in pencil, lower right
The Metropolitan Museum of Art, New York
Gift of Abraham Walkowitz, 1940 (40.26.4)

Of the American artists using the monotype process in the early twentieth century, Abraham Walkowitz was one of the few to maintain a definite orientation to European modernism. He used his experience in France in the first decade of this century as a framework for his own free spirit, and while he was making monotypes he owed his greatest artistic debt to Cézanne. Walkowitz was concerned with the representation of objects and the density of those objects in space. In his early monotypes, of which *Three Nude Men Asleep* is an excellent example, the figures have a weighty density which creates a sculptural image. As Walkowitz was interested in the mass of objects, he made no attempt to provide strict anatomical detail. The monotype process was perfect for his style — removing excess ink not only left a strong figural outline but also gave a sense of well-rounded mass to the figures, which fill the picture.[1] Walkowitz's monotypes of a few years later, usually of beach scenes, reflected his new interest in experimenting with color abstraction.

D.W.K.

1. The range of attitudes toward Walkowitz's figural style is illustrated in the following comments from the sampling of reviews of his 1912-13 exhibition at "291," reprinted in *Camera Work*, vol. 41 (January 1913), p. 26:

There are the usual men and women who occasionally are 15 heads high, with shoulders of enormous breadth, with eyes placed carelessly in any part of the face that happens to be handy, with expressions peculiar to contributors to the little gallery of the Photo-Secession, 291 Fifth Avenue. The dreariness of the humanity here presented is appalling; the ugliness is monumental; the proportions staggering!

Arthur Hoeber in the *N.Y. Globe*

When Walkowitz draws a figure or a group it is not necessarily a transcript of just what he has seen, but rather a study of the reaction in his own mind from having seen or experienced or thought.... Not representation, not the imitation of nature, is the aim of men like this, but rather the portrayal of their own souls.

Samuel Swift in the *N.Y. Sun*

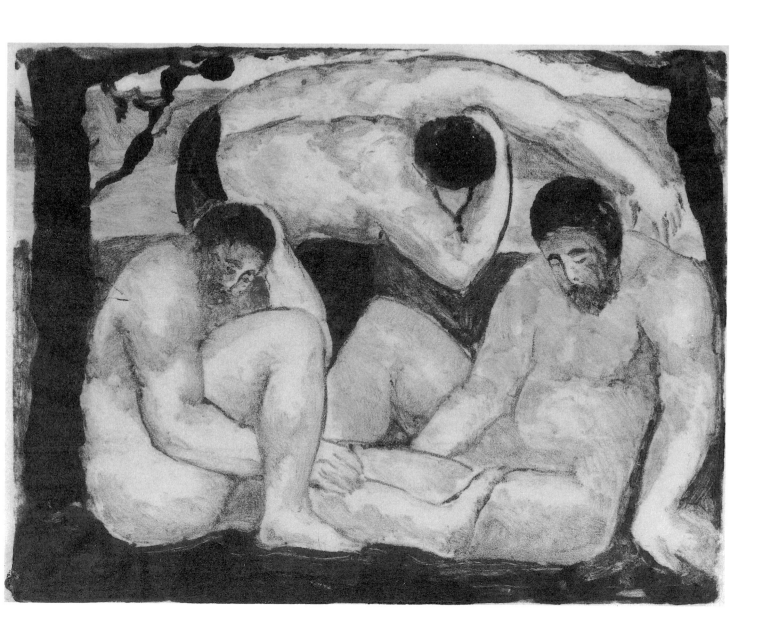

Eugene Higgins

American, 1874-1958

70. The Tired Hack, 1909

Monotype in black ink
Image, 4^{15}/16 x 5^{15}/16 inches (125 x 151 cm.);
mount, 15 x 11^5/16 inches (379 x 288 cm.)
No signature; mounted as the placard for
Higgins's exhibition at "291"
The Metropolitan Museum of Art, New York
The Alfred Stieglitz Collection, 1949 (49.55.292)

EXHIBITION:
New York, Photo-Secession Gallery, *Exhibition of Monotypes and Drawings by Mr. Eugene Higgins*, November 27 – December 17, 1909.

Eugene Higgins was not a part of what most art historians consider the mainstream of twentieth-century American art. Isolated by his highly personal choice of subject matter and technique, he most often portrayed a unified vision of the urban downtrodden in a twilit suffering world. While studying at the Ecole des Beaux-Arts and the Académie Julian, Higgins came under the spell of the peasant world of J. F. Millet and the lower classes of Honoré Daumier, two artists who sparked his own visions and theories of the world. His dark and skeptical view of the urban poor stands in direct contrast to the joyous celebration of the vitality and energy in the urban world of John Sloan, another devotee of the work of Daumier.[1] While finding Higgins an agreeable person, Sloan noted that, to his taste, Higgins's artistic style was vacant – a repetition of bowed figures lurching out of chunks of shadow or architectural fragments, and this all colored in a dingy "brownish gravy of art-rot."[2] Higgins's style was consistent in his use of broadly modeled figures, either emerging as a dark mass from shadow or silhouetted against a lighter middle ground. Anatomical detail was not an essential feature of his work – weight, mass, and volume were, though. These huddled and forlorn figures were much admired by most critics of Higgins's work, who eloquently praised the spiritual universality of his themes.

The monotype process was readily adaptable to suit Higgins's painterly needs. By carefully wiping the inked plate, he achieved the overpowering shadows from which his figures emerge, as well as the dimly lit middle ground to silhouette their masses. In the monotypes, the shadowy areas are infused with a new and partially hidden life, as the paper provides a luminosity that layers of paint cannot achieve. Even the well-lit background building in *The Tired Hack,* created in the wiping process, provides an extra weight that continually presses down on the weary driver and his equally weary nag. Additional details and strengthenings were added with a brush. Higgins's painterly use of the monotype process echoed his work in oil and probably developed from his etched plates. His work in no matter what medium has a unified appearance and vision.

In late November of 1909, Higgins had an exhibition of drawings and monotypes at Alfred Stieglitz's Little Galleries of the Photo-Secession (known as "291"). In the gallery catalogue no distinction was made between monotype and drawing. His evocative titles, as universal as his subjects, cannot be attached definitively to the existing images. *The Tired Hack* is the only monotype that is certain to have been shown in that exhibition; it is mounted on a sheet which served as the exhibition placard. Even knowing this, it is impossible to match it with its given title. Stieglitz did not sponsor much contemporary American printmaking at his gallery. Some explanation for the decision to exhibit Higgins's

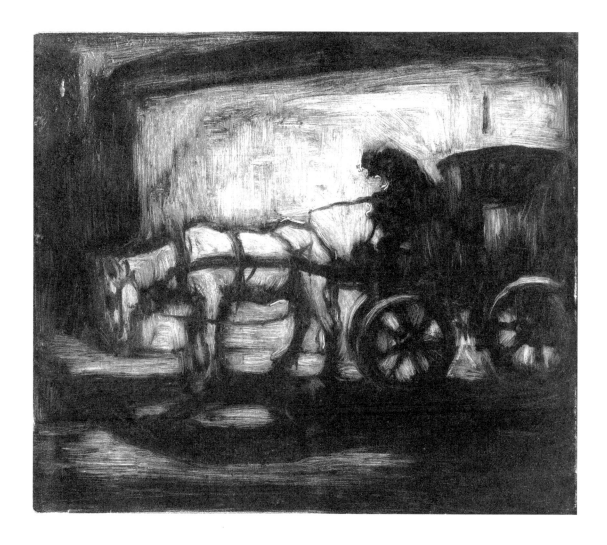

work can be found in the exhibition notes in the January 1910 issue of
Camera Work:

> "...his [Higgins's] composition being one of spotting, of the play of
> dark and light masses, and some of his monotypes have all the rich
> quality of a good platinum print."[3]

D.W.K.

1. John Sloan prized highly his own collection of Daumier lithographs.
2. Bruce St. John, ed., *John Sloan's New York Scene,* New York: Harper & Row, 1965, pp.
 317 (June 5, 1909) and 187 (January 21, 1908). This says much about Sloan's view of the
 wealthy Americans' interest in the large and often gloomy canvases of the French
 Barbizon school, a style outmoded and untruthful to his conception of the vitality of
 America.
3. "Photo-Secession Exhibitions," *Camera Work,* vol. 29 (January 1910), p. 51.

Albert Sterner
American, 1863-1946

71. Nude in a Landscape, 1911

Monotype in colored inks
Image, 19¹¹/₁₆ x 11¾ inches (50 x 29.8 cm.);
paper, 25¹¹/₁₆ x 17⁷/₁₆ inches (65.3 x 44.4 cm.)
Signed and dated in pencil, lower right margin;
location (*N.Y.*) in pencil, lower left margin
The Metropolitan Museum of Art, New York
Purchase, Anne Stern Gift, 1977.524.1

A nude woman brazenly confronts the viewer – is this an act of intrusion or departure? With Albert Sterner it is often hard to separate the two. His art was one of moods, rather than a career based on a particular and recognizable style. While he was most adept at changing media (whether painting, pen and ink, etching, lithography, or monotype) to suit a particular mood, he does not seem to have had a clear and well-defined style to his work. It would therefore be difficult to pinpoint his influence on the monotype, even though he made a number of them. Though Sterner's artistic output was championed in several articles,[1] his use of multiple styles haunted his work. He is not well known today by a public that should appreciate his artistic output.

In the boldy conceived monotype shown here, Sterner demonstrates a clear mastery of the medium to express in a very painterly style an enigmatic mood of confrontation. The body of the woman, brought out by the wiping, is sculpturally massed to balance the verticals of the poplar-filled landscape. His placement of the figure in this landscape suffused with dramatic light creates a mood of psychological drama. Sterner did other monotypes of large-scale nude figures which lack the heightened sense of drama in this example.

D.W.K.

1. Among the articles on Sterner's art, the following illustrates his monotypes: Christian Brinton, "Apropos of Albert Sterner," *International Studio*, vol. 52, no. 207 (May 1914), pp. lxxi-lxxviii. Other articles illustrated his work in other media which either have moods similar to his monotypes or a similar style: Frank E. Washburn Freund, "Albert Sterner's Work in Black and White," *Prints*, vol. 1, no. 3 (March 1931), pp. 1-12; and W. Lewis Fraser, "American Art and Foreign Influence," *The Quarterly Illustrator*, vol. 2, no. 5 (January, February, March 1894), pp. 2-9.

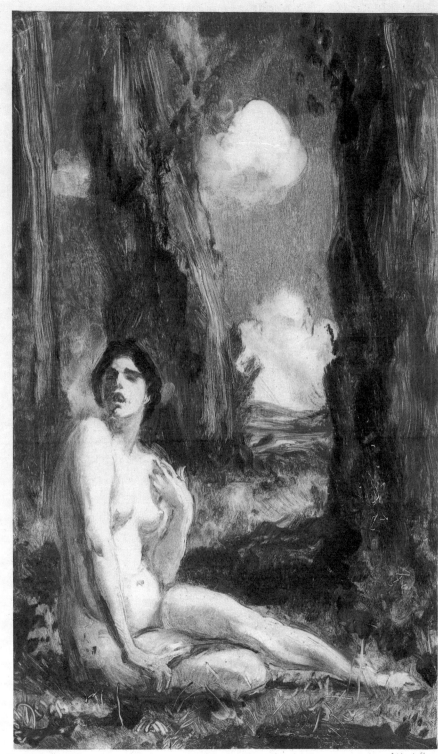

n.y. Albert Sterner
 1911

Modern Monotypes

Pablo Picasso

Spanish, 1881-1973

72. Head of a Woman, in Profile,
1905 or 1906

Monotype printed in rose and blue gouache
Plate, 11 x 8¼ inches (28 x 21 cm.);
paper, 11⅝ x 10⅜ inches (29.5 x 26.5 cm.)
Musée Picasso, Paris

REFERENCE:
Geiser, Bernhard. *Picasso, Peintre-Graveur: Vol. I. Catalogue Illustré de l'Oeuvre Gravé et Lithographié, 1899-1931.* Bern: Geiser, 1933, cat. no. 249.

No artist of this century has used the processes of art more creatively than Pablo Picasso, whose insatiable appetite for new materials and techniques called for an endless assortment of painting, sculpting, drawing, and printmaking techniques. As a printmaker Picasso practiced the traditional methods of engraving, etching, drypoint, woodcut, and lithography, adding to them the refinements of aquatint and sugar lift. He ventured quite independently, moreover, to try his hand at techniques like linoleum cut and monotype, which were seldom used by other artists. Not only did he handle these several processes authoritatively, but he lifted each one of them to expressive heights as only a painter-printmaker comparable to Rembrandt, Goya, and Degas might do.

Between 1905 and 1934 Picasso made over a hundred monotypes. (The cataloguer of his prints, Bernhard Geiser, lists 138 compositions.) These were produced simultaneously with the outbursts of printmaking activity that periodically mark the first half of Picasso's career, especially the intensive phase around 1933.

Because Degas was one of the first French masters Picasso studied when he went to Paris in 1900 and because after World War II Picasso purchased several of Degas's monotypes (eleven were recently donated to the Louvre Museum from Picasso's estate), it is tempting to conclude that it was Degas who inspired Picasso to make monotypes in the first place. But the evidence that Picasso made his first monotype in Barcelona in 1899 or 1900[1] and then used glass plates rather than the expected metal etching plates for his monotypes in 1905 suggests that he may have learned the technique from his first printmaking instructor, Ricardo Canals, or perhaps discovered it on his own.

The four monotypes Picasso printed in 1905 coincide with the production of some sixteen etchings and drypoints, thus comprising his first active period of printmaking. In the mood to experiment, Picasso also, in that year and in the year or so following, printed woodcuts that he colored by hand and drypoints that he cut in celluloid, then inked in red.

While Picasso's drypoints and etchings of this period are strictly linear and somewhat brittle, the monotypes are softly brushed in oil and sculpturally modeled. Like figures in Picasso's Rose Period paintings, this terracotta-hued *Head of a Woman* reflects the lyrical influences of classical Greek art. The profile is related to that of the statuesque maidservant who holds a mirror in his painting *The Toilette*, done in 1906 (Albright-Knox Art Gallery, Buffalo).

C.I.

1. Christian Zervos lists a *monotype en couleurs,* the figure of a toreador, probably scraped in oil paints, in his catalogue *Pablo Picasso* (Paris: Editions Cahiers d'Art, 1954), vol. 6, cat. no. 282 (ill.).

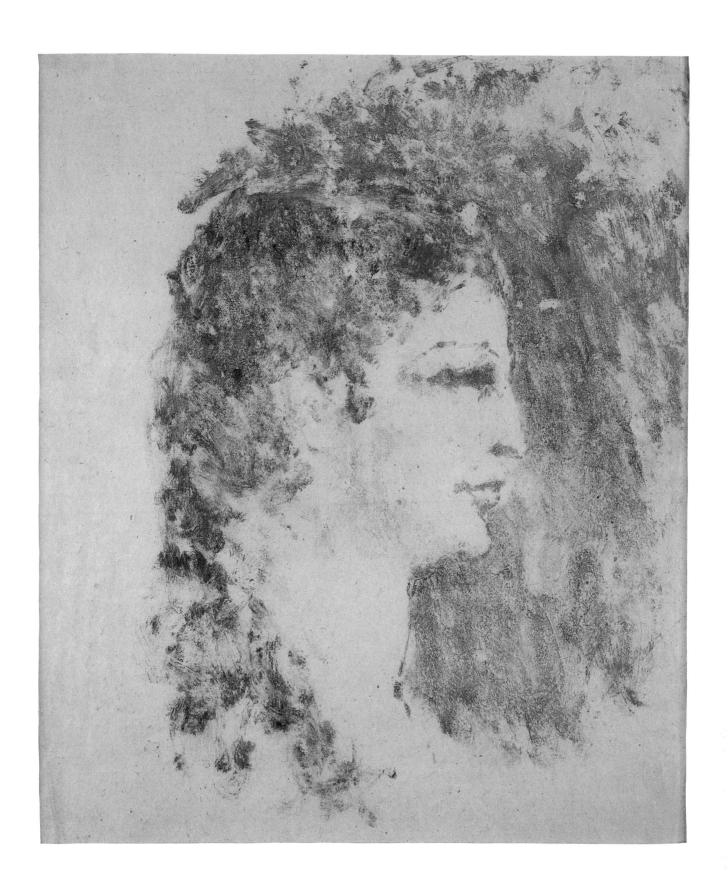

Pablo Picasso
Spanish, 1881-1973

73. Still Life, Guitar and Compote, 1922/23

Monotype printed in black ink
Plate, 2⅜ x 4⅝ inches (6 x 11.8 cm.)
Musée Picasso, Paris

REFERENCE:
Geiser, Bernhard. *Picasso, Peintre-Graveur: Vol. I. Catalogue Illustré de l'Oeuvre Gravé et Lithographié, 1899-1931.* Bern: Geiser, 1933, cat. no. 255.

After 1905, it was seventeen years or more before Picasso returned to making monotypes. In the meantime his art had undergone the radical transformations of Cubism which were monumentally summarized in his paintings of *Three Musicians* in 1921. The playfulness and decorative patterning that had come to enliven his abstract pictures appear in etchings and drypoints he made at this time, as well as in the five monotypes he printed around 1922 and 1923.

As Matisse had done some five years earlier, Picasso now put in the service of monotypes his etching plates, which he coated with black ink and then drew upon with a pointed instrument. His rhythmic, calligraphic lines are those of the "curvilinear cubism" that characterized his paintings and prints of this period: pictures of figures and still-life arrangements like this one featuring the stringed musical instrument that was central to Cubist iconography.

White lines on a dark ground appear in Picasso's prints as early as 1899 or 1900 in the figure of a toreador that is perhaps his first monotype (Zervos, vol. 6, no. 282). They surface again in 1907 in white-line woodcuts and in lithographs and etchings from the 1920s on. Scoring into paint with a brush handle to reveal the lighter underpainting in order to decorate or to accentuate a contour was a device Picasso frequently used in his Cubist paintings and continued to employ periodically into the 1960s.

C.I.

Pablo Picasso
Spanish, 1881-1973

74. Seated Flutist and Sleeper, XXXI, 1933

Monotype printed in rose, green, and blue inks and watercolors
Plate, 5⅞ x 7⅜ inches (15 x 18.8 cm.)
Inscribed, upper left: XXXI E; upper right: XXXI E/A
Musée Picasso, Paris

REFERENCE:
Geiser, Bernhard. *Picasso, Peintre-Graveur: Vol. II. Catalogue Raisonné de l'Oeuvre Gravé et des Monotypes, 1932-1934.* Bern: Kornfeld and Klipstein, 1968, cat. no. 494.

75. Seated Flutist and Sleeper, XXXIII, 1933

Monotype printed in bistre
Plate, 5⅞ x 7⅜ inches (15 x 18.8 cm.)
Inscribed, upper right: XXXI E/C
Musée Picasso, Paris

REFERENCE:
Geiser, vol. II, cat. no. 496.

76. Seated Flutist and Sleeper, XXXVII, 1933

Monotype printed in bistre
Plate, 5⅞ x 7⅜ inches (15 x 18.8 cm.)
Inscribed, upper right: XXXI E/G
Musée Picasso, Paris

REFERENCE:
Geiser, vol. II, cat. no. 500.

BIBLIOGRAPHY:
Geiser, Bernhard. *Pablo Picasso: Fifty-five Years of His Graphic Work.* New York: Harry N. Abrams, 1955, pp. xiii, 96-99.

The most intense and productive period of Picasso's printmaking centers around 1933, the year in which between January and March he produced the extraordinary quantity of 123 monotypes. For the moment, Picasso found himself less attracted to painting than to sculpture and to the printing of drypoints and etchings, a great many of which were published in 1939 in the Vollard suite.

The activity in monotypes that began in July of 1932 and lasted into August of 1934 is closely involved with Picasso's production of drypoints and etchings, and in some instances monotypes directly determined the compositions Picasso cut in copper. He used the medium of monotype to practice transforming his compositions by first printing a design he had drawn on a plate and then redrawing it with a few changes and printing it again. He thus progressed through series of metamorphoses that were, in some cases, almost as complete as those described in Ovid's *Metamorphoses* which Picasso illustrated in 1931.

In the development of the *Seated Flutist and Sleeper* the series of variations reached forty-seven monotyped images, most of which were printed two or even three times, as the freshly inked plate allowed. Picasso's etching *Flutist and Sleeper, I* (see figs. 55 and 56) is based on this monotype series, was etched into the very same metal plate on which the monotypes were drawn, and probably depends on a variation which preceded the rapid abstraction of forms illustrated in catalogue numbers 74-76. Since Picasso apparently was not content with purely linear representations of this subject he added shadows to his compositions by brushing more pigment onto his monotypes and by cutting crosshatches in his etching. Even after piling line upon line on his etching, Picasso in the end decided to hand-ink the plate and produced a group of uniquely colored impressions.

Picasso's agile jumps back and forth between monotypes and etchings or between monotypes and drypoints while he was shaping an idea are dizzying to follow. We can only surmise that he found the exercise invigorating and valued his every step.[1] His particular fondness for recording creative processes is evidenced by the fact that in 1935 he continued to ponder ways in which this might be accomplished: "It would be very interesting to preserve photographically, not the stages, but the metamorphoses of a picture. Possibly one might then discover the path followed by the brain in materializing a dream."[2]

After World War II, when Picasso became deeply involved in lithography, he found to his satisfaction that he could ring changes in his compositions by scraping and redrawing the surface of a lithographic

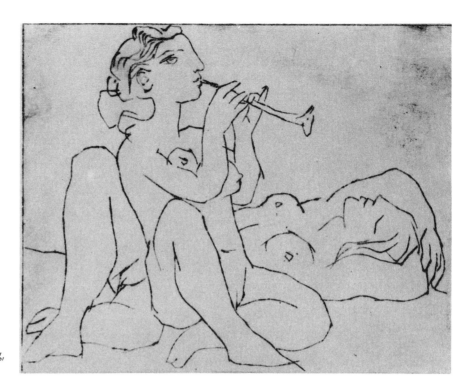

FIG. 55.
Pablo Picasso, *Flutist and Sleeper, I,* etching,
first state (Geiser, no. 287).

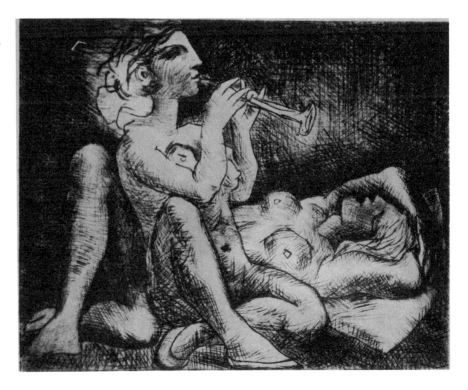

FIG. 56.
Pablo Picasso, *Flutist and Sleeper, I,* etching,
twenty-first state (Geiser, no. 287).

stone. Among the lithographs he worked through numerous changes in states is *Two Female Nudes* (1945-46), which underwent eighteen transformations. Here again, Picasso's subjects were the sleeper and her watchful companion, a recurrent theme which continued to fascinate the artist for close to seventy years.

C.I.

74

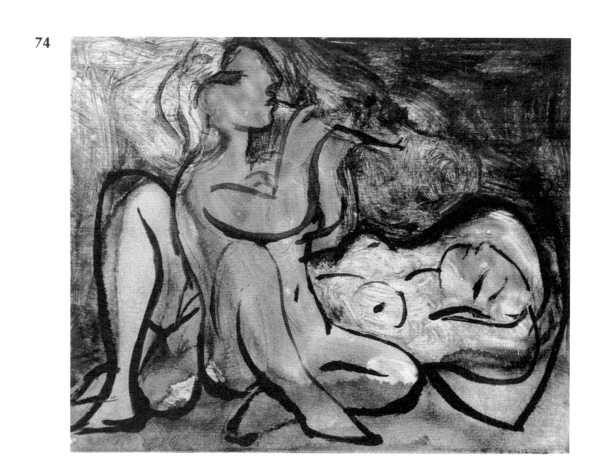

1. It is interesting to see monotypes from the *Seated Flutist and Sleeper* series spread out in Picasso's studio, as they are in a photograph taken by Brassai published with André Breton's article, "Picasso Dans Son Elément," in *Minotaure,* no. 1 (1933), p. 12.
2. Quoted in Alfred H. Barr, Jr., ed., *Picasso: Forty Years of His Art* (New York: Museum of Modern Art, 1939), p. 15.

198

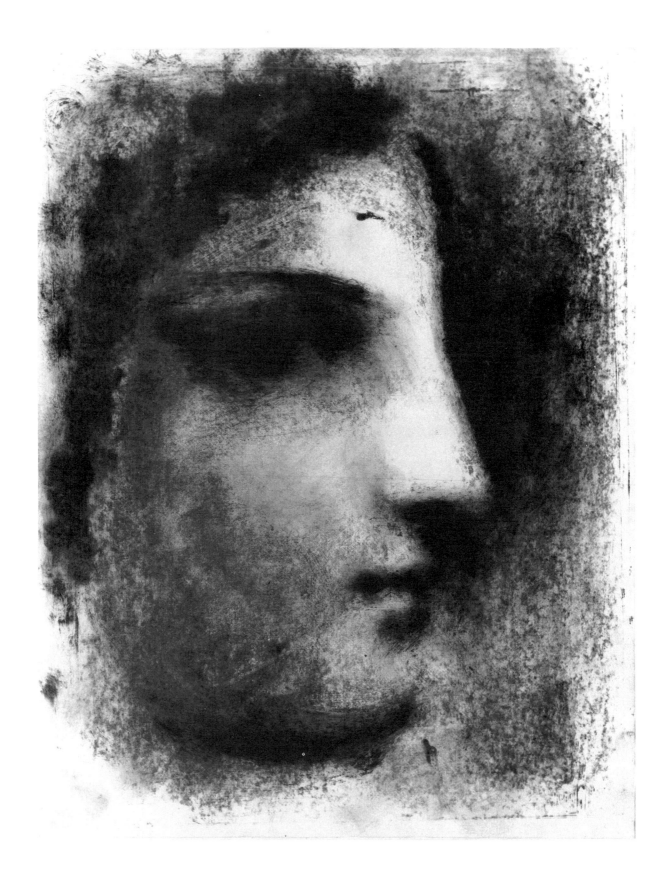

Pablo Picasso

Spanish, 1881-1973

77. Visage, 1933 (January)

Monotype printed in black ink with touches of
gouache
Plate, 13 x 10⅛ inches (33.1 x 25.8 cm.)
Musée Picasso, Paris

REFERENCE:
Geiser, Bernhard. *Picasso, Peintre-Graveur: Vol.
II. Catalogue Raisonné de l'Oeuvre Gravé et des
Monotypes, 1932-1934.* Bern: Kornfeld and Klip-
stein, 1968, cat. no. 539.

Of the many monotypes Picasso made in 1933 of heads shown in profile, this *Visage* is the largest and most perfectly resolved. It is one of very few monotypes from this period to exist as an independent image rather than as part of an evolving series. Picasso must have been sufficiently pleased with the results of his printed painting that he felt no need to alter it beyond adding later a few finishing touches to emphasize the eye, nose, mouth, and chin.

This serene and haunting profile recalls Picasso's earlier monotype *Head of a Woman*, 1905 (cat. no. 72), in its monumental classicism and its very sensitive modeling. In each case Picasso used the same technique, that of daubing and brushing pigment onto a sheet of glass. (In only three instances after 1905 did he employ glass plates rather than metal ones to produce his monotypes.)

The making of *Visage* preceded by only a matter of days Picasso's printing in monotype and in drypoint a series of heads in which classically ideal facial features surrendered completely to those surreal distortions that characterize the bulbous plaster heads he sculpted at Boisgeloup. It is one of the miracles of Picasso's genius that the classic and the mannered could live side by side in his art so harmoniously.

C.I.

Pablo Picasso
Spanish, 1881-1973

78. Minotaur Embracing a Woman, 1934

Monotype printed in black ink
Plate, 15⅝ x 9⅝ inches (39.6 x 24.4 cm.)
Dated, verso: 2 Août XXXIV
Musée Picasso, Paris

REFERENCE:
Geiser, Bernhard. *Picasso, Peintre-Graveur: Vol. II. Catalogue Raisonné de l'Oeuvre Gravé et des Monotypes, 1932-1934.* Bern: Kornfeld and Klipstein, 1968, cat. no. 572.

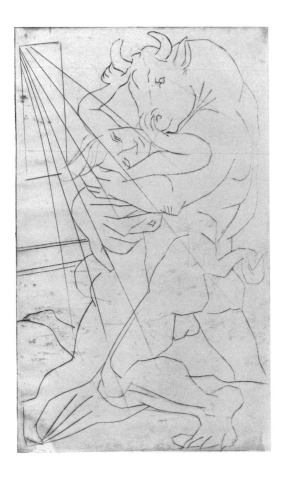

In 1933 when the Surrealists adopted the fabled Cretan monster who was half-human, half-bull as the symbol for their magazine, *Minotaure,* Picasso designed the man-beast that was pictured on the publication's first cover. Mythological half-breeds had romped through Picasso's work since 1920, first as centaurs, then fauns and satyrs. No creature, however, attracted the imagination of the artist so powerfully as did the Minotaur, who figured as Picasso's surrogate in numerous etchings and drawings between 1933 and 1935. In etchings of the Vollard suite, the Minotaur revels with models in the artist's studio, and in Picasso's most important print, *Minotauromachy* (1935), the beast bears a personal and deeply moving message.

Projecting man's primitive energies as well as his potentially violent nature, Picasso brushed into being this *Minotaur Embracing a Woman.* As in the many scenes of ravishment he created, there is the requisite vehemence and swept away turbulence, plus the unexpected grace of a ballet pas de deux. The choreography of entangled bodies is perhaps more clearly defined in the engraving Picasso made two days after printing his monotype by carving along traces of ink left on the metal plate (fig. 57). The strictly linear representation of the scene fails, however, to convey the passion of the struggle which pulsed through Picasso's first impetuous brushstrokes.

To our knowledge, this was the last monotype Picasso made. Even after the extraordinary advancements he achieved in perfecting his printmaking skills around 1933, his mastery of various media continued to grow, encompassing the intricacies of sugar lift (the most painterly method of executing an intaglio print) in 1936, color printing in 1939, and in later bursts of activity, the most sophisticated forms of lithography and linoleum cut.

C.I.

FIG. 57.
Pablo Picasso, *Minotaur Embracing a Woman,* engraving made on the copperplate used for monotype (cat. no. 78), August 4, 1934 (Geiser, no. 431).

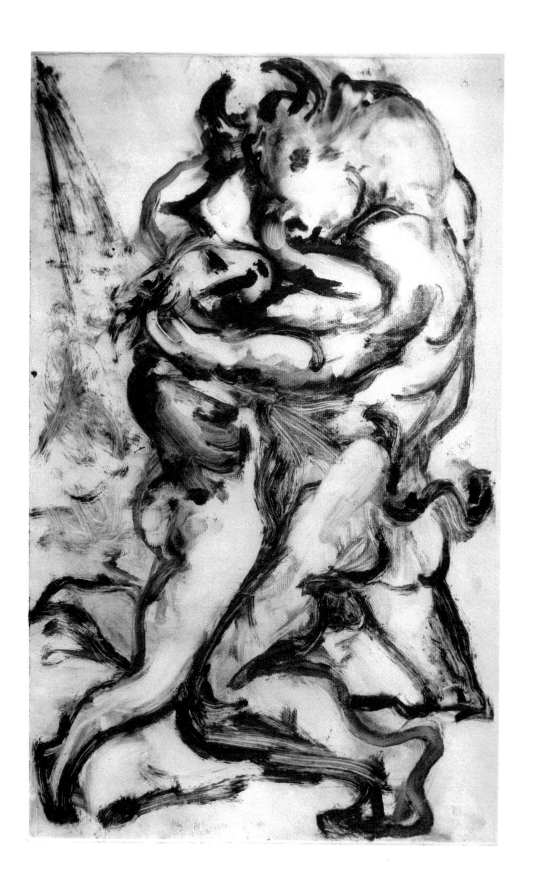

Georges Rouault
French, 1871-1958

79. Clown and Monkey, 1910

Color monotype in oil paint and solvent
Plate, 22⅝ x 15¼ inches (57.5 x 38.7 cm.);
paper, 24¾ x 17⅜ inches (63 x 44.2 cm.)
Signed with monogram and dated at lower left
The Museum of Modern Art, New York
Gift of Mrs. Sam A. Lewisohn, 25.53

PROVENANCE:
Collection of Mr. and Mrs. Sam A. Lewisohn, New
York.

EXHIBITIONS:
Galerie Druet, Paris, December 11, 1911 (*Clown
and Monkey* was probably included in this show).
The Museum of Modern Art, New York, 1945 (cat:
Soby, James Thrall. *Georges Rouault: Paintings
and Prints*, no. 83, ill. p. 94; see also p. 25). The
Cleveland Museum of Art and The Museum of
Modern Art, New York, 1953 (cat: *Rouault, Ret-
rospective Exhibition*, p. 30). Musée National
d'Art Moderne, Paris, May 27 – September 27,
1971 (cat: *Georges Rouault, Exposition du Cen-
tenaire*, no. 21).

REFERENCES:
Courthion, Pierre. *Georges Rouault (Including a
catalogue of works prepared with the collabora-
tion of Isabelle Rouault).* New York: Harry N.
Abrams, 1961, cat. no. 41, pp. 150, 410, 460. Cas-
tleman, Riva. *Prints of the Twentieth Century.*
London: Thames and Hudson, 1976, pp. 17, 53, 86.

Rouault demanded more than the usual of printmaking, requiring that it convey both the complexity and intensity of his painting. Although he made drypoints, etchings, aquatints, and lithographs, he rarely, if ever, used a given medium in the traditional way. He added roulette to etching, combined brushed acid with drypoint, printed aquatint in colors and, in the series Miserere et Guerre, piled multiple hand processes onto photomechanical reproductions of gouache and oil paintings. His experimental approach yielded results completely different from those of any other printmaker.

Rouault tried printmaking for the first time in 1910. He made two tentative drypoints and a color lithograph that year, also a group of monotypes. The period was a particularly rich one for experimentation, producing oil paintings with pastel or turpentine washes added, and several paintings on porcelain. Rouault was searching fervently for the means to express his highly personal view of life's pathos.

Michel Hoog suggests Rouault may have been inspired to make monotypes by Degas. But the process is the sort he would have dreamed up himself. We know Rouault made at least eleven monotypes because the *Paris-Journal* of December 10, 1911, announced this number would be shown at an exhibition at the Galerie Druet. Apparently few of these monotypes now survive. Besides *Clown and Monkey,* there is a *Clown Misanthrope* (1910) in the Hahnloser Collection, Bern (exhibited at the Galleria d'Arte Moderna, Milan, in 1954, cat. no. 19), and *Laborers* (about 1910) from the collection of Paul A. Regnault, Laren, the Netherlands (exhibited at the Museum of Modern Art and Cleveland Museum of Art in 1953, cat. p. 30). Isabelle Rouault recalls that her father made very few monotypes and suggests that he may have added so much pigment to them later that few traces of monotype remain, as in the *Tragic Clown* (1911) reproduced in Courthion's catalogue of Rouault's work (no. 42).

Clowns, as symbols of sadness in the masquerade of gaiety, entered Rouault's repertory in 1903. They held a lifelong fascination for him and sometimes stood as self-portraits. Most of Rouault's clowns are melancholy, world-weary, but this one, performing with a dressed-up monkey, is so wittily modeled as to entertain. His caricatural grandeur is owed to Daumier's sway, the tactile excitement to Gustave Moreau, who introduced his favorite pupil to the sensuous qualities of paint. The particularly savage brushwork and trenchant color here link Rouault, for the moment, with painters called Fauves.

C.I.

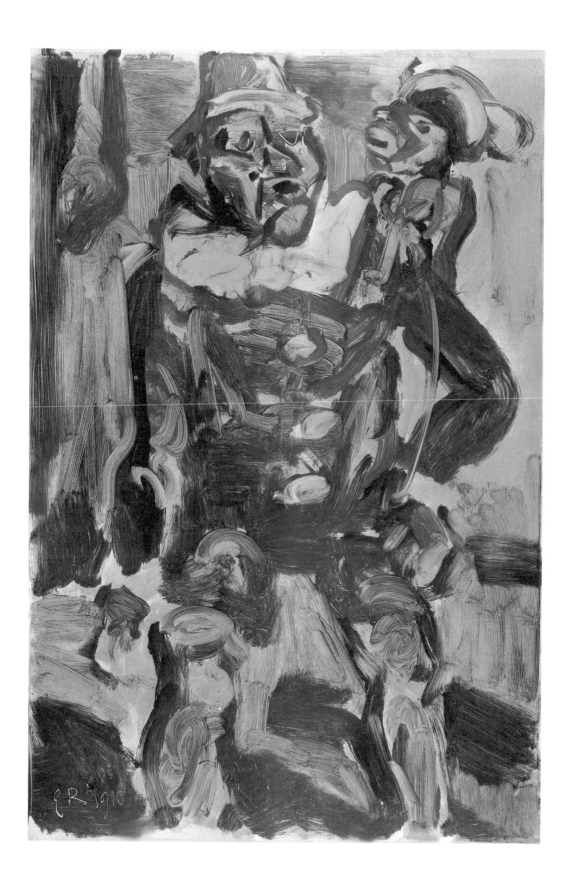

Henri Matisse

French, 1869-1954

80. Seated Nude with Arms Crossed, about 1914-17

Monotype in black ink
Plate, 6¾ x 4¾ inches (17.1 x 12.1 cm.);
paper, 14¾ x 10⅝ inches (37.5 x 27 cm.)
Signed in ink, bottom right: *Monotype/Henri
Matisse*
The Metropolitan Museum of Art, New York
Gift of Stephen Bourgeois, 1917 (17.75)

EXHIBITION:
University of California, Los Angeles; The Art
Institute of Chicago; and Museum of Fine Arts,
Boston, January 5 – June 30, 1966 (cat: Leymarie,
Jean; Read, Herbert; and Lieberman, William S.
Henri Matisse, p. 165, no. 258; see also p. 27).

REFERENCE:
Lieberman, William S. *Matisse: 50 Years of His
Graphic Art.* New York: George Braziller, 1956,
pp. 24, 76 (ill.); see also p. 8.

BIBLIOGRAPHY:
Barr, Alfred H., Jr. *Matisse: His Art and His Public*
New York: Museum of Modern Art, 1951, pp.
184, 186, 187, 399, 541, 542. *Matisse, L'Oeuvre
Gravé.* Exhibition catalogue. Paris: Bibliothèque
Nationale, 1970, pp. 20, 46-49. Elderfield, John.
*Matisse in the Collection of the Museum of
Modern Art.* With additional texts by William S.
Lieberman and Riva Castleman. New York: Mu-
seum of Modern Art, 1978; Castleman, pp. 103-
104.

While clouds of World War I hung over France, Henri Matisse grappled with his art. The diverse, programmatic paintings of this period show that he was experimenting, and coming to terms with the Old Masters, with Ingres, Delacroix, and the new trend to Cubism. To lift his war-weary spirits Matisse played the violin, and for refreshment from easel painting he made prints. Having tried a variety of techniques in 1903 and 1906 he returned enthusiastically to printmaking in 1914, producing several lithographs, a large group of etchings and, starting about this time, some thirty monotypes.[1]

A small handpress for etchings had been installed in his Paris apart-ment on the Quai Saint-Michel, and on it Matisse printed drawings he scratched on inked metal plates that were much like the pictures he scrawled in waxy grounds laid for his etchings. Matisse's daughter, Marguerite, who assisted, describes the procedure as follows: "The monotypes were realized in three stages: the delicate application of ink onto copper; the spontaneous drawing which could not be altered; the risks of destroying the work during printing. At the end of these three steps, a great moment of emotion when one discovered the imprint on the sheet of paper."[2]

Matisse presented a variety of subjects in his monotypes: nudes, portraits, still lifes, and interiors. While he developed and expanded all these themes in his paintings, the monotype process challenged him to distill them, to work them into the size of a page and in only a matter of minutes. Taking a black-inked plate in hand like a note pad, this com-pulsive, masterful draftsman produced with a minimum of lines the maximum of expression.

Since drawing or painting with a model was basic to his artistic life, studies of the figure are naturally found among Matisse's monotypes; there are at least six of them. Like the nude figures he lithographed in 1914, these are sparely, poignantly drawn and positioned perfectly within the picture's space. Gossamer outlines somehow manage to suggest real flesh as well as the pressure of a leaning shoulder.

C.I.

1. In addition to the monotypes published in this catalogue and in the sources cited above, others by Matisse exist in the Bibliothèque Nationale, Paris; Musée Matisse, Nice; The Allen Art Museum, Oberlin College, Ohio; and, as of November 1979, one at Christie, Manson and Woods, New York, awaiting auction.
2. Mme Marguerite G. Duthuit to Riva Castleman, March 7, 1978, quoted in John El-derfield, *Matisse in the Collection of the Museum of Modern Art* (New York: Museum of Modern Art, 1978), p. 103.

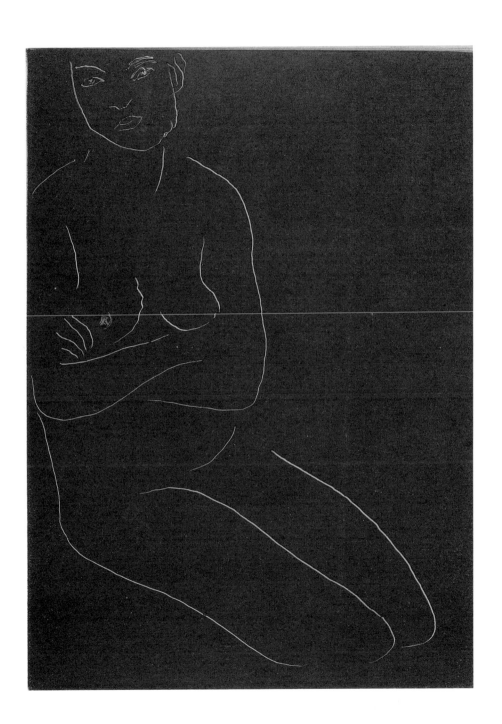

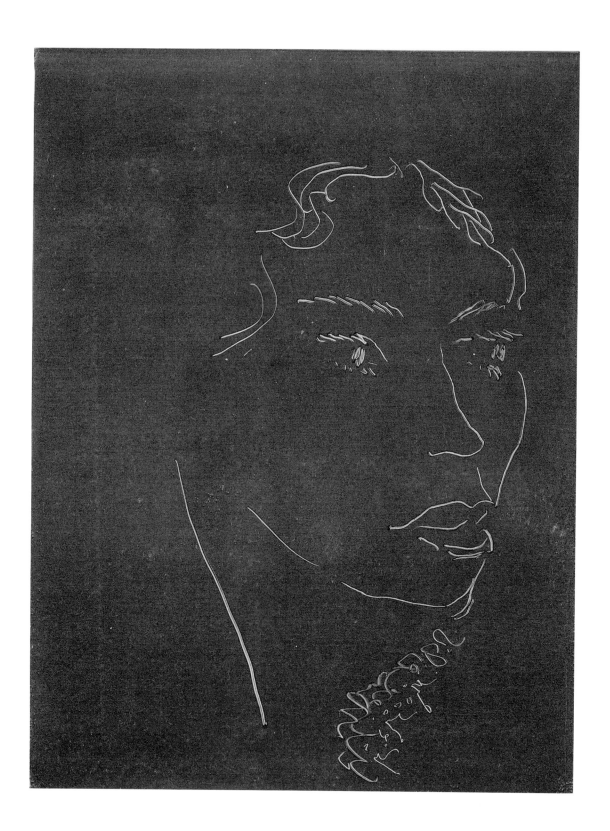

Henri Matisse
French, 1869-1954

81. Head of a Woman, Turned to the Left, about 1914-17

Monotype in black ink
Plate, 7¾ x 5¾ inches (19.7 x 14.7 cm.);
paper, 14⅝ x 10⅝ inches (37.3 x 27 cm.)
Signed in pencil, lower right margin: *Pour les Prisonniers civils de Bohain-en-Vermandois/Monotype/Henri Matisse*[1]
Private collection, New York

PROVENANCE:
Louis Ehrlich, New York.

EXHIBITION:
Isselbacher Gallery, New York, 1977.

BIBLIOGRAPHY:
See cat. no. 80.

Most of Matisse's portrait monotypes follow the small-scale "pillar print" format of his 1914 etchings that are lively sketches of models, friends, and family. They even look as though they could have been drawn on the same little copperplates. This *Head of a Woman, Turned to the Left* is not only larger than other monotyped portraits, but it is markedly more formal, almost classical in response to its subject's arresting beauty. Matisse appreciatively described his sitter's high cheekbones, full lips, and her statuesque neck adorned with ruffles in the fashion of his odalisques.

The exotic appearance of Matisse's model reminds us of the artist's early attachment to the orientalism he found first in the art of Delacroix and Gauguin, then in North Africa where he wintered between 1911 and 1913. It was in Morocco that Matisse discovered black as a color, and soon he began employing it with striking effects in canvases like *The Moroccans*, 1915-16 (The Museum of Modern Art, New York). Expanses of black with white scratched through it appear in paintings about this time also, notably in the portrait of *Mlle Yvonne Landsberg*, 1914 (Philadelphia Museum of Art), where the painter's brush handle drawn through wet paint exposed the canvas ground. Albert C. Landsberg, describing this "fierce white 'grafiti'" that figured prominently in his sister's portrait, associated it with Matisse's monotypes and recalled that the painter had been "very much pleased with those prints of his of white lines on a black ground."[2] Matisse made no monotypes that we know of after 1917 but revived his penchant for white lines on black in linoleum cuts printed between 1937 and 1944. Moreover, in many of his paintings during the late thirties and forties he adopted again a technique of scribbling in wet pigments for decorative effect.

C.I.

1. A dedication to Matisse's family, stranded during World War I behind German lines.
2. Albert C. Landsberg to Alfred H. Barr, Jr., June 1951, quoted in Barr, *Matisse: His Art and His Public* (New York: Museum of Modern Art, 1951), p. 541.

Henri Matisse
French, 1869-1954

82. Interior: Artist Drawing Three Apples and Sculpture, about 1914-17

Monotype in black ink
Plate, 7 x 5 inches (17.7 x 12.8 cm.);
paper, 14¾ x 11⅛ inches (37.5 x 28.1 cm.)
Signed, lower right
The St. Louis Art Museum
Anonymous Gift, 1951 (315:1951)

PROVENANCE:
E. Weyhe, New York.

REFERENCE:
Lieberman, William S. *Matisse: 50 Years of His Graphic Art.* New York: George Braziller, 1956, pp. 24, 79; see also p. 8.

BIBLIOGRAPHY:
See cat. no. 80, and Christie, Manson and Woods International Inc., *19th and 20th Century Prints,* auction catalogue, New York, November 15, 1979, no. 325 (ill.).

83. Apples, about 1914-17

Monotype in black ink
Plate, 2¼ x 6⅛ inches (5.7 x 15.5 cm.);
paper, 7 x 10¾ inches (17.8 x 27.3 cm.)
The Museum of Modern Art, New York
Abby Aldrich Rockefeller Fund, 615.54

PROVENANCE:
Peter H. Deitsch, New York.

EXHIBITIONS:
Peter H. Deitsch, New York, March 13 – April 14, 1956. Museum of Modern Art Circulating Exhibition, *The Prints of Henri Matisse,* November 1956 – July 1958. University of California, Los Angeles; The Art Institute of Chicago; Museum of Fine Arts, Boston, *Henri Matisse Retrospective,* January 5 – June 30, 1966. Museum of Modern Art, New York, *Matisse in the Collection of the Museum of Modern Art,* October 27, 1978 – January 30, 1979. Museum of Modern Art Circulating Exhibition, *Matisse Prints from the Museum of Modern Art,* April 1979 – June 1980.

REFERENCE:
Lieberman, William S. *Matisse: 50 Years of His Graphic Art.* New York: George Braziller, 1956, pp. 23, 72; see also p. 8.

BIBLIOGRAPHY:
See cat. no. 80.

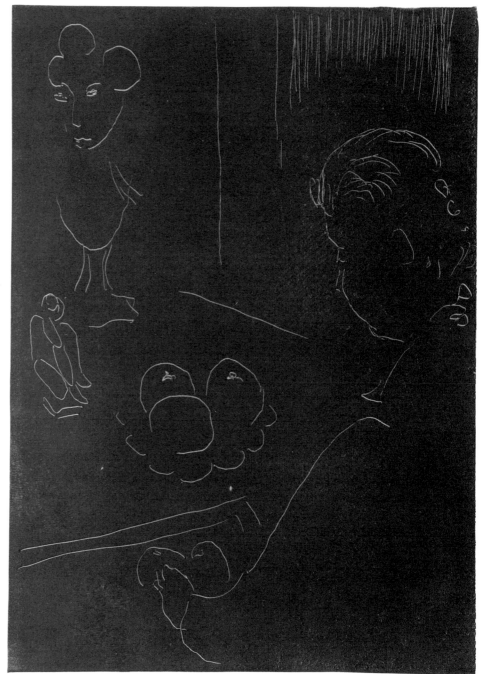

Matisse began to favor still-life subjects and decoratively arrayed interiors early in his student days. By the period 1914-17, his paintings abounded in artful arrangements of fruit, flowers, sculpture, and goldfish in bowls.

This monotype of an interior, one of three existing views of the same scene, probably pictures Matisse's own studio where a plate of apples posed beside his bust *Jeannette III* (1910-13) and the *Small Crouching Nude with Arms* (1908). The subject of the artist at work always appealed to Matisse, who occasionally portrayed himself in the role, as he did in one of his earliest prints, *Self-Portrait as an Etcher* (1903). It is likely that the sitter in this case is Matisse's wife, an artisan of note who was especially skilled in needlework.

Apples, one of six known monotypes displaying fruit, shares with the above *Interior* a piquant and informal charm. This comes of snapshot-style focusing and handwriting so rapid it skips.

C.I.

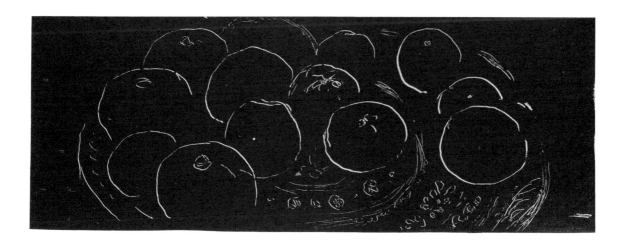

Jacques Villon
(born Gaston Duchamp)
French, 1875-1963

84. Prometheus, 1942

Monotype printed in colors
Plate, 17⅜ x 12⅝ inches (44 x 32 cm.);
paper, 25¼ x 18¾ inches (64 x 47.5 cm.)
Signed and dated lower right
Collection of A. Sutter, Paris

REFERENCES:
Sale Catalogue: Collection de M. X..., Hotel Drouot, Paris, May 16 and 17, 1961, no. 284 (under the title *Femme nue debout*). Ginestet, Colette de, and Pouillon, Catherine. *Jacques Villon: Les Estampes et les Illustrations. Catalogue Raisonné.* Paris: Arts et Métiers Graphiques, 1979, pp. 388-89, no. E. 598 *bis* (see also E. 594-98).

BIBLIOGRAPHY:
Auberty, Jacqueline, and Perussaux, Charles. *Jacques Villon. Catalogue de son Oeuvre Gravé.* Paris: Paul Prouté et ses fils, 1950, p. 42, nos. 455-75 (ills.).

Jacques Villon began printmaking in earnest during the 1890s when color was an important ingredient in French prints. Between 1899 and 1905 he produced prints that portrayed fashionable *belle époque* life in the jewel tones and velvet textures that only color inks and aquatint can bring to paper. The large quantity of trial proofs that exist for his color prints, some with watercolor and crayon added, as well as the many variants printed of works like *The Parisienne* of 1902-03 evidence Villon's obvious enjoyment in striking changes in his printing plates through an artful manipulation of lines, patterns, and colors. The extraordinary technical skills Villon developed at this early stage of his career were later, in the 1920s, turned to the production of color prints that interpretatively reproduced paintings by his contemporaries: Matisse, Picasso, Braque, and others.

Although today Villon's productions in color printing are overshadowed by his great Cubist etchings and drypoints from between 1911 and 1914 which were delineated simply in black on white, his technically more complex and colorful prints manifest a prevailing inclination toward the painterly and experimental. In the long run, painting and the handling of color consumed more and more of Villon's attention so that by 1942, when he ventured to produce six monotypes, he saw himself as a painter rather than a printmaker. Indeed, it is to Villon's paintings of the thirties and forties that his monotypes are best compared since they are composed of brushed and dabbed patches like those seen in his canvases and the spring-garden colors that cropped up after he fled to the sunny south of France ahead of the Germans, in 1940.

Villon's *Prometheus*, seen here, is the first-printed of two impressions of the same monotype and one of two monotyped compositions that bear this title. It holds to the resolution Villon made early in his career as a "Cubiste Impressioniste" to preserve the integrity of his figures however enmeshed in lines or buried under blocks they might become. Villon said, "I think that if my Cubism was not harsh it is because I have always preferred the human figure to still life. The human figure being alive, one cannot, one dare not put him in chains."[1]

A symbol of strong will in the face of adversity (a fitting subject for treatment in wartime), this *Prometheus* is preliminary to Villon's two studies for decoration of the Ecole Technique de Cachan, Seine, *The Eagle Leaving Prometheus* and *Prometheus Set Free,* both painted in the mid-1950s and later repeated in lithographs.

C.I.

1. Quoted by Peter A. Wick in *Jacques Villon: Master of Graphic Art (1875-1963)* (Boston: Museum of Fine Arts, 1964), p. 26.

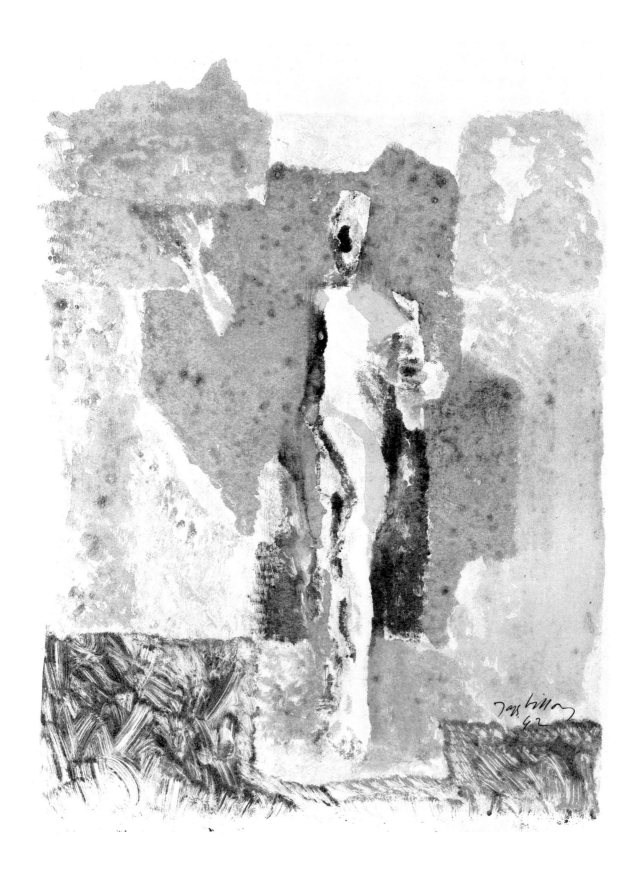

Oskar Schlemmer

German, 1888-1943

85. Slanting Head I, 1941

Color monotype in oils
Printed on the reverse of a calendar sheet,
11¼ x 8⅛ inches (28.5 x 20.8 cm.)
Schlemmer Estate, Stuttgart

86. Two Schematic Figures
(Japanese-style), 1941

Color monotype in oils
Printed on the reverse of a calendar sheet,
7⅛ x 4 inches (18 x 10.3 cm.)
Inscribed by another hand: *Japanisch*
Schlemmer Estate, Stuttgart

EXHIBITION:
Staatsgalerie, Stuttgart, August 11 – September
18, 1977 (cat: von Maur, Karin. *Oskar Schlemmer,*
cat. no. 149, ill. p. 37; see also p. 38, pp. 70-74
[*Two Schematic Figures* exhibited, but unlisted
in catalogue]).

REFERENCES:
Grohmann, Will. *Oskar Schlemmer: Zeich-
nungen und Graphik.* Stuttgart, 1965, cat. nos.
M 16 and M 18 (ills.). Von Maur, Karin. *Oskar
Schlemmer: Monographie und Oeuvrekatalog.*
Munich, 1979, vol. 2, cat. nos. G. 585/I and G. 590
(ills.); see also vol. 1, pp. 289-91.

BIBLIOGRAPHY:
Von Maur, Karin. *Oskar Schlemmer.* Exhibition
catalogue. New York: Spencer A. Samuels & Co.,
1969, see cat. no. 88, ill. p. 146 (third impression of
Slanting Head). *Oskar Schlemmer.* Exhibition
catalogue. Los Angeles: Felix Landau Gallery,
1970, see cat. no. 40 (third impression of *Slanting
Head*).

Oskar Schlemmer's experiments in depicting figures in space were combined with discoveries of novel materials in which to draw, paint, and sculpt. At times he painted oils on cardboard, lacquers on canvas, or spray pigments on grasscloth. His drawings, too, show preferences for various media at different stages in his production.

Until around 1921 when he joined the staff of the Bauhaus, Schlemmer's drawings were linear and concise, done with pen and black ink. Then, with brush and watercolors in hand, he began to explore the entire color spectrum. In 1935, owing partly to the scarcity of oil paints and canvas, he adopted colored crayons and entered what he called the "baroque phase" of his art, marked by rich textures, vibrant colors, and an expressive handwriting. After being dismissed by the Nazis from a professorship in Berlin, Schlemmer's fascination with mysticism intensified, and he wrote in his journal on May 19, 1936, of his desire to create "a sweeping painting, born of colors, of shadow and light, of structure and laws, manifest and hidden, of the unconscious and the conscious, but especially the unconscious, which holds the secret."

Seeking ways to create an art that was unpremeditated, that appeared out of nowhere (*von wannen*) and that bore none of the usual traces of the human hand, Schlemmer in 1941 chanced upon André Breton's description of "décalcomanies" published in a 1936 issue of *Minotaure* magazine. The discovery that French Surrealists made pictures by pressing pools of ink between sheets of paper prompted Schlemmer to create between 1941 and 1942 the group of about twenty-five monotypes he called *klecksographien* or ink-blot prints.

Unlike the Surrealists, Schlemmer painted his pictures on glass before printing them and, instead of abstractions, drew the stylized spool figures and flat-nosed faces that were his trademarks. His brushstrokes, moreover, were less like impulsive blots than they were calligraphy practiced from studying Chinese and Japanese draftsmen.

Because, by this time, the government had prohibited his painting, Schlemmer was forced to use materials that could be easily hidden and out of necessity printed his monotypes on the backs of calendar pages and postcards. The polished surfaces of these papers must have appealed to him, too, since they enhanced the marbling and ethereal transparency of his colors.

C.I.

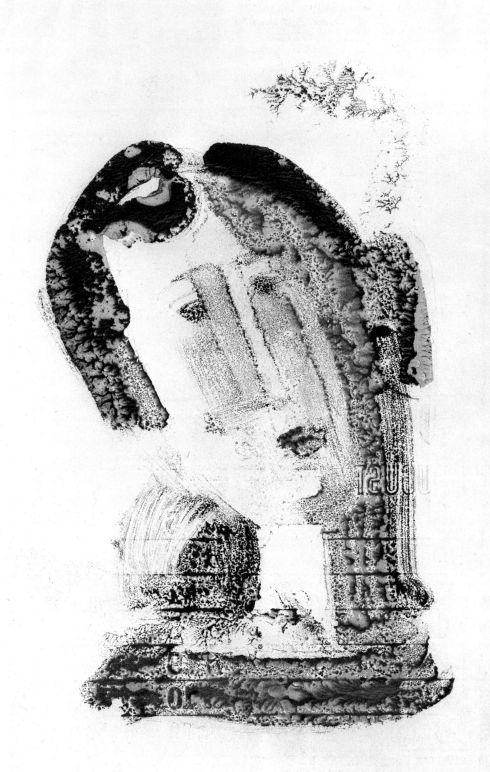

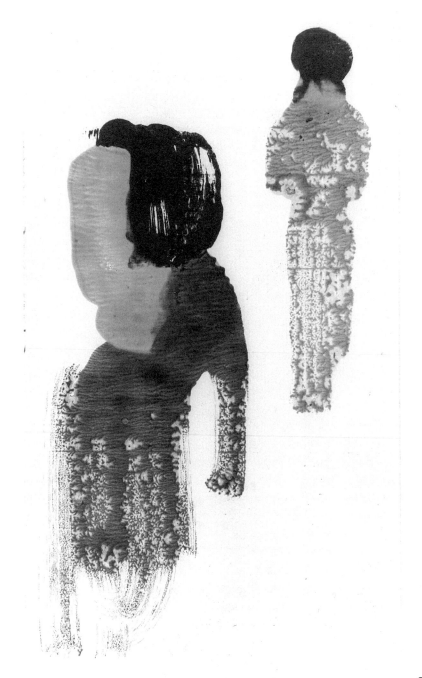

86

Jean Dubuffet

French, born 1901

37. Wall with Passerby I, 1945

Monotype in lithographic ink
14⅛ x 10⅝ inches (36 x 27 cm.)
Signed and dated, lower right
Collection of Jean Dubuffet, Paris

38. Globulous Formations, 1959

Monotype (empreinte) in oil
17¾ x 21¼ inches (45 x 54 cm.)
Signed and dated, lower right
Collection of Jean Dubuffet, Paris

REFERENCE:
Loreau, Max. *Catalogue des Travaux de Jean Dubuffet.* Paris, 1966, vol. 1, no. 434, ill. p. 228; and vol. 14, no. 137, ill. p. 92.

BIBLIOGRAPHY:
Dubuffet, Jean. "Empreintes," *Les Lettres Nouvelles,* no. 48 (April 1957), pp. 507-27. Selz, Peter. *The Work of Jean Dubuffet.* Exhibition catalogue with texts by the artist. New York: Museum of Modern Art, 1962; see pp. 42-43, 84-85, 103-106, 123-25.

In revolt against the academic and traditional in art, Jean Dubuffet studied not Old Master paintings but crumbling stone walls, graffiti, and pictures made by insane people. He mixed coal dust and tar on the artist's palette, then smeared, scraped, poked at, cut apart, and glued together materials to make his own paintings, drawings, prints, collages, and assemblages. He has put in the service of art almost everything within his reach, from lowly mud clods to butterflies' wings.

It was not long after he set up shop as an artist in 1942 that Dubuffet discovered the monotype process as a way of testing his ideas. He was preparing fifteen lithographs to illustrate Guillevic's poems *Les Murs (Walls)* in 1945 when he first printed two monotypes in lithographic ink (one is *Wall with Passerby I*) as variations on his series' theme. He later found that he could approximate the rough terrains of his paintings by printing metal or Plexiglas plates that he had inked in various ways, with rags, string or crumpled tissue, sometimes with intervening drops of solvent, torn paper, leaves, and the like. Between 1953 and 1959 he made hundreds of these monotypes or *empreintes,* as he called them, that he frequently cut into pieces and rearranged in assemblages.

Dubuffet, who described this work as "preliminary research," "an incomparable laboratory and an efficacious means of invention,"[1] applied its lessons both to his painting and to his printmaking, notably in the staggering series of 234 lithographs called Phénomènes (Phenomena) published between 1958 and 1960. That he found appealing not only the rich textures created in monotypes but also the process itself is explained by Dubuffet's attraction to the technique's power to produce surprises. Aiming for an art both unpretentious and unpremeditated he welcomed the element of chance, noting, as he did in 1946, that a creative act is "not a dance to be danced alone, but by two; chance is one of us . . . the artist steers as well as he can, but with flexibility applies himself to making the best of every accident as it occurs, forcing it to serve his ends. . . ."[2]

C.I.

1. Quoted in Peter Selz, *The Work of Jean Dubuffet* (New York: Museum of Modern Art, 1962), p. 105.
2. Ibid., p. 42.

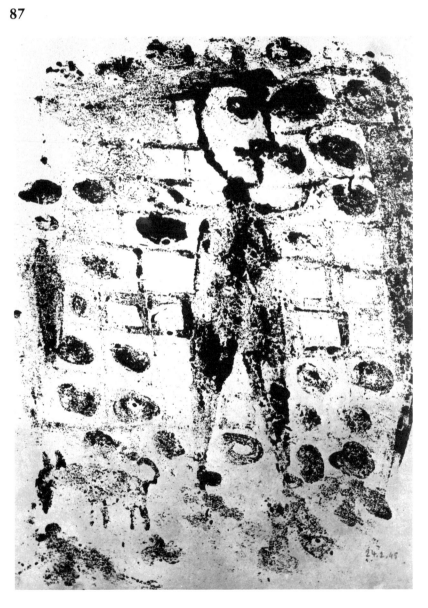

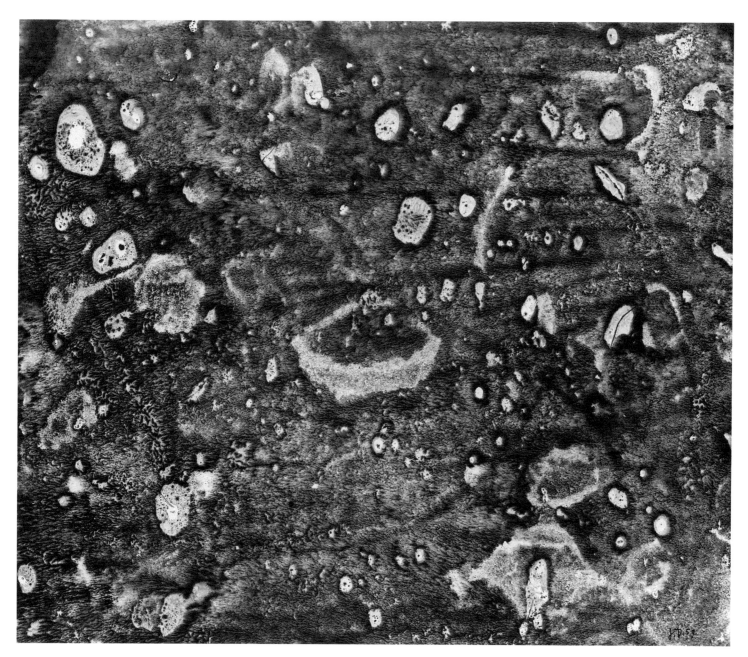

88

219

Milton Avery

American, 1893-1965

89. Myself in Blue Beret, 1950

Color monotype in oil pigments
Paper, 22 x 17 inches (55.9 x 43.2 cm.)
Signed and dated, lower right
Collection of Mr. and Mrs. Anthony Woodfield,
New York

EXHIBITIONS:
Alpha Gallery, Boston, April 26 – May 24, 1975.
Bard College, Annandale-on-Hudson, New York,
and the Smithsonian Institution Traveling Exhi-
bition Service, 1972. (cat: Phillips, Matt. *The
Monotype: An Edition of One,* cat. no. 21, ill.).

BIBLIOGRAPHY:
"Milton Avery Monotypes at Laurel Gallery." Ex-
hibition review. *Art Digest,* vol. 25 (December 15,
1950), p. 19. "Drawings, Woodcuts, Monotypes at
Mills College." *Art News,* vol. 55 (December
1956), p. 10. Johnson, Una E. *Milton Avery: Prints
and Drawings 1930-1964.* Exhibition catalogue.
New York: Brooklyn Museum, 1966, pp. 10-11, cat.
nos. 30-50. Breeskin, Adelyn D. *Milton Avery.*
Exhibition catalogue. Washington, D.C.: National
Collection of Fine Arts, Smithsonian Institution,
1969, cat. nos. 41, 50, 82. Phillips, Matt. *Milton
Avery: Works on Paper.* Exhibition catalogue.
Annandale-on-Hudson. New York: Bard College,
1971, cat. nos. 17-25, ills. Campbell, Lawrence.
"The Monotype." *Art News,* vol. 70 (January
1972), pp. 44-47. *Milton Avery: Oils on Paper,
Monotypes, Watercolors.* Exhibition catalogue.
New York: Borgenicht Gallery, 1972, cat. nos.
15-26, ills. *Milton Avery.* Exhibition catalogue.
Washington, D.C.: Lunn Gallery, Graphics Inter-
national Ltd., 1974, cat. nos. 20 (ill.), 21. Laliberté,
Norman, and Mogelon, Alex. *The Art of Mono-
print: History and Modern Techniques.* New
York: Van Nostrand Reinhold, 1974, pp. 56-57,
59, ills. Fischer, Kathy. "Excursion into the
Landscape Monotypes of Edgar Degas and Milton
Avery." Unpublished term paper, Columbia
University/Metropolitan Museum Studies
Course, 1976. Grad, Bonnie Lee. *Milton Avery
Monotypes.* Exhibition catalogue. Princeton, N.J.:
Princeton University Library, 1977. *Milton Avery
Monotypes.* Exhibition catalogue. New York: As-
sociated American Artists, 1977. Ratcliff, Carter.
"Avery's Monotypes: Color as Texture." *Art in
America,* January-February 1978, pp. 48-49.

No happier meeting of artist and medium can be imagined than that of Milton Avery and the monotype. A man of disarming simplicity and Yankee wit, Avery took to monotyping with a pioneer's sense of adventure. It was in 1950 while he was recovering in Florida from a heart attack that his artist-friend Boris Margo first suggested making monotypes as a less strenuous alternative to painting on canvas. During the next two years, wintering in Florida and summering in Vermont, Avery was most active in the medium. Between 1950 and 1956 he made well over two hundred monotypes.

Although he had produced several drypoints and etchings in the 1930s and 1940s, Avery's printmaking skills were rudimentary, and he approached printing monotypes with characteristic ingenuity. He applied oil washes to glass plates with brushes, rags, crumpled bits of paper, or his fingers, and printed them, not with a press, but usually with the back of a spoon. A base of turpentine on the glass kept his pigments from drying too rapidly and puddled them like paints in the hands of children.

Portraiture, in monotype and in other media, was a persistent enthusiasm of Avery who used as subjects his family and friends. His self-portraits in paintings, drawings, and prints dating back to the thirties are modest, unassuming, and often humorous. In life, as in art, Avery was given to understatement and usually few words, reasoning, "Why talk when you can paint?"

C.I.

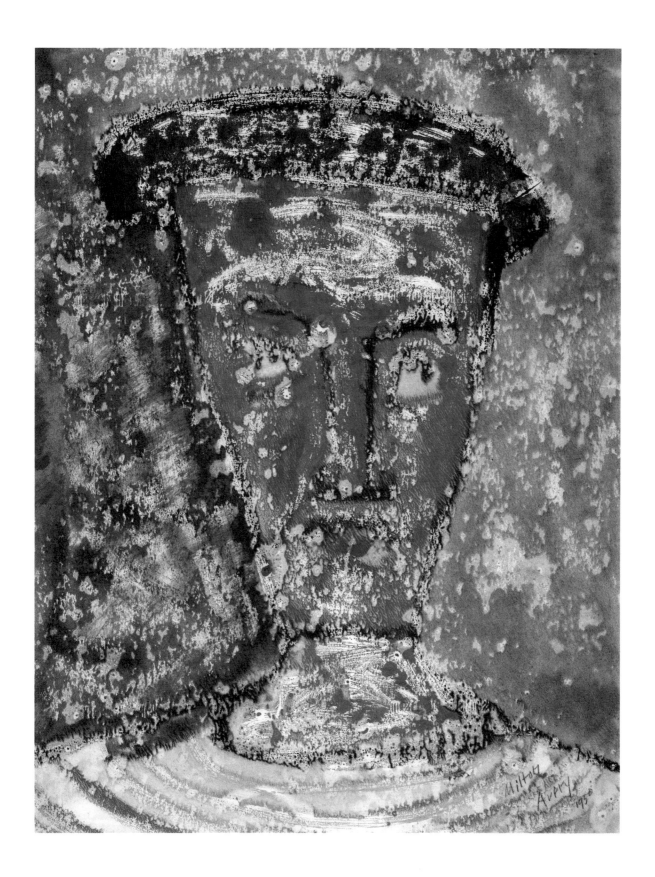

Milton Avery
American, 1893-1965

90. Pink Nude, 1950

Color monotype in oil pigments
Paper, 22 x 17 inches (55.9 x 43.2 cm.)
Signed and dated, lower right
Collection of Mrs. Milton Avery, New York

EXHIBITION:
Bard College, Annandale-on-Hudson, New York, and the Smithsonian Institution Traveling Exhibition Service, 1972 (cat: Phillips, Matt. *The Monotype: An Edition of One,* cat. no. 18, ill.).

BIBLIOGRAPHY:
See cat. no. 89.

Milton Avery put into monotypes the same subjects he enjoyed painting: landscapes and seascapes, flora, fauna, and portraits of people. He never tired of depicting the human figure and made it a lifelong practice to draw directly from a model. His manner of distorting figures has a special charm and is particularly effective within the context of landscape. Avery's seaside bathers, for instance, like pasteboard cut-outs with minuscule heads and elongated torsos merge happily with abstracted forms of dunes, rocks, and shore.

So easily and fluidly does Avery describe his Modigliani-supple *Pink Nude* that there is no trace of effort, hesitation, or the plotting that preceded the rapid painting on glass and its printing. Here, as in most all his monotypes (and even more so than in his paintings), the goal is the greatest and most persuasive simplification. The elements of the picture are reduced to the minimum: a single form, a planar ground, and two or three colors.

Upholding his reputation as a colorist of keen sensibilities, Avery treats us here to the tart surprise of flesh pink and wine. The vivid colors unite with the picture's subject, its mannered form, and the luxurious texture of its surface in perfect harmony.

C.I.

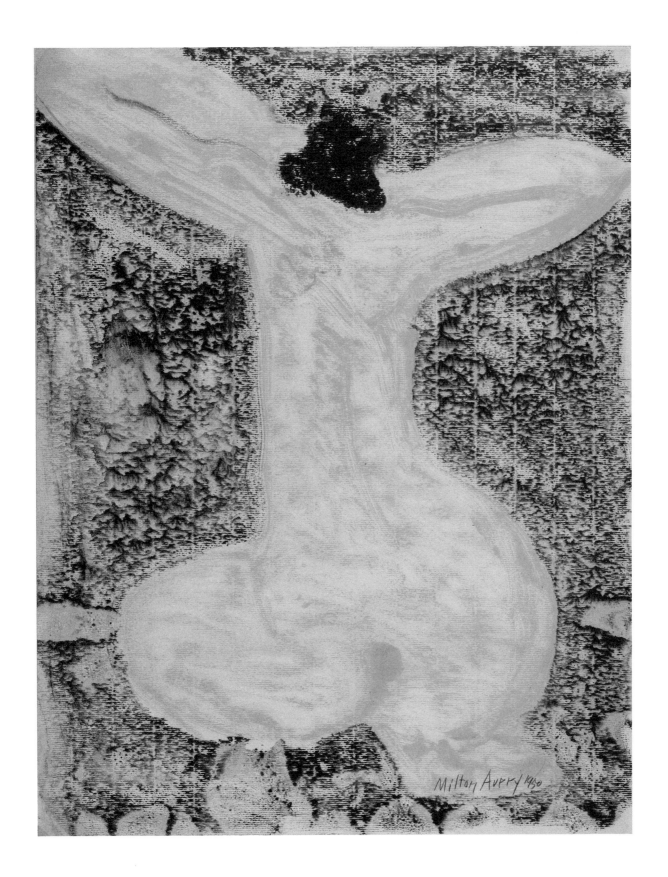

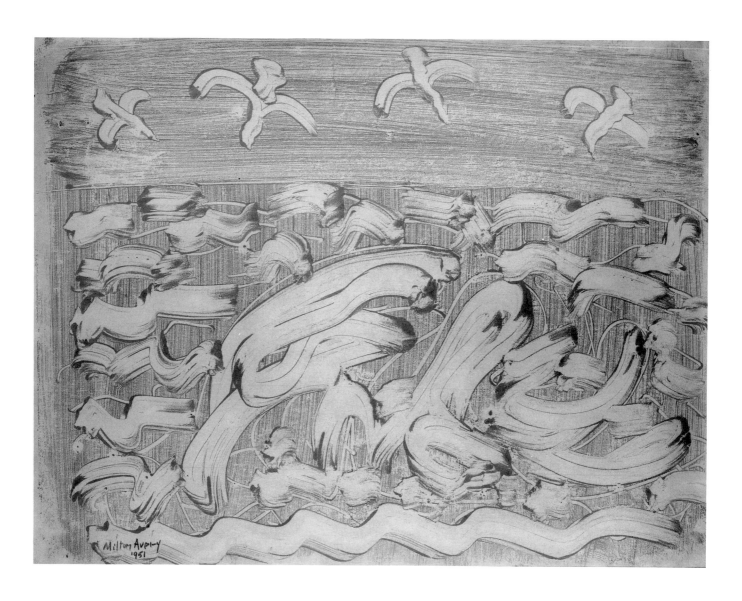

Milton Avery
American, 1893-1965

91. Birds and Ruffled Sea, 1951

Monotype in gray oil pigment
Paper, 18 x 24 inches (45.7 x 61 cm.)
Signed and dated, lower left
The Metropolitan Museum of Art, New York
The Elisha Whittelsey Collection, The Elisha
Whittelsey Fund, 1978.576

Milton Avery's highly abstract landscapes and seascapes are at once the most daring and fully satisfying of his monotypes. Avery, who began painting as a youth roaming the Connecticut countryside, developed a love of nature that enabled him to extract from scenery its quintessence.

Perhaps the fluidity of the monotype medium and its demand that the artist work swiftly enhanced Avery's resolve to portray nature rhythmically as well as economically. He was pressed to get right to the point and did so in apparently casual compositions that are awesomely well ordered. Not until later in the 1950s do we find such bracing simplicity in Avery's paintings like the *Tangerine Moon and Wine Dark Sea* (1959), *Speed Boat's Wake* (1960), and *Seabirds on Sandbar* (1960).

92. Edge of the Forest, 1951

Monotype in green and black oil pigments
Paper, 17 x 22 inches (43.2 x 55.9 cm.)
Signed and dated, lower left
Associated American Artists, New York

PROVENANCE:
Mrs. Milton Avery, New York

EXHIBITIONS:
Princeton University Library, Princeton, New Jersey, May 7 – June 30, 1977 (cat: Grad, Bonnie Lee. *Milton Avery Monotypes,* cat. nos. 6 and 14, ills.). Associated American Artists, New York, October 3-28, 1977 (cat.: *Milton Avery Monotypes,* nos. 26 and 27).

BIBLIOGRAPHY:
See cat. no. 89.

In the two scapes shown here Avery took advantage of streaks left by plate-wiping and made them the ground for his much bolder strokes. Using brush bristles and handle he tossed up waves and gulls in one breath and in another planted white birch trees, leafless yet basking in green.

C.I.

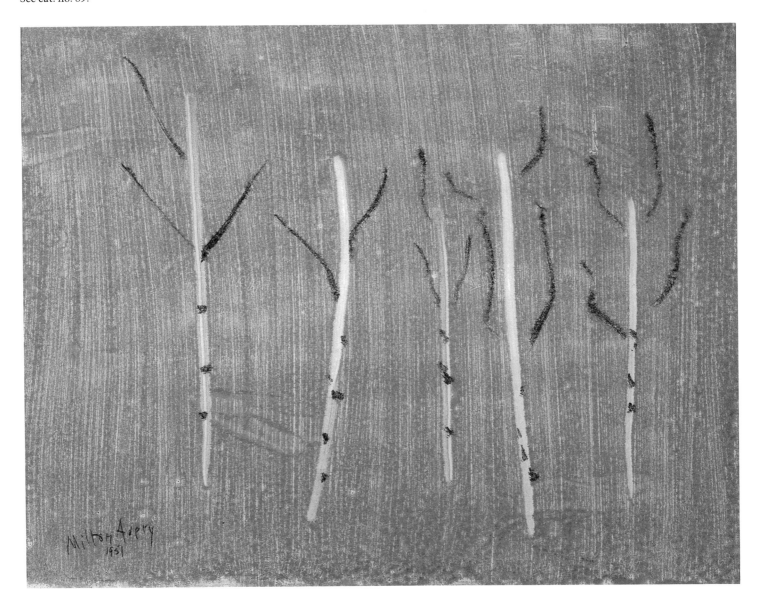

Mark Tobey
American, 1890-1976

93. Untitled, 1961

Color monotype in orange and brown tempera
on Japan tissue
Plate, 19¼ x 10 inches (48.9 x 25.4 cm.);
paper, 22¼ x 12¾ inches (56.5 x 32.4 cm.)
Signed and dated, lower right
The Metropolitan Museum of Art, New York
Purchase, John B. Turner Fund, 1972.650

PROVENANCE:
Royal S. Marks, New York.

BIBLIOGRAPHY:
Mark Tobey. Exhibition catalogue. Paris: Musée
des Arts Décoratifs, 1961, nos. 282-86 (ills.), p. 32.
Les Monotypes de Tobey. Exhibition catalogue
with text by Annette Michelson. Paris: Galerie
Jeanne Bucher, April 1965 (exhibition traveled to
Galerie Alice Pauli, Lausanne). Wheelen, Guy.
"Les Monotypes de Mark Tobey," *Les Lettres
Françaises,* April 15, 1965. Peillex, G. "Monotypes
de Mark Tobey." *Werk,* vol. 52 (December 1965),
pp. 288-89. *Mark Tobey.* Exhibition catalogue
with text by Wieland Schmied. Amsterdam:
Stedelijk Museum, 1966, nos. 85, 99 (ill.), 100-103,
108 (exhibition traveled to Kestner-Gesselschaft,
Hanover; Kunsthalle, Bern; and Düsseldorf
Kunsthalle). Phillips, Matt. "The Monotype."
Artist's Proof, vol. 8 (1968), p. 58. *Mark Tobey.*
Exhibition catalogue with text by John Ashbery.
New York: M. Knoedler & Co., 1976, nos. 54-56,
ills. pp. 59-60.

In 1957 Mark Tobey wrote to friends, "I must strike new ground – regardless of declining years."[1] Three years later, at the age of seventy, he struck out for Basel, Switzerland, and there for the first time began to make monotypes.

Changes and movement are essential to Tobey's work which is marked by transitions in style, subject matter, and technique that are based on a personal brand of logic. His art is basically graphic (his best-known paintings are called "white writing") and he always preferred to work on paper, usually in tempera. Throughout his career, weaving lines and blotches into dynamic patterns consumed his interest. The influence of Oriental brushwork dominated from the time Tobey began studying Chinese calligraphy in 1923; as late as 1957 he started a series of paintings in sumi (ink).

Pursuing new ways to stir up surfaces, Tobey printed monotypes throughout the 1960s. He also worked on color lithographs and aquatints during those years, but they are not nearly so refined in feeling and invention as the monotypes.

Tobey claimed a kinship with Klee and it may be that having settled in Klee's old environs, he was inspired by that artist's pictures painted on glass and printed with string. Tobey printed from a variety of unorthodox materials including polystyrene, fiberglass, foam rubber, and sponges. He drew in tempera, glue, varnish, and sometimes a wax crayon that resisted paints.

Although his work had been predominantly non-representational since 1944, Tobey stretched the willing monotype medium to encompass the major themes of a lifetime. We therefore find in these monotypes faces, figures, crowded places, fragments of sky and earth, as well as spiritual offerings that crackle and smoke.

C.I.

1. Mark Tobey to Joyce and Arthur Dahl, April 23, 1957, quoted in *Mark Tobey: Paintings from the Collection of Joyce and Arthur Dahl* (Stanford, Calif.: Stanford University, 1967), p. 10.

Marc Chagall
Russian, born 1887

94. Lovers and Two Bouquets, 1963

Color monotype in oil paint
Plate, 23 x 16½ inches (58.5 x 42 cm.);
paper, 33¼ x 24⅜ inches (84.5 x 62 cm.)
Signed, lower left
Collection of Gérald Cramer, Geneva

REFERENCE:
Leymarie, Jean. *Marc Chagall Monotypes 1961-1965.* Catalogue by Gérald Cramer. Geneva: Editions Gérald Cramer, 1966, cat. no. 108.

BIBLIOGRAPHY:
Marc Chagall: Monotypes en Noir et en Couleurs 1961-1963. Exhibition catalogue. Geneva: Galerie Gérald Cramer, 1964. *Marc Chagall: Monotypes.* Exhibition catalogue. Lucerne: Galerie Rosengart, 1965. Phillips, Matt. "The Monotype." *Artist's Proof,* vol. 8 (1968), p. 53. Woimant, Françoise. *Chagall: L'Oeuvre Gravé.* Exhibition catalogue. Paris: Bibliothèque Nationale, 1970, nos. 203-10, p. 115. Leymarie, Jean. *Marc Chagall: Monotypes 1966-1975.* Catalogue by Gérald Cramer. Geneva: Editions Gérald Cramer, 1976. *Marc Chagall: Ausgewählte Graphik.* Exhibition catalogue. Munich: Haus der Kunst München, 1978, cat. nos. 28, 32, 50, 51.

Few artists have made as many monotypes as Marc Chagall. After a preliminary attempt in the medium was prompted by his dealer Gérald Cramer in 1961, Chagall produced, in six successive sessions during the years 1962-75, a total of 308 monotypes. At his studio near Vence, he set aside a few days at a time to paint with oil paints on metal plates that were printed with a handpress. Jean Leymarie describes Chagall's quick work with brushes, brush handles, fingers, and fingernails. Apparently, the technique suited his hand "like a glove," responding readily to his impetuous gestures. The pigments thinned with turpentine and wiped for highlights approximated the texture of his paintings as well as the radiant colors in his stained-glass windows.

A painter, printmaker, potter, and sculptor, Chagall is obviously attracted to experiments in all media. He made his first etchings, lithographs, and woodcuts in 1923 and since then, whenever printmaking has captured his imagination, he has labored to extract its every possibility. The etchings he produced for Vollard in Paris during the 1920s and 1930s are a surprising mix of techniques, as are the color lithographs of the fifties worked with brushes, pens, and knives in every degree of ink consistency. Since, over the years, his prints have become progressively more painterly, more brightly colored and varied in their handling, Chagall's adoption of the monotype medium in the sixties was almost predictable.

Like subjects from the Bible and the circus, sweethearts and flowers have figured all along in Chagall's paintings and prints, dating at least as far back as 1915 when he painted two foot-loose lovers (himself and his fiancée) celebrating with a bouquet in *The Birthday.* In the monotype shown, flowers are foremost; a couple is glimpsed in the doorway across the room. The still life is one of those positioned in the artist's studio and recognizable in more than one picture. Its sunny temperament reminds us that Chagall's home, once Kiev, Berlin, Paris, or New York, now is in the cloudless south of France.

C.I.

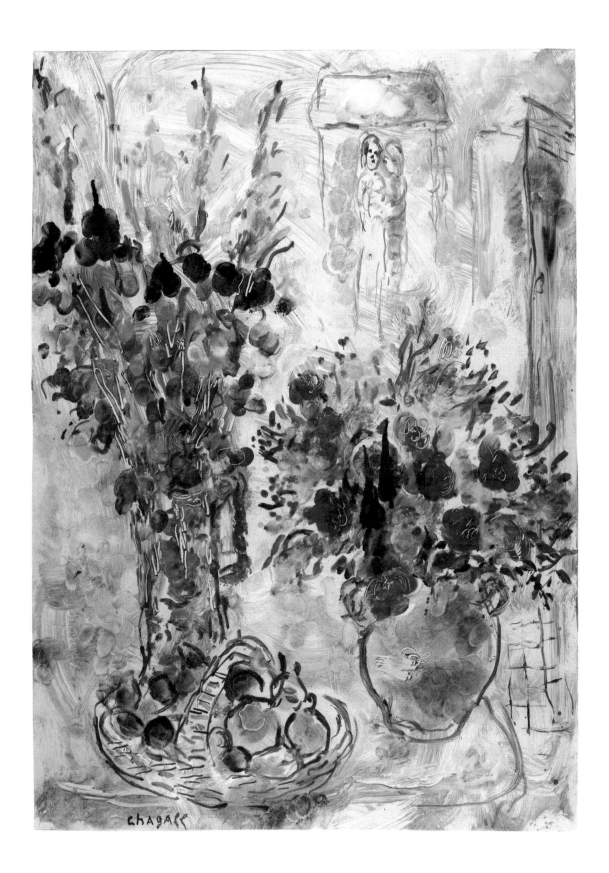

Adolph Gottlieb
American, 1903-1974

95. Untitled, 1974

Color monotype in black and red inks with yellow oil paint
Plate, 20⅛ x 30¾ inches (51.1 x 78.1 cm.);
paper, 27½ x 39¼ inches (69.9 x 99.7 cm.)
Initialed in the plate; estate seal and facsimile signature
Private collection, New York

BIBLIOGRAPHY:
Siegel, Jeanne. "Adolph Gottlieb at 70." *Art News,* vol. 72 (December 1973), pp. 57-59. Russell, John. "Adolph Gottlieb: Late Works and Monotypes." Review of exhibition at André Emmerich Gallery, New York. *The New York Times,* February 17, 1978.

Adolph Gottlieb made forty monotypes between 1973 and 1974, the last year of his life. The medium of monotype accommodated his physical limitations resulting from a stroke at the same time it suited his undiminished creative energy. While confined to a wheelchair, he brushed and rolled paints and inks onto metal plates, wiping them here and there with chips of cardboard, rags, or brushes, sometimes adding color to the paper before or after it was printed.

Having made woodcuts and etchings in the thirties and forties, silkscreens in sixties, Gottlieb was skilled in printmaking techniques. He intended to make aquatints on the etching press that was installed in his East Hampton studio in 1973, but lacking technical assistance decided to print monotypes instead since their production required less help.

As if to summarize his career as a painter, Gottlieb referred in his monotypes to the major themes that had appeared in his canvases. His very last monotype, illustrated here, combines the scribbled signs of his early Pictographs, the sweep of his Imaginary Landscapes, and the familiar discs hovering over x's, arcs or mid-air explosions in the pictures called Bursts. There is the same keen awareness of the power of color, satisfaction in balanced order, and joy in the handling of paint.

C.I.

Michael Mazur

American, born 1935

96. Window Sequence (Fire), 1974

Pair of monotypes in blue tinted etching ink
Each plate, 25¼ x 17¾ inches (64.1 x 45.1 cm.);
each paper, 30¾ x 22¾ inches (78.1 x 57.8 cm.)
Each print signed and dated in pencil, lower right
The Metropolitan Museum of Art, New York
Purchase, John B. Turner Fund, 1978.664.1-2

EXHIBITION:
Impressions Gallery, Boston, *Discover the
Monotype,* February 18 – March 31, 1977.

REFERENCE:
The Print Collector's Newsletter, vol. 9, no. 5
(November-December 1978), ill. p. 159.

BIBLIOGRAPHY:
Michael Mazur: Vision of a Draughtsman. Exhi-
bition catalogue with text by Frank Robinson.
Brockton, Mass.: Brockton Art Center, 1976, pp.
6-7, cat. nos. 66-67, 80-83, 96, 98-113, 118; ills. pp.
34-35, 38-39. Klausner, Betty. *Contemporary
Monotypes.* Exhibition catalogue. Santa Barbara:
Santa Barbara Museum of Art, 1976. Farmer, Jane
M. *New American Monotypes.* Traveling exhibi-
tion catalogue. Washington, D.C.: Smithsonian
Institution Press, 1978, pp. 28-29. Allara, Pamela.
"Michael Mazur." *Art News,* vol. 78 (March 1979),
p. 48.

Since 1968 when he saw Degas's monotypes exhibited at the Fogg Art Museum, Michael Mazur has made hundreds of monotypes. He has taught a course in monotype at Harvard's Carpenter Center for the Visual Arts and believes that making monotypes has limbered up his painting arm by allowing him to test new ideas swiftly and easily. He considers himself a painter first, but has experimented avidly with printmaking since training with Leonard Baskin and Gabor Peterdi in the late 1950s and early 1960s. He began right away to combine various techniques: drypoint, etching, and aquatint, later adding the tracks of an electrical engraver and a sander.

Mazur has said that his "most valued tools are not the ones that make the mark but those that erase or soften it: the scraper, the eraser, and the rag." His early prints, like his charcoal and wash drawings, are fretfully smudged and everywhere lines are obscured. The preference for shadow over line explains Mazur's absorption in the lush inkiness of monotype and his concurrent interest in agreeably fuzzy pastel which he, like Degas, sometimes applies to his monotypes.

Looking for new subjects as well as new materials, Mazur has fixed on daydreamy and sometimes nightmarish visions stimulated by sights at home, in his studio, and in places he has visited. For a while he studied inhabitants of controlled environments: the patients in a mental hospital, plants in a greenhouse, fish in an aquarium, and monkeys at the zoo. More recent monotypes feature the color-drenched rollers in his printing shop, and runners jogging on the banks of the Charles River.

Mazur likes things in flux, moving, shifting in their relationship to us, and since with monotypes he can easily trace changes, he may unroll a narrative in a series of prints, adding or subtracting elements as he inks over the same plate. In one seven-image sequence called *The Visitor,* we are shown first of all a porch, then a chair, next a figure sitting in the chair, and in the last frame, the disappearance of the figure. The window in the two-part sequence seen here glows ominously, then vents a fire. Once the first image had been printed, Mazur rolled fresh ink onto the plate, then tamped it with rags and the palm of his hand to cloud it.

C.I.

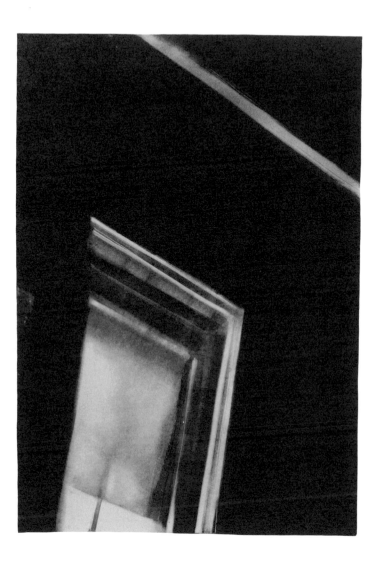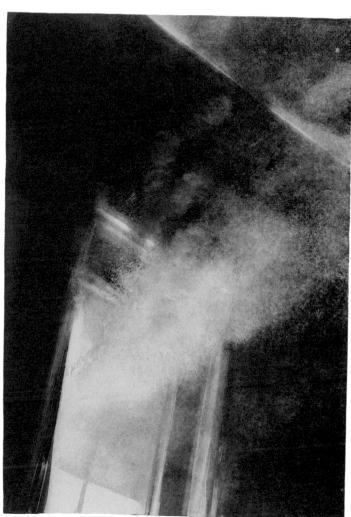

Richard Diebenkorn

American, born 1922

97. IX, 4-13-75 and X, 4-13-75

Two monotypes in black ink from a series of ten
made on April 13, 1975
Each plate, 13⅞ x 10⅞ inches (35.2 x 27.6 cm.);
each paper, 25⅞ x 19⅜ inches (65.7 x 49.2 cm.)
Each print initialed and dated in pencil
Collection of Mr. and Mrs. R. Diebenkorn,
Santa Monica, California

EXHIBITIONS:
Frederick S. Wight Art Gallery, University of
California, Los Angeles, 1976 (cat: Nordland,
Gerald. *Richard Diebenkorn Monotypes*, pls. 41,
42). Stanford University Museum of Art, 1976-77
(see *The Stanford Museum*, vols. 6-7 [1976-77],
p. 66).

BIBLIOGRAPHY:
Perlmutter, Elizabeth. "Los Angeles: Salton Sea to
Muscle Beach." *Art News*, vol. 75 (April 1976), p.
68. Farmer, Jane M. *New American Monotypes.*
Traveling exhibition catalogue. Washington,
D.C.: Smithsonian Institution Press, 1978, pp. 10,
18-19.

No living artist has had greater success in making monotypes than Richard Diebenkorn. In just two sessions of a few days each in 1974 and 1975 he produced five series of prints that are amply beautiful in themselves while providing an effective demonstration of Diebenkorn's exacting methods of composition.

Although he made a few experimentally inked woodcuts in the 1950s and has produced etchings and lithographs at various California printshops in recent years, Diebenkorn does not consider himself a printmaker and shies from involvement in the technical processes. When Nathan Oliveira sent him catalogues of monotypes (one of Oliveira's monotypes, the other of Degas's) and his interest in this technique was sparked, he sought experienced help, first from Santa Monica printer George Page and later from Oliveira who invited him one weekend to share the press at Stanford University.

Diebenkorn considers his encounters with monotype rewarding, valuing his use of the medium to record the successive stages in a composition's development. Monotyping allowed him to keep a pictorial idea intact (by printing it) while he revised its traces left on the printed plate. His special interest in his monotypes depends upon their importance as a sequence, displaying continuity and variation from one image to another.

While printing monotypes at Stanford Diebenkorn sketched a short history of his painting career, working through the decorative "spade" and "club" motifs of earlier years and proceeding to the refined geometry of his Ocean Park oils begun over a decade ago and still in progress. His last series of ten monotypes, done on April 13, 1975, starts with a rumpled, inky curtain that is gradually stretched into light-struck veils. Numerals applied consecutively to plates in this set play more important roles as the series unfolds, and in the last two plates (seen here) their numbers, IX and 10, are prominent. Signaling his arrival at a solution to the compositional puzzle worked through in ten stages, Diebenkorn switched at this point from the sturdy European paper he had been printing on to a delicate Japan.

Diebenkorn's monotypes, like his Ocean Park paintings (named after a section of Santa Monica where he established a studio), bear the contradictions of their very formal order and their casual (or so it seems) handwork. Beneath their taut linear structure confessions of false starts and corrected errors are revealed. Forms that are introduced, obliterated, and reinstated enrich the surface with their pentimenti. Diebenkorn has clarified his vision by looking at Cézanne, Matisse, and Mondrian, and he continues to learn from himself. Making monotypes is one more way for him to explore the options.

C.I.

Robert Motherwell
American, born 1915

98. Untitled No. 1, 1976

Color monotype in black and red etching inks
29½ x 37 inches (74.9 x 94 cm.)
Signed in plate, upper left, and margin, lower right
Collection of George Gelles, New York

EXHIBITIONS:
Brooke Alexander Gallery, New York, December
4, 1976-January 4, 1977 (cat: *Robert Motherwell,
Monotypes 1974/1976,* unlisted). University of
Connecticut, Storrs, *Robert Motherwell and
Black,* March 19-June 3, 1979.

BIBLIOGRAPHY:
Colsman-Freyberger, Heidi. "Robert Motherwell:
Words and Images." *The Print Collector's News-
letter,* vol. 4, no. 6 (January-February 1974), pp.
125-29. "Robert Motherwell" at Brooke Alexan-
der Gallery, New York. *Arts,* vol. 51 (February
1977), p. 24. Farmer, Jane M. *New American
Monotypes.* Traveling exhibition catalogue.
Washington, D.C.: Smithsonian Institution Press,
1978, pp. 30-31.

Robert Motherwell is a painter, printmaker, collage-maker, and a lover of language. His writing spills onto canvas, but most of it is put on paper which is, he says, his favorite ground. Motherwell's calligraphy is forceful and bold; even writ small it looks mountainous.

Although he studied etching with Kurt Seligmann and Stanley William Hayter in the 1940s, Motherwell did not become seriously involved in printmaking until 1961 when he began to make lithographs at Tatyana Grosman's workshop on Long Island, where his appreciation for paper's aesthetic properties was shared. He has since printed etchings, aquatints, and silkscreens, occasionally combining these techniques with lithography and collage in unexpectedly logical ways.

While proofing the aquatints for his *livre d'artiste, A la Pintura,* Motherwell became interested in the sensitive inking of plates, and since then he has introduced hand-inking in his printed work. He set up his own print studio in a former stable on his Connecticut grounds in 1973, and in May the next year, encouraged by print publisher Brooke Alexander, made his first group of monotypes, followed by a second in 1976, each comprising between fifty and sixty prints.

The monotypes of 1974 are usually marked by lines, blotches, and spatters of acrylic ink on a white ground; those of 1976 offer white streaks on a dark ground of oil-based ink rolled across a metal plate, then wiped like lightning. Motherwell's satisfaction in the materials and physical activity of drawing and painting, the pushing, dragging, and flinging of pigment, is vitally realized in these monotypes. Here, too, is his lifelong devotion to the color black, so deeply felt in the series titled Spanish Elegies, and dating at least to 1943 when he began to paint his nearly totally black canvases.

C.I.

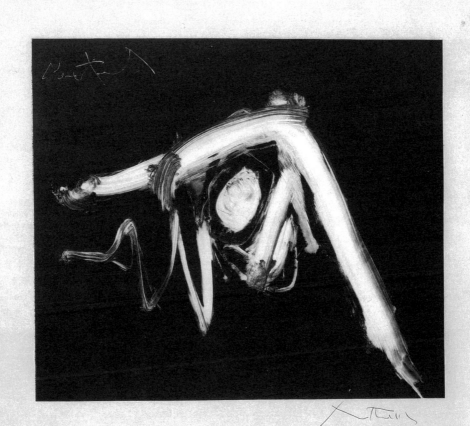

Sam Francis

American, born 1923

99. Untitled, 1977

Color monotype in oils and dry pigments
Handmade paper, 22½ x 28¼ inches (57.2
x 71.8 cm.)
Signed and dated in pencil on verso
The Metropolitan Museum of Art, New York
Purchase, John B. Turner Fund, 1980.1000

BIBLIOGRAPHY:
Selz, Peter. *Sam Francis.* With an essay on his
prints by Susan Einstein. New York: Harry M.
Abrams, 1975. Farmer, Jane M. *New American
Monotypes.* Traveling exhibition catalogue.
Washington, D.C.: Smithsonian Institution Press,
1978, pp. 20-21.

Sam Francis was the first American to celebrate action painting in a significant body of prints. He began tossing, spilling, and dripping ink onto lithographic stones in 1959, and since then has worked in printing shops around the world – in California, New York, Switzerland, and Japan. In 1970 he opened his own lithography workshop near his studio in Santa Monica.

Although Francis obviously enjoys painting large, often mural-size canvases, some of his most exciting work has been done in watercolor, gouache, acrylic, or oil on paper. He often experiments in prints or drawings, trying out various ways of layering color before moving on to canvas. In the sixties he practiced changing the colors as well as the printing order of the stones in his lithographs so that no combination was repeated and each print was unique.

A painter who has sent helicopters up in the clouds and skiers down snowy slopes with cans of color and instructions to paint the sky, Francis follows no formulas for creating art. A fresh background is important to him, however, and since 1974 he has made monotypes on the handmade papers cast by Garner Tullis at the Institute of Experimental Printmaking in San Francisco. These coarsely textured papers soak up and puddle pigments in pleasantly unpredictable ways. They will also hold the imprint of metal plates stacked up and put through the press all at once, as they were in the monotype shown here. Piling one plate on top of another, Francis rimmed straight edges with paint then showered on colors in the *haboku,* or flung-ink style he mastered in Japan.

Grids and colored boxes figure prominently in Francis's monotypes, as they do in his paintings of the last decade. In 1972 his first Mandala paintings appeared, featuring as the monotype here does, the arrangement of concentric forms that in Eastern cultures represents the cosmos, and in Jungian psychology symbolizes the effort to unify the self. Francis's ongoing concern with perimeters and centers is admirably served by this configuration.

C.I.

Mary Frank

American, born in England, 1933

100. Amaryllis, 1977

Color monotype in two parts
Each plate, 17¾ x 23¾ inches (45.1 x 60.3 cm.);
each paper, approx. 22¼ x 29½ inches (56.5
x 74.9 cm.)
Signed and dated, lower right
The Metropolitan Museum of Art, New York
Purchase, Stewart S. MacDermott Fund,
1977.550(a&b)

EXHIBITIONS:
Zabriskie Gallery, New York, 1977. The Met-
ropolitan Museum of Art, New York, *Recent Ac-
quisitions*, December 1977 – February 1978.
Neuberger Museum, Purchase, New York, 1978
(cat: Hayden Herrera. *Mary Frank: Sculpture,
Drawings, Prints*, cat. no. 112; see also pp. 27-33).

REFERENCE:
Munro, Eleanor. *Originals: American Women
Artists*. New York: Simon & Schuster, 1979,
pp. 305-306.

BIBLIOGRAPHY:
Kingsley, April. "Mary Frank: 'a sense of time-
lessness.'" *Art News*, vol. 72 (Summer 1973), pp.
66-67. *Mary Frank: Sculpture, Drawings and
Monotypes*. Exhibition catalogue. Chicago: Arts
Club of Chicago, 1976. Farmer, Jane M. *New
American Monotypes*. Traveling exhibition cata-
logue. Washington, D.C.: Smithsonian Institution
Press, 1978, p. 21. Ratcliff, Carter. "Mary Frank's
Monotypes." *The Print Collector's Newsletter*,
vol. 9, no. 5 (November-December 1978), pp. 151-
54.

Like her ceramic sculptures of women lying on the ground or striding against wind and waves, the subjects of Mary Frank's monotypes are in close contact with the forces of nature. They are Daphne: woman turned to tree; or they are water lily, poppy, laurel, and amaryllis: leaf turned to flower.

Before she began to sculpt, Mary Frank learned to draw. She is a pro-lific, admittedly compulsive sketcher, and fills books with drawings made in her studio, in museums, or in the woodland garden that sur-rounds her Lake Hill, New York, retreat. In 1967 she made a painting on glass, and when told she could print it, she produced her first monotype.

The monotype process fits comfortably into her hands since it can be, and is especially for her, partly drawing, partly sculpture. She coaxes ink physically, pushing it with rollers and brushes, pulling it away with rags, and piling up colors so that they glow through each other. Should an image grow too large for the press or for the zinc plates she draws on, she adds another section, as is her practice in forming monumental clay figures pieced together of parts just large enough to fit the kiln. Close in scale, color, and texture to these large stoneware figures is a monotype made in 1976 of Daphne whose limbs stretch out over three sheets of paper and reach four feet in height.

The luxuriant surfaces produced in monotypes are particularly sym-pathetic to Mary Frank's romantic nature. And the ease with which the medium allows her to alter an image by adding ink or wiping it away is especially appealing to her. Since the inking process invites improvisa-tion she has recently introduced elements of collage and stencil. She frequently, as in this *Amaryllis*, prints plates in series, either enriching successive impressions with additional color or allowing the images to pale like ghosts. In monotypes' quicksilver changeability Mary Frank finds magic.

C.I.

Joan Miró

Spanish, born 1893

101. Untitled, 1977

Color monotype in oil paint with additions by
hand
22⅞ x 18⅞ inches (58 x 48 cm.)
Signed at right
Collection of Henry D. Ostberg and Jerry
Brewster, New York

PROVENANCE:
Galerie Maeght.

Miró has given tangible proof of his sensitivity to and respect for the materials of art during a lifetime devoted to fine craftsmanship in painting, sculpture, collage, ceramics, drawings, and prints. Beginning in the 1930s he has applied himself to printmaking with extraordinary vigor, and since then he has produced works fairly bursting with creative energy. The importance of his prints within his entire output may be estimated by the fact that Miró has made many of them the fortunate messengers of his most appealing and mind-boggling statements.

Now in his eighties and still our leading Surrealist, Miró maintains his fascination with the challenge of unleashing the subconscious through freely scribbled signs and symbols. He has continually sought new ways in which to express his liberated spirit and to this open-minded search we owe quantities of colorful etchings, lithographs, and aquatints plus the production, in 1977, of a group of hand-colored aquatints and nine monotypes printed from oil paintings on glass plates. These monotypes make the most of Miró's attachment to the heavily laden paint brush, to the bold ciphers he formulates in fearlessly rapid gestures, and to his perpetual alliance with the mysterious vagaries of chance.

C.I.

Nathan Oliveira
American, born 1928

102. Walking Woman with Staff, 1977

Color monotype with touches of watercolor
26½ x 22 inches (67.3 x 55.9 cm.)
Signed in pencil, signed and dated in plate: *8.11.77*
Collection of Mr. and Mrs. Harry W. Anderson,
Atherton, California

BIBLIOGRAPHY:
Heyman, Therese Thau. *Monotypes in California.*
Exhibition catalogue. Oakland: Oakland Museum, 1972, no. 36. Eitner, Lorenz. *Nathan Oliveira, Tauromaquia 21.* Exhibition catalogue.
Palo Alto: Galerie Smith Andersen, 1973.
Laliberté, Norman, and Mogelon, Alex. *The Art of Monoprint: History and Modern Techniques.*
New York: Van Nostrand Reinhold, 1974, p. 60.
Nordland, Gerald. *Nathan Oliveira.* Exhibition catalogue. New York: Dorsky Galleries, 1975.
Klausner, Betty. *Contemporary Monotypes.* Exhibition catalogue. Santa Barbara: Santa Barbara Museum of Art, 1976. Farmer, Jane M. *New American Monotypes.* Traveling exhibition catalogue. Washington, D.C.: Smithsonian Institution Press, 1978, pp. 9, 32-33. Johnson, Robert Flynn. *American Monotypes: 100 Years.* Exhibition catalogue. New York: Marilyn Pearl Gallery, 1979, nos. 20-21. Smith, Michael H. *Nathan Oliveira: A Survey of Monotypes, 1973-78.* Traveling exhibition catalogue. Pasadena: Baxter Art Gallery, California Institute of Technology, 1979.

While a student in California, Nathan Oliveira began protecting the oil paintings he was working on by covering them overnight with sheets of newsprint. He was immediately intrigued by the images that were transferred from his canvases onto their paper covers, but not until the 1960s did he consider pictures printed this way works of art in themselves.

Oliveira credits Eugenia Janis's 1968 catalogue of Degas's monotypes with prompting his first serious efforts in that medium. He had become actively involved in printmaking after his appointment to the faculty of Stanford University in 1964 and frequently experimented with ways of achieving density and texture in his prints. At first he painted over proofs of his lithographs with acrylic pigments. Then, in 1969, he began making monotypes by painting on glass plates and printing them with a brayer.

When he was given a large batch of hand-laid paper in 1973, Oliveira decided to use it in a special way. He combined his respect for traditional printmaking with his own painterly inclinations by making a series of nearly a hundred monotypes based on one of Goya's bullfight etchings, plate 21 of the *Tauromaquia.* Oliveira painted one variation after another onto a copperplate and printed each on a press. The traces of ink left on the plate after it was printed helped to determine the course of each succeeding interpretation, so that when the series is viewed as a whole one sees its graphic evolution. The Tauromaquia series was followed the next year by a group of some thirty monotyped interpretations of another Old Master print, Rembrandt's *Three Crosses.*

Beginning in 1975 Oliveira developed both a highly sophisticated method of printing monotypes and a very personal subject matter. His series of Sites, Site Interiors, and Bundles, made over the past five years, remind us in the objects they depict of the outfittings of primitive tribes: tent poles, sleds, crossbows, and magic fetishes. Precise in detail but elusive in meaning, these still-life compositions seem to glow. Their phosphorescence comes from colored inks that have been thinned with turpentine and printed one on top of the other sometimes as many as ten to twelve times.

Oliveira's fascination with nomadic peoples and exotic artifacts continues to furnish his monotypes. His portraits of women called Shaman done in 1977-78 evidence a strong revival of his early interest in depicting the single figure standing, walking, or sitting in an undefined space.

C.I.

Matt Phillips

American, born 1927

103. Blue Phantom III, 1977

Color monotype in thinned oil paints of black, blue, and brownish hues
26¾ x 15 inches (67.9 x 38.1 cm.)
Signed and dated, lower left
Donald Morris Gallery, Birmingham, Michigan

EXHIBITION:
The Phillips Collection, Washington, D.C., and Des Moines Art Center, 1978 (cat: *Matt Phillips: Monotypes 1976-1977.* With text by Judith Goldman, no. 19 [ill.]).

BIBLIOGRAPHY:
Phillips, Matt. "About Monotypes." *Prometheus.* Newsletter of the Makler Gallery, Philadelphia, March 1962. Moses, Paul. *Matt Phillips: Monotypes and Other Media.* Exhibition catalogue. New York: Peter Deitsch Gallery, 1965. Phillips, Matt. "The Monotype." *Artist's Proof,* vol. 8 (1968), pp. 50-59. Phillips, Matt. *The Monotype: An Edition of One.* Exhibition catalogue. New York and Washington, D.C.: Bard College and the Smithsonian Institution Traveling Exhibition Service, 1972. Phillips, Matt. *Monotypes.* Exhibition catalogue. New York: Pratt Graphics Center, 1972. Field, Richard S. *Matt Phillips: Monotypes.* Exhibition catalogue. New York: William Zierler, Inc., 1973. Johnson, Robert Flynn. *Matt Phillips: Monotypes, 1961-1975.* Exhibition catalogue. Baltimore: Baltimore Museum of Art, 1976. Klausner, Betty. *Contemporary Monotypes.* Exhibition catalogue. Santa Barbara: Santa Barbara Museum of Art, 1976. Farmer, Jane M. *New American Monotypes.* Traveling exhibition catalogue. Washington, D.C.: Smithsonian Institution Press, 1978, pp. 34-35. Johnson, Robert Flynn. *American Monotypes: 100 Years.* Exhibition catalogue. New York: Marilyn Pearl Gallery, 1979, nos. 22 and 23. Sawin, Martica. *Matt Phillips: Monotypes.* Exhibition flier. New York: Marilyn Pearl Gallery, 1979.

Matt Phillips started making monotypes in 1959. Since then he has been the medium's most active practitioner and proselytizer. He has written articles about the process and history of monotype-making and has organized exhibitions of monotypes by Maurice Prendergast, Milton Avery, and Abraham Walkowitz.

Phillips noticed monotypes by Paul Rohland at the Barnes Foundation where he studied in 1950-51, but later found Degas and Prendergast more inspiring. In his seascapes, candy-colored and naive, there is a debt to Avery, while Walkowitz's bulky nudes might have modeled for his bathers.

Among the pleasant subjects Phillips chooses are the hillsides, fields, and marketplaces of sunny climes he has visited: Spain, Morocco, Guatemala, and elsewhere. At home he is comfortable in rooms such as the one depicted in *Blue Phantom III,* where there is a familiar and decorative clutter (including the magician's prop called a Blue Phantom, seen in the central foreground) and his wife, Sandy, reading the newspaper.

Phillips patches scenery together with color-laden brushes and fingers, here and there wiping spaces clean. The white of the paper, retrieved with rags has become increasingly important for Phillips, especially since the early 1970s when he enlarged the scale of his compositions and simplified them at the same time.

An amateur magician, Phillips no doubt appreciates monotypes' chance results. Moreover he enjoys turning his prints into something else. No other artist is known to have illustrated original manuscripts with monotypes, to have constructed folding screens from them, or to have printed monotypes, as he has, on canvas and framed them to hang on the wall like paintings.

C.I.

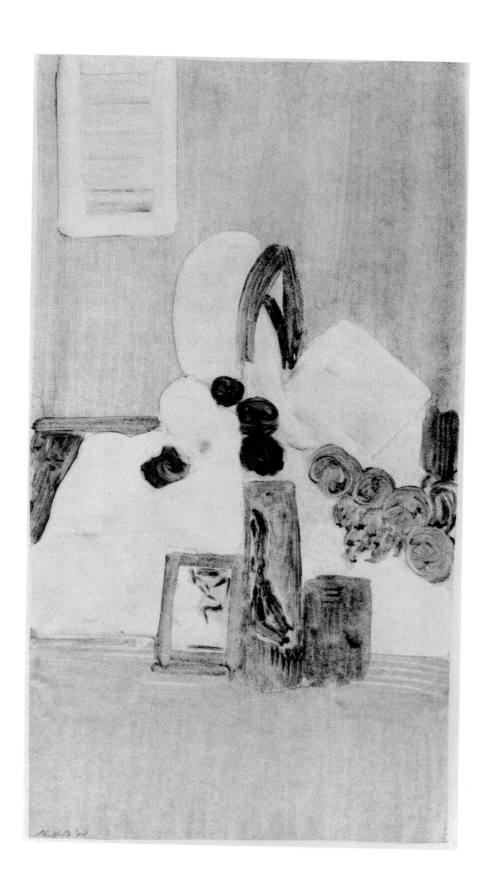

Wayne Thiebaud

American, born 1920

104. Freeway Curve, 1977

Monotype
22 x 30 inches (55.9 x 76.2 cm.)
Signed and dated, lower right
Collection of Mr. and Mrs. Harry W. Anderson,
Atherton, California

EXHIBITION:
San Francisco Museum of Modern Art, *Recent
Works by Wayne Thiebaud*, May 17-June 25, 1978.

BIBLIOGRAPHY:
Wayne Thiebaud: Graphics 1964-1971. Traveling
exhibition catalogue. New York: Parasol Press,
1971. Farmer, Jane M. *New American Monotypes.*
Traveling exhibition catalogue. Washington,
D.C.: Smithsonian Institution Press, 1978, pp. 40,
41. Atkins, Robert. "Wayne Thiebaud." Review of
exhibition at San Francisco Museum of Modern
Art. *Arts,* vol. 53 (September 1978), p. 13.

Wayne Thiebaud frankly delights in the substance of paint and applies it to canvas so thickly it stands up in ridges in the wake of his brush. With wit and a confectioner's panache he has frosted cakes, glazed apples, and creamed pies that are trademarks of his paintings. He has also practiced nearly every traditional printmaker's process that could call for inking wood, metal, stone, linoleum, or silk. When Nathan Oliveira invited him to make monotypes at Stanford University in 1977, Thiebaud started printing up what he calls "the backside of the brushstroke," and to date, he has made well over a hundred monotypes.

In the mid-1960s there began to appear, among Thiebaud's displays of pastries and brightly colored toys, slices of California's dizzying landscape, its eroded cliffs and earthquaked ridges. To these have been added, in the last three or four years, cityscapes of San Francisco and its roller-coaster streets that invite police-car chases.

Freeway Curve, one of a sequence of monotypes, relates to Thiebaud's cityscape paintings, but its clipped focus on a high-speed road (as seen from an overpass) typifies the simplification that takes place when Thiebaud pares down one of his themes for the press. Under the glaring light and play of shadows this is sweet and simple geometry: a cake-wedge of highway, lusciously iced with candy-striped lanes and rows of matchbox trucks and cars.

C.I.

Jasper Johns

American, born 1930

105. Savarin, 1977-78

Monotype/monoprint in color inks
Image, 18 x 13⅛ inches (45.7 x 33.3 cm.);
Japan paper, 27½ x 19½ inches (69.9 x 49.5 cm.)
Signed and dated in plate: 1977; signed and dated
in pencil: 1978, numbered 1/4
Collection of the artist

BIBLIOGRAPHY:
Field, Richard S. *Jasper Johns: Prints 1960-1970.*
New York: Praeger Publishers in association with
the Philadelphia Museum of Art, 1970; see cat.
nos. 74, 81, 88. Field, Richard S. *Jasper Johns:
Prints 1970-1977.* Middletown, Conn.: Wesleyan
University, 1978; see pp. 56, 122.

Because of his supreme skill as a printmaker, Jasper Johns has managed to produce in prints the kind of dense and excitingly tactile surfaces we expect to find only in paintings. His success is based on a readiness to complicate infinitely the printmaking process and a compulsive urge to, in the artist's words, "Take an object/ Do something to it/ Do something else to it." This command applies to materials, like etching plates and lithographers' stones, as well as to subjects, like targets, flags, and ale cans.

The stock-in-trade objects Johns fixes on repeatedly figure in works in various media, as does the Savarin coffee can holding paint brushes that he first sculpted in bronze in 1960, then etched, photoengraved, and aquatinted in the years 1967-69 and later, in 1977, printed as a monumental 17-color lithograph. The monotype illustrated here is a by-product of a series of six Savarin lithographs dating from 1977. It began as a drawing on a prepared aluminum plate discarded from that set but retrieved in 1978 when Johns painted it with multicolored inks and printed it. He brushed the colors on so thickly and controlled the pressure of the offset press so carefully that four impressions could be taken before the plate surrendered all its ink. This impression is the first printed.

Johns, who delights in presenting layers of meaning in layers of pigment, offers another paradoxical allegory on the painter's activity, his tools at rest while colors bolt of their own accord. There is a surprising looseness and spontaneity in the application of color here, even though we have come to expect messy surfaces on Johns's neatly organized pictures. Usually a more cautious colorist, he now ventures farther into the color wheel, but anchors himself to the primaries: red, yellow, and blue.

We may consider this image of skeletal brushes fleshed out with paint an emblem of the painter's art, but it is tempting also to interpret it as a relic of Jackson Pollock.

C.I.

1/4

Jim Dine
American, born 1935

106. Self-Portrait (with green), 1978-79

Monotype in black, green, and flesh-color oil paint
Plate, 28 x 21¾ inches (71.1 x 55.2 cm.); paper,
28½ x 22½ inches (72.4 x 57.2 cm.)
Signed and dated, lower right
The Pace Gallery, New York

BIBLIOGRAPHY:
Castleman, Riva. *Jim Dine's Etchings.* Exhibition
catalogue. New York: Museum of Modern Art,
1978. *Jim Dine. Prints: 1970-1977.* Traveling exhi-
bition catalogue with texts by Thomas Krens, Jim
Dine, and Riva Castleman. New York: Harper &
Row in association with the Williams College
Artist-in-Residence Program, 1977.

For almost two decades Jim Dine's statuesque red bathrobes, his boots, wrenches and boltcutters, painter's palette, and rainbow-tinted hearts have stood in as surrogate portraits of the artist. In recent years, however, Dine has broken barriers that kept him from picturing himself, and he says that making monotypes has helped ease him into drawing the human figure and his own face in particular. His first monotypes, made from a model in Michael Mazur's studio during the summer of 1978, disappointed him, but out of some fifty made a few months later, he found four satisfying self-portraits.

Dine is a disciplined draftsman, who prefers with his line the stuff of scratches, washes, or a drip of color. He has been making prints actively since 1960, persistently bucking conventional methods by combining techniques like aquatint and mezzotint, or etching with lithography and silkscreen. He introduces color with care, only where it counts, and right from the first began adding it by hand to drypoints of neckties and toothbrushes, then to etchings he rubbed with crayon and charcoal.

Dine's nimble ways with printmaking made him receptive to the process of monotype, and as early as 1962, when he flooded a lithograph, *Four C-Clamps,* with seductively oozing ink, there were indications that the technique would suit him. In 1975 and again in 1978 when he came to grips with self-portraiture he did so with his own complex mix of techniques, hand-painting his etched, drypointed, and lithographed plates before printing them and later hand-coloring individual prints.

The self-portraits Dine made in monotype during the winter of 1978-79 are his most intense to date. Assaulted with oil paint and pastel, aching colors piled on in three to six printings, these are resolute survivors of a personal war.

C.I.

BIBLIOGRAPHY

Books

Adhémar, Jean, and Cachin, Françoise. *Degas: The Complete Etchings, Lithographs, and Monotypes.* New York: Viking Press, 1975.

Bacher, Otto. *With Whistler in Venice.* New York: Century Co., 1908, pp. 116-21.

Butlin, Martin. *William Blake: A Complete Catalogue of the Works in the Tate Gallery.* London, 1971 (thorough bibliography).

Delogu, Giuseppe. *G. B. Castiglione detto Il Grechetto.* Bologna: Casa editrice Apollo, 1928.

Dortu, M. G. *Toulouse-Lautrec et son œuvre.* 6 vols. New York: Collectors Editions, 1971, vol. 3, pp. 532-33, M.1-M.6.

Galeries Georges Petit, Paris. *Vente Degas: Catalogue des tableaux, pastels et dessins par Edgar Degas et provenant de son atelier dont la vente . . . aura lieu à Paris . . . mai 6-8, décembre 11-13, 1918; avril 7-9, juillet 2-4, 1919.* 4 vols. Paris, 1918-19.

Galerie Manzi Joyant, Paris. *Vente d'Estampes: Catalogue des eaux fortes, vernis-mous, aquatintes, lithographies, et monotypes par Edgar Degas, et provenant de son atelier.* Paris, November 22-23, 1918.

Gallatin, Albert Eugene. *Whistler's Pastels and Other Modern Profiles.* New ed. New York: John Lane Co., 1913, pp. 13-16.

Geiser, Bernhard. *Picasso, Pientre-Graveur. Vol. I. Catalogue Illustré de l'Oeuvre Gravé et Lithographié, 1899-1931.* Bern: Geiser, 1933, cat. nos. 248-57.

_____. *Picasso, Peintre-Graveur. Vol. II. Catalogue Raisonné de l'Oeuvre Gravé et des Monotypes, 1932-1934.* Bern: Kornfeld and Klipstein, 1968, cat. nos. 445-572.

Ginestet, Colette de, and Pouillon, Catherine. *Jacques Villon: Les Estampes et les Illustrations Catalogue Raisonné.* Paris: Arts et Métiers Graphiques, 1979, pp. 388-89.

Grohmann, Will. *Oskar Schlemmer: Zeichnungen und Graphik.* Stuttgart: Verlag Gerd Hatje, 1965.

Halévy, Ludovic. *La Famille Cardinal.* Preface by Marcel Guérin. Paris: August Blaizot & Fils, 1939.

Herkomer, Hubert. *Etching and Mezzotint Engraving.* London: Macmillan Co., 1892, pp. 104-107.

Johnson, Una E. *Introduction to the Monotypes of Joseph Solman.* New York: Da Capo Press, 1977.

_____, and Miller, Jo. *Adja Yunkers Prints 1927-1967.* New York: Brooklyn Museum, 1969.

Laliberté, Norman, and Mogelon, Alex. *The Art of Monoprint, History and Modern Techniques.* New York: Van Nostrand Reinhold, 1974.

Levin, Gail. *Edward Hopper: The Complete Prints.* New York: W. W. Norton & Co. in association with the Whitney Museum of American Art, 1979, p. 9, pls. 1-5.

Leymarie, Jean. *Marc Chagall Monotypes 1961-1965.* Catalogue by Gérald Cramer. Geneva: Editions Gérald Cramer, 1966.

_____. *Marc Chagall: Monotypes 1966-1975.* Catalogue by Gérald Cramer. Geneva: Editions Gérald Cramer, 1976.

Lieberman, William S. *Matisse: 50 Years of His Graphic Art.* New York: George Braziller, 1956.

Loreau, Max. *Catalogue des Travaux de Jean Dubuffet.* Paris: Jean-Jacques Pauvert and Weber, 1966-69.

Marsh, Roger. *Monoprints for the Artist.* New York: Transatlantic Arts, 1969.

von Maur, Karin. *Oskar Schlemmer: Monographie und Oeuvrekatalog.* 2 vols. Munich: Prestel-Verlag, 1979.

Paton, Hugh. *Etching, Drypoint, Mezzotint.* London: Raithby, Lawrence & Co., 1895, pp. 103-106.

Pennell, Joseph. *Etchers & Etching.* New York: Macmillan, 1919, pp. 309-10.

Rasmusen, Henry. *Printmaking with Monotype.* Philadelphia: Chilton Co., 1960.

Rhys, Hedley Howell. *Maurice Prendergast 1859-1924*. Boston: Museum of Fine Arts, 1960.

Roof, Katharine Metcalf. *The Life and Art of William Merritt Chase*. New York: Charles Scribner's Sons, 1917, pp. 249, 250.

Rouart, Denis. *Degas à la Recherche de sa Technique*. Paris: Floury, 1945, pp. 56-63.

_____. *E. Degas Monotypes*. Paris: Quatre Chemins-Editart, 1948.

St. John, Bruce, ed. *John Sloan's New York Scene: From the Diaries, Notes and Correspondence, 1906-1913*. New York: Harper & Row, 1965, p. 120 (entry for April 7, 1907).

Vitali, Lamberto. *Incisioni Lombarde del Secondo Ottocento all' Ambrosiana*. Vicenza: Neri Pozza Editore, 1970.

Weitenkampf, Frank. *American Graphic Art*. New York: Macmillan, 1924, pp. 133-36.

_____. *How to Appreciate Prints*. New York: Charles Scribner's Sons, 1929, p. 130.

Exhibition Catalogues

Brooke Alexander, Inc., New York. *Yvonne Jacquette: Paintings, Monotypes and Drawings*, 1976.

_____. *Robert Motherwell, Monotypes 1974/1976*, 1976.

Allen Memorial Art Museum, Oberlin College, Oberlin, Ohio. *The Stamp of Whistler*. Text by Robert H. Getscher, 1977.

American Watercolor Society, New York. *Forty-third Annual Exhibition of the American Watercolor Society*, 1910.

Art Works Gallery, Hartford, Connecticut. *Monotypes Today III*. Text by Roger L. Crossgrove, 1979.

Associated American Artists, New York. *Milton Avery, Monotypes*. Foreword by Sylvan Cole, Jr., 1977.

The Baltimore Museum of Art. *American Prints 1870-1950*. Text by Robert Flynn Johnson, 1974.

_____. *Matt Phillips: Monotypes, 1961-1975*. Text by Robert Flynn Johnson, 1976.

Bard College, New York, and the Smithsonian Institution Traveling Exhibition Service, Washington, D.C. *The Monotype: An Edition of One*. Text by Matt Phillips, 1972.

Baxter Art Gallery, California Institute of Technology, Pasadena. *Nathan Oliveira: A Survey of Monotypes*. Text by Michael H. Smith, 1979.

Bibliothèque Nationale, Paris. *L'Estampe impressioniste*. Text by Michel Melot, 1974.

Brockton Art Center, Brockton, Massachusetts. *Michael Mazur: Vision of a Draughtsman*. Text by Frank Robinson, 1976.

Galerie Jeanne Bucher, Paris. *Les Monotypes de Tobey*. Text by Annette Michelson, 1965.

The Buffalo Fine Arts Academy – Albright Art Gallery, Buffalo, New York. *Catalogue of an Exhibition of Paintings by Frank C. Penfold*, March 6 – April 5, 1915, nos. 25-29.

Chapellier Galleries, New York. *William Merritt Chase: 1849-1916*, 1969.

Davis & Long Co., New York. *Charles Conder, Robert Henri, James Morrice, Maurice Prendergast: The Formative Years – Paris 1890s*. Text by Cecily Langdale, 1975.

_____. *The Monotypes of Maurice Prendergast*. Text by Cecily Langdale, 1979 (complete bibliography).

Fogg Art Museum, Harvard University, Cambridge, Massachusetts. *Degas Monotypes*. Text by Eugenia Parry Janis, 1968.

Hudson Guild, New York. *Exhibition of Paintings, Etchings and Drawings by John Sloan*, February 10 – April 10, 1916.

Kleemann-Thorman Galleries, New York. *Exhibition of Recent Drawings and Monotypes by Albert Sterner*, April 13, n.d. (after 1931).

M. Knoedler & Co., Inc., New York. *William Merritt Chase 1849-1916*. Text by Ronald G. Pisano, 1976.

Lefevre Gallery, London. *Degas Monotypes, Drawings, Pastels, Bronzes*. Foreword by Douglas Cooper, 1958.

Lunn Gallery/Graphics International, Ltd., Washington, D.C. *Jacob Kainen. Recent Works*, 1978.

Macbeth Gallery, New York. *Monotypes in Black and White by Seth Hoffman*, February 4-18, 1930.

Museum of Fine Arts, Boston. *American Prints 1813-1913*. Text by Clifford S. Ackley, 1975.

The Museum of Modern Art, New York. *The Work of Jean Dubuffet*. Text by Peter Selz and Jean Dubuffet, 1962.

_____. *Marc Chagall: Prints, Monotypes, Illustrated Books*. Text by Riva Castleman, 1979.

National Collection of Fine Arts, Smithsonian Institution, Washington, D.C. *John White Alexander (1856-1915)*. Text by Mary Anne Goley, 1976, nos. 32 and 33.

Neuberger Museum, Purchase, New York. *Mary Frank: Sculpture, Drawings, Prints*. Text by Hayden Herrera, 1978.

The Newark Museum, Newark, New Jersey. *Walkowitz: An Exhibition of Paintings, Drawings and Prints,* January 7–April 6, 1941.

Oakland Museum. *Monotypes in California.* Text by Therese Thau Heyman, 1972.

Marilyn Pearl Gallery, New York. *American Monotypes: 100 Years.* Text by Robert Flynn Johnson, 1979.

Philadelphia Museum of Art. *Giovanni Benedetto Castiglione, Master Draughtsman of the Italian Baroque.* Text by Ann Percy, 1971.

_____. *Paul Gauguin: Monotypes.* Text by Richard S. Field, 1973.

Philadelphia Society of Etchers. *Catalogue of the First Annual Exhibition of the Philadelphia Society of Etchers,* December 27, 1882 – February 3, 1883.

The Phillips Collection, Washington, D.C., and Des Moines Art Center. *Matt Phillips: Monotypes 1976-1977.* Text by Judith Goldman, 1978.

Photo-Secession Gallery ("291"), New York. *Exhibition of Monotypes and Drawings by Mr. Eugene Higgins,* November 27–December 17, 1909.

Portland Museum of Art, Portland, Maine. *Paul Dougherty: Paintings, Watercolors, Monotypes,* 1978.

Pratt Graphics Center, New York. *Monotypes.* Text by Matt Phillips, 1972.

Princeton University Library, Princeton, New Jersey. *Milton Avery Monotypes.* Text by Bonnie Lee Grad, 1977.

St. Louis Museum of Fine Arts. *Paintings, Watercolors, Etchings, Pastels, and Monotypes by Mr. L. H. Meakin,* January 1909.

Salmagundi Sketch Club, New York. *Catalogue of the Fourth Annual Black and White Exhibition,* December 1-21, 1881.

_____. *Catalogue of the Fifth Annual Black and White Exhibition,* December 1-21, 1882.

Santa Barbara Museum of Art. *Contemporary Monotypes.* Text by Betty Klausner, 1976.

Galerie Smith-Andersen, Palo Alto, California. *Nathan Oliveira, Tauromaquia 21.* Text by Lorenz Eitner, 1973.

Smithsonian Institution Traveling Service, Washington, D.C. *New American Monotypes.* Text by Jane M. Farmer, 1978.

Society of Iconophiles, New York. *Twelve Reproductions in Colored Photogravure of Monotypes by C. F. W. Mielatz,* October 26, 1908.

Alan N. Stone Works of Art, Northampton, Massachusetts. *American Monotypes of the Early Twentieth Century.* Text by James A. Bergquist, 1976.

Utah Museum of Art, Salt Lake City. *Abraham Walkowitz: 1878-1965.* Text by Martica Sawin, 1974.

Mrs. H. P. Whitney's Studio, New York. *Exhibition of Paintings, Etchings and Drawings by John Sloan,* January 20 – February 6, 1916.

Frederick S. Wight Art Gallery, University of California, Los Angeles. *Richard Diebenkorn Monotypes.* Text by Gerald Nordland, 1976.

Worcester Art Museum, Worcester, Massachusetts. *Catalogue of an Exhibition of Monotypes in Colour by Henry A. Wight,* April 22 – May 13, 1923.

William Zierler, Inc., New York. *Matt Phillips: Monotypes.* Text by Richard S. Field, 1973.

Periodicals

"A New Black and White Art." *The Studio,* vol. 7, no. 35 (February 1896), pp. 30-36.

"Art Notes [A. H. Bicknell and C. A. Walker]." *Art Journal,* vol. 43, no. 11 (November 1881), p. 352.

"Art Notes. The Monotypes . . . [C. A. Walker]." *Art Journal,* vol. 43, no. 12 (December 1881), p. 379.

Baldridge, Cyrus LeRoy. "A Chinese Album. Monotypes by C. LeRoy Baldridge." *Asia,* vol. 21, no. 12 (December 1921), pp. 1013-21.

Ballantyne, Kenneth M. and Mary E. "On Monotypes." *Art in New Zealand,* vol. 7, no. 4 (June 1935), pp. 197-208.

Benke, Marjorie. "How to Make a Monotype." *Design,* vol. 41, no. 5 (January 1940), p. 27.

Bluemner, Oscar. "Walkowitz." *Camera Work,* vol. 44 (March 1914), pp. 25-38.

Brayer, Yves. "La Technique du Monotype." *Bulletin de la Bibliothèque Nationale,* March 1978, pp. 36-38.

Breton, André. "D'une Décalcomanie sans objet préconçu." *Minotaure,* no. 8 (1936), pp. 18-24.

Brinton, Christian. "Apropos of Albert Sterner." *International Studio,* vol. 52, no. 207 (May 1914), pp. lxxi-lxxviii.

————. "The Field of Art: Monotypes." *Scribner's Magazine,* vol. 47, no. 4 (April 1910), pp. 509-12.

Calabi, Augusto. "The Monotypes of Gio. Benedetto Castiglione." *The Print Collector's Quarterly,* vol. 10, no. 3 (1923), pp. 221-53.

————. "The Monotypes of Gio. Benedetto Castiglione: A Supplement." *The Print Collector's Quarterly,* vol. 12, no. 4 (1925), pp. 435-42.

————. "Castiglione's Monotypes: A Second Supplement." *The Print Collector's Quarterly,* vol. 17, no. 3 (1930), pp. 299-301.

Campbell, Lawrence. "The Monotype." *Art News,* vol. 70 (January 1972), pp. 44-47.

Coffin, William A. "Monotypes with Examples of an Old and New Art." *Century,* vol. 53, n.s. 31 (November 1896-April 1897), pp. 517-24.

Cogle, Henry G. "On Making Monotypes." *The Artist,* vol. 14, Part I (September 1937), pp. 6, 7; Part II (October 1937), pp. 38, 39; Part III (November 1937), pp. 70, 71.

Craven, Wayne. "Albion Harris Bicknell, 1837-1915." *The Magazine Antiques,* vol. 106, no. 3 (September 1974), pp. 443-49.

Dodgson, Campbell. "Quarterly Notes [James Nasmyth]." *The Print Collector's Quarterly,* vol. 16, no. 1 (January 1929), pp. 2-4.

Dubuffet, Jean. "Empreintes." *Les Lettres Nouvelles,* no. 48 (April 1957), pp. 507-27.

Ertz, Edward. "Monotyping." *International Studio,* vol. 17, no. 67 (September 1902), pp. 172-77.

Field, Richard S. "The Monotype: A Majority Opinion?" *The Print Collector's Newsletter,* vol. 9, no. 5 (November-December 1978), pp. 141-42.

Fullwood, A. Henry. "The Art of Monotyping." *International Studio,* vol. 23, no. 90 (August 1904), pp. 149-50.

Gallatin, Albert Eugene. "The Art of Ernest Haskell." *International Studio,* vol. 44, no. 174 (August 1911), pp. xxxii-xxxiv.

Gilbert, Lundi. "The Monotypes of Seth Hoffman." *Bulletin of the Milwaukee Art Institute,* vol. 4, no. 5 (January 1931), p. 5.

————. "The Monotypes of Seth Hoffman." *Prints,* vol. 1, no 2 (January 1931), pp. 28-35.

Guarino, Salvatore Antonio. "Monoprints." *Country Life* (American), vol. 35, no. 5 (March 1919), pp. 49-51.

Guérin, Marcel. "Notes sur les monotypes de Degas." *L'Amour de l'Art,* vol. 5 (1924), pp. 77-80.

Gusman, Pierre. "Les monotypes de G.-B. Castiglione." *Byblis,* vol. 2, no. 8 (Winter 1923), pp. 153, 154.

Haviland, Paul. B. "Photo-Secession Notes [Walkowitz Exhibition]." *Camera Work,* no. 44 (March 1914), pp. 39-44.

Haynes, Pauline. "How to Make a Monotype." *The American Art Student,* vol. 1, no. 7 (March 1917), p. 5.

Hoffman, Seth. "The Making of Monotype." *Bulletin of the Milwaukee Art Institute,* vol. 4, no. 5 (January 1931), p. 12.

Janis, Eugenia Parry. "Degas and the 'Master of Chiaroscuro.'" *Museum Studies 7.* The Art Institute of Chicago, 1972.

————. "The Role of the Monotype in the Working Method of Degas." *Burlington Magazine,* vol. 109, Part I (January 1967), pp. 20-27; Part II (February 1967), pp. 71-81.

Koehler, Sylvester R. "Das Monotyp." *Chronik für vervielfältigende Kunst,* vol. 4, no. 3 (1891), pp. 17-20.

————. "The Works of the American Etchers: XVIII.—William M. Chase." *The American Art Review,* vol. 2, no. 1 (1881), p. 143.

Lauderbach, Frances. "Notes from Talks by William Merritt Chase, Summer Class, Carmel-by-the-Sea, California. Memoranda from a Student's Note Book." *The American Magazine of Art,* vol. 8, no. 11 (September 1917), pp.432-38.

Mather, Frank Jewett. "Paul Dougherty's Monotypes." *Vanity Fair,* vol. 12, no. 5 (July 1919), p. 44.

Mayer, R. "Monoprints." *American Artist,* vol. 34 (December 1970), p. 16.

Melot, Michel. "Les Monotypes d'Adolphe Appian." *Nouvelles de l'estampe,* no. 25 (January-February 1976), pp. 13-16.

Miller, John R. "The Art of Making Monotypes." *Brush & Pencil,* vol. 11, no. 4 (March 1903), pp. 445-50.

Montezuma (pseud.). "My Notebook [C. A. Walker and A. H. Bicknell]." *Art Amateur,* vol. 6, no. 2 (January 1882), p. 24.

————. "My Notebook [A. H. Bicknell and J. G. Low]." *Art Amateur,* vol. 7, no. 3 (August 1882), p. 47.

Nelson, George. "Notes on the Monotype. A Few Experiments with a Neglected Medium." *Pencil Points*, vol. 18, no. 12 (December 1937), pp. 785-92.

Ostertag, B. "Monotypes." *Brush & Pencil*, vol. 1, no. 2 (November 1897), p. 24.

Phillips, Matt. "About Monotypes." *Prometheus*. Newsletter of the Makler Gallery, Philadelphia, March 1962.

————. "The Monotype." *Artist's Proof*, vol. 8 (1968), pp. 50-59.

Poole, Emily. "The Etchings of Frank Duveneck." *The Print Collector's Quarterly*, vol. 25, no. 3 (October 1938), pp. 312-31.

Ratcliff, Carter. "Avery's Monotypes: Color as Texture." *Art in America*, January-February 1978, pp. 48-49.

————. "Mary Frank's Monotypes." *The Print Collector's Newsletter*, vol. 9, no. 5 (November-December 1978), pp. 151-54.

Renault, Malo. "Le Monotype." *Art et Décoration*, vol. 37 (February 1920), pp. 49-57.

Rouart, Denis. "Degas: Paysages en Monotype." *L'Oeil*, no. 117 (September 1964), pp. 10-15.

Russell, John. "Adolph Gottlieb: Late Works and Monotypes." *The New York Times*, February 17, 1978.

[Salisbury, William]. "A Monotype Made on Glass [Seth Hoffman]." *Prints*, vol. 1, no. 1 (November 1930), p. 53.

Schwarz, Katherine. "Monotypes: Where are they?" *The Print Collector's Newsletter*, vol. 9, no. 5 (November-December 1978), pp. 155-58.

Shapiro, Barbara, and Melot, Michel. "Les Monotypes de Camille Pissarro." *Nouvelles de l'estampe*, no. 16 (January-February 1975), pp. 16-23.

[Stieglitz, Alfred]. "Photo-Secession Exhibitions. Monotypes by Eugene Higgins." *Camera Work*, no. 29 (January 1910), p. 51.

"Try Your Hand at Monotype. Two Unusual Art Projects for Advanced Amateurs." *Design*, vol. 55, no. 1 (September-October 1953), pp. 20, 21.

Watson, Ernest W. "Monotypes of A. Henry Nordhausen." *American Artist*, vol. 11, no. 6 (June 1947), pp. 16-21, 54, 55.

————. "The Monotypes of Paul Branson." *American Artist*, vol. 12, no. 4 (April 1948), pp. 34-37.

Weitenkampf, Frank. "Mielatz, An Etcher of New York." *International Studio*, vol. 44, no. 175 (September 1911), pp. xxxix-xlvi.

Woolfolk, Eva Marshall. "Monotyping." *Palette and Bench*, vol. 2 (September 1910), pp. 306-308.

INDEX OF ARTISTS

Titles of works by each artist are followed by their catalogue number.

COMPOSITION BY
Finn Typographic Service
PRINTED BY
Acme Printing Company, Inc.
BOUND BY
American Book-Stratford Press

Photographs are by the Metropolitan Museum Photograph Studio,
and by staff photographers of the lending institutions; also
by Geoffrey Clements (fig. 33), eeva-inkeri (cat. no. 98),
X. de Gery (cat. no. 104), Studio/Nine, Inc. (cat. nos. 54, 56),
Soichi Sunami (cat. no. 82), John Szaszfai (fig. 50).